DRAWING AS EXPRESSION

D0209508

Drawing as Expression

TECHNIQUES AND CONCEPTS

SECOND EDITION

Sandy Brooke

Oregon State University

Upper Saddle River New Jersey 07458

Library of Congress Cataloging-in-Publication Data

Brooke, Sandy.
 Drawing as expression / Sandy Brooke.—2nd ed.
 p. cm.
 Includes index.
 ISBN 0–13–194005–8
 1. Drawing—Technique. I. Title.
 NC650.B697 2006
 741.2—dc22
 2006015701

Editor-in-Chief: Sarah Touborg
Senior Acquisitions Editor: Amber Mackey
Editorial Assistant: Cara Worner
Developmental Editor: Clare Payton
Director of Marketing: Brandy Dawson
VP, Director of Production and Manufacturing:
 Barbara Kittle
Senior Managing Editor, Production: Lisa Iarkowski
Production Liaison: Harriet Tellem
Manufacturing Manager: Nick Sklitsis
Manufacturing Buyer: Sherry Lewis
Cover Design: Sue Behnke
Cover Illustration/Photo: Brice Marden, *The Studio*,
 1990. Oil on linen. 92⅜ × 59 in. (235 × 150 cm.)
 MARB.PA.20957. Courtesy of Matthew Marks
 Gallery, New York. © Artists Rights Society
 (ARS), NY.

Pearson Imaging Center: Corin Skidds, Greg Harrison,
 Robert Uibelhoer, Ron Walko, Shayle Keating,
 Dennis Sheehan
Site Supervisor, Pearson Imaging Center: Joe Conti
Manager, Rights and Permissions: Zina Arabia
Image Permission Coordinator: Joann Dippel
Manager, Cover Visual Research & Permissions:
 Karen Sanatar
Cover Image Coordinator: Cathy Mazzucca
Composition: Pine Tree Composition Inc.
Full-Service Project Management: Jan Pushard
Printer/Binder: Courier, Kendallville, IN
Cover Printer: Phoenix Color Corp.

Credits and acknowledgments borrowed from other sources and reproduced, with permission, in this textbook appear on appropriate page within text. The Washington Consortium consists of: The Henry Art Gallery, University of Washington, Seattle; Museum of Art, Washington State University, Pullman; Northwest Museum of Arts and Culture, Spokane; Seattle Art Museum; Tacoma Art Museum; Western Gallery, Western Washington University, Bellingham; Whatcom Museum of History and Art, Bellingham.

Copyright © 2007, 2002 by Pearson Education, Inc., Upper Saddle River, New Jersey, 07458.
Pearson Prentice Hall. All rights reserved. Printed in the United States of America. This publication is protected by Copyright and permission should be obtained from the publisher prior to any prohibited reproduction, storage in a retrieval system, or transmission in any form or by any means, electronic, mechanical, photocopying, recording, or likewise. For information regarding permission(s), write to: Rights and Permissions Department.

Pearson Prentice Hall™ is a trademark of Pearson Education, Inc.
Pearson® is a registered trademark of Pearson plc
Prentice Hall® is a registered trademark of Pearson Education, Inc.

Pearson Education LTD.
Pearson Education Singapore, Pte. Ltd
Pearson Education, Canada, Ltd
Pearson Education–Japan
Pearson Education Australia PTY, Limited

Pearson Education North Asia Ltd
Pearson Educación de Mexico, S.A. de C.V.
Pearson Education Malaysia, Pte. Ltd
Pearson Education, Upper Saddle River, New Jersey

10 9 8 7 6 5 4 3 2 1

0-13-194005-8

To future artists Sydney Gladu and Chance Gladu,
along with my main support Henry Sayre.

CONTENTS

PREFACE

The critic Théophile Thoré wrote, "A composition exists at that moment when the objects represented are not there simply for their own sakes, but in order to contain, beneath a natural appearance, the echoes that they have placed in our soul." It is in this spirit that I titled the book *Drawing as Expression*. The work of the great masters, Michangelo, da Vinci, and Rembrandt, is respected because they went beyond representation. They achieved a quality of vision and understanding about nature that changed the way we see nature. Expressive drawing is the expression of ideas and emotions using a two-dimensional visual language. It is the translation of invisible states of mind into a visual language.

The title *Drawing as Expression* directly refers to both the tradition of drawing prior to 1900 and the change in the direction that drawing has undertaken since the beginning of the twentieth century. Since 1900, illustration of nature has been of no real importance to artists from Picasso to de Kooning. Drawing has changed even more dramatically since 1940 when the possibilities of drawing expanded across media and disciplines. Currently, Susan Rothenberg, Terry Winters, Jonathan Borosky, and Robert Morris have redefined the possibilities of drawing, opening new arenas. In addition to this historical division, *Drawing as Expression* is about thinking through drawing. Through drawing, you express your ideas, create a visual language and a narrative. You use your critical thinking skills along with your intuition. Drawing is equally a function of the left brain, or structure and logic, and the right brain, chaos, deconstruction, and dreams. Expression is the ultimate goal of critical and creative thinking and it is well founded in the techniques and concepts of drawing.

The book is not written sequentially. Instructors may use any chapter in any order they prefer. Instructors may also use any amount of the chapter that fits their curriculum. It was not intended to cover only what an instructor might complete in one term or one semester, but selections can be taken out of the book to match the instruction given in the course. It covers all aspects of drawing to help with instruction through basic skills, techniques, and concepts. If instructors want students to gain more knowledge about an aspect of drawing that they can only touch on with a couple of lessons in class, they can assign the students to read a few pages of the book. This will reinforce their teaching and increase the students' understanding of the material at hand. Students can use the book as a resource to look up what the instructor is teaching or just to better understand the concepts and techniques of drawing.

The book was designed to provide instruction on many levels. It provides students with information about drawing techniques, the function of drawing, and the concepts associated with good drawing. Drawing exercises are placed throughout the chapters, providing students with lessons to reinforce the concepts and techniques they are studying. Chapter 1 is a brief overview of the history of drawing to orient the students. Chapters 2 through 9 of the book cover the basic skills from the tradition of drawing. Chapter 10 is solely dedicated to the advancement of color in drawing. I have expanded the discussion of contemporary art in Chapter 11 with a discussion of the changes in drawing and thinking in the arts from Paul Cézanne to Jonathon Borofsky. It is the type of chapter that instructors might use in a concepts of drawing course. Chapter 12 discusses in depth the various papers and drawing mediums to help students understand the tools of drawing.

This book was written directly to the student in an effort to help students better understand the instruction they receive in class. I have tried to keep the writing in the book direct, factual, short; neither flowery nor ambiguous. I have used only a few student examples of drawing that I hope will relate to the students and provide them a window into the

process of drawing. In addition, I have written an in-depth discussion of certain drawing processes: hatching and crosshatching, the use of value in a drawing, the process of drawing drapery, perspective, and foreshortening. Professional and student drawings are analyzed sometimes with diagrams in the book to explain drawing concepts like the picture plane, the importance of value, and the qualities of line. Historical profiles of artists are distributed throughout the chapters in which the artist's direction, style, and use of drawing is discussed.

NEW IN THE SECOND EDITION

In this second edition are many new examples of drawing by contemporary, professional artists such as Kevin Appel, Jennifer Pastor, Paul Noble, Shahzia Sikander, Kara Walker, Georg Baselitz, William Kentridge, and the young Chinese artist Cai Guo-Qiang who draws with gunpowder and imagines huge projects that are conceptually challenging. An effort was made to locate fresh, new images different from those available in other drawing books, such as Kara Walker's, *Look Away, Look Away*, a wall installation from The Battle of Atlanta: Being the Narrative of a Negress in the Flames of Desire–A Reconstruction, 1995, Frank Helmuth Auerbach's *Untitled (E.O.W. Nude)*, Donald Sultan's, *Warm and Cold*, Christo's Wrapped Reichstag (project for Berlin), 1982, and The Gates, Central Park, NYC, 2005, and *Soho on the Beach* by William Kentridge.

An Art Critique was designed and placed at the end of each chapter to help students understand how to look at a drawing. The work of professional artists is discussed, describing their intent, purpose, and direction. It attempts to address what artists are doing and how they are using the formal elements in their drawings.

Strategies for Drawing are points for the students to review when making a drawing. The intent was to focus students in the beginning on a particular aspect or formal element of drawing. If the direction of the drawing is a perspective drawing, gesture drawing, or line drawing, students are given some directives to think about in starting the drawing in an effort to keep them focused on the assignment.

A new feature titled, Journal Focus, appears at the end of each chapter and provides a sketchbook exercise for the student to further explore the subject of the chapter. The sketchbook is an invaluable tool for students and the Journal Focus is there to give them a goal to work on in a sketchbook.

The content of the book was reorganized. The section on gender and race moved from Chapter 1 into Chapter 11 on modern and contemporary drawing as suggested by reviewers. New Chapter 9 covers the figure, the portrait, and drapery all in one chapter, combining content from three previous chapters. The clarity of the writing is improved overall, with the help of a few good editors.

ACKNOWLEDGMENTS

I would like to try and thank many of the people who have helped me. The student work in the book was photographed by Elizabeth Miller. The museums that provided the art were wonderful to work with. I wish to thank first and foremost Anita Duquette, from The Whitney Museum of American Art, without whose generosity this book would not have the number of contemporary drawings it now has. Anita single handedly brought artist after artist to my attention, sent art overnight, and was always there for me, thank you. Thanks to The Metropolitan Museum of Art, Stanford University and Alica Egbert, The Washington Consortium, The San Francisco Museum of Modern Art, The Hirshhorn Museum and Sculpture Garden and Amy Densford for their kindness and helpfulness, Yale University Art Gallery that sent me art overnight, The Art Institute of Chicago, Barbara Wood at The National Gallery of Art, The Tate Modern in London, and The Art Museum at RSID. The galleries I called were equally helpful and I would like to thank the Paula Cooper Gallery, Dawson Weber at Regen Projectgs, Froelick Gallery, Elizabeth Harris Gallery, Nolan/Eckman Gallery, Cai Guo-Qiang Studio, and the Phyllis Kind Gallery. I would like to thank my students for their drawings, and Peter Sears for his editing of the chapters. To the people at Prentice Hall thank you, Amber Mackey, Clare Payton, Harriet Tellem, and Bud Therien. I know I was difficult for my family to deal with, starting with my daily progress reports to the lists of what I had left to do, so for your patience and support, I salute Alberta and Milton Griffith, Christen, Christian, Sydney, and Chance Gladu, and my most tolerant husband Henry Sayre. Thank you all.

DRAWING FROM THE BEGINNING

The modern American painter Barnett Newman once said that the first artist was a man who picked up a stick and made a line in the dirt with that stick, thus creating the first drawing. Newman and other painters in New York City from the 1940s to the 1960s saw drawing as the most direct and unmediated method of catching the creative process as it happened. The cave dwellers at Chauvet in the south of France some 30,000 years ago may have felt the same way when they drew on the walls of the caves. The cave at Chauvet has the oldest recorded drawings of animals and human hand prints to date. Previous to Chauvet are the drawings in the cave at Lascaux dating back only 14,000 years. These drawings are a record of human expression prior to written language by some 12,000 years.

The walls were scraped before the drawings were placed on them, telling us that these early people purposefully prepared the surface to make the drawings. These drawings can be thought of as an early form of language and, as such, are directly tied to thinking as well as to seeing. Hand prints and thumb prints were placed alongside drawings of horses, rhinos, and large cats.

In addition to the drawings, some images were engraved or carved into the walls. This early **bas relief** (carving that is slightly elevated out from the stone background) can be viewed as a precursor to later engraving and printmaking. Printmaking and drawing themselves are closely related, sharing line techniques such as cross-hatching, contour, and other marking methods. To illustrate a concept of drawing, books about drawing will often use an **etching,** a printing process in which lines can be engraved on a metal plate or drawn into a ground on the plate and then etched into the plate with acid. A **lithograph** may also be used; it is a drawing done on transfer paper or directly on a stone with a greasy pencil or an ink-like material known as tusche. Barnett Newman's (fig. 1.1) *Untitled, 1961*

is a lithograph. Once the drawing is constructed on the plate or the stone, the drawing is etched with acid, and then it can be reproduced using a printing press. The initial development of the print is technically a drawing.

The history of drawing is a continuous one, from cave drawings to the Renaissance. Drawing plays a significant role in one of the last primitive cultures living today, the Australian Aboriginals. The Aboriginals have no word for art: they have only songs, ceremonies, maps, rock paintings, and body painting as lifestyle forms. Communicating through symbols, marks, and pictures, they have developed a series of symbols that we might class as abstract but that to them represent ideas, locations, descriptions of events, and symbols for ceremonies important to their way of living. The Aboriginals draw on the sand, the earth, rock walls, birch panels, and sticks.

There are also ancient drawings made by the ancestors of the Aboriginals; depictions of animals have been found on the walls of caves and cliffs, which were made thousands of years ago. The Aboriginals believe that through drawings and paintings, they can communicate with their ancestors, whom they revere on the highest level as the creators of all things in their world. fig. 1.2 is a modern example of an Aboriginal image. Anthropologists in the 1970s, fearing that the folklore of the Aboriginals would be lost, provided them with acrylics and canvas board upon which to record their traditional symbols and stories. Today many of these paintings are sold in New York at high prices.

In the Western world, drawing was first considered an art during the Renaissance (1400 to approximately 1540 CE). In 1419 Alberti discussed linear perspective in his book on painting in 1419. Filippo Brunelleschi, an architect and a painter, together with Alberti, developed the process and concept in which the three-dimensional world could

FIGURE 1.1

Barnett Newman, (1905–1970), *Untitled,* (1961). lithograph, 17/25, 38 cm. × 28.5 cm. *Works on Paper: 1945–1975.*. The Washington Art Consortium Henry Art Gallery, University of Washington, Seattle; Museum of Art, Washington State University, Pullman; Northwest Museum of Arts and Culture, Spokane; Seattle Art Museum; Tacoma Art Museum; Western Gallery, Western Washington University, Bellingham; Whatcom Museum of History and Art, Bellingham. Photo credit: Paul Macapia (1976). 76.12. © 2005 Barnett Newman Foundation/Artists Rights Society (ARS), New York

be interpreted on a two-dimensional surface. The Italians refer to sketches as *pensieri,* meaning "thoughts" or "rough drafts." fig. 1.3 is such a rough draft, a loose line study by Pietro Da Cortona for a ceiling fresco.

The intellectual curiosity and inventiveness of Leonardo da Vinci is recorded in his drawings. Being left-handed increased his ability to do "mirror-writing," which is to write backwards. He used this skill to record entries in his notebooks that he did not want other people to read. In addition, he

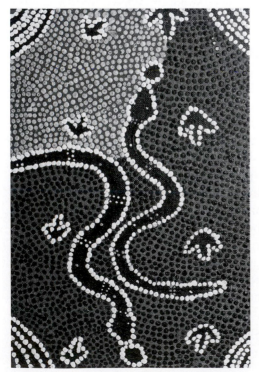

FIGURE 1.2

Billy Jaburula, *Snake Traveling North,* acrylic on canvas board, 9" × 12". From the collection of Henry Sayre and Sandy Brooke.

FIGURE 1.3
Pietro Da Cortona (Pietro Berret-
tini), Italy, (1596–1669), *Study for a
Figure Group in the Ceiling Fresco
of the Palazzo Barberini* (c. 1623),
pen and brown ink on ivory laid
paper, 110 mm. × 149 mm. In-
scribed lower right in another
hand: P Cortona. Mortimer C.
Leventritt Fund, Stanford Univer-
sity. Iris and B. Gerald Cantor
Center of Visual Arts at Stanford
University. 1977.12.

had his own system of signs and abbreviations that he used in writing about his working drawings to hide their meaning. We surmise that this was for his own protection against those who might charge him with heresy and witchcraft because his ideas and projects were so far ahead of their time. He also feared that his inventions might be put to destructive uses. He once wrote, "What would secure the good, if the bad invaded from the sky?"

In his art, Leonardo looked at analogies and universal principles of organic growth. A drawing of swirling grasses might relate to winding tresses of hair or the spiral movement of eddies of water. Each of his drawings was a complete statement influenced by a deep awareness of the relationships between all that exists and tireless exploration. The drawing *Designs for a Maritime Assault Mechanism and a Device for Bending Beams* (fig. 1.4)

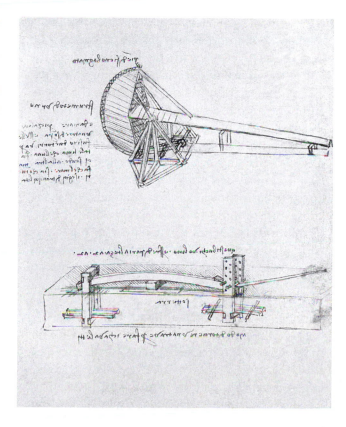

FIGURE 1.4
Leonardo da Vinci, (1452–1519), *Designs for Two Machines.*
(*Designs for a Maritime Assault Mechanism and a Device for
Bending Beams),* pen and brown ink, with traces of lead 11⅜" ×
7¹⁵/₁₆", (243 mm. × 188 mm.). Gift of trustee, Pierpont Morgan
Library, New York, NY. U.S.A. inv. [recto] [Drawing is known by
two titles.]. Photo Credit: The Pierpoint Morgan Library/Art Re-
source, NY. 1986.50.

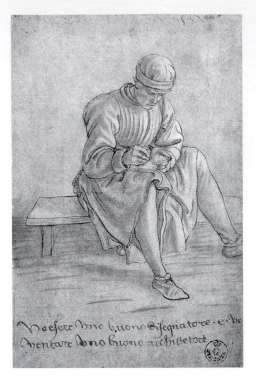

FIGURE 1.5
Maso Finiguerra, (1426–1464), *Draftsman,* pen and brown ink, brush and brown wash, over traces of black chalk or leadpoint, on off-white paper partly tinted with red-pink wash, 194 mm. × 125 mm. Gabinetto Disegni e Stampe dei Uffizi, Florence, Italy. Scala/Art Resources, New York. 115F.

shows two images. The image on the top is a monumental device intended to be attached to the bow of a large boat attacking an enemy's castle on the coast. The long arm at the right would swing up with a counterweight; the curved receptacle on the left was filled with heavy, wet hay. Once the ladder was placed against the walls or towers, soldiers then could climb over the walls. Da Vinci's note on the left of the image and in mirror-writing says, "device to be used during daytime from the sea to climb a tower above, and . . . make sure the sea shows all signs of being calm." At the bottom of the paper, in a larger proportional scale than that of the device above, appears a *Device for Bending Beams.* The design is a wedge-and-lever assembly on posts buried in the ground that can be used to apply pressure to make a wood beam curve. Leonardo's note below the image says, "manner of bending a beam to make frameworks"—a device that would have been very helpful to architects contructing large domes.

Some scholars believe that Leonardo never intended to build many of the ideas in his drawing books. Drawing not only provided an outlet for the thousands of ideas that he had but also preserved his thinking process. Therein lies the difference between an artist's sketches and his finished work. The sketches could be done quickly, by working out problems of space, volume, form, engineering and technical solutions. The artwork itself often took years and the help of many apprentices to complete. "Tell me if anything was ever done," Leonardo asked in his manuscripts. This quote expresses his frustration at having limitless vision in all fields while having constraints that left him powerless to realize a final form or product.

Leonardo is credited with developing a soft modeling in light and dark called **sfumato,** similar to the description of chiaroscuro in this book, which enabled him to overcome a previous drawing process called **quattrocento.** Vasari described the earlier techniques of qauattrocentro as "the dry and hard manner of modeling form," and he praised Leonardo's new method.

An artist's course of study during the Renaissance was gradual. The first drawing surfaces were wooden tablets, which were boxwood panels the size of the hand. The young student artist would draw on this box with a steel point. Fig. 1.5 shows a student working on such a box. After each drawing was completed, it was smoothed out with powdered cuttlebone on both sides. Bone dust and saliva were mixed together to create the working surface. The metal point used for drawing was similar to that used in silverpoint, which is discussed in Chapter 12.

The process of studying to be an artist during the Renaissance was a long one. The hand, the eye, and the memory were schooled first to understand form. Leonardo once described the plan of study for apprentice artists. They must begin as apprentices to a master artist and study for five years. First, they studied perspective and then the shapes and measurements of many objects. In "rilievo," the second stage, they analyzed the surface by drawing from a simple natural object or a plaster cast. In addition, they drew copies of the master's work in order to accustom themselves to good proportions. By the third stage, students were expected to understand proportion and perspective by comparing sizes and relationships between near and distant objects. They went from drawing outlines to developing a sensitivity to shape, space, and light. This step would involve drawing outdoors. Finally, students drew from nature to test their learning. They were expected to spend time looking at the work of various masters. In addition to everything else, students—such as those studying under the Carracci family (fig 7.4) in Bologna—drew studies of bones, muscles, sinews, and veins from dissected corpses. Drawing the nude model was the last step in the five-year apprenticeship.

There was a dictated order for the use of drawing media in this study. Students started with silverpoint on wood boxes for the first year. In the second year, they made pen-and-ink sketches with wash, and then ink on colored paper with highlights. Finally, they drew with charcoal. Tintoretto's *Study after Michelangelo's Group of Samson Slaying the Philistines* (fig. 1.6) is black chalk heightened

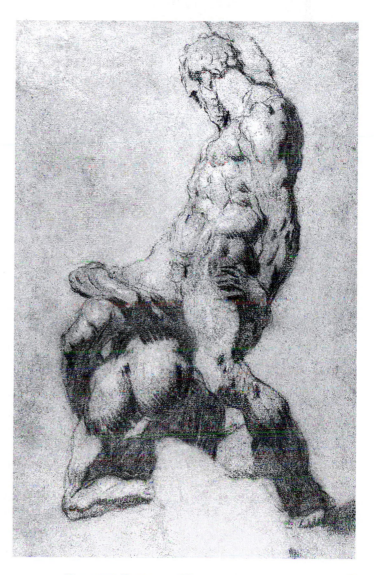

FIGURE 1.6
Tintoretto (Jacopo Robusti), Italy, (1518–1594), *Study after Michelangelo's Samson Slaying the Philistines,* black chalk heightened with touches of white chalk, on buff-gray paper, 245 mm. × 227 mm. Committee for Art Acquisitions Fund. Iris and B. Gerald Cantor Center of Visual Arts, Stanford University. 1983.231.

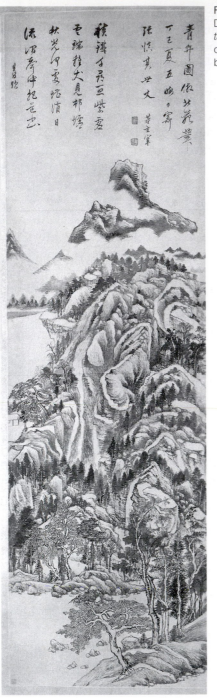

FIGURE 1.7
Dong Qichang, Chinese (1555–1636), *The Qingbian Mountains,* (1617), hanging scroll, ink on paper, 224.5 cm. × 67.2 cm.). The Cleveland Museum of Art, Leonard C. Hanna, Jr., bequest. 1980.10.

an artist was to "Read ten thousand books and walk ten thousand miles." He meant that one must first study the works of the great masters and then follow "heaven and earth," studying the world of nature. Dong's view was that a painting or drawing of scenery and the actual scenery are two very different things. Paintings of his own, such as *The Qingbian Mountain* (fig. 1.7) reflect his feeling that the excellence of a painting or drawing does not lie in its degree of resemblance to reality—that gap can never be bridged—but in its expressive power. The expressive language of drawing and painting is inherently abstract and lies in its nature as a construction of brushstrokes. For example, in drawing a rock, the rock itself is not expressive but the marks and the brushstrokes that build the rock are expressive.

The stages of knowledge, initiation, learning, and illumination are completed by creativity. The idea is just the beginning: the artist must have the ability to develop unity and integrity in the entire composition. For the great artists of the Renaissance, the path to art began in drawing.

By the end of the fifteenth century, drawing was considered an act that embodied the artist's personality and creative genius. In fact, people began collecting drawings, thereby confirming their value. Giorgio Vasari himself was a major collector of drawings. During this period of time, Michelangelo destroyed most of his drawings because he didn't want anyone to steal his creative process or discover his way of working. Vasari was the first to recognize drawing as a manifestation of creative thinking. He observed that the drawings of artists such as Michelangelo and Leonardo were as close as we would come to seeing the "actual creative moment."

The progress and significance of drawing can be seen in the drawings and the purpose of the artists from the Renaissance forward who regarded their drawings as a highly personal activity. Francisco José de Goya y Lucientes (1746–1828) created work that was comic, tragic, light and dark, passionate yet sardonic. The political and social upheavals of the French Revolution and the

with touches of white chalk on buff-gray paper. A well-proportioned drawing in perspective.

There are many similarities between Leonardo's course of study for students and that proposed by the Chinese poet, calligrapher, and painter Dong Qichang, who worked between 1555 and 1636 in southern China. Dong Qichang, in what is now a famous statement, said that the proper training for

FIGURE 1.8
Francisco Jose de Goya y Lucientes, (1746–1828), *Revenge upon a Constable,* wash drawing in sepia, 8¼ in. × 5¹¹⁄₁₆ in. The Metropolitan Museum of Art, Harris Brisbane Dick Fund, (1935). New York, NY, U.S.A. 35.103.49.

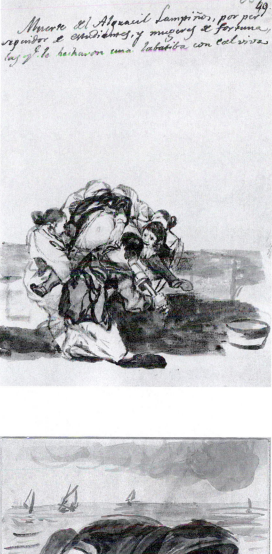

Napoleonic invasion of Spain were often the themes of his work. *Revenge upon a Constable* (fig. 1.8) illustrates the death of Constable Lampinos for his persecution of students and women of the town, who in this drawing are giving him a douche of quicklime. The tension between black and white in Goya's drawings embodies the moral ambiguity of modern life as well as it annnounces a new approach to using value changes in drawings. In *Revenge upon a Constable,* Goya is not modeling light falling on these figures; rather, the use of black and white creates volume by separating the figures in this tightly woven scene.

During the eighteenth and nineteenth centuries, great European draftsmen like Jean Auguste Dominique Ingres (Chapter 8, fig. 8.18) and Francisco José de Goya y Lucientes (fig. 1.8), worked to extend the tradition of drawing both realistically and expressionistically. The artists who followed these masters and learned from their example would be the ones to break with the traditional techniques begun in the Renaissance. Édouard Manet by 1880 would end modeling, as can be seen in *Isabelle Diving* (fig. 1.9), and would extend the high-contrast drawing developed by Goya. Vincent van Gogh (Chapter 6, figs. 6.25 and 6.27) concentrated on gestural marks to create the patterns and textures that make up his work. In his 1899 *Eqestrienne* (fig. 1.10), Henri de Toulouse-Lautrec (1864–1901) inaugurated a new scale and sense of perspective. In fig. 1.10 the horse is huge, dwarfing the rider and ring. His purpose is not to follow correct linear perspective by any means, but rather to express how he saw this rider and this horse. These are just some of the ways that Modernism freed drawing of old techniques and began to concentrate on drawing as an end in itself. By 1971 Cy Twombly (fig 7.25) compeltely flattened the picture plane rejecting the tradition of drawing in persective

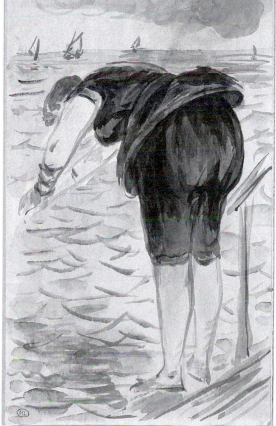

FIGURE 1.9
Edouard Manet, (1832–1883), *Isabelle Diving,* (1880), watercolor, 7⅞″ × 4⅞″ (20 cm. × 12.3 cm.). Photo: Gerard Blot. Louvre, Paris, France. Réunion des Musées Nationaux/Art Resource, New York, NY. © 2007 Artists Rights Society (ARS), New York, NY, U.S.A.

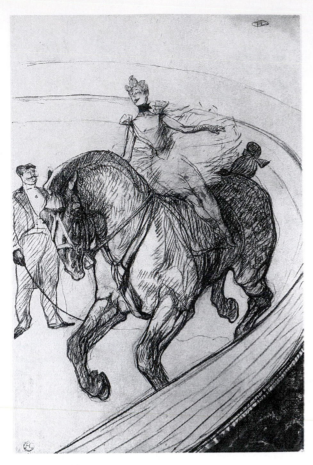

FIGURE 1.10
Henri de Toulouse-Lautrec (1864–1901), *Equestrienne* (1899), crayon, wash, 19¼″ × 12⅜″. Museum of Art, Rhode Island School of Design. Gift of Mrs. Murray S. Danforth.

whose main concern is the "process" whereby the meaning of the drawing is in the making of it. These two approaches to drawing are two very different ways of thinking. Drawings now go beyond a documentary purpose, achieving a different aesthetic: what Johann Gottlieb Fichte, a German Romantic philosopher, referred to as *sehen* ("knowing"), a knowing that includes perception, memory of perceptions, and the preservation of beautiful things that you want to remember.

John Ruskin, a British artist, aesthete, and critic, said that the purpose of drawing was to "set down clearly and usefully, records of such things as cannot be described in words, either to assist your own memory of them, or to convey distinct ideas of them to other people."

Jennifer Pastor may strive to know her subjects by drawing them, but not necessarily by drawing from life. She prefers artificial sources, such as photographs, props, and mass-produced decorations. These hybrids of images are, for Pastor, nature made more fabulous. In the series of motion studies of a rodeo rider on a bucking bull (figs. 1.11 to 1.17), Pastor is not so much sketching the bull and rider as tracing various circula-

DRAWING TODAY

Drawing cannot be clearly defined today. A drawing may be the result of an impulse by some artist to explore natural phenomena by recording them graphically, or a drawing may be made by an artist

FIGURE 1.11–1.17
Jennifer Pastor, *Flow Chart for the "Perfect Ride" Animation*, (1999–2000), pencil on paper, seven sheets each, 13½″ × 17″, (34.3 cm. × 43.2 cm.). Courtesy of Regen Projects, Los Angeles, California.

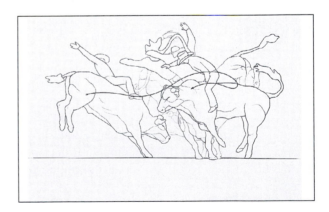

FIGURE 1.12

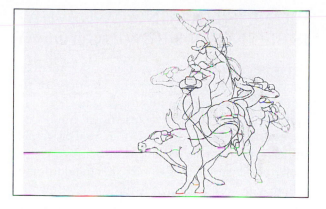

FIGURE 1.13

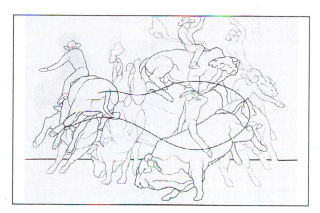

FIGURE 1.14

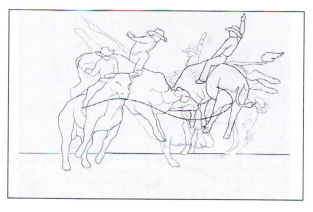

FIGURE 1.15

FIGURE 1.16

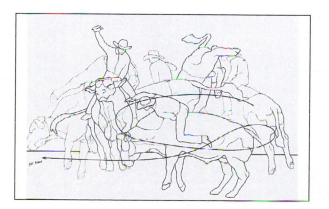

FIGURE 1.17

tion systems. The rodeo studies are less about the rider and his mount, and more about the parabolic trajectory of the body in motion. These studies are probably closer to a moving picture than to a drawing.

Drawing is a magical art. In no other medium can you go so directly from the thought process to image, unencumbered by materials or extensive preparation. Drawing accomodates all attitudes, whether you react directly to the forms around you or whether like Pastor you combine memory, inventing the space and planning complicated relationships.

WHAT IS LOOKING AND WHAT IS SEEING IN DRAWING TODAY

Seeing is at the heart of the interactive process of drawing. We perceive the external reality—or the real world, as it is commonly referred to—with our eyes open. With our eyes closed, the mind's eye searches the images of our inner reality, which stores memories of past adventures, activities, interactions, loves, feelings, and fears. In addition, it is here where we imagine the future. Our drawings come out of these two forms of vision—one external and the other internal.

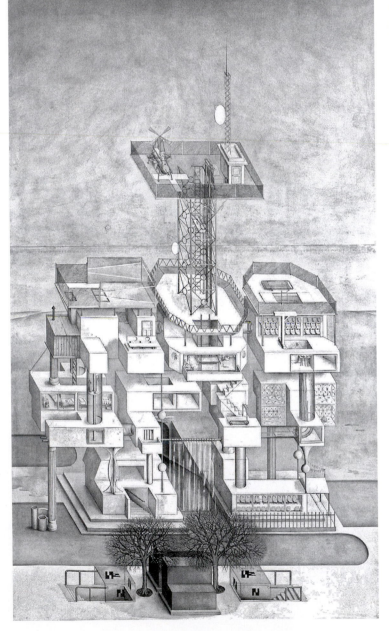

FIGURE 1.18
Paul Noble, *Nobspital,* (1997–98), pencil on paper, 8′ 2½″ × 4′ 11″ (250 cm. × 150 cm.) Courtesy of Maureen Paley London, England.

A drawing can communicate our thoughts and perceptions as well as our awareness of the world. The mind's eye is powerful. The information that our eyes send to our brains begins an active search by the brain and by the mind's eye for structure and meaning. Drawing takes more than manual skill, then—it also takes imagination. The imagination triggers the imaging and the visual thinking skills. In many ways, drawing creates a separate but parallel world to our reality. These drawn and created images speak to the viewer's eye. No matter how real these images appear, they can never be a reality; they are always an interpretation.

Barry Schwabsky, a critic, says, "Rational planning and utopian fantasy have always been surprisingly difficult to disentangle as in Paul Noble's *Nobspital* (fig. 1-18) he envisions a building from a world in his imagination. It is hyper-realistic in detail, and is drawn from an aerial perspective. His choice of the aerial perspective is intentional, he wants everyone to fly over the space. Here fantasy and reality mix. The drawing's realistic presence is deceiving, as it does not represent an actual building, it is a completely imaginary building. This drawing for Noble represents not a dream but a warning, is it what might be or what has been? Both take form, above all in drawing." For Susan Rothenberg, the significance is the very finding of a new formal device, the thickened line, which she de-

scribes as neither line nor shape but rather a "band." *For the Light*, 1978-79, (fig. 1.19) is a frontal, fully charging horse filling the canvas from top to bottom, held back against the picture plane by an abstracted bone shape that seems to smack against it and bar forward movement. She has managed to create motion and restrict it at the same time through the contemporary use of line; her line redefines the purpose of line. Her images of this period are both forceful and fragmented. It was Philip Guston in the early 1970s who set the state and tenor for Rothenberg's, and other artist's, figurative and autobiographical explorations in the years that followed. Guston was exemplary, not only for his exquisite surfaces and boldly convincing paintings, but also for his integrity and truthfulness in revealing, however painfully, the life of the artist as an integral part of their work.

We are visual thinkers. For example, we search for images in the clouds, making up animals out of cloud shapes from our imaginings. We see images in the outlines of stars in the night sky, and we have even named constellations. Seeing these forms is seeing in the abstract; we match new images with information in the mind's eye. The imagination is a visual bridge between our memories of the past and our vision of the future.

Drawing influences and changes thought just as thought informs drawing. Leonardo da Vinci is a marvelous example of an artist who

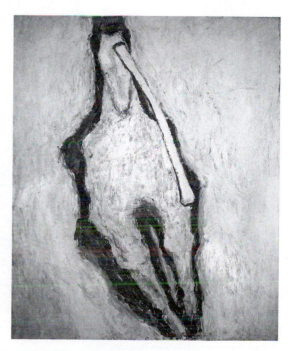

FIGURE 1.19
Susan Rothenberg, (1945–), *For the Light,* (1978-79), synthetic polymer and vinyl paint on canvas, 105″ × 87¼″, (266.7 cm. × 221.6 cm.). Purchased with funds from Peggy and Richard Danziger. Photograph credit: Geoffrey Clements. Collection of the Whitney Museum of American Art, New York, NY, U.S.A. © Artists Rights Society (ARS), New York, NY.

recorded his thoughts in his sketches and drawings. Leonardo knew that the design process began with an idea, and that the idea could be preserved in a drawing to be used later in a painting or sculpture.

One drawing can express only a limited amount of our perception. Both the area we focus on and the drawing tool or medium that we choose to use will alter the perceived information. In this way, a drawing never reproduces reality; instead, it parallels our experience, drawing creates another reality. Drawing is visual communication that stimulates awareness. A good drawing engages the viewer's eye and their imagination.

You can challenge your perception and check it by turning a drawing upside down to look at it. Change the distance at which you look at the drawing: move in very close, and then turn your back and walk twenty feet away. Set up the drawing in front of a mirror, and look at it in the mirror. You will be able to see any problems in the drawing if you change the way you look at it. Small errors that muddy the communication of the drawing's meaning become clearer.

Ambiguous figures challenge one's visual awareness. Think about the images in figs 1.20 and 1.21 as positive and negative space. Look at the white shape, and then look at the black shape. You should be able to shift between the two, seeing first the vase and then the faces. In addition, the perception of these pictures is altered by their placement. The one on the left is enclosed by a black border, making it generally easier for the mind's eye to recognize. The one on the right has no outside border; thus, it is a bit more difficult to visually form the images inside it.

Betty Edwards wrote a very perceptive book called *Drawing on the Right Side of the Brain*, in which she discusses the two sides of the brain. The left side is dominant, controlling (1) verbal abilities; (2) analytic figuring; (3) symbolic understanding, in which we recognize that a symbol stands for something; (4) rational thinking, including reason and facts; (5) digital thought, or the use of numbers; (6) temporal awareness, which keeps track of time; and (7) abstract thinking, which can take small bits of information and create a logical and linear process by which one

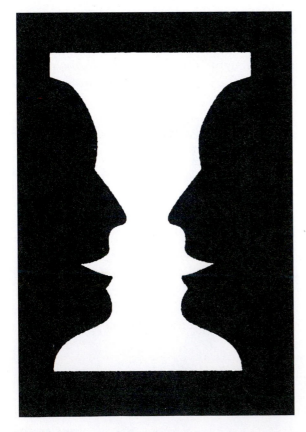

FIGURE 1.20
Ambiguous space, the Vase and the Face.

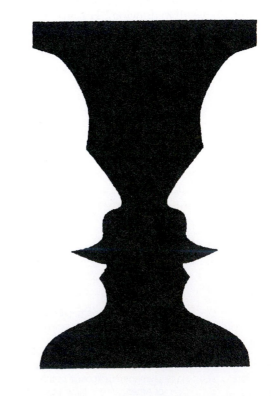

FIGURE 1.21

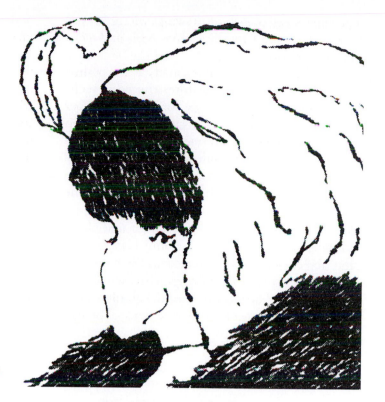

FIGURE 1.22
An illusion designed by psychologist E. G. Boring in 1930. The profile of a young woman or the head of an older woman.

thought directly follows another. The right side of the brain controls (1) nonverbal awareness; (2) synthetic meaning in which we can put ideas together; (3) the nonrational, in which we suspend judgment; (4) the spatial, where we put parts together in relation to each other; (5) the intuitive, including leaps of faith; and (6) holistic thinking, which allows you to see the whole all at once and to perceive overall patterns leading to divergent conclusions.

The image in fig. 1.22 is an illusion designed by psychologist E. G. Boring in 1930. If you look carefully, you will see either the profile of a younger woman or the head of an older woman. Illusions like these are meant to convince you that you sometimes don't see what is right in front of you and that your brain doesn't automatically and unconditionally understand what you see. The information you see and how you perceive it depends on how hard you are willing to push your brain out of its comfort zone. You have to make an effort to see all that is around you, and you need to practice seeing to improve your drawings. Seeing is a learned and developed skill.

Often students draw much better when an image is placed upside down. The reason for this outcome may rest in the separation of powers in the brain. When the logical left side can't match this information in the mind's eye, it quits and turns the job over to the right side. It is the perfect task for the right side, which rises to the occasion.

Drawing requires practice. When some people don't achieve perfection, they quit. They believe that they have no talent for art, and so they push it away. If you think about it, you really had no talent for walking when you were born, but you are doing quite well at walking at the age you are now. You got here with practice, and practice will also teach you to draw. Your drawings do not need to represent the subject in a perfect likeness. If you will draw your subject over and over, you will improve.

Henri Matisse once said that he would rather students did not see his drawings because the uninitiated student thinks that his simple line looks easy and so was easy to do. But in fact, he did at least a hundred drawings to reach one in which this simple line was the descriptive line he desired.

THE POSSIBILITIES OF DRAWING TODAY

From the beginning you should experiment with all modes of drawing. Don't seek a polished technical performance or style. You need to explore.

The experience of making drawings will teach you how to draw and how the various tools and techniques function.

In the twentieth century, many artists pushed the envelope of what consitutes the basic techniques and tenets of drawing. For example, Jasper Johns was one of the young artists who expanded on the priniciples of the Abstract Expressionists. He took their drip, their brushstroke, their composition based in abstraction, and turned them into techniques for the new directions of Pop Art. The Pop Artists used the "found object" and products of mass culture as their subject matter and pictorial images. In the mid-1950s, Johns began to exploit objects like flags and targets as the basis for a series of paintings and drawings with two related consequences. The first involved the absolute closing out or flattening of the picture space. The second was the depersonalization of the pictorial image. Here in *Painting with Two Balls*, 1971 (fig. 1.23), the velvety stroke of pencil or crayon seems to create an expressive surface, but these marks sit on top of the surface with the title of the work stenciled on the bottom of the piece. To further remove the personalization of the abstract expressionists mark, he goes one step further, by translating this drawing into a print. The previous handwrought and unique aspects of drawing are now a mechanical reproduction. The image can be reproduced over and over by a machine instead of his hand. In some ways, his work is the constriction of gesture, not the expansion it would be to the Abstract Expressionists.

In later chapters, you will see artists create art with scribbling, fingerprint stamps, and dripping. Artists may draw on the floors and on the walls, in-

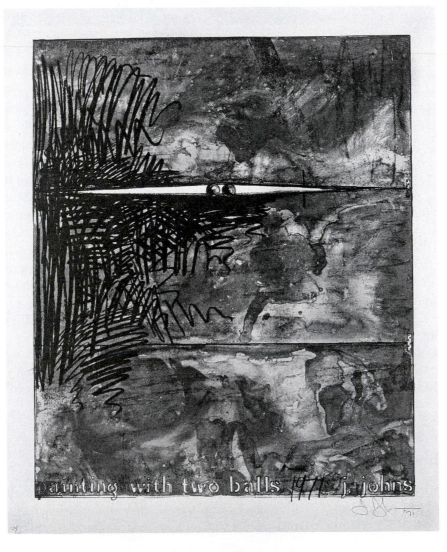

FIGURE 1.23
Jasper Johns, New York, U.S.A., (1930–), *Painting with Two Balls,* (1971), silkscreen print, 22/66, 88 cm. × 72 cm. The Washington Art Consortium: Henry Art Gallery, University of Washington, Seattle; Museum of Art, Washington State University, Pullman; Northwest Museum of Arts and Culture, Spokane; Seattle Art Museum; Tacoma Art Museum; Western Gallery, Western Washington University, Bellingham; Whatcom Museum of History and Art, Bellingham. Photo Credit Paul Brower. Jasper Johns/Licensed by VAGA, New York, NY. 76.

stalling their drawings more permanently into a space. They might use nontraditional materials such as gunpowder or Xerox fluid. At the same time, there are artists today using very traditional materials and subject matters. Drawing today is open to invention.

PROFILE OF AN ARTIST: *KÄTHE KOLLWITZ 1867–1943*

Käthe Kollwitz, who was born in 1867, was fortunate to have been given instruction in the arts, an unusual opportunity for a woman to have at this time. When she decided to marry at a very young age, her father was disappointed. He feared that, as had happened with her sister, Käthe's marriage would end her art career. He warned her that it would be hard to combine her art and her family. Kollwitz struggled with the demands of family and of art, and she somehow was able to balance her two lives.

She believed her art had a purpose, and she wanted "to be effective in this time when people are so helpless and in need of aid." Kollwitz was married to a doctor who felt that his calling was to help poor workers, not the people of the middle or the upper class. This was a philosophy she shared.

Käthe Kollwitz is often called the "Mother of Expressionism," in the same manner that the artist Edvard Munch, who painted *The Scream,* could be called the "Father of Expressionism." Her work, however, came well before the work of the German Expressionists. Like Goya, her work combined the personal and the political. She too was a master at using high contrast, balancing black and white to create the greatest drama and the richest space of drawing. The human figure was her subject. Kollwitz showed us the horror of hunger, war, and poverty, as well as beauty, love, and caring.

Determined to make prints that workers could afford, she worked in black and white, simply and inexpensively. She concentrated on the life of the workers in Germany, illustrating the working conditions that were worse than sweatshops in Third World countries today. Kollwitz made posters that called attention to the issues of abortion, hunger, alcoholism, children's safety, and worker safety. In *The Downtrodden* (fig. 1.24), there is a helplessness for

FIGURE 1.24
Käthe Kollwitz, (1867–1945), *The Downtrodden,* (1900), silkscreen in 3 colors on J.B. green, 882. cm. × 71.7 cm., etching and aquatint on paper, 12⅛″ × 9¾″. The National Museum of Women in the Arts, Washington D.C. Gift of Wallace and Wilhelminia Holladay.

FIGURE 1.25
Käthe Kollwitz, (1867–1945), *Self-Portrait, Drawing,* 1933. Charcoal on brown laid Ingres paper (Nagel 1972 1240), 18¾ in. × 25 in. *Works on Paper: 1945–1975.* Rosenwald Collection. Image © 2006 Board of Trustees, National Gallery of Art, Washington D.C. © 2003 Artists Rights Society, New York/VG Bild-Kunst, Bonn. 1943.3.5217.

the child who is probably dying because the parents can't afford any medical help.

The death of her son Peter in World War I confirmed Kollwitz's lifelong opposition to war. She saw the irony of the old sending the young to kill one another. Till the time of her death she worked as an antiwar promoter. Both her private suffering and her political oppression were reflected in her art: her politics and aesthetics were joined in her prints and drawings.

For Kollwitz, drawing and graphic techniques were best suited to her quest to express the darker aspects of life, for she believed in the power of line and gesture. In the drawing *Self-Portrait* (fig. 1.25), we see a fine example of the strength with which she empowered lines. The hands in her drawings are generally drawn large making them extremely expressive.

She made over a hundred drawings, lithographs, and sculptures of herself, thus leaving an amazing biography. Looking from one to another, we watch her grow old, and it seems that her face begins to reflect the faces of the workers. She once said that bisexuality was a necessary factor in artistic production and that it was the piece of masculinity within her that helped her in her work.

With stoic strength Kollwitz endured both World War I and World War II, defending her art to the Nazis. She died convinced that one day a new ideal would arise and never again would there be war.

1. The first strategy is to learn to draw what you see, not what you know. For example, consider the circle and the square. When a circle—or a cylinder, as it becomes in still life—sits on a table, it is no longer a circle: it is an ellipse. The square in perspective, or as it sits on a table, no longer has sides at angles of 90 degrees. The sides vanish and angle together toward the horizon in order to fit correctly in the composition. You must be familiar with the shape of the circle and the square, but to see them in order to draw them, you need to apply linear perspective (Chapter 5). Seeing is more informed than knowing.

2. Patience is important, as well as thinking about the space you are planning to draw.

3. Seeing is subjective, not objective. Not everyone sees the same thing. To test this phenomenon, take a walk with friends down one block of your city, and then sit down with your friends and ask each one what he or she saw. Each one will have seen something different.

4. It is this difference that is important to drawing, because it is in difference that personal expression develops. Draw your personal view, your thoughts, and your memories. Develop your visions, to develop the expressive quality in a drawing that separates the obvious or mundane from the visionary. You must be insightful.

Drawing in a journal is great practice, and no one but you needs to see the drawings. Here you explore and experiment with all the tools. You may take a picture, turn it upside down, and draw it from that view. You may select a focus and draw it forty times from a different view, angle, and distance. This practice can teach you a lot about seeing. After you draw in your journal for three months, go back through the pages, and look at the drawings. You will be surprised at what you find.

GESTURE DRAWING

Gesture drawing refers to a style of drawing that uses rapidly drawn lines to express and define space, volume, and movement. The purpose of gesture drawing is to capture the essence of the subject, not to record fine details or to draw an accurate outline. Gesture drawing provides you the opportunity to search for the essential elements of the form and to discover new ways of seeing. To the uninitiated eye, gesture drawings may look like an unstructured mess, but gesture drawing is a creative act that develops visual awareness. You learn to "see" clearly, to analyze things visually, and then to respond accurately to the subject.

DEVELOPING VISUAL AWARENESS

In *Dissent* de Kooning (fig. 2.1) captured the essence of his line. *Dissent* is a gesture construction of sections cut from a number of his other drawings and reassembled into a collage. *Dissent* demonstrates the possible, abstract character of gesture drawing. Not all drawings need to be photographic representations. Drawings may stem from feelings as well as from the imagination. The act of drawing generally requires a leap of faith. Trusting in the unknown, untraveled territory ahead is never easy.

Willem de Kooning's drawing *Figure* (fig. 2.2) from 1966 is charcoal on paper. He made this drawing on notebook paper simply because it was handy. De Kooning drew on any type of paper, thereby demonstrating that paper was not precious to him. His favorite type was vellum tracing paper.

Gesture drawing develops "seeing," which is the ability to analyze and translate objects from a three-dimensional space to a two-dimensional space. Gesture drawing develops a rapport, or communication, between the act of seeing and the marks you make on your paper representing what you are seeing. When your hand moves spontaneously in large gestures, you are storing information about what you are drawing that will help you draw more accurately later. What information are you storing? You are measuring each object in a still life against the other objects. You are noting the proportions, size, and scale of the objects. Gesture drawings should be relaxed with loose or jagged incomplete lines. As you look at the still life, notice the baseline of each object, and compare the height of each form to that of the others. A gesture line can go over the planes and through the air. It is not restricted to the outline or the contour. When you begin another drawing of the same still life, you will apply this information, making this second drawing much easier.

A drawing starts with the eyes gathering and sending information to your brain. The brain then sends directions to your hand. Gesture drawing can be called a "thinking line" because it requires you to make intuitive decisions. In gesture, not only do you render the outline of the object being drawn, but you also look further to the surface and the planes of the form. The drawing may use overlapping strokes that are created by moving the drawing tool across the paper in an effort to render what you see. The drawing may not look photographically like your subject; instead, it may be more of an impression with energy.

TECHNIQUES FOR GESTURE DRAWING

The tools used in gesture drawing range from Conté, compressed charcoal, ink, and charcoal pencils, to woodless pencils, lead sticks, and 6B drawing pen-

FIGURE 2.1
Willem de Kooning, American, born Rotterdam,
The Netherlands, (1904–1997), *Dissent*,
(1957–1958), oil and collage with strips of paper
on tan wove mount, 310 mm. × 305 mm. Signed
lower right in pencil: de Kooning. Bequest of Dr.
and Mrs. Harold C. Torbert. Iris and B. Gerald
Cantor Center of Visual Arts at Stanford University.
© 2006 Willem de Kooning Foundation/Artists
Rights Society (ARS), New York, NY. 1984.511.

cils (fig 2.3). (See Chapter 12, Media) for a complete description of materials. For gesture drawing sheets of newsprint or white drawing paper, 18 × 24 inches, ranging in weight from 60 to 80 pounds, work well. Smaller sizes or heavier weights of paper restrict freedom in making the drawing.

Because large arm movements are used in a gesture drawing, standing up to draw is better than sitting down. Do not rest on your drawing hand. It is important to keep your shoulder, elbow, and wrist free to respond to what you are looking at. With the drawing tool in contact with the paper, you may

FIGURE 2.2
Willem de Kooning, American, born Rotterdam, The Netherlands, (1904–1997), *Untitled,* charcoal on paper, 17″ × 13¾″, (43.1 cm. × 35.6 cm.), Hirshhorn Museum and Sculpture Garden, Smithsonian Institution, Washington, D.C. The Joseph H. Hirshhorn Bequest (1981). © 2006 Willem de Kooning Foundation/Artists Rights Society (ARS), New York, NY. 86.1345.

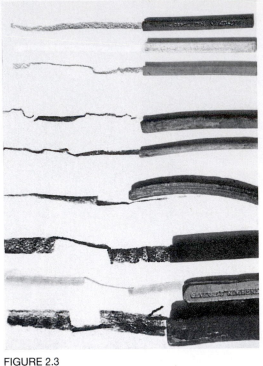

FIGURE 2.3
Conté and charcoal sticks in various thicknesses and lengths.

let the side of your hand or your little finger lightly touch the paper to guide the line. In some gesture drawings, you will keep the drawing tool in contact with the paper at all times. This method will help you keep in contact with the drawing because in most gesture drawing, you will not be looking at the paper but looking only at your subject.

The looseness of a gesture drawing allows the lines new freedom in your drawing. There will be overlapping lines as you search through the subject. These lines create volume rather than flat outlines. Gesture drawing is a great way to practice and improve your abilities and your depth of seeing.

By continually looking at the still life while your hand is moving spontaneously, you will improve your understanding of the space of the still life. Think of seeing as looking with intention. The depth of your observation skills and your visual awareness improves through gesture drawing. You can judge how your awareness is changing by making five drawings of the same subject from the same spot or position. Notice what is different and what is similar. How you see changes.

PROFILE OF AN ARTIST: *WILLEM DE KOONING, A MODERN MASTER 1904–1997*

Willem de Kooning was born in Rotterdam and was trained in a traditional art school in Holland. He was highly skilled in the techniques of drawing from the Renaissance forward. De Kooning came to New York in the 1920s as stowaway on a freighter, beginning his career in New Jersey as a sign painter, but by 1926 he had moved to New York City.

Willem de Kooning's drawings are almost all working drawings. Working drawings do not necessarily grow into a painting at any certain point. Working drawings are thinking drawings in which the artist experiments with shapes, line, and surface. As his paintings and drawings evolved, they did not depend upon each other. The drawings can stand alone, without becoming a study for a painting. Like Rembrandt, de Kooning drew constantly, and like Rembrandt, he drew from life around him. Drawing for de Kooning was different from his approach to painting. According to Tom Hess, a critic and close friend, for de Kooning to paint he felt he needed to be in a certain state of awareness to work. Drawing was different: he could draw while his mind was idling or when he

was resting in crucial stages during the process of making a painting. Throughout his career, de Kooning invented, enlarged, and perfected a huge repertory of shapes. He continually returned to older shapes, re-creating new ones from them. He would make drawings on transparent tracing paper, scatter them one on top of the other, study the composite drawing appearing on top, make a drawing from this image, reverse it, tear it in half, and put it on top of another drawing.

De Kooning preferred a hard-surface paper for both painting and drawing. He bought smooth stock, evenly glazed or sized papers, in which the rag or wood pulp fibers are compressed to a smooth, even plane. The smooth, hard surfaces enabled him to draw with the high velocity he enjoyed, whereas a highly absorbent surface would have impeded the free motion of his line. De Kooning also liked tracing papers, commercial vellums, or parchments that were semitransparent and slightly oily, because their slick surfaces increased the speed of the line. He developed one technique to save a passage in his

FIGURE 2.4
Willem de Kooning, American, born Rotterdam, The Nether-
lands, (1904–1997), *Woman, Sag Harbor,* (1964), oil and
charcoal on wood, 80″ × 36″, (203.1 cm. × 91.2 cm.). Hirsh-
horn Museum and Sculpture Garden, Smithsonian Institution,
Washington, D.C. Gift of Joseph H. Hirshhorn, (1966).
© 2007 Willem de Kooning Revocable Trust/Artists Rights
Society (ARS), New York, NY. 66.1209.

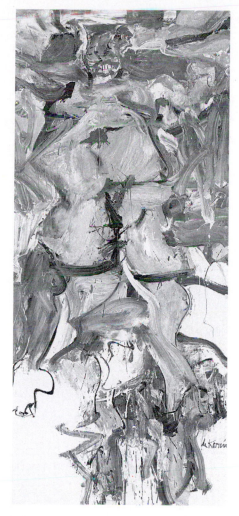

painting before he wiped the area off the canvas. He
would use parchment or vellum to preserve what he
had painted by pressing the paper into the painting's
surface and lifting the area off. This technique al-
lowed him to refer back to that passage while con-
tinuing to paint. *Woman, Sag Harbor,* (fig. 2.4) is an
example of what one of his tracings now in the Hir-
shhorn looked like. De Kooning's drawings tend to
dissolve the definition of "drawing." In the black
enamel drawings of 1950, he drew with sapolin,
black house-paint enamel on white paper. Whereas
the drawings were on bare white paper, the paintings
were white paint on a black ground. *Zurich* (fig. 2.5)
is such a painting. The drawings and paintings slip
elusively from one to another.

We seldom get to watch an artist work. The fol-
lowing insight by Thomas Hess, art critic and editor
of *Art News* in the 1950s, gives us a glimpse: "I
watched de Kooning begin a drawing, using an or-
dinary pencil, the point sharpened with a knife to ex-
pose the maximum amount of lead. He made a few
strokes; then almost instinctively, began to go over
the graphite marks with the eraser, moving them
across the paper to turn them into planes."

Erasing was a drawing technique de Kooning
used to create, not to destroy, the drawing. His line—
the essence of drawing—is always under attack. It
is smeared across the paper, pushed into widening
planes and shapes. He might rub the entire surface
of the drawing with the eraser, lightening the value of
the lines and shapes. In this way, another level of
lines can be added on top of the rubbed surface.
The wiping, erasing action continues until he sees
something in it, something he wants to keep—or to
destroy. For the drawing to be useful in launching a

FIGURE 2.5
Willem de Kooning, American, born Rotterdam, The
Netherlands, (1904–1997), *Zurich (Zot),* (1947), oil
and enamel on paper mounted on fiberboard, 36″ ×
24⅛″. Hirshhorn Museum and Sculpture Garden,
Smithsonian Institution, Washington, D.C. The
Joseph H. Hirshhorn Bequest, (1981). © 2006 Willem
de Kooning Foundation/Artists Rights Society (ARS),
New York, NY. 86.13355.

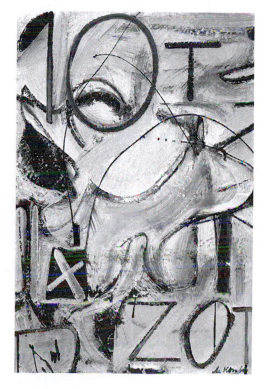

painting, it needs to be balanced by line and plane held in tension.

Zurich (fig. 2.5) is a painting that is formed by line and plane held in tension. The overlapping lines prevent solid planes from forming on the ground. The "X" is a solid plane whose right side dissolves in a thick and thin line. The hard edge of a plane near the "Z" at the bottom is brushed into the ground, and you can see his wiping and smearing actions from there to the top of the painting. The ground is a huge plane against which the line expands and contracts but never stops moving.

De Kooning's drawings could be characterized as an open composition in which the positive and the negative spaces are both pushed to their fullest statement and then allowed to exist together. De Kooning's line and compositions have been called ambiguous, meaning that the foreground and the background of the drawings shift back and forth. Unclear which marks are in the foreground and which are in the background, his meaning is hidden, the structure problematic, and the space of the drawing capable of having two or more interpretations. In his drawings de Kooning sacrifices nothing to the academic ideals of harmony or unity. He invents a new definition for harmony and unity.

In this same spirit, de Kooning devised a process of tearing drawings and paintings to reassemble the parts in a different order. This technique allowed him to study the shapes in an unlimited number of associations and relationships. De Kooning liked paper because it was easy to cut and to tear. The torn edge of the paper acts like a line in these collage drawings, but it is a constructed line rather than a drawn line. *Untitled, December 1959* (fig. 2.6) is a ripped paper, collaged drawing.

De Kooning's collage drawings embody three principal relationships between the human and the universe. The first step is to develop an awareness and knowledge of the space around you. Second, you must process these perceptions and this new awareness. Third, you may then appropriate the shapes you have discovered as your own. These shapes or formations no longer belong to the world—they belong to you.

De Kooning once said, "Content is a glimpse of something, an encounter, like a flash." In abstraction you can create out of one small glimpse.

FIGURE 2.6
Willem de Kooning, American, born Rotterdam, The Netherlands. (1904–1997), *Untitled,* ink and paper mounted on paperboard, (mounted: 28⅝″ × 40¼″). Hirshhorn Museum and Sculpture Garden, Smithsonian Institution, Washington, D.C. Gift of Joseph H. Hirshhorn (1966). © 2006 Willem de Kooning Foundation/Artists Rights Society (ARS), New York, NY. 66.1194.A-B.

COMPOSING DRAWINGS WITH GESTURE

Salvator Rosa's gesture drawing *Fall of the Giants* (fig. 2.7) is a complete plan for his later large etching. Gesture drawing allowed him to rapidly think out the sequences he needed for his future composition. In this drawing, Rosa worked to capture the tumbling, turning, twisting forms of the giants through the air as they are thrown off Mount Olympus by the Greek gods. Everything is moving. He has overlapped figures and stacked them. Years of practice have informed his memory of the human form, making it possible for

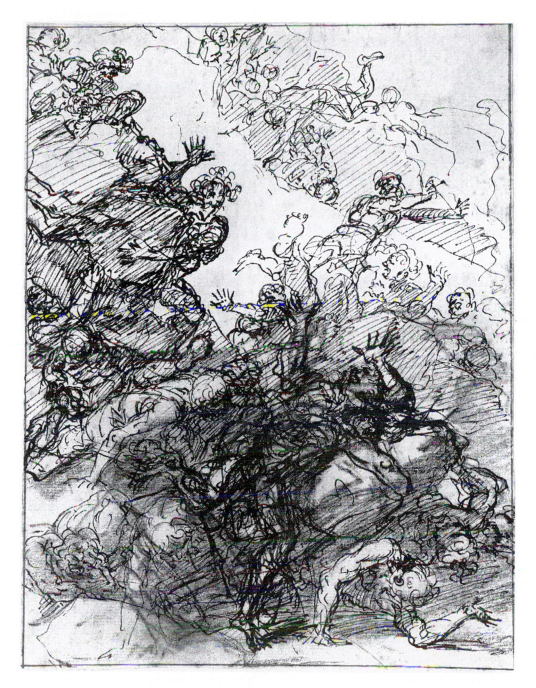

FIGURE 2.7
Salvator Rosa, (1615–1673), *Fall of the Giants,* 17th century, pen and brown ink, over black chalk, 10⅜" × 7¹³⁄₁₆" (26.1 cm. × 19.5 cm.). The Metropolitan Museum of Art, Rogers Fund, (1964). Photograph, all rights reserved, The Metropolitan Museum of Art, New York, NY. 64.197.6.

Rosa to create this drawing without using any models.

His hatching strokes are diagonals drawn toward the right top corner, whereas the figures themselves follow a diagonal line moving from the top left corner downward. This contrast is a deliberate attempt to create tension. He has small figures in the top right and medium figures in the middle and foreground. One large figure has been drawn on top of the pile of figures at the bottom of the page. The gesture lines forming the large figure are dark and bold. The figures to the left, in contrast, are mostly white. They float out at us as the hatched figures are pushed back. By manipulating the value of the hatching strokes from dark in the foreground to light in the background, he creates depth. One of the techniques to control the value of the mark is the pressure put on the drawing tool. Increased pressure darkens the lines, whereas lighter pressure returns a light line. The placement of the hatching line is important. Hatching lines placed close together read darker than lines placed farther apart.

To develop the fluency of visual thought that artists like Rosa and de Kooning have, a good understanding of the basic construction blocks for drawing is important; the function of line, value, and perspective, along with scale, placement, unity, and harmony, will be important. Learn to analyze and visualize spatial relationships, and experiment with your drawing tools to develop a good understanding of their individual properties.

DRAWING EXERCISE 2.1
Testing Visual Memory

Take a pen and a sketchpad outside, and find a place to draw where there are people walking by. Focus your attention on a specific space, building, or group of people. Quickly analyze the forms and shapes in a few moments. Look away and draw, or sketch loosely, what you saw. Allow your hand to scribble lightly as you think about the relationships of the forms in the space. The lines may be unconnected. Draw for only a few minutes, and then look back at the scene. Study it, and then work back into the drawing, darkening areas by adding hatching lines or by increasing the pressure on the drawing tool to achieve darker lines. Make a second drawing, and, this time still looking at the scene, use loose, flowing lines or diagonal hatching lines to create the drawing. Using a pen facilitates both a flowing and a hatching line, and by using a pen, you cannot erase which is important for your progress. Erasing takes time away from drawing, and if you are erasing because you felt a line was incorrectly placed, you will lose the line as a marker to help you place a new line. Instead, look at the errant line, and decide where to place a line you prefer. Always start with light, thin lines that will be easy to cover with a second layer of line.

TIME REQUIRED TO MAKE A GESTURE DRAWING

Gesture drawings can be done in one minute or up to five minutes. Sustained gesture drawings can take up to twenty or thirty minutes. Warming up with gesture drawing can take thirty seconds to three minutes per drawing. You can make four or five quick drawings on one piece of paper, and the drawings may even overlap or change in size and scale. A twenty-minute sustained gesture drawing, on the other hand, is meant to slow you down and allow you time to closely study the subject.

Learning "to see" is to accumulate visual knowledge about the subject being drawn. Before you start drawing for the first minute, look at the subject. Let your eyes roam over the figure and the ground (the ground is the space around the subject). Then begin to draw.

MASS GESTURE DRAWINGS

There are no outlines in mass gesture drawings; only volumes and planes to define the forms and compose the drawing. Drawing the mass allows you to think about your subject differently. The shape of the form results from concentrating on creating the mass of the planes and connecting them. The edges of such a drawing will be fuzzy.

In Jan Reaves's drawing *Body* (fig. 2.9), the balance of lightness and darkness creates a sense of volume. The range of tonal areas in Reaves's drawing may be achieved by changing the pressure on the drawing tool as well as by the material used to make the drawing. Reaves left white holes in the top of her drawing, creating a way to look through the form; the viewer can see the top, front, and side planes. This arrangement creates an increased sense of the volume. The success of the drawing lies in

FIGURE 2.8
Raymond Pettibone, *No Title (Liz stepped out)*, (2002), ink on paper, 22¼″ × 30″, (56.5 cm. × 76.2 cm.). Private collection, courtesy of Regen Projects, Los Angeles CA.

her mastery of the range of tonal values, not the accuracy of the rendering. Her drawing medium is not a traditional tool. She has developed a process of drawing with Xerox toner.

Raymond Pettibone, fig. 2.8, is not a mass gesture drawing that depends on the manipulation of the drawing tool, rather the drawing has the strength of mass gesture drawing under the direction of the artist. Pettibone often creates a graphic environment where individual drawings such as *No Title (Liz stepped out)* are placed on the wall and layered with drawings made directly over them on the wall. Pettibone's work can be understood as a highly personal combination of images and text, an evolving commentary on the American cultural universe; its visual and literary manifestations, its suppressed desires and fears, and its political and religious beliefs. It is the fluidity of this drawing that gives it the sense that it is a gesture drawing. The diagonal lines create movement and action, and the overlapping of these ink strokes creates a sense of space. Just imagine a room size installation of a drawing this powerful.

FIGURE 2.9
Jan Reaves, *"Body,"* (2004), Xerox toner on paper, 15″ × 12″. Courtesy of the artist.

DRAWING EXERCISE 2.2
Creating the Mass Gesture Drawing

Set up a still life of shapes that are of various heights and weights. It is the volume of the forms that you are interested in observing. For example, place boxes next to volley balls, or stack some objects so that they overlap and leave space between others.

Use a piece of Conté crayon that has been broken to fit between your thumb, forefinger, and middle finger. Place the flat side of the stick down on the paper. Pick a starting place in your subject, and then lightly push the Conté across the surface of the paper, drawing to represent the first plane of the first form. Twist and turn the Conté to create the mass of your subject. If your first marks are light, you will be able to alter them later.

Remember that a plane is a surface on a form. One side of a box is a side plane, and on a cylinder the front plane is the area on which you can rest your palm. A change of plane on a cylinder may be identified by resting the palm of your hand on the surface; when you turn your hand to touch the area next to the first area, you have changed planes. Pretend that your hand is actually moving on the surface of your subject. Move your hand as if you were drawing right on the surface of the form with the Conté while you are representing it on the paper. By twisting and turning your wrist and at the same time moving the Conté up and down and back and forth, you create overlapping strokes, which define the volume of your forms. Like a sculptor, you are creating a volume that should fill the page. Press harder on the Conté to darken the planes, and use light pressure to create light planes. Lift the Conté to begin drawing the next form.

MASS TO LINE GESTURE DRAWING

In mass to line gesture drawing, first lightly establish the mass as described earlier, and then increase the definition of the form by adding line to improve the shape of the contour of the form. The new line should be the same value of the plane it defines. You may need to use your eraser on some planes. Continue to use Conté to draw the lines. Turn it on its side, or tip it up on end. Either the corner or the side plane of the crayon will create marks and lines. The corner makes a thin, rich line. Turning the Conté to use the side plane of the end makes a wider line. Remember this style of drawing will leave a trace, no matter how hard you try to erase the lines some trace of them will be left. The drawing *Head of Catherine Lampert VI*, by Frank Auerbach (fig. 2.10), is an example of mass gesture drawing with loose defining lines on top of the ground.

MASS GESTURE AND VALUE CHANGE

The drawing by Frank Auerbach *Head of Catherine Lampert VI* (fig. 2.10), was carved out of the ground with an eraser followed by a loose gesture line. Auerbach drew, rubbed the drawing off, wiped it out, and layered charcoal to achieve the volume of the head. He may or may not have depended on the actual light on his model, but he did chose to lighten the top planes of the face, which actual light would have highlighted. He erased the face planes, bringing the light out of the gray background. The dark lines on top shift the planes of the face, adding a quality of movement.

DRAWING EXERCISE 2.3
Value and Mass Gesture Drawing

Mass gesture drawings depend on balancing the values. When you start drawing, begin with very light pressure on the drawing tool. Use a piece of compressed charcoal or Conté broken to fit between your thumb, forefinger, and middle finger. The subject may be a still life. A selection of large, round forms is easy to work with. Choose three vases or bottles sitting close together, or large sunflowers, or plates sitting on edge, or a watermelon or other large fruit. Stand within four to five feet of the still life. Pick a starting point on your subject, and begin moving the charcoal on the paper, making overlapping strokes to construct the volume of each form plane by plane. Pretend you are actually holding the form in your hand and drawing directly on it. Value changes are determined by you. You may arbitrarily establish the light and dark planes.

Consider the ground that the objects are set on. Draw the space of the ground and the background behind your objects in large, flat strokes. Your strokes describe the presence of the ground, or table, and the air behind it.

Look at the lighting of the still life setup. If the lighting is poor and undirected, decide how to balance the light.

FIGURE 2.10
Frank Auerbach, (b. 1931) *Head of Catherine Lampert VI*, (1979–1980), charcoal on paper, 30¼″ × 22⅞″, (76.8 cm. × 58 cm.). Museum of Modern Art, New York. Licensed by Scala-Art Resource, NY. Purchase (436.1981). Digital Image © 2001 the Museum of Modern Art, New York, NY.

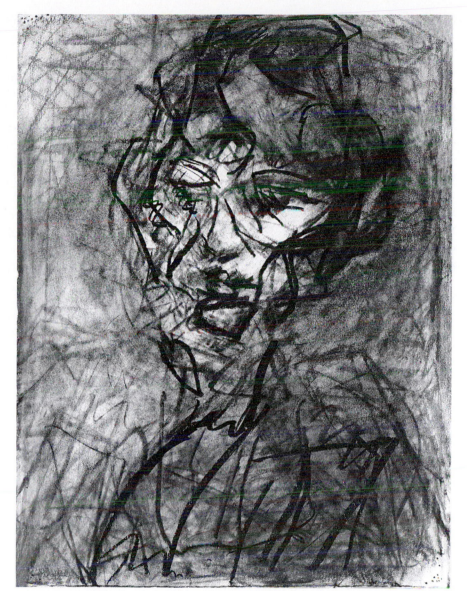

If you make top planes light, then the left or right side of each object will be gray or black. You will often make a very dark drawing in which all planes have charcoal on them. With a kneaded eraser, remove the charcoal from the planes to designate the lightest planes. Wiping some charcoal off then changes each form into a volume. The harder you rub with an eraser, the more charcoal you can remove, giving you the lightest white possible. Light rubbing will leave more charcoal on the object's plane, which will read as gray. Continue erasing to achieve a balance between the light planes and the dark planes. Experiment with both the white plastic eraser and the kneaded eraser to lighten areas. The beauty of working with charcoal is that the charcoal makes it so easy to add and subtract values.

Balance the light and the dark planes on each form. Assign a darker value to the ground planes under the forms. Balance the space front to back by moving from light to dark through the space. Increase the dark values for the background objects. Darken those areas between or behind objects. Return to the darkest areas of the drawing, and add another layer of charcoal to darken these areas.

SUSTAINED GESTURE DRAWING

Sustained gesture drawings look more expressionistic than formal or tightly rendered. Since the artist is exploring the visual relationships of proportion and scale, a sustained gestured drawing will take on a realistic appearance, but it will be infused with

an expressive quality illustrating the process that the artist used to make it.

The artist Alberto Giacometti once remarked that he used his family as subjects because he knew them intimately. Knowing them means he had stored visual knowledge about them, so he didn't have to start from scratch with an unfamiliar subject. In the drawing of his wife, *Annette* (fig. 2.11), the woman seems to float in the space, pushed back by the lines that define the air in the space around her. In this drawing, Giacometti focused on her head, wrapping it over and over with line, searching for the true or real form, plane by plane. His attempts are seen in his continually adding and subtracting lines to the drawing. These lines represent his thinking.

ORGANIZATIONAL LINE DRAWING

Giacometti's drawing *Annette* (fig 2.11) is sometimes called an organizational line drawing. Organizational lines measure form and space by extending through space. These lines relate the figure to the ground as well as locating the figure in the space. They help the artist determine proportion, size, and scale along with height, width, and depth. Also, they establish the location of planes finding them along the line, cutting through the edge of the form and through the space. An organizational line may continue from the figure to the wall to determine the proportions of the space.

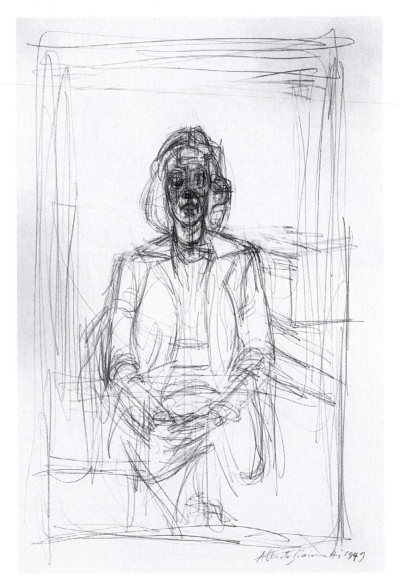

FIGURE 2.11
Alberto Giacometti, Swiss, (1901–1966), *Portrait of the Artist's wife, Annette,* (1949), pencil on ivory wove paper, 63.8 cm. × 49.9 cm. Adelaide C. Brown Fund. Photograph © 2001, The Art Institute of Chicago. All rights reserved. The Art Institute of Chicago Collection. © 2006 Artists Rights Society (ARS), New York/ADAGP, Paris, France. 1955.636.

Take twenty to thirty minutes to complete this gesture drawing. Select a drawing tool such as a charcoal pencil. Study your subject, and choose a starting point. One of the easier subjects to draw would be a large object on a table in a room. Consider the placement of the subject on the page. Start with light pressure, creating the lightest line possible. Try to draw quickly at first, keeping the energy of the form. Let the lines go through the center of the subject, let them wrap around the subject, and draw from the subject to the floor as well as to the ceiling. After three minutes you should have lines locating your subject in the picture plane. Step back and study the drawing. Resist the temptation to outline the forms; instead, allow them to exist with loose line edges and planes. Next, determine the planes that are to be gray, and move to the gray planes, increasing your layers of lines to darken these areas. Identify the darkest sections, and increase the pressure on the drawing tool there. Avoid outlining the contour or making impatient marks.

Your line may cross open space, negative space, or the space of the table or ground. Lines in the sustained gesture define the forms without outlining them, and many lines reach for the form's edge without stopping at it. But it is this loose edge and absence of a solid or firm outline that gives your drawing its energized look. Feel free to stop and start and to lift the tool off the paper. Concentrate on where you feel the drawing needs more development. Look at the placement of tables, chairs, cabinets, and walls in the room. You may use lines to define the location of these room references in respect to your subject.

If you find that you want to erase any lines, use a chamois to rub them out or to reduce their value. A chamois is a soft piece of leather sold in art stores and in car-supply sections of multipurpose stores. The chamois will lighten the charcoal or Conté. You may also use a kneaded eraser to lighten areas and lift off lines. Wipe the eraser across the lines. When the eraser gets dirty (which is almost immediately), pull it, stretching the area with charcoal on it. Then roll the eraser back on itself, exposing a clean area to continue wiping the drawing. Don't worry about any remaining lines. These faint lines create body in the drawing; they don't interfere with the final reading of the drawing.

CREATING SPACE IN GESTURE DRAWINGS

We feel a sense of space in a drawing depending on the placement of light and dark in the picture plane. A still life drawing tends to be arranged in light to dark. A light foreground relative to a dark background establishes the volumes of the still life in space. If, however, in a still life, the objects in the foreground are rendered in dark lines and values, and the objects in the background are done in light lines, the forms push boldly forward. So, can the space in a landscape be organized from well-developed dark values in the foreground to faint light values on the horizon? We have seen this technique in Salvator Rosa's drawing (fig 2.7). The dark to light arrangement reads visually as distance.

Jan Reaves's drawings (figs. 2.12 and 2.13) are studies of a construction site. The artist has

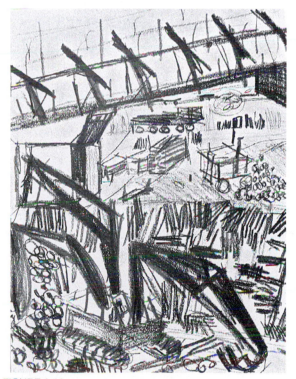

FIGURE 2.12
Jan Reaves, *Black Drawings*, (1990), pencil, 12″ × 9″. Courtesy of the artist.

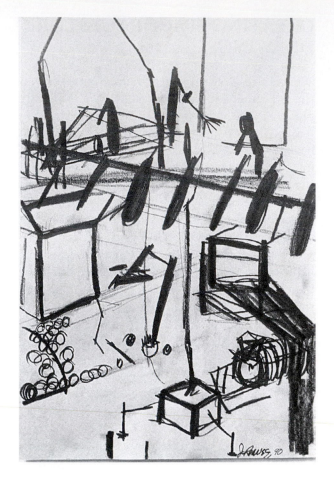

FIGURE 2.13
Jan Reaves, *Black Drawings,* (1990), pencil,
12″ × 9″. Courtesy of the artist.

created space in the drawings, first with the changes of value in the loose gesture lines, and then from the size and scale of the marks. Diagonal lines in the drawings suggest receding space. A rule of perspective is that things get smaller the farther away they are from you, and she uses this rule in fig. 2.12 to increase the space of the drawing. Notice the little forms up the page toward the back. In fig. 2.13, she drew bold lines placed across the picture plane, framing the rest of the space in the drawing.

DRAWING EXERCISE 2.5
Gesture Drawing in Landscape

The space of the drawing is determined by the relationships of the forms. Go outside and pick a view of an alley or a space between buildings or another framed space. Let your eyes roam over the area to be drawn, and then start with a series of loose, organizational lines that frame the space. Draw vertical lines for the buildings in the front of the space. Draw horizontal lines across the open space to es-

tablish the height of either side. Your lines in the drawing are relative. You judge the height and the width of each building in terms of where it stands in relation to the others. A line drawn across the surface from one building to another determines the location of the second building in relationship to the first building that you sketched in the picture plane.

Add each receding object in the space, using scribbled gesture lines placed in terms of what has been drawn. Make some gesture lines dark and some light, and then use hatching and invent lines that you need to express the space.

GESTURE AND TEXT

Text became a working part of drawings and paintings with the Cubists, early in the 20th century. Picasso and Braque used words, sometimes written directly on the surface, sometimes cut directly from the pages of newspapers and pasted into the drawing. Later other artists would expand the use of

FIGURE 2.14

Jean-Michel Basquiat, (1960–1988), *Hollywood Africans*, (1983), acrylic and mixed media on canvas, 84″ × 84″, (213.4 cm. × 213.4 cm.). Collection of The Whitney Museum of American Art, New York, NY. © 2007 Artists Rights Society (ARS), New York/ADAGP, Paris, France.

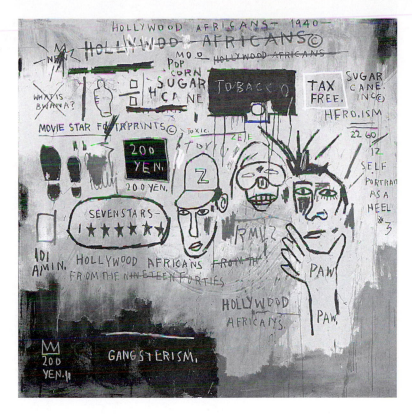

numbers and letters as the subject of their drawings and paintings. Jean-Michel Basquiat's *Hollywood Africans*, (fig 2.14) is a commentary on Hollywood by a young African-American artist. Basquiat used text as a compositional element in this painting. This work seems more like a drawing because of all the contour line drawings and symbols organized in rows across the picture plane. Basquiat was making a statement about the absence of African American actors in the movies in the forties. Basquiat has written HOLLYWOOD AFRICANS FROM THE NINETEEN FORTIES, SUGAR CANE, TOBACCO, GANGSTERISM, and WHAT IS BWANA?, all referring to the types of roles and dialogue to which black actors were limited. The words POPCORN and MOVIE STAR FOOTPRINTS continue his attack on the movie industry. This work was painted in Los Angeles while Basquiat was visiting his friends, Toxic and Rammellzee. The portraits in the painting, *Hollywood Africans*, are of these three young "Hollywood African-Americans." Toxic is scribbled above the face in the baseball cap with a Z, and RMLZ is written below the face with the goggle like glasses.

Basquiat identified himself in this group as SELF PORTRAIT AS A HEEL #3, the numbers 12, 22, and 60 are his birthdate. The words, Sugar Cane, Tobacco, and Tax Free also double as a reference to slavery.

DRAWING EXERCISE 2.6
Gesture and Text

Think about your community. What would you like to focus on in a drawing with text and contour outlines to explore and reveal something you would like people to think about? Introduce a number of associated directions, like Basquiat's combining movie star footprints with a reference to tobacco. There is an intellectual jump in these words. His ground is also important. Yellow has many meanings. Used as the ground it covers black in two corners and blue in the bottom right corner. To make your drawing, use a heavy piece of paper so you can use markers, oil sticks, pastels, acrylics or charcoal. Notice how Basquiat used layering to make his drawing stronger.

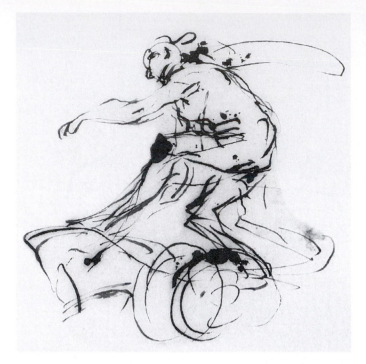

FIGURE 2.15
Domenico Gargiulo, (Micco Spadaro), Italian, (c. 1612–1675), *Charioteer,* 17th century pen and brown ink, 5¹³⁄₁₆″ × 5⁷⁄₁₆″, (14.7 cm. × 13.8 cm.). The Metropolitan Museum of Art, Gift of Harry Walters, (1917). Photograph, all rights reserved, The Metropolitan Museum of Art, New York, NY. 17.236.36.

Domenico Gargiulo lived and worked between 1612 and 1675, an artist whose contemporaries were Rembrandt van Rijn, Annibale Carracci, and Claude Lorrain. He appears to have much in common with Rembrandt, who also sketched in this loose drawing manner, (*Value*, fig. 4.34 to 4.36). A gesture drawing was not a common practice of artists in this period. The *Charioteer*, (fig. 2.15), is in pen and brown ink, and is only 5 × 5 inches. Gargiulo has created a tremendous energy in a small space employing thick and thin gesture lines, angular strokes, and overlapping, unconnected lines to completely convince you this is a drawing of a man driving a chariot. You feel the wheels turn, and the charioteer whipping the horses, but he has not drawn the horses. Your knowledge of a charioteer adds the horses. Gargiulo has captured an action without details in this drawing. Gesture depends on unconnected lines, planes, and forms. In this drawing you see how line and value are effective in creating movement.

STRATEGIES FOR GESTURE DRAWING

1. Look at the subject for a few minutes before beginning to draw.
2. Follow the contour with your eyes, and using your forefinger, draw the volume in the air with your finger.
3. Start the drawing from the inside of the form, not on the contour edge. Draw from the middle to the edge of the form. Don't draw the contour of the form; instead, draw across the planes of the form to establish relationships.
4. Keep your drawing arm free.
5. Maintain a continuous line by keeping the drawing tool in contact with the paper.
6. Look at the subject as much as possible and at the paper as little as possible.
7. Use charcoal pencils, 6B pencils, or a flowing pen line, on 18 × 24 inch paper.

Eugenio Lucas and Cy Twombly

Eugenio Lucas, in the "The Chastisement of Luxury" (fig. 2.16), used gesture drawing techniques. The main figure is in motion, striking an active stance. That is, he holds a pose that we understand to be one frozen moment from a series of back and forth movements. Lucas's drawing is a good example of mass gesture. The background contains no outlines. Notice how the value changes move your eye through this drawing? The background of the Carnival Scene is in motion and as such is somewhat abstract. Things are moving so quickly that we are unable to get a hold of any one image.

In *Untitled, 1969*, fig 2.17 Twombly covered the ground with repeated rectangles overlapping each other. The overlapping forms create rhythm and movement in his drawing. His dispersion of rectangles is accompanied with additional letters and numbers appearing in and out of the ground. The surface is like a blackboard, covered with personal doodles. Twombly used marking and erasing to construct his drawing. The binder for the chalk mixes here and there with the house painter's dark gray of the background and it is erased or absorbed creating layers of drawing. There is no focal point.

FIGURE 2.16
Eugenio Lucas, Spanish, (1817–1870), *The Chastisement of Luxury*, 19th century brush and dark brown wash with traces of red chalk, 10⅛″ × 15¼″, (25.7 cm. × 38.7 cm.). Fletcher Fund, (1942). Photograph, Metropolitan Museum of Art, New York, NY. All rights reserved. 42.186.2.

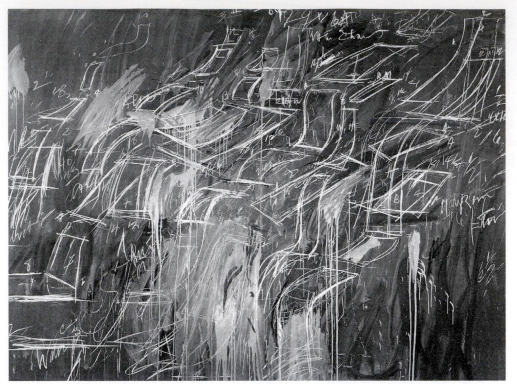

FIGURE 2.17
Cy Twombly, (1928–),
Untitled, (1969), oil and
crayon on canvas, 78″
× 103″, (198.12 cm. ×
261.62 cm.). Gift of Mr.
and Mrs Rudolph B.
Schulhof. Whitney Museum of American Art
New York, NY. © Artists
Rights Society (ARS),
New York, NY.

The formal elements of composition have been abandoned. There is a certain framework in which he starts his marks on the left of the ground and he moves to the right. If you start at the top right corner, the marks seem to run off the left edge. The marks and rectangles dance across the picture plane sometimes contained within the surface, framed, and distributed, and sometimes moving off the edge.

Untitled and *Carnival Scene* are both gesture drawings without much else in common. Lucas without the figure holding the front of the composition would be close to Twombly's overall composition. But he has the figure directing the scene or about to walk into it while Twombly's drawing employs a scribbled message. The artist's purpose and meaning of each drawing is different.

JOURNAL FOCUS

In your journal, explore volume and space with gesture drawing. Use the street as your subject. Find a café with an outside table, or locate a park bench where people are walking or sitting nearby. Try to make a tree active with gestural marks, or choose someone to draw. Don't stare at your subject, but glance at the person, making note of the person's body posture and clothing. Quickly sketch, scribbling your brief impression without looking continuously at the person. Let your drawing be angular with the gestural lines wrapping around the figure. Explore other forms—a table, chairs, planter boxes, or anything placed on the street. If a bus pulls up quickly, add it to your drawing.

Use a ball point pen or a charcoal pencil to make this gesture drawing. The line should not surround nor outline a plane. You may use compressed charcoal wiped in the areas to be dark, and with a brush and water you can turn the compressed charcoal into a wash.

LINE

On October 22, 1882, Vincent van Gogh wrote a letter to his brother asking, "What is drawing? How does one come to it? It is working through an invisible iron wall that seems to stand between what one feels and what one can do. How is one to get through that wall—since pounding at it is of no use? In my opinion, one has to undermine that wall, filing through it steadily and patiently."

Henri Matisse's drawing *Self-Portrait* (fig. 3.1) is a fine example of contour line drawing. Like van Gogh, he fought his way through the "iron wall." Whereas Matisse stands at the forefront of modern drawing, Do-Ho Suh, on the other hand, expands modern thinking and the possibilities of drawing in *Dream House* (fig 3.2).

Do-Ho Suh was born in Seoul, Korea in 1962. He has a BFA and an MFA in Oriental painting from Seoul National University. After fulfilling his term of mandatory service in the South Korean Military, Suh relocated to the United States to continue his studies at Rhode Island School of Design and Yale. Moving to the United States produced a disorientation which he called transcultural displacement. His displacement was a feeling of being neither here nor there. He said, "I don't really get homesick, but I've noticed that I have a longing for this particular space or to bring that space wherever I go." Since 1999, Suh has made replicas of his living spaces—his childhood home in Seoul, and his apartment in New York—in semi-transparent fabrics that he can literally pack in a suitcase and carry with him. When his spaces are installed you can walk through the fabricated grey nylon, a full size space, you see his fireplace, stove, sink, doorknob, locks, and more all sewn into the hanging fabric. The rooms are playful and amazing, like one of Claes Oldenburgs soft sculptures. *Dream House* (fig. 3.2) is a drawing in ink on mylar and paper. The mylar will be transparent following his transparent room installations. The drawing is another way to find the particular space he longs for.

Drawing is a language that communicates through visual symbols. The basic ingredients for creating a drawing are strokes and marks, which can be thought of as creating a symbolic relationship with experience. The depth of your visual awareness of the world helps you read the visual symbolism in drawings, and it also determines your ability to create the symbols yourselves. Drawing relies on seeing, but drawing also increases the artist's level of seeing. To *see* is to understand the objects and the space they occupy completely, thereby increasing your ability to translate the three-dimensional space into the two-dimensional picture plane.

Lines, the raw material of drawing, can be used to describe forms, to record observations, and to suggest, evoke, or imply a range of experiences. Lines, in other words, can represent thoughts, as well as feelings. A simple line drawing may be an outline drawing or a contour drawing. An outline is like a tracing of your hand on a piece of paper. By drawing around the edge of the shape, you create an outline. We recognize the shape of the hand, but it could be any hand and has no defining characteristics. Outline drawings simply define the shape. The line in a contour drawing, on the other hand, is specific to the shape of the form drawn.

CONTOUR LINE DRAWING

A contour line defines the shape of the form in detail. The line denotes the individual qualities of the form by specifically describing the edge. Thus, contour line drawings reflect a volume that outline drawings do not. When you look at Matisse's *Self Portrait* (fig. 3.1), you see how the quality of the

FIGURE 3.1
Henri Matisse, (1869–1954), *Self-Portrait*. The Thaw Collection. The Pierpont Morgan Library, New York, N.Y., U.S.A. Art Resource, NY. © 2007 Succession H. Matisse, Paris/Artists Rights Society (ARS), New York, NY.

contour line defines his head. From his cheekbone through his chin you feel the volume.

A contour line drawing can take a long time to complete because you need to spend time looking carefully at the subject. As you study your subject, decide where you perceive the edge of the form to be and where to begin. Look from where the line begins to where it ends. Return and inspect the distance between the beginning and the end for other important line qualifiers.

The contour is considered in terms of where to use light, dark, thick, or thin lines. In addition, the di-

FIGURE 3.2
Do-Ho Suh, *Dream House*, (2002), ink on mylar and paper, sheet: 11 in. × 14 in., (27.9 cm. × 35.6 cm.), board: 13¾ in. × 16⅛ in., (34.9 cm. × 40.8 cm.), framed: 13¾ in. × 16⅛ in. × 1¼ in., (34.9 cm. × 42.5 cm. × 3.2 cm.). Purchase, with funds from the Drawing Committee. Collection of the Whitney Museum of American Art, New York, NY.

FIGURE 3.3
Richard Diebenkorn, *Seated Nude* (1966), charcoal on paper, 33″ × 23½″ (83.8 cm. × 59.7 cm,). San Francisco Museum of Modern Art Collection. Gift of the Diebenkorn family and purchased through a gift of Leanne B. Roberts, Thomas W. Weisel, and the Mnuchin foundation. © Artemis Greenberg Van Doren Gallery for the Estate of Richard Diebenkorn.

Diebenkorn has rubbed this drawing out many times and redawn lines over the rubbings. This is a record of his critical thinking and decision-making

Notice how he has created the curved space of the chair so the figure sits in the chair. Look at the chair legs. The back legs in perspective sit just a bit higher up the paper on a diagonal line from the front legs.

To understand the volume of the figure take note of where all lines start and where they end.

He has clearly defined the torso. It sits foreshortened inside the legs. We see the side plane of the torso on the right.

Using a heavy contour line he defines the bottom of the thigh sitting across the top plane of the other leg. The right leg pushes the left leg changing its shape. The bottom leg has a top plane, side plane and back plane all defined by two contour lines carefully placed.

rection of the lines forward or back will be important. Richard Diebenkorn's drawing exemplifies a high quality of contour line drawing. *Seated Nude* (fig. 3.3) seems simple, although perhaps chaotic from the erasing, but like Henri Matisse, Diebenkorn's skill as a draftsman makes his drawing look simple.

LINE TONE AND QUALITY

Pietro Berrettini da Cortona's *A Wind God* (fig. 3.4) is a contour line drawing in which the volume of the figure is defined by lines of varying thickness and value. The thick lines are dark in value, and the thin lines are light in value. Artists will refer to the weight of a line. A heavy line is thick and dark, whereas weightless lines are light and thin. The arms of the Wind God illustrate the use of the thick contour line to create volume. The thick line exaggerates the large muscles of the Wind God's shoulders. Part of learning to draw is developing your ability to translate the volume of a form into a contour line drawing.

Closely examine the drawing, starting with the Wind God's left arm, which is on our right. Look at how his left arm fits into the side plane of the body. The bottom contour line of the arm starts at the wrist and ends behind his chest, close to his back. Follow the top and bottom contour lines forming the arm. Notice where the muscle curves in and the line increases in width and darkness. As the line lifts out of the grooves, it thins out, revealing the top plane of the muscle on the arm. It is important to note where a line starts and ends.

The lines on top of the hand on the left are thin, whereas the bottom lines are thick, giving weight to the hand. A line can completely expand into a plane. The elbow on the left is a good example of line becoming plane. Often one line defines two planes, as in where the forearm on the left meets the bicep. In addition, Cortona combined contour line and gesture in this one drawing. The

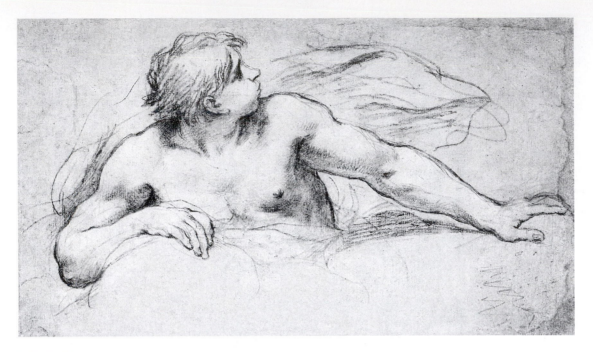

FIGURE 3.4
Pietro Berrettini da Cortona, (1596–1669), *A Wind God*, 7⅞″ × 13⅛″, (18.9 cm. × 33.3 cm.), black chalk heightened with white on brownish paper. The Metropolitan Museum of Art, The Elisha Whittelsey Collection, The Elisha Whittelsey Fund, (1961). Photograph, all rights reserved, The Metropolitan Museum of Art.

lines on the left and just behind the arm look like a false start. Perhaps the arm started out farther back, and then the artist moved it forward. More gesture lines are seen in the Wind God's breath drawn on the right. A few more gesture lines in the foreground define the clouds surrounding the Wind God. Cortona places the figure in the space through the use of a few quick gesture lines, one under the arm on the left and a shadow under the arm to the right.

CONTOUR AND GESTURE WITH VALUE

John Singer Sargent, in the drawing of *Paul Manship* (fig. 3.5), used a loose contour line that is thin and flowing. It follows the curves in the drapery, breaking into hatching strokes to form planes. This hatching technique separates the top planes from the side planes. The few dark areas under the collar and under the arm subtly increase the volume of the figure. By choosing to make the bow tie a dark value, Sargent frames the chin. His line does not flail; he directs the line. Sargent has not tightly modeled the sleeves or the face with value. Rather, the value was placed as loosely as the flowing contour line.

 DRAWING EXERCISE 3.1
Loose Contour and Value Exercise

This exercise, although very simple, quickly creates an understanding of how to manipulate line quality. In this exercise you have an opportunity to practice making lines without the pressure of drawing something. First, hold a sharpened 6B pencil between your thumb and flattened index finger, keeping your wrist and elbow free. Practice making lines across a sheet of newsprint. Next, start on the pencil's tip with light pressure, and draw a line across the paper. Make a second line and increase the pressure, curving the line in and out. Make a line that is light to dark, thick to thin, by rotating the pressure on the pencil from light to firm. Now, change your hand position and hold the pencil under your hand, pushing it with your thumb to create a light and dark line. (There is an illustration of holding the pencil in these two ways in Chapter 12, Media.)

Experiment with contour lines by drawing the folds of your coat. Hang it on the back of a chair, and begin with a light line following the contour. Follow the curve of a fold into the groove, and increase the pressure to darken the line. After the line dips in a groove, lighten the pressure coming up out of the dip. Let the top lines be thin. Add light hatching on the side planes to separate them

FIGURE 3.5
John Singer Sargent, (1856–1925), *Paul Manship*,
(1885–1966), pencil on brown paper, 21¼" × 16⁷⁄₁₆",
(54 cm. × 43.3 cm.). The Metropolitan Museum of Art
bequest of Paul H. Manship, (1966). 66.70. Photo-
graph, all rights reserved. The Metropolitan Museum of
Art.

*from the top planes. Hatch the direction of the plane as
if you were actually drawing on the surface of your coat.*

WRAPPED LINE DRAWING

Dan Christensen, in *Study for Vela* (fig. 3.6), regu-
larized the continuous line and motion of Jackson
Pollock's dripped line. These wrapped lines can be
seen as either a two-dimensional scrawl across the
grid or as a spinning volume. Christensen was a For-
malist or a Minimalism artist in the 1960s and
1970s. These art movements developed theories
and ideas opposite to those of the Abstract Expres-
sionists before them. Minimalism took issue with
the edge—the edge of the picture plane as well as
the edge of the canvas or paper. As we look at *Study
for Vela*, the lines reaching the edge of the drawing
turn back into the center, eliminating any sense of
contour. Minimalist artists sought solutions that
were not confined by the edge nor framed by the
edge but transcended it visually with the intent to
move beyond it to infinity, if possible. By compar-
ison, there are no abrupt transitions in the line and
no change in the quality of the line. It is one width,
which is exactly the opposite of Jackson Pollock's
line in *Number 3* (fig. 3.16) later in this chapter.
Pollock's line results from a gesture, a loosely di-
rected hand motion. Christensen's line is ordered
and planned from the beginning.

FIGURE 3.6
Dan Christensen, (1942–), *Study for
Vela*, (1968), crayon, 32 cm. × 37 cm.
Virginia Wright Fund, The Washington
Art Consortium. Photo: Paul Brower. Art
© Dan Christensen/Licensed by VAGA,
New York, NY.

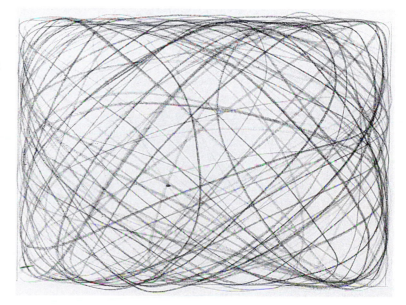

SCRIBBLED LINE DRAWING

A scribbled line drawing uses an overlapping line that wraps around the object being drawn as though it were wrapped in string. The looseness of a scribbled line creates motion, texture, and volume in the drawing, unlike outline drawing. This type of drawing sets the entire form in motion. To make such a drawing, you start a continuous line that follows the front, side, and "back" planes of the form. The line follows your eyes across the surface as they look up and down the form. As a result, your line crosses itself several times, moving in different directions to draw on each plane of your subject. This wandering line wraps around the figure as if you are drawing both the front and the back planes of the figure at the same time. The drawing *Untitled* (fig. 3.7), by Susan Rothenberg, is both a rhythm drawing and a scribbled line drawing.

RHYTHM DRAWING

In rhythm drawings, one form repeats itself over and over, creating the illusion of movement. Each outline is drawn and then overlapped by the following outline. The two-dimensional surface of the paper is now active and is made three-dimensional by the lines. Rhythm drawings may be done in marker or pen. These tools stay sharp and create crisp lines. Pens are probably best since, by their nature, they provide a clean line.

Susan Rothenberg, by 1985, was experimenting with the qualities of speed and motion in her drawings and paintings. In *Untitled*, 1987 (fig. 3.7), her figures spin continuously. There is nothing static about this composition. She draws continuous motion, with a sense of air whipping around the body or bodies. The dancer becomes a blur of light, sending off sparks or kicking up dust as it twirls across a floor.

On the other hand Cy Twombly's, *Untitled*, drawing (fig. 3.8) was drawn with scribble like forms sweeping across the picture plane from the bottom left to the top right. It is a cosmic wind or a sunami wave picking up the forms and tossing them to the right. Twombly repeats forms, but does not use a surface of overlapping forms. He uses a diagonal base line rather than a horizontal base to keep the forms active. In this drawing you can find a circle with a dot in the middle repeated on either side of the drawing. It might represent a breast, phallic symbols tend to float in his drawing with hearts upside down, insinuating breasts or buns. The window may reference the early Willem DeKooning's drawings where a window is often found in the back right or left corner. Here the window is scribbled and erased in almost overlapping drawings.

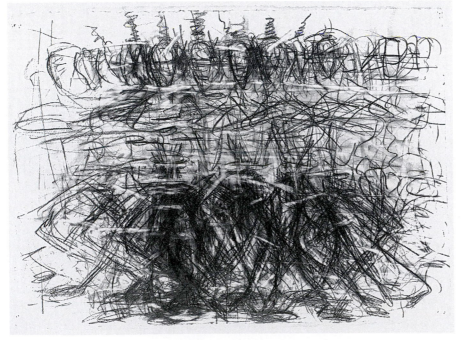

FIGURE 3.7
Susan Rothenberg, *Untitled,* (1987), graphite on paper, 22⅜" × 31". Collection Charles Lund. Courtesy of Sperone Westwater, New York. Photo © Dorothy Zeidman, (1987). © Artists Rights Society (ARS), New York, NY.

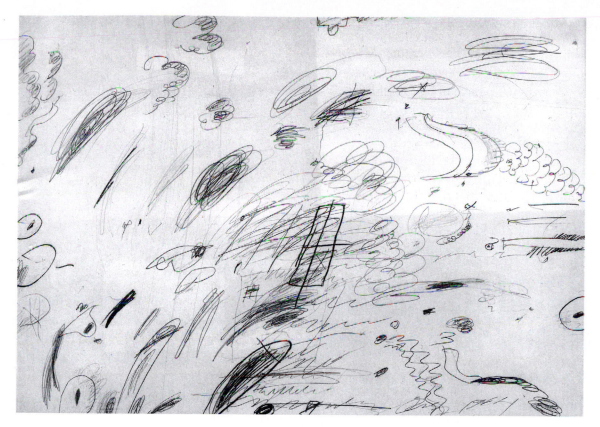

FIGURE 3.8

Cy Twombly, (1928–), *Untitled,* (1964), graphite, colored pencil and crayon on paper, 27½″ × 39⅜″, (69.85 cm. × 100.01 cm.). Collection of the Whitney Museum of American Art, New York, NY. Purchase, with funds from the Drawing Committee. Photograph and digital image © Whitney Museum of American Art. © Artists Rights Society (ARS), New York, NY.

DRAWING EXERCISE 3.2
A Rhythm Drawing

Select one object, such as a tool—a hammer, a pair of scissors, or a screwdriver. Draw the outline of the object once on the paper. Then draw a second outline so that it overlaps the first outline somewhere on its contour. Continue drawing the same outline of the object, overlapping the contour of the outline next to it. The arrangement of these outlines may go horizontally, vertically, or diagonally across the paper. Size can vary. You may go from small outlines to large outlines, or vice versa. The space between each outline is generally close. You may start out with a very small outline and expand it into larger and larger outlines. Draw the outlines running off three edges of the paper. The forms now seem to move through the paper.

Notice that in Susan Rothenberg's drawing, the lines have been wrapped over each other, and then erased and rubbed to break the forms up with partial and overlapping lines. Your first drawing will not be wrapped up. Try Rothenberg's approach, using wrapped and overlapped lines to create movement in your next drawing.

CONTINUOUS-LINE DRAWING

Continuous-line drawing is a drawing process in which your hand draws without your eyes checking the progress of the line on your paper. A continuous-line drawing is composed of one line moving from start to finish. You should keep the drawing tool in contact with the paper throughout the drawing. Try not to lift the tool, and try not to look at your drawing. The intrinsic value in making continuous-line drawings is how this process increases your understanding of the volumes you are drawing and the space around them. You are using and developing critical thinking skills as you visually move through the space of drawing, since each time you move the drawing tool you make a decision. It is not important what the drawing looks like. What is important is the information you have mentally accumulated by making such a drawing.

In a continuous-line drawing, you are investigating the spatial relationships between the objects and the ground. As you direct the line, you make choices and decisions about the size, location, and scale of the objects in the space. As you work,

you increase your knowledge and understanding of how to translate three-dimensional space into the two-dimensional space of the paper. The fact that the paper does not realistically reflect this knowledge is not important—your brain now has considerable information about the space of the drawing, and this will improve your drawing when you draw this space again.

You need a free-flowing pen for continuous-line drawings. Any felt-tip pen or marker works well. Drawing pencils like the 6B or charcoal pencils are soft, and they make beautiful lines, but the lead will get flat, and the lines will smudge. There is no erasing in continuous-line drawing; all changes are made by drawing another line to correct or restructure the line that you felt was inaccurate or wrongly placed.

DRAWING EXERCISE 3.3
Continuous-Line in Still Life

Set up a still life. Pick a starting point on the left or the right of the still life. Place your pen on the paper to correlate to the place where you intend to start. Begin by drawing a line around and across the surface or edge of the first object. This line will then move across the ground plane (the table top) to the next object. Again, the line may define the planes of the object or its contour. Your hand will follow your eyes as they look from one object to

the next. Don't let your eyes get ahead of your hand or your hand get ahead of your eyes. Draw one object at a time. The line must cross the top of the table's surface in order to continue from the first object to the second object. The line is now defining the air and space between the objects, as well as the ground under the objects. The line defines both the negative and the positive space. Thus, line is used not only to draw the outline or contour but also to indicate a solid flat and empty surface.

Don't worry about what the drawing looks like. The line in your drawing will overlap itself because you are searching to define the space, not trying to keep tight control of the line's location. It will wander. Overlapping lines are fine; they give the drawing a transparent effect. The objects don't feel quite solid, and you can see through them to the objects in the background, to the space of the table, and to the space of the wall behind them. If you lose your place when drawing, keep your pen on the paper, glance down to see where you are, and then look back at the subject and continue the line. The entire piece of paper should be filled from side to side, and top to bottom.

Willem de Kooning's *Untitled* (fig. 3.9) is a continuous line that goes from line to plane. De Kooning may well have been drawing a figure in his studio, but he has abstracted the drawing, so we can't be sure. This enamel on paper is done with a "liner" brush and a scraping tool. As he draws he

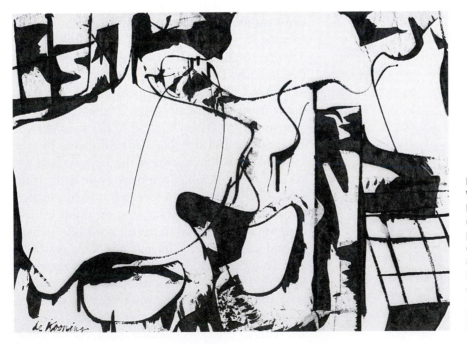

FIGURE 3.9
Willem de Kooning, American, born Rotterdam, The Netherlands (1904–1997), *Untitled,* enamel on paper, (1949), 21¹¹⁄₁₆″ × 30″, (55.7 cm. × 76.2 cm.). Hirshhorn Museum and Sculpture Garden/Smithsonian Institution, Washington, D.C. The Joseph Hirshhorn Bequest 1981.66.1220. © 2007 Willem de Kooning Revocable Trust/Artists Rights Society (ARS), New York, NY.

FIGURE 3.10
Claes Oldenburg, American, born Sweden, (1929–), *Fagend Studies,* (1976), charcoal and chalk on paper, 101.7 cm. × 76.2 cm. Photograph © 1976. Purchased from Richard Gray Gallery, Chicago, IL. Dr. Eugene Solow restricted gift and Print and Drawing Fund. The Art Institute of Chicago. All rights reserved. 1977.511

chooses places to scrape the line into a plane. For both de Kooning and Close (fig. 3.7), (3.8) the purpose of a continuous line drawing is to investigate the spatial relationships between the objects and the ground. This includes studying the size, location, and scale of the subject. Claes Oldenburg's drawing *Fagend Studies* (fig. 3.10) is not continuous-line, but it is a good example of how continuous-line and cross-contour lines have found their way into contemporary drawings. His line wraps around the cylinder, cutting across the top plane. He uses the line freely on the ground to define the space. The cylindrical shape appealed to Oldenburg. He explored baseball bats, drainpipes, and lipstick tubes in the same way that he transformed the cigarette butt. For him, they are soft columns. He has taken a repellent, vilified object, the cigarette, and through his skilled draftsmanship has created an image somewhere between the cartoon and a monument. Lisa Cain's drawing (fig. 3.11), is a student's first approach to continuous line.

FIGURE 3.11
Lisa Cain, Continuous Line Drawing, (1999), student art, Oregon State University.

CROSS-CONTOUR LINE DRAWING

Line is defined, conceptually, as a point in motion having only one dimension, length. Another way to think about line is as two points placed on a surface. The space between them is considered a line, which can be visually or physically connected. Thus, rows of points across a surface form lines. Lines are used to indicate visual direction, to create shapes, and to create the illusion of movement. Line, then, is more than just an outline of shapes and forms. It is direction. It can also be texture, value, and plane. Cross-contour line drawing describes the topography of the surface rather than the outside contour of the form.

DRAWING EXERCISE 3.4
Cross-Contour Drawing

Select something organic or round with soft edges — a hat, a stuffed bird, a cow skull, an acorn squash, a folded drapery, a folded coat, a pair of blue jeans, or a sweater. Study the form, and then pick a starting place. Maya Hayes'

drawing, (fig 3.12) is a crosscontour figure study. Draw a line from one side of the form to the other, moving with the concave and the convex (depressions and rises) on the surface. Move off the first line one inch up or down, and draw a second line across the surface, continuing to define the top planes of the form. Continue drawing cross-contour lines until you have fully described the form. The outside contour is established by the ends of each of your cross-contour lines. The outside edge is open between the lines. This type of study helps you slow down and look at the structure of the surface. In cross-contour you work from the inside of the form to the outside. The outside edge does not dominate the drawing or your thoughts; rather, the relationships of the curves, grooves, dips, and rises across the surfaces of the form are the focus. Vlad Voitovski's drawing, (fig. 3.13) is a good example of the contour edge established by the end of the cross-contour lines.

ORGANIZATIONAL LINE DRAWING

The Giacometti drawing, *Interior* (fig. 3.14) is a drawing constructed out of lines crossing the entire

FIGURE 3.12
Maya Hayes, *Cross Contour Drawing,* (2000), student drawing, Oregon State University,

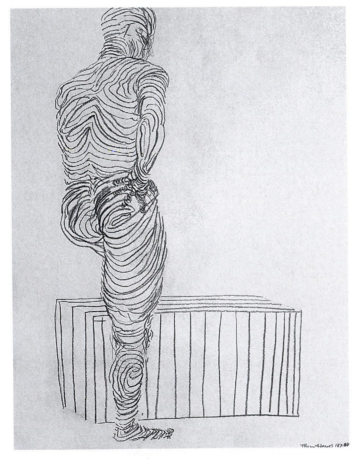

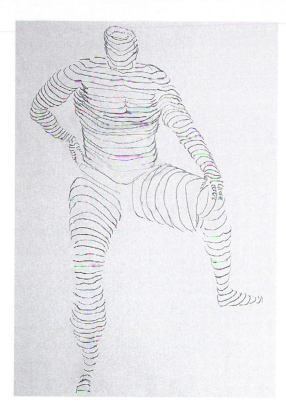

space of the room. The stool is the key to defining the space of the room. Lines from the stool gauge the location and distance of everything in the room to it. Organizational line is helpful in constructing space. By establishing a single unit to which you can relate everything else, you can determine the location of tables and other furniture as well as their height and width. A room is difficult to draw. In this drawing, a volume is constructed from the organizational lines measuring the distance and

FIGURE 3.14
Alberto Giacometti, *Interior,* (1949), oil on canvas, 25⅝″ × 21⅛″, (65.1 cm. × 53.7 cm.), signed and dated on the back: "Alberto Giacometti, 1949". Tate Gallery, London, England. Licensed by SCALA/Art Resource, NY.

proportions of the surrounding grounds to the stool. By considering the relationship of the stool to the tables and cabinets in the room, Giacometti has put the space in perspective and proportioned it.

DRAWING EXERCISE 3.5
An Organizational Line Drawing

Place a stool or chair in the space of a room, and locate your drawing board approximately 10 to 12 feet back from your subject. Work on 18 × 24 inch paper. Draw the stool on an 18 × 24 inch piece of paper so that it takes up three-quarters of the paper, and place it in the center of the paper. Next draw a horizontal line from the top of the stool to the wall, left and right, on both sides. Visually follow this horizontal line and locate other objects in the room where they intersect this horizontal line. Use vertical lines to mark the location of where the objects intersected the horizontal line. For example, there may be a cabinet, an easel, or a table. Make a mark on the first horizontal line where you see them to locate them in your drawing. Draw a vertical line from the center of the stool to the ceiling, and mark off any object, window, or door with a horizontal line that intersects this vertical line. Now, look at the floor. Draw lines from the base of the stool to the front edge of your paper, and mark those lines with verticals where tile, wood flooring, or a rug intersects them. Continue drawing lines from the stool to locate the height and width of all the objects in the room. Develop your drawing of the room by using organizational lines. Try to resist putting a contour line around the edge of the objects in your room.

CALLIGRAPHIC AND EXPRESSIVE LINE DRAWING

Willem de Kooning was known as the master of "the calligraphic line." In addition he was know to draw on any available paper, although he preferred vellum

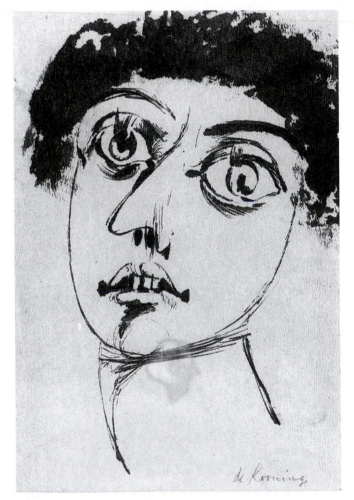

FIGURE 3.15
Willem De Kooning, American, born Rotterdam, The Netherlands, (1904–1997), *Head of a Woman* (study for *Queen of Hearts*), (c.1945), pen and wash on brown wove paper (paper towel), 280 mm. × 195 mm. Iris and B. Gerald Cantor Center of Visual Arts at Stanford University. Gift of Victor and Paula Zurcher. © 2007 The Willem de Kooning Foundation/Artists Rights Society (ARS), New York, NY. 1984.224.

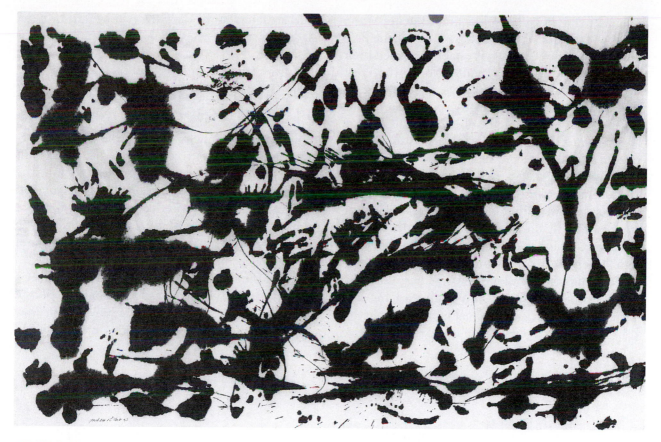

FIGURE 3.16

Jackson Pollock, (1912–1956), *Number 3,* (1951), ink on paper, 24½ in. × 38¾ in. (62.5 cm. × 98.5 cm.). Virginia Wright Foundation. Paul M. Macapia, The Washington Art Consortium. © 2007 The Pollack-Krasner Foundation/ Artist Rights Society (ARS), New York, NY.

and shiny, slick papers on which his line moved easily and quickly. There are de Kooning drawings on napkins, notebook paper, and other scraps. He sometimes drew keeping his eyes closed or by using the eraser to move the charcoal or graphite around. *Head of a Woman* (fig. 3.15) (study for *The Queen of Hearts*), for example, was drawn on a paper towel in pen and ink. The woman's wide-staring almond-shaped eyes are anatomically accurate with full pupils, eyelids, and eyelashes, proof of de Kooning's knowledge and concern for the form of the features. *Head of a Woman* has an overall expressive effect, the mouth curls into a grimace; the nose turns in profile; the nostrils are placed under the nose; and the hair is a scrubbed mass. Quick lines on the neck enhance the turning effect of the head with direct, flowing strokes. Expressive drawings are not necessarily anatomically or photographically correct. Their strength is in their presence as something more than a photographic record.

Calligraphic line comes from letter forms, such as the Japanese and Chinese forms of writing, with characters drawn using brush and ink. The Japanese prints of the 1800s had a strong influence on the French Impressionists in the late 1800s when the prints arrived in Paris. In the 1950's the Abstract Expressionists in New York also were influenced by the Japanese line. Jackson Pollock's line in his drawing *Number 3* (fig. 3.16) expands the definition of the function of line. Spatial ambiguity results from his balance of the positive and negative space, giving them equal emphasis. The shift in scale of the marks, as well as the layers of thick and thin lines gesturally drawn without a horizon, continue to create a space that makes us uncertain which layers are on top, or in the front, and which are underneath, or in the background. Ambiguous space is that in which you can't distinguish foreground, background, and middle ground. The grounds shift visually back and forth with the calligraphic marks.

Crucial to calligraphic line drawing is the quality of the line. Chinese painters before the People's Republic of China was established used their pigtails dipped in ink to paint with. In the West the brush is important in making calligraphic lines. The lines are usually made with a pointed soft hairbrush. The calligraphic brush stroke will change according to the amount of ink and water in the bristles as well to the pressure that the artist puts on the brush from the start of the stroke to the end. De Kooning was extremely experienced in using thick and thin calligraphic lines. His sweeping strokes, rapidly created, made an evenly tapered line. De Kooning used a sign painter's brush known as a "liner." With six inch brush hairs this brush was a natural to make long flowing lines. With this brush, he could change the quality of his line abruptly from thick lines of calligraphic quality to thin lines. The calligraphic line and the expressive line are found in the drawings of other artists in the late twentieth century: Pablo Picasso, Henri Matisse, Pat Steir, Robert Rauschenberg, Jasper Johns, Cy Twombly, and Jean Michel Basquiet.

BLIND CONTOUR DRAWING

Blind contour drawings differ from gesture drawings in both concentration and focus. Blind contour is so named because you do not look at the paper as you draw; you look only at the subject. Your intent is to describe a certain quality of what you are looking at without looking at what you are drawing. It is an expressive style of drawing.

In blind contour drawing, you first select a place to start then place your drawing tool on the paper, returning your eyes to the subject, you draw slowly, keeping your eyes on your subject. In a still

FIGURE 3.17
Deborah Finch, *Blind Contour,* (1999), student drawing, Oregon State University.

life, for example, study the contour of one object at a time. The blind contour drawing is formed using either a single continuous line or a line for each object that follows the outside contour of the objects; but the line may also cross the planes on the object and on the ground, to reach the contour on the other side or to start another object.

Your line will not be an outline. It has a different function. It may describe the form in a partial way, or it may look distorted; not all of the information about the shape of forms in the still life will be rendered. The size of each one will be inaccurate. This line will twist and turn, following the curves and dents, in and out on the form's contour. While you are drawing, you are studying the form. You are looking to create a complex line that describes planes as well as edges. This is not a searching line. Try not to add meaningless lines that don't describe, in your mind's eye, the specific edge or planes of the form you are seeing. The line may cross itself, but it is not a wrapped line. Wrapped and scribbled lines create mass, weight, and volume in a drawing, but blind contour is an adventure in seeing. Finally, do not erase, but continue to look carefully, not allowing your hand to get ahead of your eye or letting your eye get ahead of your hand. You may glance at your paper to reposition the drawing tool, if you feel you must, but only to start the next form.

In blind contour you may vary the pressure on the drawing tool to change the quality of your lines. Heavy pressure makes dark lines; light pressure creates light lines. Dark lines serve to enhance the areas between the forms and in the shadows. Forms in the background may be darker than forms in the foreground. Light lines form the edge of the form sitting in the light. When you no longer need to worry about the accuracy of the drawing, you can concentrate on a different and an equally important part of drawing: developing a stronger sense of space, spatial relationships, and value locations. Fig. 3.17 and fig. 3.18 are student blind contour drawings in which you see the character of this form of drawing.

FIGURE 3.18
Blind contour drawing, *Cutty The West Highland Terrier*, 2000.

FIGURE 3.19

Robert Morris, (1931–), *Blind Time XIX,* (1973), graphite, on wove paper 34⅝ in. × 45¾ in. (88 cm. × 116 cm.) Virginia Wright Fund, The Washington Art Consortium. Photographer: Paul Brower. © 2007 Robert Morris/Artists Rights Society (ARS), New York, NY.

In the drawing by Robert Morris, *Blind Time XIX* (fig. 3.19), he has used a blind drawing process a bit differently from the one previously described. *Blind Time XIX* was constructed with the artist blindfolded to eliminate his vision in the process. Morris set himself the task of covering a sheet of paper evenly with strokes of graphite in a predesignated amount of time for each drawing. *Blind Time XIX* above is composed of powdered graphite applied directly by the artist's fingers onto the paper. The surface of the paper, then, mirrors touch itself. Morris places his fingers into a plate of powdered graphite after which he places his fingers on the paper. The placing of his hands and the movement of his body determines the outcome of the drawing. The resulting images were a symmetrical projection of the internal plane of the body, meaning that this drawing reflects Morris's internal and innate sense of balance. The drawing did not represent images or ideas. Instead, it was the result of a particular act of expression resulting from the artist's actions of grasping, touching, placing, and reaching. We all have a sense of order, a physical one as well as a mental one. Artists like Robert Morris are confident relying on their internalized sense of order. Morris made ninety-four drawings in this series.

Blind contour is directly related to the intuitive side of your brain, not to the logical side of the brain. Through blind contour drawing, you gather information that is sensual, not factual. Thus, blind contour drawing uses the senses more than lines of logic and reasoning. Your other senses—smell, hearing, and touch—enter this playing field and contribute to a greater awareness of the making of art. The linear thinking skills are not your only strength. Blind contour is a drawing process in which you learn through the act of drawing.

The drawing *Hercules in the Augean Stables* (fig. 3.20) was made by Honoré Daumier in 1862, twenty years after he had made a series of fifty lithographs on this same theme. In these lithographs, made over a period of two years from 1841 to 1843, Daumier lampooned the pseudo-classicism of the period by recasting fifty hallowed episodes from ancient history and myth. His intent was to give new life to the great tradition of art, to free it and bring it closer to the reality of common experience. These lithographs proved to be some of the most hilarious inventions of his career. The image of Hercules in the Augean stables must have particularly moved him, because he returned to it in this later drawing. Hercules is resting after the fifth of twelve labors, in this case, after cleansing the stables of King Augeas of thirty years of dung by diverting two rivers through the stables. An overweight Hercules leans on a broom, not a club, and Daumier has given him the look of a street cleaner, not a god. The contours of the body are erratic, discontinuous pen strokes that hesitantly shape the figure. The face of Hercules is done in the kind of line that seems spontaneous. He looks disgusted with the world. In the first lithograph, the mood was humor; in this one it is pathetic.

In his time, Daumier was criticized for the sketchy, almost unfinished quality of his work. Today he is praised. Daumier did not receive formal training in the arts. He was self-taught, and he was well-versed in the style and techniques, of the masters, his predecessors. He was a gestural master in the tradition of Tiepolo, Goya, and Rembrandt. Daumier's animated drawing style conveys and compels empathy with Hercules' human presence and experience.

Satire and humor permeate his narratives. His figures are usually twisting, turning, swinging, caught in the moment. Gesture lines are the perfect style to capture moments in time. For example, in a Daumier drawing of a courtroom, a lawyer's arm might be flung back toward a passive defendant as the lawyer passionately addresses the court.

As a social critic commenting on the institutions of his day, Daumier is perhaps most famous for his many drawings of lawyers and law courts. He

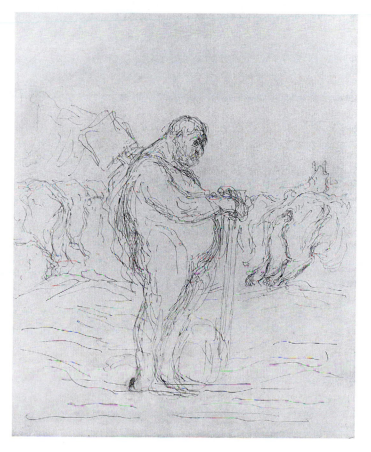

FIGURE 3.20

Honoré Daumier, France, (1808–1879), *Hercules in the Augean Stables,* pen and gray ink on cream paper, 345 mm. × 264 mm. Committee for Art Acquisitions Fund. Iris and B. Gerald Cantor, Center of Visual Arts Center, Stanford University. 1972.181.

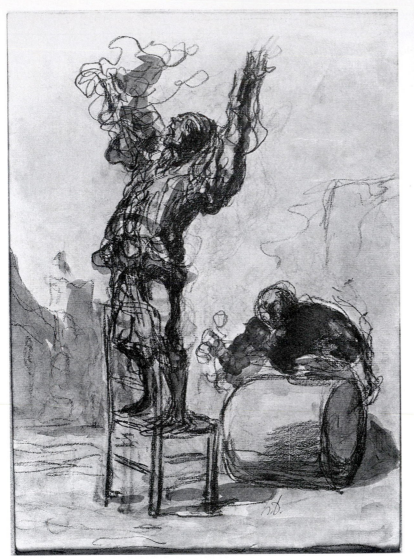

FIGURE 3.21
Honoré Daumier, (1808–1879), *Street Show (Paillasse),* charcoal and watercolor 14⅝ in. × 10¹⁄₁₆ in., (36.5 cm. × 25.4 cm.). The Metropolitan Museum of Art, Rogers Fund, (1927). 27.152.2. Photograph, all rights reserved, The Metropolitan Museum of Art.

made his living portraying the human comedy, drawing seven lithographs a week for a Paris newspaper. Daumier's radical but brilliant cartoons would land him in jail for lampooning the corruption of postrevolutionary French politics and society.

Daumier's drawings are intimately tied to the human drama of the artist's own time. He was intrigued by the spectacle of city life—and by the theater, where long before Toulouse-Lautrec, he had observed the effect of footlights on the performers' faces. Like Lautrec, Daumier drew from memory. Once when in the country with a friend, he stopped at a pond with ducks. As he stood intently staring at the birds, his friend asked why he didn't draw the birds. He replied, "You know perfectly well that I never draw from nature."

In the *Street Show (Paillasse)* (fig. 3.21), Daumier's line is loose, defining the end of the subject without an outline. His line is more like a fishing line that is loose and floating around the form. This active, expressive line describes movement. Daumier reinforces the shapes and volumes in the drawing with an ink wash on the figure, behind the figure, and on the ground. The figure in the back is dark, thus separating him from the front figure. Daumier places the values very consciously to create a sense of space. The white drum separates the gray figure on the chair from the man behind him, who is depicted in very dark values. This rotation of values moves the eye through the drawing.

It was a surprise when, at the end of Honoré Daumier's life in 1878, a gallery in Paris displayed

ninety-four of his paintings, unseen drawings, watercolors, and sculptures, so that the full range of his genius was evident. It was not until 1900, however, that Daumier, the "people's artist," was acknowledged as one of the great pioneers of the modern movement.

IMPLIED LINE DRAWING

An implied line is a broken outside line that implies the contour of the form but does not follow it exactly or tightly. Implied line starts by following the form and then stops, leaving a gap. Our sense of form is so strong that our eye completes the line on the form by using previous visual information stored in our brain. This type of drawing is also referred to as having lost and found edges. It is one way in which artists create visual interest because without the completed edge, the viewer remains uncertain as to how far a form may move into or out of the paper. Implied line can also reflect actual light conditions in which bright light dissolves an edge.

The implied line is an expressive line that opens up the picture plane, increasing the sense of space. In Édouard Vuillard's *Studies of a Seamstress* (fig. 3.22), he has used implied line to capture the working gestures of a seamstress. With this open

[FIGURE 3.22
Edouard Vuillard, France, (1868–1940), *Studies of a Seamstress*, (1891), brush with India ink on buff wove paper, 361 mm. × 305 mm., Mortimer C. Leventritt Fund. Iris and B. Gerald Cantor Center of Visual Arts at Stanford University. 1970.21.

line, she seems actively involved and very much alive.

In *Untitled*, 1952 (fig. 3.23), Phillip Guston created lines that pull you in and out of the space of the picture plane. This effect happens as a result of the size and direction of the placement of the lines. The quality of his line is elegant, with a broken and blurred edge. His small, almost unnoticeable, overlapping of lines creates a sense of shallow space. The few diagonals against the horizontal and vertical lines either send you into the interior or push against the eye, moving out into the viewer's space, outside the picture plane. Drawing provided Guston with a unique language to explore pure drawing, and also to prepare for paintings later. In spite of the fact that ink is impossible to erase, he chose to draw with ink because the quill pen and the brush responded to the pressure of his touch. Ink line is fluid, flowing more like a painting than a pencil drawing. His drawings are like explored spaces not bound by perspective. He once commented, "I wanted to make drawing more like painting, without contour. These are drawings with masses from accumulated strokes." Guston focused on a rigorous structuring of space and on the articulation of the painter's mark with it. His marks were directed, not accidental. He didn't just toss a mark upon the paper—rather, he had a purpose and a direction in mind, thus the articulation of the painter's mark.

FIGURE 3.23
Philip Guston, (1917–), *Untitled*, (1952), ink, 44 cm. × 57.5 cm. Virginia Wright Fund. The Washington Art Consortium. Photographer: Paul Brower. 75.3. © Philip Guston.

1. Warm up your hand and your eyes before you start drawing with a quick gesture drawing.
2. What style of line will you use in your drawing, contour line, scribbled line, or blind line.
3. Look carefully at your subject. Consider what kind of lines you need in order to render the contour and the volume.

4. Use reference points to help you locate the forms in your drawing. Look at the baseline of all the objects and the relationships of size and scale from one to another.
5. Draw the negative space as well as the positive space.

ART CRITIQUE: DARRAUGH & RIVERS ●▶

In 1965 Larry Rivers' *Seated Woman* (fig. 3.24) seemed as radical as David Darraugh's *Untitled Preliminary Drawing for Sculpture*, seems today. Rivers' line is loose and broken. The figure sits reading on a barely defined couch. Heavy lines form the con-tour, but incompletely. In 2002, Dave Darraugh was considered a post-modern artist, stepping out of mainstream art practices. He transforms industrial materials, such as house paint, into drawings strangely reminiscent of the traditional sumi-ink

FIGURE 3.24
Larry Rivers, American, (1925–), *Seated Woman,* (c. 1965–70), pencil on buff wove paper, 357 mm. × 424 mm. Anonymous gift. Iris and B. Gerald Cantor Center of Visual Arts, Stanford University. Art © Larry Rivers Estate/Licensed by VAGA, New York, NY. 1973.123.3.

drawings done by the Japanese artists. Darraugh separates himself from the use of the traditional art process and materials. He uses non-art substances, such as motor oil mixed with gouache, crayons, and mineral spirits, plaster with bailing wire, felt, rubber, rope, rebar, and artificial fur. These materials provide the foundation for a raw expressiveness in his sculptural forms and drawings. His drawings are often preliminary studies exploring approaches to his sculptures, a traditional role for drawing, but often Darraugh's drawings become completed works in themselves.

His drawings reflect his thought process. He likes the integrity of house paint. By that he means its versatility and toughness. His process involves covering wet paper with house paint. The wet on wet binds the paper and paint together, and also protects the paper when he sands the drawing later. His process is not within the tradition of the draftsman, whose hand controlled and directed the line. His tools may be trowels instead of pen or pencil, and his process is indirect.

Once house paint and paper are joined, marks are added. Paint and marks are added layer over dry layer, each covering the one under it, but these layers are later revealed by the sanding. When the layers have dried, he sands over the marks of the drawing, continuing down through the layers to achieve the final form. His drawing (fig. 3.25) is a preliminary sketch for a sculpture. When you first look at the Darraugh drawing, you may have no frame of reference for it, but if you think of it as representing sculpture that is referencing mirrors, your perception of the drawing changes.

FIGURE 3.25
Dave Darraugh, *Untitled,* preliminary drawing for sculpture, (2002), graphite, house paint on paper, 30″ × 22″. Courtesy of Froelick Gallery, Portland, Oregon. FG inv. #108.

Darraugh has said of his work:

The volatility, immediacy, and physicality apparent in the drawings derive from the back-and-forth process of developing an idea. My understanding of what that idea may be is not static or fixed in place. Sometimes the method for advancing an idea is to do nothing but observe it for a span of time and address it later . . . Fundamentally, you must be willing to destroy (fail) the drawing or sculpture, and your own aesthetic, in the pursuit of exploring the full potential of the material and idea, in the process, you destroy and reconstruct yourself and the ideas at the same time.

Art Critique Questions; Darraugh, Rivers

1. Consider the work's title. Does the title help you interpret what you see?
2. How has the artist used line? Is line now the subject of the drawing?
3. Was line used as an outline or a contour?
4. How would you describe Darraugh's lines compared to Rivers' lines forming an abstract figure?
6. What kind of space results from the artist's use of line?
7. Were lines used as texture?
8. Consider and analyze the lines in both drawings, determining the volumetric aspects and the spatial effect of the line in the drawing.

JOURNAL FOCUS

Explore the use of line in your journal. You may sit outside or inside. Select a tree or bush, a vase, or a tool from the garage to draw. Analyze the contour and the shape. Render your subject with implied line. Next, draw the subject in a scribble line drawing, wrap the subject up in lines, and, finally, make a blind contour drawing. Which drawing appeals to you? Change from a roller ball pen to a 6B pencil and draw all three again. What is the difference in the quality of the line between these two drawing tools? How does the tool affect each of these types of line drawings? Construct a row of objects in a drawing that have some element in common but have no meaning; e.g., they are mostly tall or mostly tools. Add real objects to your collage to extend the drawing. Consider using one or all of the three drawings, the implied line, the scribble, or the blind contour, in your notebook.

VALUE: THE IMPORTANCE OF LIGHT AND DARK

The term *value* refers to the range of light to dark used in a drawing. Changes in value from light to dark create the illusion of volume on a two-dimensional surface. The placement of light and dark in the picture plane can create a sense of deep space or shallow space. Value further enhances a drawing in the following ways: light and shadow create the appearance of three-dimensional forms; value changes can create surface texture and pattern; and value changes can control the mood of a drawing. The terms *model*, or *modeled* or *modeling*, *shading*, *value change*, and *gradations* all mean the same thing; they refer to the artist's use of light to dark across a form or through a space to create volume and space. Drawing is an illusion created by line, value, perspective, texture, and color: In this chapter the power of value is discussed.

Value changes in a drawing provide a sculptural quality expressing the subject's volume and weight. Vija Celmin's *Ocean: 7 Steps #1*, (fig. 4.1), seems at once flat to the picture plane and then incredibly deep because of our knowledge of the ocean. Her use of graphite is so fine it reminds you of a silverpoint drawing not a graphite drawing. Working on an acrylic sprayed ground, she has developed a technique of layering graphite very lightly to avoid any pencil strokes or hatching lines. The surface is uniform and virtually photo perfect. In *Ocean: 7 Steps #1*, (fig. 4.2), she creates the surface of the ocean gently gradated from light gray values to medium gray values in seven separate rectangles.

It seems likely that Celmins starts with an HB pencil followed by a 3B, 4B and on to the 6B pencil for her darkest rectangle.

Altar of Orpheus by Mark Rothko (fig. 4.3) is an example of layers of wash creating a dark, yet not black, drawing. Some of the white looks as if it is a wax resist, whereas other areas may be the white of the paper showing through. Ink wash on a heavy watercolor paper will be grainy in appearance and textured. Here you can see that layers of wash do not obliterate the image, but enhance it.

Forms in a drawing will seem to advance or recede according to their degree of light and dark. The placement of values—light, gray, and black—in the picture plane orders the space in the drawing to manipulate how you perceive the space. The term *picture plane* refers to the area being drawn and to the actual space on the drawing paper. The picture plane is the same space as the paper you draw on. The picture plane is used to define the boundaries of the drawing.

George Bellows, in his drawing of *Elsie Speicher, Emma Bellows, and Marjorie Henri* (fig. 4.4), has balanced the space of the drawing, from dark in the foreground to white in the background. The value changes in the drawing are aligned on a diagonal line from Marjorie Henri, the woman on the right in the foreground, to Elsie Speicher, the woman in white on the left. Bellows has applied his understanding of how light falls in a room to create this space. His drawing does not necessarily

FIGURE 4.1
Vija Celmins, (1939–), *Ocean: 7 Steps #1, (detail)*, (1972–1973), graphite on acrylic sprayed ground, 12⅝″ × 99⅛″, (32.1 cm. × 251.8 cm.). Purchase, with funds from Mr. and Mrs. Joshua A. Gollin. © 1997 Whitney Museum of American Art, New York, NY. 73.71.

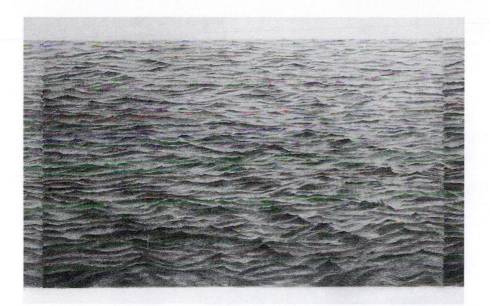

FIGURE 4.2
Vija Celmins, (1939–), *Ocean: 7 Steps #1, (detail),* (1972–1973), graphite on acrylic sprayed ground, 12⅝ in. × 99⅛ in., (32.1 cm. × 251.8 cm.). © 1997 Whitney Museum of American Art, New York, NY. Purchase, with funds from Mr. and Mrs. Joshua A. Gollin. 73.71.

reflect actual light patterns in the room; rather, he offers an interpretation of light to create space.

FOUR DIVISIONS OF LIGHT

Each area of a drawing may be analyzed in terms of the amount of light it receives. There are four major divisions of light: light on light, light on dark, dark on light, dark on dark. Light on light is light falling on a white ground; it is the brightest and whitest light. Light on dark is light falling on a dark surface. Dark on light is a white surface with a shadow on it. Dark on dark is the darkest area of a drawing, and it is where a shadow covers a dark form or space. These light divisions control the space of a drawing.

FIGURE 4.3
Mark Rothko, (1903–1970), *Altar of Orpheus,* (1947–1948), watercolor and ink, 19.75 in. × 13 in., (50 cm. × 33 cm.), *Works On Paper: 1945–1975.* Virginia Wright Fund, The Washington Art Consortium. Photo credit: Paul M. Macapia. © 2007 Kate Rothko Prizel and Christopher Rothko/Artists Rights Society (ARS), New York, NY. 75.13.

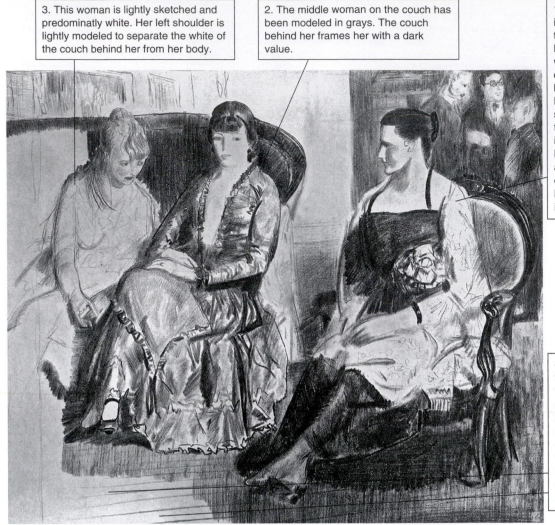

3. This woman is lightly sketched and predominatly white. Her left shoulder is lightly modeled to separate the white of the couch behind her from her body.

2. The middle woman on the couch has been modeled in grays. The couch behind her frames her with a dark value.

1. The woman in black is in the foreground. Her shawl is white, in high contrast to the black dress. Her black hair separates her from the men in gray behind her. The dark at the bottom of the chair holds her firmly in the chair.

4. The floor in front of the wormen is gradated from black on the right to white on the left. A few thin lines lead the eye out of the gray into the light.

FIGURE 4.4

George Wesley Bellows, American, (1882–1925), *Elsie Speicher, Emma Bellows, and Marjorie Henri,* (1921), black crayon over touches of graphite, on cream wove paper, 44.1 cm. × 52.6 cm. Gift of Friends of American Art Collection. Photograph © 1995 The Art Institute of Chicago. All rights reserved. 1922.555.3.

Richard Diebenkorn's *Seated Figure* (fig. 4.5), displays the four divisions of light. It is both a lithograph and a drawing. (A lithograph is a drawing done on a stone or a metal plate with a grease crayon and *tusche,* a greasy inklike liquid.) Diebenkorn uses line, wash, and value as he would in a drawing to create the space. You enter the drawing on the white tabletop—the light on light surface—which is balanced by the woman's black purse. This initial high contrast is softened by the woman's striped shirt with a light wash modeling her body for a dark on light effect. Her black hair is framed by a white headband, and then it is balanced with the medium gray wash behind her head.

Her light arms and legs press forward. The white squares on the right of the drawing separate themselves from the background, framing the figure in the space. The dark areas below the table are light on dark, and the shadowed surface on the lower right—dark on dark, completing the rotation of white to black through the space.

LIGHT TO DARK

When the overall effect of the lighting moves from dark values to light values in the distance, then we say it is "dark to light." Architects compose their drawings in "dark to light," with the dark values in

VALUE: THE IMPORTANCE OF LIGHT AND DARK

FIGURE 4.5
Richard Diebenkorn, *Seated Figure*, from the portfolio, *Ten West Coast Artists*, (1967), lithograph, Collectors Press, 9/75, 29¼" × 22⅜". San Francisco Museum of Modern Art. Gift of Spaulding Taylor. © Artemis Greenberg Van Doren Gallery for the Estate of Richard Diebenkorn. 82.481.3.

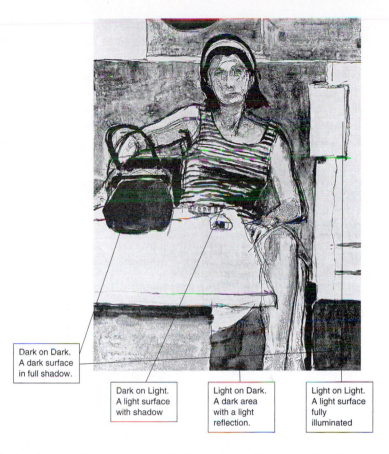

Dark on Dark.
A dark surface in full shadow.

Dark on Light.
A light surface with shadow

Light on Dark.
A dark area with a light reflection.

Light on Light.
A light surface fully illuminated

the foreground moving to light values in the background. Landscape will often be drawn in dark full values in the foreground, moving to light in the background. This shift in value visually creates an imaginary space or a space representing the space of landscape. Landscape may be considered either deep space or shallow space. Creating the illusion of space depends on the eye's recognizing the dark, fully modeled forms in the foreground and the light values of the hills in the background.

George Seurat, in his *Place de la Concorde, Winter* (fig. 4.6), reverses the balance of dark to light to

FIGURE 4.6
Georges Seurat, French (1859–1891), *Place de la Concorde, Winter*, (1882–1883), Conté crayon, 9⅛" × 12⅛" (23.2 cm. × 30.8 cm.). Solomon R. Guggenheim Museum, New York, NY, (1941). Photograph by Robert E. Mates © The Solomon R. Guggenheim Foundation, New York, NY. 41.721.

light to dark. The scene feels like dusk or night after it has snowed. The ground is white with light reflecting on it: a light on a light surface. Moving back, the ground is white, with dark long shadows on the light areas. The lack of any reflected light at the top of the drawing prevents you from seeing through the treetops. The trees become a dark mass through the use of dark on dark. There is a small sense of light on

dark at the top of the trees and on the right side of the drawing, where Seurat has lessened the overlapping strokes, leaving these areas slightly lighter than the center. This drawing is a high contrast drawing, because of the absence of grays.

Theodore Gericault's *The Black Standard Bearer* (fig. 4.7) stands by itself as a finished composition, not as a drawing for a later painting. The

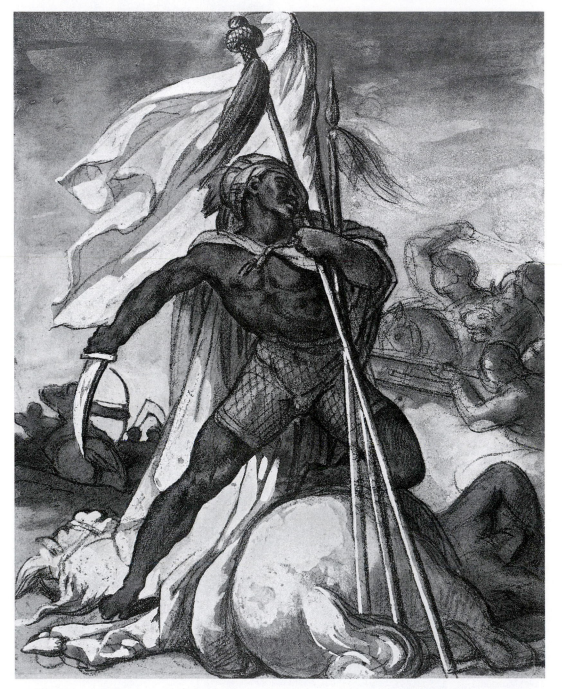

FIGURE 4.7
Theodore Géricault, French, (1791–1824), *The Black Standard Bearer,* (c. 1818), pencil, black chalk, and gray wash heightened with white on buff wove paper, 203 mm. × 163 mm. Iris and B. Gerald Cantor Center of Visual Arts at Stanford University. Mortimer C. Leventritt Fund and Committee for Art Acquisition 1972.6.

FIGURE 4.8
Chiaroscuro light effects on a sphere.

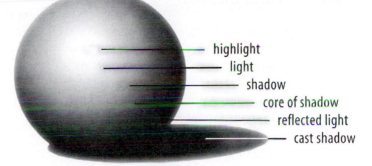

- highlight
- light
- shadow
- core of shadow
- reflected light
- cast shadow

subject was drawn from exemplary acts of courage during the Napoleonic Wars. Gericault's wash and gouache technique with pencil and black chalk are examples of mixed media. Like Seurat, Gericault has used blacks and whites to create a high contrast drawing, a black soldier holds a white flag over a dying white horse. They are flanked by figures in gray wash and charcoal lines growing out of a white cloud. The foreground is completely developed, whereas the background is hazy and undefined. The manipulations of value create a dramatic space in this expressive use of value.

CHIAROSCURO

Chiaroscuro is a word that was coined in the Renaissance to describe light into dark. *Chiaro* means "light" and *oscuro* means "dark" in Italian. The term was first used by the artist Leonardo da Vinci, who changed the process of modeling from a dry and hard manner into the soft modeling of light and shade. The process—and technique—involved in chiaroscuro creates the illusion of volume, space, depth, and mass on a two-dimensional surface. Fig. 4.8 is an example of chiaroscuro. There are six defining areas; the highlight where light strikes the form first, the lightest area on the form. The area below the highlight is called *light,* followed by areas known as *shadow* and *core of shadow.* Reflected light refers to light bouncing from a neighboring object onto this sphere. Reflected light strikes the sphere where the form is changing from the top planes to the bottom planes. Finally, the cast shadow is at the bottom; the angle of the shadow follows the angle that the light strikes the sphere. McDonal, (fig. 4.9), applied Chiaroscuro to his drawing manipulating value to create volume and space.

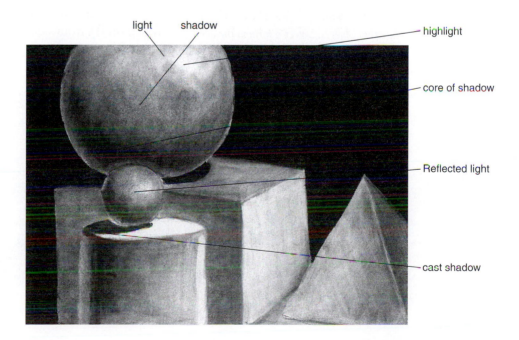

light shadow highlight

core of shadow

Reflected light

cast shadow

FIGURE 4.9
Matt McDonal, value study,
student drawing, 1999.

THE VALUE SCALE

As artists, we cannot duplicate the range of values in nature—we can only approximate the effects. Most people can easily distinguish nine steps in a value scale, including white and black, but the eye is capable of seeing many more levels of light. Our perception of value is affected by several factors. First, the color of the object affects our reading of the value. Second, lightness and darkness are relative to their surroundings; we interpret values in relation to other values. And third, the direction that light falls on a form affects its perceived value.

Analyze the values in your subject before you start drawing. The following exercise is designed for you to practice the range of values possible in a drawing.

DRAWING EXERCISE 4.1
Light and Dark

There are many ways to use light and dark in drawing. In your first drawing, try combining flat shapes and forms with some modeled forms to see what this type of relationship creates visually. In a second drawing, use only flat black shapes and experiment with materials. Try compressed charcoal and Conté, both of which dissolve in water. Oil stick must be dissolved while wearing gloves from the grocery store, or plastic disposable gloves are also available. Next, carefully choose light and dark values in a still life. Rotate the values so you do not place the same value behind or beside two objects. Select a form in the cen-

ter to be dark and place the white side of an object next to the dark one. The goal is to balance and rotate values without any attention to a light source. This process will most likely flatten the space of your drawing and may squeeze the space together. In this drawing, when you start with a dark value on your first form, make sure the one next to it is white or gray where the contours of the forms meet. Fig. 4.10 is a value scale illustrating a number of value changes from white to black.

"Race" ing Sideways (fig. 4.11), by Nikolai Buglaj, displays a full value scale in his drawing. It is a graphic riddle, reflecting society's sociological illusions of race and class in terms of skin color and a formal value study at the same time. Technically, his illusion depends on a gradation of light to dark. It is a stunning example of the four qualities of light. Each man is individually rendered using the technique of chiaroscuro, but the technique is overpowered by the "expressive" meaning of the drawing. His technique is perfect, precise, and correct, but the content of the drawing—its subtle message—is more powerful.

USING CHIAROSCURO IN DRAWING

Light falls on form both vertically and horizontally; therefore, when you are using light to dark values to model a form the planes must change from light to dark. The gradation of light will change vertically, from top to bottom, as well as horizontally, from side to side. Occasionally, forms

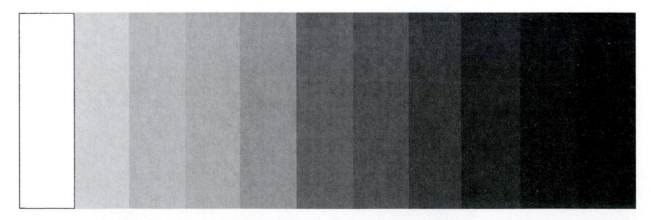

FIGURE 4.10
Value Scale

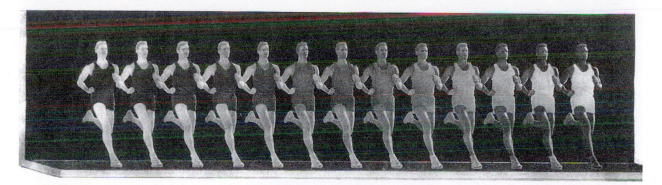

FIGURE 4.11
Nikolai Buglaj, "*Race"ing Sideways,* (2003), graphite and ink, 30″ × 40″. Courtesy of the Artist.

will be underlit or backlit, with light coming from below or behind them. This type of lighting forms a halo of light on the contour of the form. Light rays cannot turn, they maintain a continuous straight light from the source. It is the form that turns away from the light creating the areas of shadow and the core of the shadow. It is important in the beginning of the drawing to establish firmly in your mind the direction in which the light is falling.

The drawing *Figure of a Woman* (fig. 4.12) by Colin follows the traditional application of chiaroscuro while Richard Serra (fig. 4.13) disregards chiaroscuro for a modern application of value.

Paul Colin in, (fig. 4.12), demonstrates the application of the Chiaroscuro process. Colin's, *Figure of a Woman,* was drawn with the highlight on her forehead and where the skull turns back at the middle of eyebrow and the cheek bone the value is markedly darker separating the side plane from the

front planes of her face. The light bounces across the features. Note the light on the eyelid, the bridge of the nose the inside of the cheeks and the chin. He has modeled her head into a believable volume using Chiaroscuro.

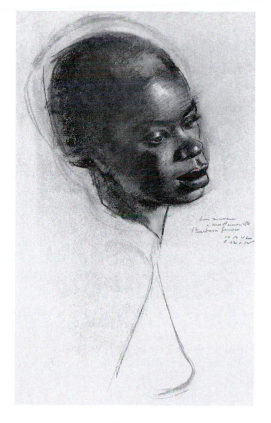

FIGURE 4.12
Paul Colin, French, (1892–1985). *Figure of a Woman,* (c. 1930), black and white crayon on light beige paper, 24 in. × 18½ in. Collection of the Frederick and Lucy S. Herman Foundation to the University of Virgina Art Museum. © 2007 Artists Rights Society (ARS), New York, NY.

FIGURE 4.13
Richard Serra, (1939–), *Out-of-round IX,* (1999), oil paint stick on paper, 79½ in. × 79½ in. (201.93 cm. × 201.93 cm.). Collection of the Whitney Museum of American Art, New York, NY © 2000. Purchase, with funds from James Hedges and an anonymous donor. © 2007 Richard Serra/Artists Rights Society (ARS), New York, NY. 2000.10

Richard Serra is more interested in the application and effect of his materials. Here, in *Out-of-round IX,* he chooses oil paint stick on paper, drawing this circle 79½ in., making this drawing at least four times the size of Colin's. In Serra's drawing the placement of the circle in the square is important. It is not centered, it pushes the right edge of the square, easing itself across the picture plane in a effort to move off the plane. The ground around the circle is 'blasted.' It radiates out from the circle like rays of the sun and comet trails falling away from a moving form. Normally, a black circle of this scale would sit back in the frame, but here, because of the thickness of the application of the oil stick, it raises up off the surface as bas-relief. For Serra there is no concern for chiaroscuro. He has no intention of creating a volumetric shape with lighting; rather, he creates a volume by its size, scale, and through the thick application of oil stick.

DRAWING EXERCISE: 4.2
Light and Dark

Make a series of drawings in vine and then compressed charcoal by looking at the light falling on the forms or objects in your still life. Look closely at each object in the still life to interpret the light areas, gray areas, and black areas. Use vine charcoal for this first drawing. In your next drawing cover a shape lightly with vine charcoal and then use the kneaded eraser to lift off most of the charcoal. Cover a second form firmly in vine charcoal and then remove the charcoal with the kneaded eraser.

Finally cover a form in compressed charcoal and work to remove the charcoal with the eraser. This process will give you a gray you cannot create any other way. Finally take a geometric approach to one drawing dividing each object in half. Make one object half black and half gray or make one half white and half black. Choose any value to put with another on the object and you may divide the form vertically or horizontally.

The placement of light and dark values will control the space of the picture. For example, using black to entirely fill a form without any gray or white can create a silhouette. The resulting flat shape has a contour, often with a shape we recognize. Although we may perceive that the form is volumetric, we do so only because we recognize the form and know it to be three-dimensional.

Kara Walker (fig. 4.14), like Richard Serra (fig. 4.13), has created flat black forms. They are silhouettes of people who create a narrative of the deep south prior to and during the Civil War. Kara Walker's installation (fig. 4.14) is a story of oppression. It is constructed out of cut paper silhouettes. She has made a very clear statement without employing modeling. Walker has also used the extreme values of black and white to strongly remind us of the plight of the African American culture long before civil rights.

PLANAR ANALYSIS

All figures and objects are composed of planes. You must train your eyes to see form in terms of interlocking planes. Planes are important in determining where to place light or dark values in a drawing and where to change from one value to another. Value changes may be gradual or abrupt, depending on the angle of the light. Light changes according to the direction in which it is falling and the location of the planes on the objects. Fig. 4.15 demonstrates values changing as planes change. The cylinder is the hardest place to determine

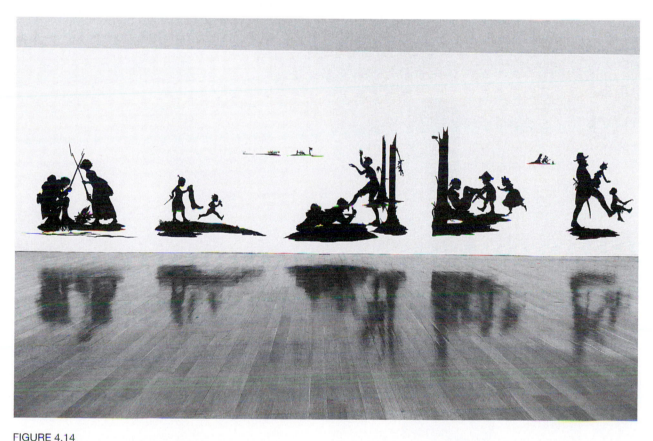

FIGURE 4.14
Kara Walker, *The Battle of Atlanta: Being the Narrative of a Negress in the Flames of Desire—A Reconstruction*, (1995), cut paper and adhesive on wall installation, dimensions variable. Image courtesy of Sikkema Jenkins & Co., New York, NY.

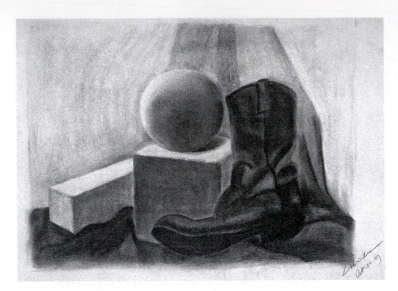

FIGURE 4.15
Lili Xu, charcoal value study, student drawing,
(1999), Oregon State University.

where the planes are changing. In fig. 4.16 Alisa Baker demonstrates a definite shift of value across the cylinders.

Shimon Okshteyn's drawing, *Metal Container* (fig. 4.17) is graphite and pencil on gessoed canvas. It is rendered in photographic realism. Notice the subtle light changes; the planes on the left side are darker than some of the planes on the front. The front of the container changes value as the planes of the form are pushed out and dented in. This drawing is impressive not only in detail and it's super real presentation, but in its size, it is 116½ × 92¾ inches or nine feet, eight and one-half inches by seven feet, eight and three-quarter inches. It is

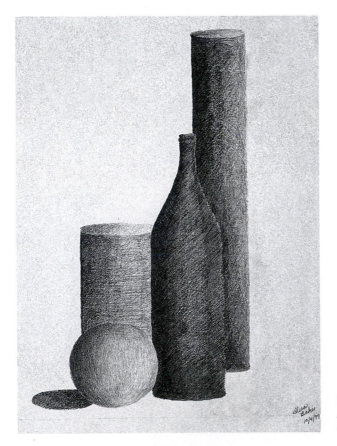

FIGURE 4.16
Alisa Baker, value planar analysis in pencil, student drawing,
(1999), Oregon State University.

FIGURE 4.17
Shimon Okshteyn, (1951–), *Metal Container,* (2000), graphite
and pencil on gessoed canvas 116½ in. × 92¾ in. × 2³⁄₁₆ in.
(295.9 cm. × 235.6 cm. × 5.6 cm). Gift of O.K. Harris Gallery,
New York, NY. Whitney Museum of American Art, New York.
2002.303.

taller than most people who view it in the gallery
or museum. He has captured the texture of the sur-
face and all the dents, with the light to dark on the
planes creating a volume on his flat canvas.

USE OF LIGHT WITH PLANAR ANALYSIS

In choosing light to dark for your drawing you may
return to the value scale as a palette of choices.
You are not restricted by any order of light to dark.
You may choose to use only the first half of the
value scale, working from white to medium gray.
The gray in the middle of the scale would then be
the darkest value in your drawing. In the same
way, you can work from the mid point of the scale
to black.

 In the student still life drawing (fig. 4.18) the
forms have been divided to locate the planes of
the cylinders, which is harder than identifying the
planes of a box. Geometric forms have very defi-
nite beginnings and endings of their planes. A
plane on a box would be the top or the side of the
box. Most forms have a top plane, a side plane, and
a back plane. Planes of a cylinder change with the
curve of the cylinder. To understand where the
planes are on a cylinder, place the palm of your
hand flat on the surface of a cylinder such as a bot-
tle. Where the flat of the palm rests flat is a plane.
To change planes, turn your palm to touch the sur-
face area next to the first plane. When you bend
your hand to touch the next surface, you have

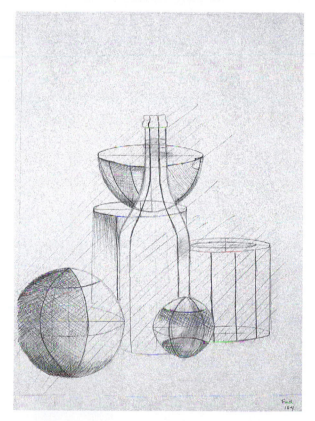

FIGURE 4.18
Deborah Finch, pencil, study of the planes of cylinders with first
value changes added, (1999), student drawing, Oregon State
University.

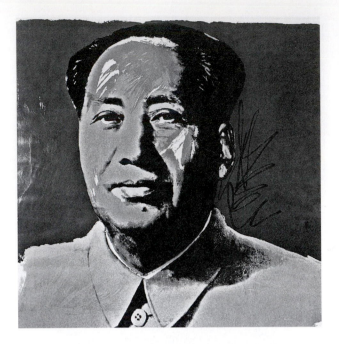

FIGURE 4.19
Andy Warhol, (1928–1987), *Chairman Mao*, (portfolio of 10 silkscreen prints), (1973), 150/250, 91.5 cm. × 91.5 cm., Virginia Wright Fund. The Washington Art Consortium. Photographer: Paul Brower. © 2007 Andy Warhol Foundation for the Visual Arts/ARS, New York, NY. 76.25.

changed planes. Warhol's silkscreen print of *Chairman Mao* (fig. 4.19) is defined as a high contrast drawing. Where the front plane of the skull changes to the side plane you see a dramatic use of black. Again the black value defines the side plane of Mao's nose, increasing the sense of volume.

Robert Moskowitz's drawing, *Empire State* (fig. 4.20), is oil on paper, and in one aspect presented as one perfectly flat plane. On the other hand, the drawing shows the irregular outside contour of the Empire State building's floors. The mind's eye can easily shift to seeing this shape as three-dimensional because we have seen and memorized the Empire State building before. If you haven't seen it in real life, you have seen it in the movies, *An Affair to Remember*, *King Kong*, and probably on *Saturday Night Live*. Drawing can depend on what is actually drawn as well as what is insinuated, relying on memory.

DRAWING EXERCISE 4.3
Planar Approach to Still Life

Learning to identify the planes on a cylinder is not easy because you don't really see them. You must make an arbitrary decision as to where the planes start and stop. Once you establish the points of change, you will also be able to model the cylinder using light to dark.

Set up a still life of four or five objects, and study the surface of each object. It helps to hold the objects in your

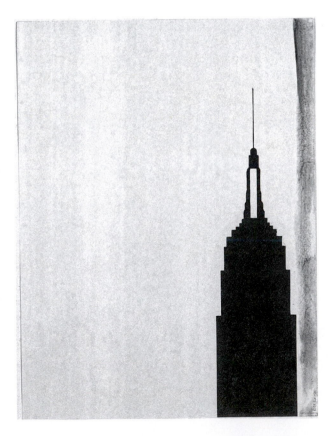

FIGURE 4.20
Robert Moskowitz, (1935–), *Empire State, 2000,* oil on paper, 12 in. × 9 in. Purchase, with funds from the Drawing Committee. Collection of the Whitney Museum of American Art, New York, NY.

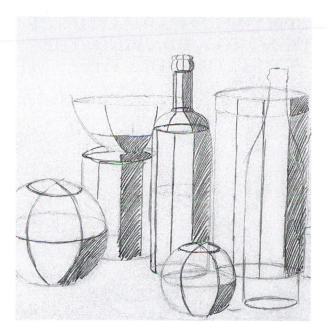

FIGURE 4.21
Sabrina Benson, planar study, (1999), pencil, student drawing
Oregon State University.

hand. *Place your palm on the surface to feel where the surface turns or curves.*

Using vertical lines, divide each object by plane. Establish light and dark values, changing value for each plane. The gradation, the light to dark, of your values should change both vertically and horizontally because the light will change as it moves across the cylinders, and from the top to the bottom. The interior planes follow the outside contour of your objects. On the wine bottle in the student drawing (fig. 4.21), you can see how the lines follow the bottle's contour.

Work at interpreting the light on the basis of your knowledge of chiaroscuro and other drawing techniques. It is difficult to actually follow light changes on a form. It is a skill that you will develop. When nature doesn't provide enough contrast to make a drawing intriguing, you can add or subtract values to push the drawing toward your vision.

Ron Graff, in his charcoal drawing *Cloth, Shell, and Pitcher* (fig. 4.22), skillfully utilizes the four

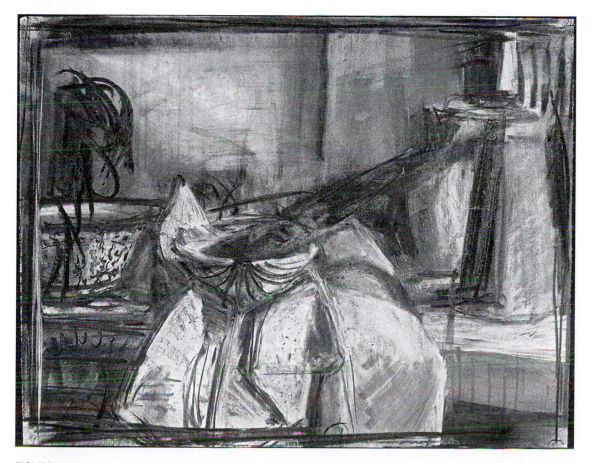

FIGURE 4.22
Ron Graff, *Cloth, Shell, and Pitcher,* (2001), charcoal, 22 in. × 26 in. Courtesy of the artist.

divisions of light in his drawing. His manipulation of the values stumps your eyes in the drawing. The white cloth pulls you into the space, and then you search through this interior space, suddenly realizing that the space is conflicted. In the lower left corner of the drawing where the drapery hangs over the edge, it does not reflect the table's edge under it. And just a little farther to the right, the bend in the table is seen as a bend in the drapery. The forms on the right have been pulled apart. You can see through the coffee pot to the vase in the background. A drawing that at first glance seems like a simple still life is actually full of ambiguous forms and values. It is drawing of this nature that creates character and mood. It is *surreal*, abstract and real, all at the same time. Graff created this drawing by using a technique of wiping off the charcoal with a chamois and re-applying it again until he found the space acceptable, or finished.

APPLYING THE QUALITIES OF LIGHT TO A DRAWING: THE ARTIST CONTROLS THE LIGHT

There are two approaches to using values in a drawing. The first approach is used when you accurately record your observations of where light is falling on a form. The second is used when the artist chooses the placement of light to dark. You must consider the spatial relationships between the forms and shapes in your drawing when you are controlling the values. In *Mirth* (fig. 4.23), Francisco de Goya has placed and alternated the values of light and dark to create these two people in his drawing. Follow the values in Goya's drawing, starting with the sole on the woman's slipper in front. The boxes starting with the left side will take you through Goya's rotation of value. The value changes in this drawing have nothing to do with rendering actual reflected light. They have been orchestrated and manipulated to create form and volume in space by the artist. Goya floats the figures in the drawing in a kind of jubilant dance.

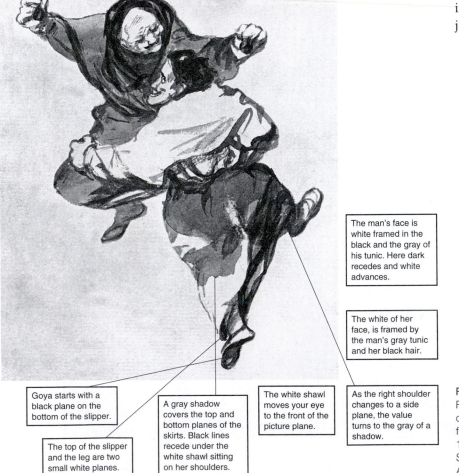

The man's face is white framed in the black and the gray of his tunic. Here dark recedes and white advances.

The white of her face, is framed by the man's gray tunic and her black hair.

Goya starts with a black plane on the bottom of the slipper.

The top of the slipper and the leg are two small white planes.

A gray shadow covers the top and bottom planes of the skirts. Black lines recede under the white shawl sitting on her shoulders.

The white shawl moves your eye to the front of the picture plane.

As the right shoulder changes to a side plane, the value turns to the gray of a shadow.

FIGURE 4.23
Francisco José de Goya y Lucientes, *Regozyo (Mirth),* sketch from the 1815 album, 23.7 cm. × 14.7 cm. Courtesy of the Hispanic Society of America. New York, NY. A3308.

DRAWING EXERCISE 4.4
A Tonal Analysis

Fig. 4.24 and 4.25 illustrate this value study exercise that involves close observation. You will need two pieces of white drawing paper cut into ten-inch squares, one piece of tracing paper, and three graphite drawing pencils, an HB, a 3B, and a 6B. Center and draw a five-inch square on one of the ten-inch papers. Select a fruit or vegetable as your subject. Draw the contour of the fruits' form lightly in HB, filling the five-inch square with the shape, leaving very little white around the contour of the fruit or vegetable's contour. Set your subject near a light source so that you can see light falling on the form. You may use five values to render the values on the surface of your subject: white of the paper, light gray, medium gray, dark gray and black. Use the HB pencil in the light gray areas, the 3B pencil in medium value areas, and the 6B pencil for the dark gray and black areas of the drawing, because each of the three leads has a different value. Work from light to dark values and from light pressure to firm pressure.

Before you start, examine the fruit to determine where the planes on the form change. Remember, light changes both vertically and horizontally. Make the first drawing a light to dark rendering like the artichoke (fig. 4.24). When the contour, modeling, and the separation of the planes is complete in the first five-inch square, draw a five-inch square on a piece of tracing paper, divide the tracing paper into a grid using 1/4 or 3/8 inch divisions. Tape the tracing paper over the drawing of the fruit, aligning both five-inch squares.

Assign each square of the grid on the tracing paper one value from white to black. Set up a numerical system of 1 to 5, in which, 1 is white, 2 is light gray, 3 is medium gray, 4 is dark gray, and 5 is black. Make your choice depending on what the predominant value is in the square on your original drawing. On the second ten-inch paper, center and draw a five-inch square, and divide it into the same size grid. Each square in the new grid (fig. 4.25) directly correlates to its counterpart on the tracing paper. Tape the tracing paper over the second paper to easily refer back and forth. Transfer one line of the values at a time to stay focused. Fill each square on the second piece of paper with the value you assigned it off your first rendering. Each square in the grid may have only one value.

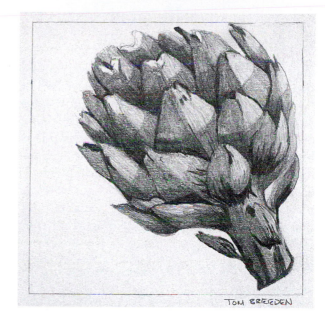

FIGURE 4.24
Tom Breeden, *Artichoke.*

FIGURE 4.25
Tom Breeden, grid transfer by value from *Artichoke*, (1999) student drawing.

CROSS-HATCHING: PENCIL DRAWING AND VALUE

Cross-hatching requires intense precision in using hatching lines placed very closely together. Hatching is a series of parallel strokes, or lines, which create values from light to dark, depending on the number of lines layered on one area. Hatching is done with a sharp pencil, pen, or silverpoint in order to make a clean, fine line. The more layers there are, the darker the value. These layers of parallel lines are placed horizontally, vertically, and diagonally. Lines should be fine, straight, and thin. Hatching follows the direction of the contour of the surface planes, strengthening the effect of mod-

eling by the varied weights of the line. Line is considered heavy when it is dark and light when it is thin. Gericault's drawing *The Fall of the Rebel Angels after Rubens* (fig. 4.26) was created with cross-hatching. Notice how the hatching turns across the arms, legs, and torso, defining the side planes. Examine the changes from light to dark according to the number of layers of hatching strokes.

Cross-hatching creates light to dark tones. Hatching becomes cross-hatching when a series of hatching lines are drawn in overlapping layers. These lines can create texture as well as value changes. One layer of hatching reads as a light value, but each additional layer of hatching darkens this value. The tools used in cross-hatching

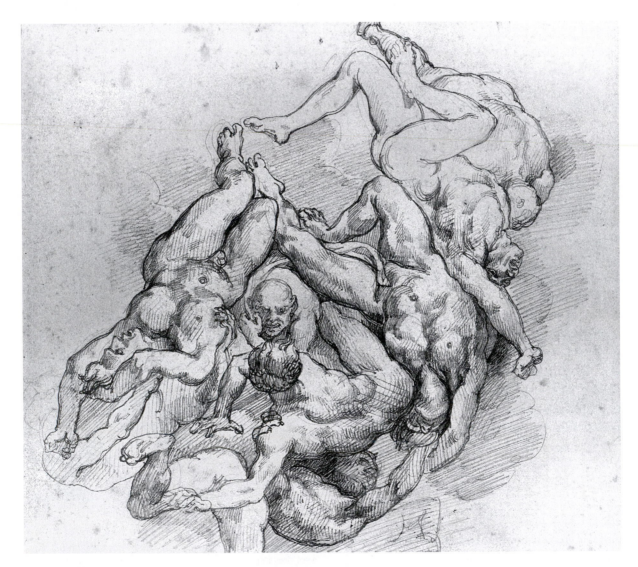

FIGURE 4.26
Theodore Géricault, French, (1791–1824), *The Fall of the Rebel Angels (after Rubens)*, (c. 1818), pencil on ivory laid paper, 205 mm. × 232 mm. Committee for Art Acquisitions Fund. Iris and B. Gerald Cantor Center of Visual Arts at Stanford University. 1967.50.

FIGURE 4.27
Bruce Nauman, (1941–), *Wax Template of My Body Arranged to Make an Abstracted Sculpture,* (1967), pen, 63.5 cm. × 48.2 cm., Virginia Wright Fund. The Washington Art Consortium. Photographer: Paul Brower. 76.7.

alter the qualities of the values as well. Light pressure with an HB pencil will make a lighter value than light pressure with a 6B pencil because the graphite in a 6B pencil is darker, thus creating a darker value. Darkness is controlled also by the amount of pressure you put on the tool. Ink, Conté, compressed charcoal, or charcoal pencils can also be used in cross-hatched drawings,

When drawing hatching lines, the pressure on the pencil or pen at the beginning of the stroke should be firm, but the pressure at the end of the stroke should be light. Loosening the pressure on the pencil as you make the line allows it to fan out as it ends in the next plane.

Bruce Nauman, in *Wax Template of My Body Arranged to Make an Abstracted Sculpture* (fig. 4.27), draws the hatching lines through the edges of the rectangular forms, continuing the hatching line into the background. By not stopping at the edge of the form, he avoids creating a stiff and distorted form. In addition, the sculpture is united with the background, and the two are balanced without any awkward changes between the contours of the forms and the ground around them. In this drawing, Nauman has created two points of view. We are looking from a heightened view at the base while at the same time looking directly at the top. He does this by placing the darker value at the top, which brings the top forward, leaning out of the picture plane. While the top pushes forward, the lighter base recedes. This perspective, which is often used by Degas in drawing his dancers, creates a sense of spaciousness.

VALUE: THE IMPORTANCE OF LIGHT AND DARK

75

The top planes are white. You decide how much area to leave for the top plane.

The side planes are gray and black, and they end on the back plane.

The back planes rest against the wall. Changing value separates the planes and creates volume

FIGURE 4.28
Lili Xu, *Pencil Drapery Study*, (1999), Oregon State University.

HATCHING AND DRAPERY

To draw drapery, you must identify and map out the planes of the folds on the drape. Lili X's drapery (fig. 4.28) has been diagramed to help you find the planes.

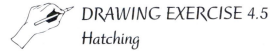 DRAWING EXERCISE 4.5
Hatching

Start by making a series of studies experimenting with different mediums, using cross-hatching. Try 3B and 6B pencils, ink pens, charcoal pencils, and Conté. Once you are comfortable with the technique, do the following drawing exercise.

Using HB, 3B, and 6B pencils, make a study of a still life containing apples, pears, drapery, or bottles. Identify the direction of the light falling on the forms, and, starting with the HB pencil, make a light outline of all the objects in the drawing. For the drapery, follow the folds from top to bottom with your pencil, mapping out with light lines the divisions of light, gray, and dark planes. Establish a top plane, side plane, and back plane for the drapery, indicating where one value starts and the other ends.

Your first layer of hatching lines will cover the entire space of the drawing. Cross the entire picture plane side-to-side and top-to-bottom with one light line. This first layer of light line unifies the surface from front to back. Identify the gray planes, and move to hatching them with a 3B pencil, crossing your first layer of lines. Hatch lightly through the edge of all the planes to unify them. By going through the edge, you will be able to develop smooth transitions and seamless relationships between the figure and the ground.

Continue to select the darker planes, and hatch over them. To darken the value, increase the pressure slightly on the sharpened tip. Each layer of hatching—whether placed vertically, horizontally, or diagonally over the first one—darkens the value of the plane.

76 VALUE: THE IMPORTANCE OF LIGHT AND DARK

Change to a sharpened 6B pencil, hatching over the next areas that are a medium gray in value. Continue the lines through the gray planes and into the dark planes.

Change the direction of the hatching stroke from a diagonal to a horizontal or vertical line with each layer. Continue this cross-hatching into and over the dark gray planes on your objects.

Finally, use the 6B pencil over the 3B layers if you need them darker. The cast shadow is the very darkest area at the bottom. Use layers of the 6B with increased pressure for this dark plane.

RUBBED AND ERASED PENCIL DRAWING

This process results in a soft and rich finished drawing. The pencil is used on its side to avoid textural marks on the surface of the drawing. The dark planes or the dark areas of the drawing are modeled first by covering them with a layer of graphite pencil or charcoal. This first layer is then rubbed across the entire picture plane with a tissue or soft cloth don't use your hand as the oil in your skin interferes with layering. The eraser is the drawing "tool" for this drawing. It is used to lift out the rubbed gray on the white planes. The dark planes will need another layer of graphite applied over them, and the gray planes were established when you first rubbed the surface.

William Kentridge, in his drawing (fig. 4.29), used the process of rubbing and erasing to create the grays in this drawing. Notice how the subtle gray is "active" because of the rhythmic smearing of the lines. This drawing is actually one frame from the movie *The History of the Main Complaint* he made by changing one drawing with rubbing and erasing, then shooting one frame of each changed drawing. When the drawing completed its sequence, he started a new drawing. His film is then based on one adjustment of one drawing at a time.

FIGURE 4.29
William Kentridge, *History of the Main Complaint*, (1996), animated film, 35mm, series of 21 drawings in charcoal and pastel on paper; dimensions variable. Editing: Angus Gibson. Sound: Wilbert Schübel. Music: *Madrigal* by Monteverdi. Drawings, photography, and direction: William Kentridge. Courtesy of Marion Goodman Gallery, New York, NY.

FIGURE 4.30
1st layer of Conté.

FIGURE 4.31
2nd layer of Conté.

FIGURE 4.32
Final stages of layering Conté using cross-hatching strokes with white on top.

DRAWING EXERCISE 4.6
Creating a Rubbed and Erased Drawing

Set up a still life of objects. Using an HB pencil, establish the contour of the objects in the picture plane. Determine the direction of the light source, and map out the darkest planes on each object in a simple light outline.

Using a 6B pencil, hatch a series of lines closely together on the dark planes, using a medium pressure and the side of your pencil tip. To rub the drawing, use a tissue to spread the 6B lead over the entire drawing.

Take a plastic eraser, and erase the shape of the light planes on each form and on the grounds. The rubbed gray will serve as the intermediate value in the drawing; the erased areas are the lightest; and the first hatched 6B areas are the darkest. To finish the drawing, add another layer of 6B pencil over the dark planes with the side of the pencil tip. Rubbing will blend areas. If you need to change a gray area or plane, use a 3B pencil over them.

CONTÉ AND VALUE

To create value changes with Conté, you must learn to control the pressure applied to the stick or the pencil. Conté drawings are built up through many layers (figs. 4.30, 4.31 & 4.32). The qualities of the Conté are better realized on colored charcoal and pastel papers rather than on white drawing paper. For example, the still life drawing (fig. 4.34) by Leslie Eleveld, was done on gray Canson paper with black and white Conté. "Canson" is a brand name for charcoal paper, which has a rough surface, or tooth, that stands up to the Conté. When the Conté is wiped or *lightly* hatched on the surface of the paper (fig. 4.31) the rough tooth of the paper will appear through the Conté. Seurat's drawing *Study for "Les Poseuses"* (fig. 4.33) is an example of the Conté being wiped lightly across the paper, and it is the tooth of the paper that is showing through the Conté, creating the bumpy or pebbled look to the drawing.

If the paper is rubbed hard, the tooth of the paper will vanish. Firm layers of pressured strokes reduce the tooth of paper, (fig. 4.32) which results in a smooth shiny or rich surface. In, (fig. 4.34), the drawing has been layered with Conté, and each

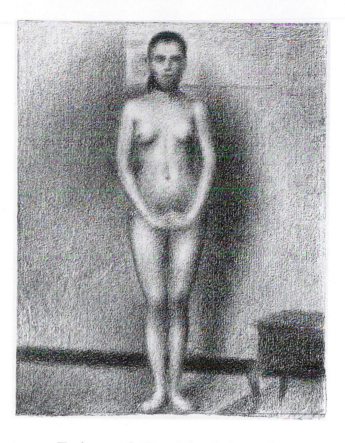

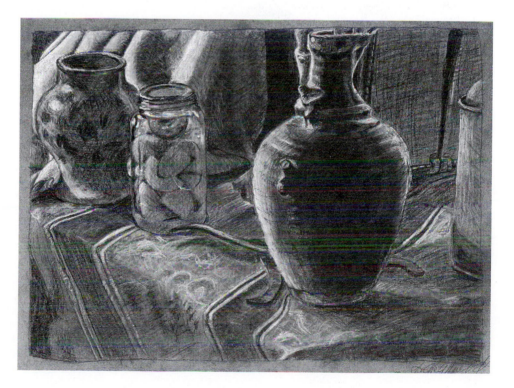

FIGURE 4.33
Georges-Pierre Seurat, (1859–1891), *Study for Les Poseuses,* (1886), Conté crayon on laid paper, 11¹¹⁄₁₆ in. × 8⅞ in., (29.7 cm. × 22.5 cm.). Metropolitan Museum of Art, Robert Lehman Collection, (1975). Photograph, all rights reserved, The Metropolitan Museum of Art, New York, NY. 1975.1.704.

layer was rubbed to achieve a very realistic look. The student drawing (fig. 4.34) was composed from dark forms in the foreground to light in the background. By controlling dark to light, a sense of volume and space was created in the composition.

To draw with Conté, break the stick in two, and hold the small piece of Conté between your thumb, index finger, and middle finger. Conté can be put on with small, close hatching strokes using the corner of one end. The sides of the stick can be used

FIGURE 4.34
Leslie Eleveld, *Conté Still Life,* (2000), student drawing.

flat to add large planes of value. Pressure is key in Conté drawing. Start with very light pressure in all areas of the drawing for the first layer. To continue, keep light pressure on the light areas while increasing pressure on the Conté for the darker areas. Plan to put two or three layers on the darker areas. This application of layering hatching strokes over each other is one way or technique to apply Conté.

The second technique that you can use in making a Conté drawing is to rub each layer with a Kleenex before adding another layer; this process builds a very rich surface. Conté can be rubbed with a stump, a piece of newsprint, or your finger with a tissue around it. When you rub it in, you dull the vibrancy of the surface somewhat. To avoid a dull look to the drawing, come back with a second and sometimes a third layer of Conté that you don't rub. This last layer sits on top of the rubbed layers, providing a rich quality to the values in the drawing. White Conté should be added last to create the highlights and whitest planes on the forms, but it can also be used in the rubbed layers as you are drawing.

PROFILE OF AN ARTIST: *REMBRANDT VAN RIJN 1606–1669*

Rembrandt was a master of manipulating light and dark in his drawings. He had the ability through value to create a sense of mystery in his work. He also used light and dark in symbolic ways, setting a mood of calm or chaos, revealing the space to us in the most striking ways. His portraits, for example, contain figures that look out at you, questioning you, the viewer, before you can question them. Thus Rembrandt fulfills one of the purposes of an artist: to help us see the world in a new way and to give visible or tangible form to ideas, philosophies, or feelings.

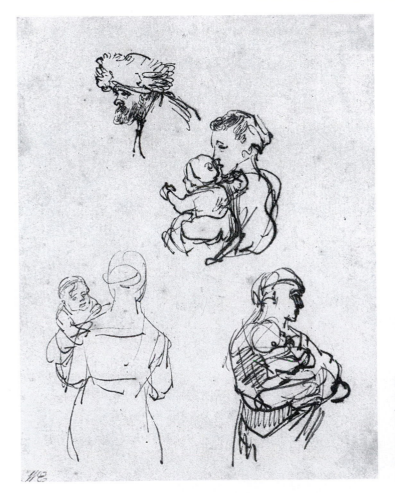

FIGURE 4.35
Rembrandt van Rijn, Dutch, (1606–1669), *Three Studies of Women, Each Holding a Child,* pen and brown ink, 7⅜ in. × 5⅞ in. (19 cm. × 15 cm.). Pierpont Morgan Library, New York, NY, U.S.A. Photo Credit: The Pierpont Morgan Library/Art Resource, New York, NY, U.S.A. SO156059. ART149924. Inv.1,190.

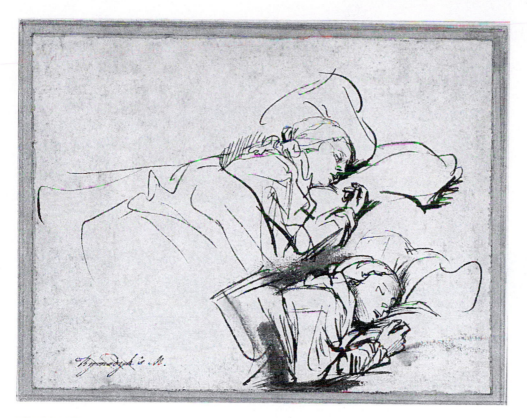

FIGURE 4.36
Rembrandt van Rijn, Dutch, (1606–1669), *Two Studies of Saskia Asleep,* (c.1635–1637), pen and brown ink, brown wash, 5⅛ in. × 6¾ in. (13 cm. × 17 cm.). Pierpoint Morgan Library/Art Resource, New York, NY, U.S.A. SO156065.

When, in 1699, the French Academy paid tribute to Rembrandt's originality as a draftsman, it was considered a huge honor, since drawing had no economic value then and was not considered an important form of art. Yet Rembrandt drew constantly, and his sketches were independent creations, unlike those of other artists of his time. His concept of drawing as an independent means of personal expression was new to his contemporaries, who were busy painting grand historical subjects and who used drawing only to map out what they intended to paint. Rembrandt may have used elements from his drawings in his paintings and etchings, but the drawings were not intended to be studies for his paintings.

For Rembrandt, drawing was a highly personal activity, a means of training his eye and keeping his hand in practice. It satisfied his urge to express his most intimate impressions, thoughts, and feelings. In Rembrandt's drawings (fig. 4.35 and 4.36) you can see the inventive nature of his mind. He drew daily life: his wife, his son, people on the street, animals, landscapes, and fleeting gestures or common life activities. Initially, he preferred to use red or black chalk, but by 1630, ink was his medium, which he

used with a reed pen or brush, finding that they responded best to his sense of line and gesture. In addition, Rembrandt was prone to using small pieces of paper rather than large folio sheets as did most of the other Flemish and Baroque masters. He preferred half- and three-quarter sheets or even the smallest scrap, and he might piece sheets together if the drawing needed more space. Though his followers eagerly collected his drawings, Rembrandt also had his critics. Some people were unconvinced that a quick sketch had any value. To the people who found his late work lacking in finish, Rembrandt replied that a work was finished when the artist had expressed what he had to say.

Rembrandt was fascinated by the play of light and dark, pushing the contrast between light and dark values to achieve great drama and a fine sense of volume. From this energy and direction his forms emerge out of the darkness.

His pen and ink drawings were exquisite with a mastery that was unrivaled. His lines are precisely drawn and wrapped on and around the form, thus indicating more than a contour. It is as if the lines are part of the form. The quality of his line changes from

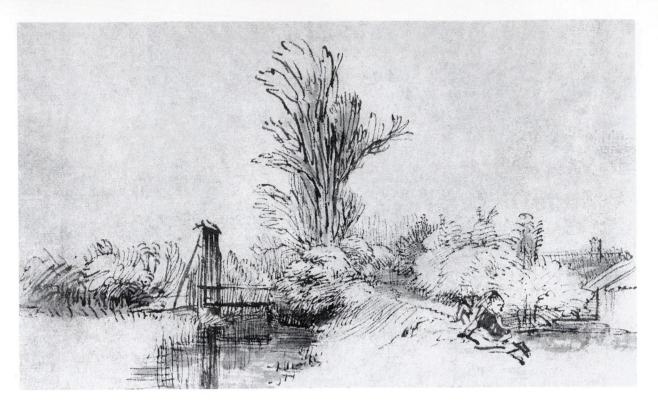

FIGURE 4.37
Rembrandt van Rijn, Dutch, (1606–1669), *Sketch of River with Bridge,* pen and brown ink, brown wash,
5⅝ in. × 9⅝ in. (14 cm. × 24 cm.). Pierpont Morgan Library/Art Resource, New York, NY, U.S.A.
SO156054.

thick to thin, light to dark, creating a sense of volume as his values change. It is value, not line, that directs your eye in Rembrandt's work. Rembrandt cuts into the picture plane with cross-hatched lines of great density, leaving the white to advance out of the dark receding areas (fig. 4.37). His line may envelop the scene, shroud it in darkness, move you side to side or front to back. His drawings may be elegant, emotionally charged, or serene, but they are always composed from a deep understanding of space and light.

Robert Henri, the legendary early-twentieth-century American painter and teacher, paid Rembrandt the ultimate compliment when he told his students, "The beauty of Rembrandt's lines rests in the fact that you do not realize them as lines, but are conscious only of what they state of the living person."

REVERSED CHARCOAL DRAWING

Drawing usually begins with a black mark on a white sheet of paper. The white values are left alone, and the gray to black values are added in lay-

ers. In reversed charcoal, your ground is a dark gray layer of charcoal out of which you will erase the light and gray areas first. Gray and black values are added back into the erased areas if modeling is your goal. Frank Auerbach's drawing *Untitled (E.O.W. Nude)* (fig. 4.38) was erased and scraped out of a charcoal ground. He has used a minimum of modeling on the figure, leaving the image rather ghostly.

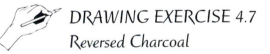 DRAWING EXERCISE 4.7
Reversed Charcoal

Choose a subject: a still life, a group of chairs, or a corner of a room. Start by drawing a border around your paper one inch from the edge. This border frames the picture plane. Cover the entire area inside the border with a layer of vine charcoal. Apply the charcoal with light pressure to avoid too much loose dust. Shake the loose dust from the charcoal gently into a garbage can; don't blow it off the paper. Blowing it will send it airborne, and when it drifts down, it covers the room with a black film that can also get inside your lungs.

FIGURE 4.38
Frank Helmuth Auerbach, British, (1931–), *Untitled (E. O. W. Nude)*, (1961), charcoal and pastel with stumping, erasing, scraping, and brushed fixative on white wove paper, 78 cm. × 57.2 cm. Restricted gift of Mr. and Mrs. Willard Gidwitz. © 1995, The Art Institute of Chicago. All rights reserved. 1993.17.

Study your subject, and consider the volume of the entire space. Your drawing tools are two erasers — the kneaded eraser and the Mars white plastic eraser. Use the white plastic eraser first. Erase entire forms or only the light and gray planes, leaving the dark areas in the first layer of vine charcoal. The harder you rub, the more charcoal is removed. You can't remove it all, and you shouldn't try to, as the light charcoal residue in the paper is part of the quality of this drawing. The kneaded eraser will lift out less charcoal, thereby leaving the area in more of a gray value. If you choose to model planes use the vine charcoal in both the foreground and background areas. Add another layer of charcoal over the dark planes to darken them more. To change values, erase the plane and add vine charcoal. Compressed charcoal is darker than vine but harder to erase. However, it is a beautiful black and may be used in this exercise.

WET CHARCOAL DRAWING

Compressed charcoal is used for wet charcoal drawings. Water brushed over compressed charcoal, acts like an ink wash. When the wash is dry, either vine or compressed charcoal can be layered on top of a wash area. This process is labor intensive in creating value changes in a drawing. Compressed charcoal is charcoal that was pulverized into a powder and mixed with a binder. It is blacker than vine charcoal. The process involves placing compressed charcoal on your paper and wiping a wet brush across this area. When the brush is dirty, it can be used to continue adding values to other planes.

Wet charcoal can be used in drawing to create a plane out of the contour line (fig 4.39). The line made by the compressed charcoal can be expanded into a top or side plane by washing over the line with a brush. This process will lighten the value of the line and expand it. At this time you may also use this dirty brush on other planes. In value studies, you want to destroy the outline and to create the plane. To outline a form is to flatten it.

DRAWING EXERCISE 4.8
Wet Charcoal

You will need compressed charcoal, a soft Chinese brush or a soft hair brush, and a cup of water. Line up a row of objects as your subject. Draw the space between the objects—the inner space or "negative" space—using the compressed charcoal. See fig. 4.40 Follow the outline of the first cylinder from top to bottom. Then draw the outside edge of the next cylinder in the row. Draw only the

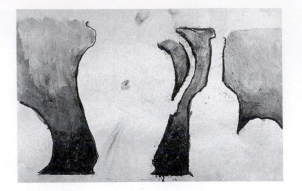

FIGURE 4.40
Chris Pangle, compressed charcoal and water in the negative space, student drawing, OSU.

space between the objects. Continue outlining each of the spaces between the objects in your row of cylinders. The outlines may run off the top of the paper.

Rub a layer of compressed charcoal over the bottom one-quarter of each negative space by setting the stick on end or using the side to wipe over the area. Dip the brush in the water, squeeze out the excess water, and paint over the charcoal. The wet brush picks up the charcoal and holds it for a long time. Continue to change the value moving up this inner space with the wet brush. To keep the brush wet dip the tip of the brush in the water. When the brush dries out the bristles splay out making it unuseable. Dipping the tip once in water, without swishing, will revitalize it so that you can continue applying the value left in the brush. Move up the space to the top with the dirty brush. Don't go back over any areas. By not adding any more charcoal, you create a light-to-dark gradation by dipping the brush and as it runs out of charcoal.

FIGURE 4.39
Chris Pangle, wet charcoal, top ink and charcoal layers, student drawing, OSU.

FIGURE 4.41
Frank Lobdell, (1921–), *Seated Woman*, (1972), pen
and wash in black ink with white gouache and blue
ballpoint pen on ivory wove paper, 363 mm. × 334
mm. Gift of the artist in honor of Lorenz Eitner. Iris
and B. Gerald Cantor Center of Visual Arts at Stan-
ford University. 1988.92.

LAYERING VALUE TO CREATE WEIGHT

Beginning students tend to be hesitant when "push-ing" or working a drawing. To "push" a drawing means to work on it perhaps even when you think more work will ruin it. When you push a drawing, you get a more in-depth drawing, especially when you are working with layers of value or line. The purpose is to make a stronger statement.

In layered drawing, adding water to ink or charcoal dilutes it, which is helpful in building lay-ers and making subtle changes. When ink is diluted with water, each layer dries lighter than black. When you place layer on layer, leave some of each layer exposed. You can always darken areas, but you cannot lighten them. Use a dark wash at the end of the drawing. In fig. 4.40, Pangle layered wet char-coal wash and charcoal.

Frank Lobdell's *Seated Woman* (fig. 4.41) is a pen and wash drawing, done in black ink, white gouache, and blue ballpoint pen on ivory wove paper. Lobdell used a range of values in the ink washes. Darker values frame the side planes of the

hair and the areas between the arms and the legs. The form seems more geometric than organic. The upper torso and the head seem solid as a stone. A number of false starts are evident in this drawing; they are not seen as mistakes but as opportunities to correct and change the direction of the drawing. False starts cannot be erased in ink drawing, but they can be covered with a wash or hatching. Lob-dell uses scribbled hatching combined with the ink, increasing the solid feeling of the blouse and the legs. The claw hand on the left expands forward, enlarged by the dark shadow

DRAWING EXERCISE 4.9
Layering

To start a layered drawing, lightly outline the objects, the planes, and the grounds of your subject. This process is known as "mapping out." Use a light line HB pencil. Next, take an HB charcoal pencil, and using light pressure, place a layer of hatching on the darkest planes. Continue the hatching lines into and on the medium gray planes, but lighten the pressure of your strokes. Hatching through the

end of one plane and into the next makes a smooth value gradation from one to another, moving dark to gray. In addition to adding layers of hatching through charcoal pencil strokes, use an ink wash over the hatching to darken the areas further. An ink wash is made of a little water and a drop of ink. If your first wash is too dark when you test it on a scrap of paper, add more water.

Layering creates relative light and dark, and each layer changes the degrees of the darks. Therefore, in order to create volume and space in a drawing, the areas in shadow must be relatively darker than the lightest areas and the highlight. Remember that your dark should not be the ink straight from the bottle, nor can you expect that one layer will give you the perfect black or gray. By putting one layer over another, you build the volume slowly, creating the different values of gray and darks across the space of the drawing. See how many layers you can make in your drawing.

INK DRAWING: THE BRUSH

Velvety black India ink can be diluted into a full tonal range of values for drawing. Ink is elegant, clear, and expressive. In the beginning, ink is a difficult medium to use, but with practice it becomes much easier. One advantage is that once it is dry, it won't smear in your sketchbook.

An ink wash is created by diluting Sumi or India ink, which is a permanent ink, with water. A light gray wash is highly diluted ink in water. The dark wash areas of a drawing will stand out to the eye first because they are strongest. The light areas are more subtle, not attracting attention immediately.

Ink wash drawings are built up from light layers to dark layers. Each wash overlaps and darkens the one before it. The white of the paper is left for

FIGURE 4.42
Jean-Baptiste Greuze, French, (1725–1805), *Study for the Recruiting Officer* in *The Father's Curse* (c.1777), gray wash over graphite on ivory laid paper, 350 mm. × 220 mm. Committee for Art Acquisitions Fund. Iris and B. Gerald Cantor Center of Visual Arts at Stanford University. 1978.23.

the lightest or highlighted areas. It is generally best to leave a little more of the white areas than you actually need. You can always go over it with a wash at the end. There is no erasing an ink drawing. If ink is dropped in a spot unintentionally, let it dry and then remove it with a razor blade by carefully scraping it off. Mistakes can be worked into the drawing by covering them with more wash or line work. Early miscalculations aren't evident in the finished drawing.

Drawing with a brush and ink results in a certain painterly appearance, creating a soft drawing of flowing lines, unlike the crisp, narrow lines of a pen. There are many brushes you can use. The pointed and the quill brushes are the most responsive, but stiff bristle oil-painting brushes can also be used. The bristle brush produces angular lines. Jean-Baptiste Greuze's *Study for the Recruiting Officer in "The Father's Curse"* (fig. 4.42) was made with a brush.

Artists will often start an ink drawing with a light pencil line, bringing the brush and ink over this line. Brush lines are very expressive. Brush lines

addressing the planes to create volume. The lines aren't scribbles placed whimsically. Greuze has paid strict attention to the back planes and side planes. His front planes are framed by the brushwork on the side planes. The brushwork in ink drawing does not have to outline a plane. For example, the back leg has been covered in dark ink wash with only the loose lines on the boot defining it as the back leg. Dark brush strokes work with light areas and strokes forming the figure. There is an economy of line in this drawing.

The brush is the most difficult of the drawing tools for ink, but it is also perhaps the most expressive. A brush line can easily shift from a line to a plane by flattening out across the surface. You can see this effect in the lines forming the man's raised right arm. Greuze brings a loose, gestural stroke across the arm and then spreads it out on the man's chest.

The painting, *Perilous Night*, by Jasper Johns (fig. 4.43) is a collage of images. He presents a multiplicity of themes to express his interest in the complexities of how we see, and how we know what

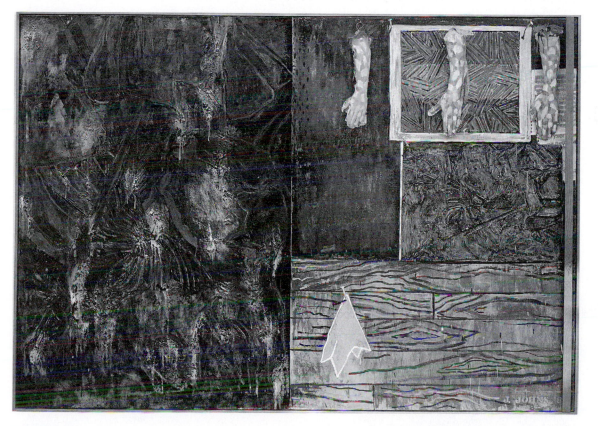

FIGURE 4.43

Jasper Johns, American, (1930–), *Perilous Night*, (1982), encaustic on canvas with objects, 67⅛ in. × 96¼ in. × 6¼ in., (1.705 m. × 2.442 m. × .159 m.). Photograph © 2006 Board of Trustees, National Gallery of Art, Washington, D.C., Art © Jasper John/Licensed by VAGA, New York, NY. Robert and Jane Meyeroff Collection. 1995.79.1/PA.

we see. *Perilous Night* is dark and dense with obscure images mysteriously juxtaposed. They act almost as an armor preventing you from understanding the meaning of the painting. The paintings structure is clear. It is a diptych, made up of two halves. On the left is a single dark image. On the right are a number of disjointed but well defined images and objects. There is an excellent discussion of this painting on the website http://www.nga.gov/feature/artnation/johns/index .shtm. The left side is from the Isenheim Altarpiece by Matthias Grünewald. Johns focused on one detail, a soldier whose body twists dramatically after being knocked down by the light emanating from the resurrected Christ in Grünewald's painting. The drawing of this soldier is so embedded in the dark paint that it is extremely difficult to make it out. On the right, three arms are suspended from the top, the middle one covers a copy of a painting Johns made during the 1970's when crosshatching was his subject and technique. The arm on the right edge of painting hangs over a musical score by John Cage titled *Perilous Night*. It is an odd contradiction that this composition by Cage is considered

one of his most emotional works about the loneliness and terror one feels when love becomes unhappy. Johns has said he prefers a complete lack of meaning in his work and yet he picks very emotional symbols for this painting. The handkerchief is another one of these emotional symbols. It is from Picasso's work, *Weeping Woman*—an image of protest against the Spanish Civil war death toll. It is pinned to the wall with a trompe l'oeil nail that is a faux surface of wood grain flooring. If you didn't know the reference, you might think it looked more like a cartoon, but knowing its source it now suggests sadness and grief. Johns' work constantly incorporates art history, art-making, found images and references to his earlier works and experiences. In his work there are always many possible meanings.

PEN AND INK WASH DRAWING

The French eighteenth-century painter Jean-Honoré Fragonard, in his *Rinaldo Raises the Magic Cup to His Lips* (fig. 4.44), is a good example of ink used in the planning stages of a future composition. This

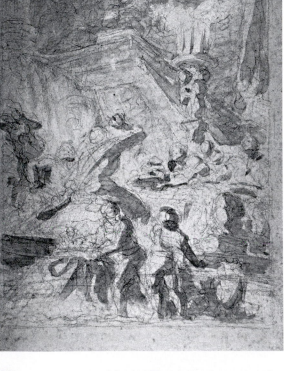

FIGURE 4.44
Jean-Honore Fragonard, French, (1732–1806), *Rinaldo Raises the Magic Cup to His Lips,* pale brown wash over black chalk on cream laid paper, 440 mm. × 294 mm. Iris & B. Gerald Cantor Center of Visual Arts at Stanford University. Robert E. and Mary B.P. Gross Fund. 1998.36.

FIGURE 4.45

Fra Bartolomeo, (Baccio della Porta), Italian, (1472–1517), (recto), *The Virgin with the Holy Children* pen and brown ink over black chalk, on tinted paper, 7½ in. × 6½ in. (18.4 cm. × 15.9 cm.). The Metropolitan Museum of Art, Robert Lehman Collection, (1975). The Metropolitan Museum of Art, New York, NY. 1975.1.271.

drawing started with an even, light wash, upon which he rapidly drew with black chalk, densely filling the picture plane with a range of complex images. Notice that the second wash of a darker value was placed over the chalk drawing. The wash covers the picture plane rotating between the side planes of the figures and the ground. Using a light wash in the beginning creates a uniform ground upon which artists can draw quickly, recording their thoughts almost like a symbolic record or shorthand for future compositions. Here the black chalk serves the same purpose that a pen would: but the lines can be erased and buried in the drawing.

You can choose from a selection of different types of pens for ink drawings. Quill pens are cut from the heavy pinion feathers of large birds and then shaped to an angular point. They produce a flexible line. Calligraphers use quill pens because they are responsive and draw curves easily. Reed pens, which are stiffer, are made from hollow wooden stems of shrubs. Their stiff nibs, or points of the pens, create lines that are bold, but the pens are hard to handle. They were, however, the favorite drawing tool of Van Gogh and were excellent for the type of mark making that he used in his drawings. Today, we tend to use the metal pen, which was introduced at the end of the eighteenth century. Metal pens come with various nibs that can be changed in the pen holder. A "C6" nib in a speedball pen is often used for line drawing. The scratch pen has one point that is not interchangeable, but it is a very versatile point.

Fra Bartolomeo's *Madonna and Child with the Infant Saint John the Baptist and Two Putti*, (fig. 4.45) is a pen and brown ink over black chalk. You can see the hatching marks of the pen on the drapery. The finely placed hatched lines create the shadows. The crisp outlines are also a result of work with the pen.

DRAWING EXERCISE 4.10
Ink Wash and Layering

Bristol board is excellent for ink wash because it will neither shred nor ripple. 120-pound to 140-pound paper is best for ink. Tape a piece of plate Bristol to a drawing board by taping each edge down completely.

Mix a light wash, and loosely apply it to the center of the paper with a brush. Let it dry. By abstractly placing a value that is unrelated to any plane, you give yourself something to work against besides the white of the paper.

Set up a still life or select a subject; then use a black chalk or a charcoal pencil to very lightly outline the contours over the dry wash. Now you are ready to determine the dark planes and darken them with either a pen or charcoal (or if you prefer, you may make a wash drawing using layers of ink wash applied with a brush).

Hatching and cross-hatching are the main techniques for adding line over wash in a drawing. Place the hatching strokes close together, and direct them across the first plane with your pen or charcoal. Determine the direction of the hatching strokes by imagining that you are holding the actual form in your hand and actually hatching on that form. Which direction should you turn the lines to draw the form with accuracy? Apply the lines to your drawing with that question in mind. Vertical lines may be used, but only lightly and in the middle of the lay-

ering. Vertical lines alone on a cylinder will flatten the form. Diagonal lines and horizontal lines tend to lean more toward roundness.

Return with your light wash, and cover the lines on the gray and the medium gray areas or planes. Work between adding hatching lines and adding wash over them to develop each form plane by plane, moving from light to dark. Add a bit more ink to your wash to darken it for the medium and dark planes.

You may use straight black ink in between the objects or behind the lightest side. In Fra Bartolomeo's *The Madonna and Child with the Infant Saint John the Baptist and Two Putti*, (fig. 4.45), you can see the effect of the dark wash behind her leg on the left. You may use white Conté chalk to heighten the lightest areas on the objects.

Don't stop the hatching strokes at the edge of the forms or on the contour lines. Instead hatch through the contour lines, lightening the stroke by lifting the pressure off the drawing tool as you pass through the edge. Let the line feed out into the surrounding space.

PROFILE OF AN ARTIST: *AUGUSTE RODIN 1840–1917*

When the great French sculptor Auguste Rodin left over eight thousand drawings to the French government as part of his estate in 1917, he left behind an invaluable and a huge collection of his drawings. There were student drawings from his studies at Petite École in Paris between 1854 and 1857: sketches from his imagination; thousands of drawings from live models; and drawings done from looking at photographs of his sculpture. As a sculptor he used drawing to plan his work, but Rodin felt his *études* (his "studies") were complete and on par with Salon art. Time would prove him right.

The drawing *Squatting Female Nude* (fig. 4.46) was made about 1894. Rodin coined the term "instantaneous drawings" to describe his drawing process in which he drew by looking only at the model and never referring to his paper. Today we would call it "blind contour". His continuous line results from letting his hand go where it will, often leading the pencil off the page. In his drawings, limbs may be lost, but he caught the movement or the action of the figure. Proportion is destroyed, but the impression of life is fixed. He often asked his models to take an unstable pose and then he would make the drawing in less than a minute.

In 1906, Rodin spoke of this process to his secretary: "The lines of the human body must become part of myself, embedded in my instincts so it will all flow naturally from my eye to my hand." He felt he had to possess complete knowledge of the human form, along with a deep feeling for every aspect of it so that as a sculptor, he could mold the figure as a mass, and a volume. Around 1880 when Rodin was working on sketches for *The Gates of Hell* (two huge bronze doors that were never cast in his lifetime). The advance provided him enough money to hire many models at one time. He had his subjects move freely about the studio without setting them in any particular pose. He preferred nonprofessional models who were more natural in their poses. When he spied a movement or gesture that attracted him, he asked the model to hold the pose, and then he would make his "instantaneous drawing."

The nude in fig. 4.46 is one of these models frozen unself-consciously and unposed. Like many of his drawings, this is not a traditional académie figure drawing. Rodin drew big planes through which you feel the entire volume. The pen line is expressive, exaggerating the contour, probing it, as if the point of

90 VALUE: THE IMPORTANCE OF LIGHT AND DARK

FIGURE 4.46
Auguste Rodin, French, (1840–1917),
Squatting Female Nude, (c.
1895–1896), pen and brown ink on buff
wove tracing paper, 12 in. × 7⅝ in.,
(305 mm. × 193 mm.). Committee for
Art Acquisitions Fund. The Iris and B.
Gerals Cantor Center of Visual Arts at
Stanford University. 1983.26.

the pen was in touch with the contours of the real body. He might add light strokes or change lines to rectify the appearance later, and he would often use wash on the figure to increase the sense of volume.

Here, too, the relation between the figure and the ground is strong. He sets the figure like a cube in space the contours relating the mass and volume. The unsupported nude form drawn without modeling is bold, autographic, like his own handwriting, but kinetically drawn. This would become his signature style, his figures moving and alive, not static or posed. Rodin's instincts and strong visualizing skills were building blocks for artists moving toward Modernism. A change in thinking was occurring.

Not surprisingly, many of Rodin's French art contemporaries did not think that the drawings were high-quality works, but by 1900 his "instantaneous drawings" a form of continuous line drawing were being reproduced in periodicals such as *La Revue Blanche* and shown internationally in large numbers.

Auguste Rodin, and later Henri Matisse, redefined drawing and launched it as its own discipline. Drawing, thereafter, had new meaning in the art world.

THE EXPRESSIVE USE OF VALUE

Expressiveness is always a major component of good drawings. Expressive drawings may be realistic like van Gogh's drawing *Landscape with Pollard Willows*, fig. 6.24 in Chapter 6, Texture and Pattern or abstract like Mark Tobey's *Firedance* (fig. 4.47). In looking at Van Gogh's *Pollard Willows* in Chapter 6, the lines and marks appear windblown and seem to be moving. Again motion plays a big part in an expressive drawing. The "mark" is crucial in expressive drawings. In Tobey's, *Firedance*, the black forms jump and dance against a loosely defined background. The use of black against the white ground is dramatic. The painterly marks are slightly attached to the edge of the forms and then not attached at all, increasing the feeling of motion. Here expressive can be seen as rhythmic, in a high-contrast ground. The ability to record and render what is observed with perfect accuracy can result in an expressive drawing when the artist goes beyond technical prowess and reveals an attitude or an emotion in the drawing. Drawing, then, becomes a process of empathy, the ability to externalize feel-

ings and to give meaning to the commonplace. Our capacity to identify with the subject leads to expressive drawing. However, even if specific emotions—sadness, anger, jealousy, and love—do indeed generate expressiveness in drawings, they may not be specifically visible in the work. Mark Tobey's *Firedance* (fig. 4.47), is explosively expressive, but of what feelings? It is impossible to say, even though we know, looking at the drawing, that we are witness to what Vincent van Gogh once called an "ardent temperament."

The drawing *Trabajos de la Guerra*, (fig. 4.49), by Nathan Oliveria, was influenced by the Spanish artist, Francisco de Goya. Oliveira's ink drawing is a free adaptation of an ink wash drawing taken from Goya's *Black Border Album* in which he recorded impressions of the Peninsular Wars. Fig. 4.48 by Goya is from his series titled "*Disasters of War*," specifically referring to the Peninsular Wars. This drawing called "*It's no use crying out*" shows veterans begging because they are maimed and wounded. Oliveira's drawing is of a maimed veteran reduced to beggary, sardonically entitled *The Works of War (Trabajos de la guerra)*.

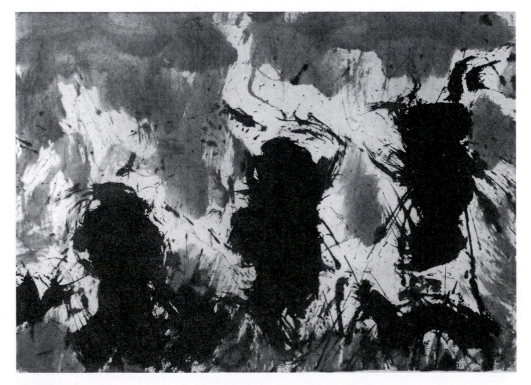

FIGURE 4.47
Mark Tobey, American, (1890–1976), *Firedance,* (1957), sumi ink and pale gray wash on Japanese paper, 540 mm. × 735 mm. Gift of Mrs. Joyce Lyon Dahl. Iris & B. Gerald Cantor Center of Visual Arts at Stanford University. © 2007 Artists Rights Society (ARS), New York, NY. 1979.122.

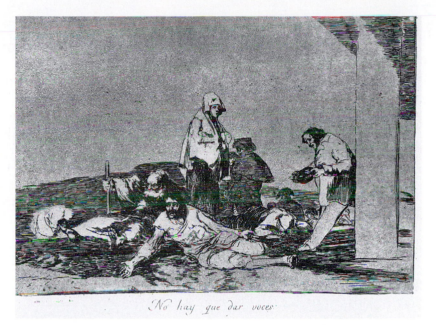

FIGURE 4.48
Francisco de Goya y Lucientes, (1746–1828), *Ho hay que dar voces (It's no use crying out),* plate 58 from *The Disasters of War (Los Desastres de la Guerra),* etching with burnished aquatint and burin, plate: 5⅞ in. × 8⅜ in., (15 cm. × 21.2 cm.), sheet: 9⅞ in. × 13½ in., (25.1 cm. × 34.3 cm.). The Metropolitan Museum of Art. Purchase, Rogers Fund and Jacob H. Schiff Bequest, (1922). Photograph, all rights reserved, The Metropolitan Museum of Art, New York, NY. 22.60.25.58.

Oliveira's soldier seems related to the man leaning against the pillar on the right in Goya's *It's no use crying out*. Both figures have an outstretched hand; both hold an elliptical shape; the positions of the figures leaning in the space are similar; and even the shadows beneath the figures seems related. It is the gesture of the figures along with the subject of the drawings that creates an Expressive Drawing.

FIGURE 4.49
Nathan Oliveira, American, (1928–), *Trabajos de la guerra,* after Goya, (1989), charcoal and brown wash on white wove paper, 692 mm. × 511 mm. Gift of the artist in honor of Lorenz Eitner. Iris and B. Gerald Cantor Center of Visual Arts at Stanford University. 1989.87.

1. Analyze the space of your drawing. What areas should recede, and what areas should move forward? Dark will recede, and light will advance.

2. Consider each form or object and its placement in the picture plane. Value controls how you perceive their locations.

3. Model your forms according to what space you want them to occupy and whether or not you want them volumetric.

4. You may choose to follow actual light falling on your subject, or you may arbitrarily determine the location of all lights and darks.

5. Remember that each drawing material responds differently. Choose the tool that you will be most comfortable using.

6. As you decide where to place light and dark, consider the planes of your subject; if you rotate the values, you will create volume; if you use the same value side by side, you will create flatness. Both are acceptable—it is whatever you intend for your drawing.

ART CRITIQUE ●━━━

Diebenkorn and Degas on the Use of Value

Richard Diebenkorn's drawing *Untitled* (fig. 4.50), from *The Ocean Park* series, is a modern abstract drawing. This drawing was not a study for a painting but a finished piece of art. It is more of a meditation on the local landscape of Santa Monica in 1968 than a rendering of the exact space. The formal elements themselves—line, value, texture, and perspective—are often the subject of modern drawings. In this

FIGURE 4.50
Richard Diebenkorn, American, (1922–1993), *Untitled (Ocean Park),* (1971), ink and gouache on cut-and-pasted coated paper, 604 mm. × 451 mm. Gift of Paul Rickert. © Artemis Greenberg Van Doren Gallery for the Estate of Richard Diebenkorn. Iris & B. Gerald Cantor Center of Visual Arts at Stanford University. 1983.322.

FIGURE 4.51
Edgar Hilaire Germain Degas, French, (1834–1917), *Dancer Bending Forward*, (1874–1879), charcoal with stumping heightened with white and yellow pastel with stumping on blue laid paper, 46.2 cm. × 30.4 cm. Mr. and Mrs. Martin A. Ryerson Collection. Photograph © 2001. The Art Institute of Chicago. All rights reserved. 1933.1230.

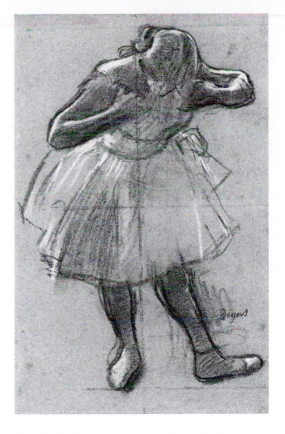

drawing, Diebenkorn focuses on line and light values to create its formal structure, balanced by sensual geometry and painterly effects. There is a vitality in the line: the line grows, takes on weight, bends, thins out, and resumes moving. Some lines are drawn, others are formed by tearing or cutting and then pasting the paper back together. Diebenkorn then veiled the drawing in white gouache. The very absence of linear perspective, modeling, or value changes, emphasizes the flatness of the picture plane. The small amount of wash following the diagonal lines creates a slight lift on the surface.

Edgar Degas's *Dancer Bending Forward* (fig. 4.51), which was drawn 32 years prior to Diebenkorn's drawing, was made as a study for a painting about ballerinas. Degas drew a vertical and horizontal line over the figure that he used to check the proportions of the figure and the relationships of each body part to another. By lining up the shoulder, hand, and center of the skirt with the back of the foot, he accurately placed the body parts. This vertical and horizontal axis assists him in getting the figure bent over correctly in a beautiful example of foreshortening. He used light values to heighten the top planes of the arms, feet, head, and the folds in the skirt.

These two drawings (fig. 4.50 and 4.51) have an interesting element in common. They both bend forward at the top. They both have fine line qualities, although what they depict is quite opposite. Both used white—Degas as highlight, Diebenkorn as an overall wash—to soften and tone down the entire drawing. When you look at drawings don't let whether the drawings is realistic or abstract stop your review of what they may have in common.

JOURNAL FOCUS ▸

Albrecht Dürer once declared that all his creative work sprang from one source, which is "the gathered secret treasure of the heart." In looking at *Six Pillows*, (fig. 4.52), it is evident that Dürer embraced the most varied aspects of life. The drawings of the pillows are expressive, almost animated—floating, dancing, and shifting—in the drawing. Notice his use of hatching in the dark planes and the way that it creates volume against the large white planes.

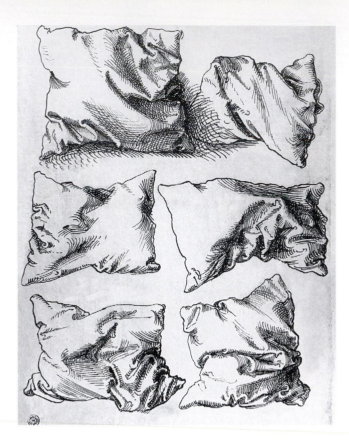

FIGURE 4.52
Albrecht Dürer, German (1471–1528), *Six Pillows,* (1493), pen and ink, 11 in. × 8 in., (28 cm. × 20.3 cm.). The Metropolitan Museum of Art, Robert Lehman Collection, (1975). The Metropolitan Museum of Art, New York, NY. 1975.1.862.

Practice using pen, ink and wash to draw a pillow, turning it into a volumetric form.

Experiment with ratios of ink and water by placing water in a cup and, using a soft hair brush or a Chinese brush, to add a brush tip of ink into the cup. If it is too dark, take part of the mix out, and dilute further with water in another cup. To start, dip the entire brush in clean water first, and squeeze out the excess water by pressing the brush between your fingers. Dip the brush tip in the wash, and cover the entire form except for any area that will be left white. Let it dry.

Use a sharpie or black pen, hatching the dark groves. Next, put a second wash on the dark planes. A second layer of the first wash will darken the plane further, but you may also add a little ink to your wash to darken it. While you are practicing, the brush will run out of wash. When the bristles start to become unmanageable, dip the brush in water to reform the brush.

At the end of the drawing, try using straight ink on the cast shadow at the bottom of the form. Your shape should now appear volumetric.

Now that you have some feel for the pen, the brush, and the wash technique, try drawing from life. Sit outside if it is warm enough, and make a light sketch of the buildings or trees. Then apply a wash to selected planes to add form and volume to your drawing. When the wash is dry, it can be drawn on top of with charcoal pencils, ink pens, or graphite pencils, thereby darkening the areas one more level in value, and these marks also add texture. The lovely thing about this process is that you watch the surface change, and as long as the layers are diluted or light pencil layers, you can continue slowly building your drawing. You never make a mistake, since you just cover that area with a wash.

PERSPECTIVE

LINEAR PERSPECTIVE

In the fifteenth century during the Italian Renaissance in Florence, a scientific method of determining the correct placement of forms in space was formulated by the architect Filippo Brunelleschi and by the artist Leonbattista Alberti. The first printed description of what came to be known as *linear perspective* appeared in Alberti's treatise on painting, *Della Pittura*, published in 1435, and dedicated to Brunelleschi. The formal rules for perspective came from these men's direct observations. Brunelleschi had observed a scale change while looking at a colonnade (a line of columns) that he had constructed for a hospital in Florence. As he looked down the line of columns directly in front of him, the columns appeared to get smaller the further they were from him. The baselines at the bottom of the column seemed to be moving up to the horizon, while the top of each column seemed to drop down toward the horizon.

Before Brunelleschi and Alberti's discovery of linear perspective, artists had relied on *empirical perspective. Empirical perspective is also based in observation, but it does not have a set of rules;* rather, it relies on a well-trained eye to determine the size and scale of what is to be drawn.

In linear perspective, receding lines vanish to a point on the horizon. Lines above the horizon vanish down to the horizon, and lines below the horizon vanish up to the horizon. A mathematical grid can be used to determine the size and scale of the figures in the space. Modifications of the space can be made with light and color and the clarity of the forms, depends on the distance they are from the eye. As Leonardo da Vinci observed, "There are two perspectives, reduction in size and distinctness of things seen from a distance, the paling of colors, some of which at the same distance from the eye pale more than others." Leonardo reminds us that objects get smaller the further they are from us and the closer they are to the horizon. Distance will also determine how clerly we see any form. The value of the color, how pale it is, controls how well we see it.

The drawing *Place Eau de Robec*, Rouen (fig. 5.1), by Richard Parkes Bonington, depicts an animated street scene, done using linear perspective. The line of old houses on the left of the market square leads the eye down the rue Damiette toward the distant tower of Saint Maclou. The baseline is hidden, but the roofs of the houses follow a receding line, each one lower than the one before it. Bonington increases the feeling of depth by manipulating the values from the darker foreground to the lightly sketched architectural facade of Saint Maclou in the background this is the "paling of color" Leonardo referred to. The shadows under the eaves are darkened with fine hatching lines.

EMPIRICAL PERSPECTIVE

Before linear perspective was established, artists used modular systems to create illusions of space. Perspective that created a certain unity seemingly reasonable to the eye. They depended on sighting to establish shape, size, and scale. The early rule of thumb was to reduce each receding figure or form by one-third the depth of its forward predecessor. In the modular system, the feet of the smallest and most distant figures had to line up with the knees of the figure in front of the drawing.

Evidence of the use of empirical perspective dates back to the Greeks in 300 B.C.E. These perspective devices were used to construct the buildings in the landscape painting *Architectural view. Wall painting from a villa at Boscoreale, near Naples* (fig. 5.2). The buildings seem to sit in the space as volumes. If you dissect the buildings starting with the colonnade at the top of the painting, you find

97

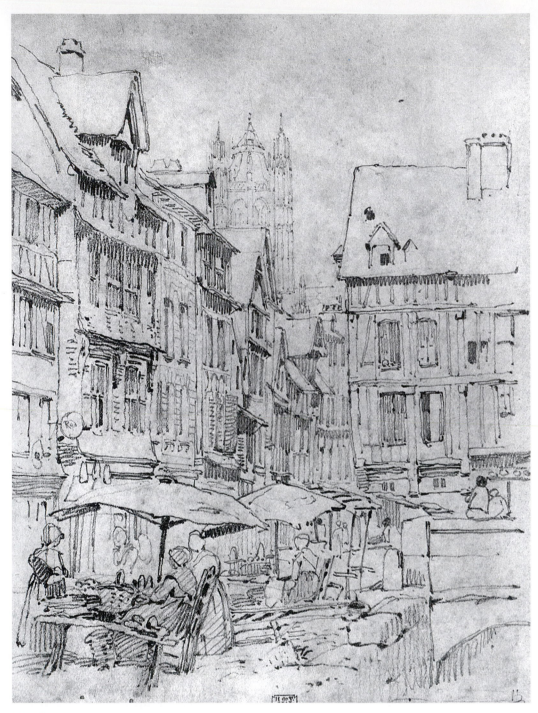

FIGURE 5.1
Richard Parkes Bonington, English, (1802–1828), *Place Eau de Robec, Rouen,* (c. 1823), pencil on ivory wove paper, 260 mm. × 198 mm. Committee for Art Acquisitions Fund. Iris & B. Gerald Cantor Center of Visual Arts at Stanford University. 1968.83.

that it is not in the same perspective as the buildings near it: the lines running to a horizon are counter to the receding lines in the rest of the painting. If you compare the receding lines on the box below and to the right of the colonnade, to the small structure with the grid roof on the left, you can see all three structures vanish in different directions unrelated to each other. The relationship of the sun and shadows, in the foreground and background, does not represent any rendering of actual light. The artists were trying to create a recognizable space with light and dark, but without a sophisticated understanding of chiaroscuro, without the formula for light into dark, they were limited.

FIGURE 5.2
Wall painting from the Cubiculum of the
Villa at Boscoreale, Panell II, Fresco.
The Metropolitan Museum of Art,
Rogers Fund, (1903). All rights re-
served, The Metropolitan Museum of
Art, New York, NY. 03.14.13 a-g.

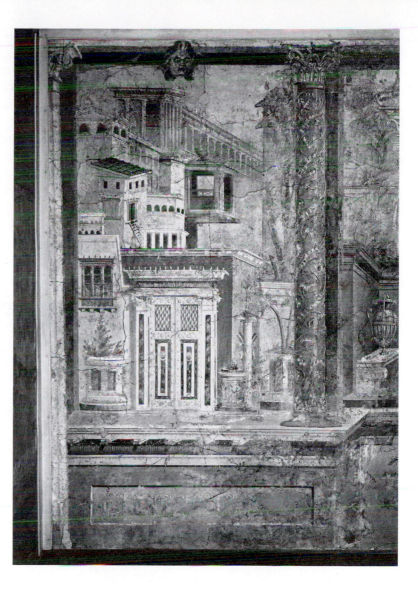

Empirical perspective reflects direct observa-
tion, that is, relying on a well-trained eye to judge
the size and shape relationships. Sighting, using an
object to take visual measurements, is done against
vertical and horizontal lines that the artist estab-
lishes mentally or with a hand held transparent grid.
By using sighting, a convincing and relatively ac-
curate space can be constructed without a T-square
and a triangle. On the other hand, linear perspec-
tive allows artists to check the space with exact
measuring. Artists today who understand the rules
of linear perspective may stretch the placement of
forms in the picture plane on the basis of their
knowledge of the rules of linear perspective, or or-
ganize their compositions employing empirical per-
spective. Empirical perspective offers more leeway
and freedom in modern drawing. Linear perspec-
tive can be restrictive.

The Florentines were delighted with this new
pictorial space that accurately represented real
space. Vasari, one of the first biographers of artists
and the author of *The Lives of the Artists* published
in 1439, summed up the feelings in Florence over
linear perspective when he said, "What a sweet
thing is this perspective!" One of the first great col-
lectors of drawings, Vasari understood that linear
perspective gave artists one more tool to represent
their thoughts and perceptions.

SEEING IN PERSPECTIVE

Perspective is an invaluable tool of drawing because
it allows you to convincingly recreate the three-
dimensional world on the two-dimensional surface
of a flat piece of paper.

You don't really see in linear perspective, because it depends upon a fixed view from a single "eye." You have binocular vision, and your two eyes create a total picture from two different focal points. For you to see in linear perspective, one single eye would need to be located on the bridge of your nose between your eyes. To test how you see, hold your index finger at arm's length in front of your eyes. Locate it against a fixed background, such as a picture on a wall, a chair, or a pile of rocks, but not in open air. Holding your finger out, close one eye, and line your finger up with the background. Make a mental note of what your finger is in front of. Change eyes, keeping your finger in the same position. Open your other eye. What happened to your finger? It seems to have moved, and this is because your eyes are not focused at one point—each has its own focal point. In addition to binocular vision, you also have peripheral vision that allows you to take in 180 degrees without moving your eyes or your head. If you rotate your eyes side to side, you see everything clearly, whereas when you don't, the side view may be a little out of focus. It is, therefore, important to realize that to use linear perspective, you may need to make adjustments to your drawing. To draw in perspective, you must hold your head in one place. If your head moves, the entire perspective changes.

Dürer has given you an accurate rendering of how linear perspective works in his drawing (fig. 5.3). A draftsman is using a grid on a glass picture plane placed between himself and his model. His paper has an exact grid matching this picture plane. In this way he translates where the nude figure intersects the grid between them onto the exact location in the grid on his paper. To properly proportion his drawing he must keep his head and his eyes in one position. To help him with this there is a device attached to his drawing board. The grid will create a mechanically precise drawing. Linear perspective in drawing is a practical tool for working out space and design problems.

ELEMENTS OF PERSPECTIVE

Linear perspective involves the cone of vision, the picture plane, the horizon, the baseline, the vanishing point and the focal point, and the ground plane.

CONE OF VISION

The cone of vision is all that you can see without moving your head or eyes. Perspective depends on a single fixed point of view. The boundaries of the

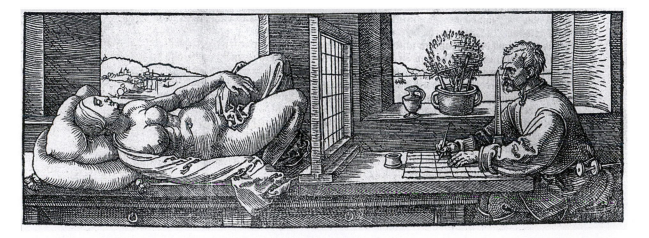

FIGURE 5.3
Albrecht Dürer, German (Nuremberg), (1471–1528), *Draftsman Drawing a Reclining Nude,* woodcut, second edition, 11¹¹⁄₁₆ in. × 8¹⁄₁₆ in. × ¹³⁄₁₆ in. (29.7 cm. × 20.4 cm. × 2 cm.). Photograph © 2005 Museum of Fine Arts, Boston. Horatio Curtis Fund. Museum of Fine Arts, Boston, all rights reserved. 35.53.

cone of vision determine what is to be included in the perspective drawing. A normal cone of vision is 60 degrees. Thus, the principal subjects should be placed within the 60-degree frame (in reality, most people have a field of vision that extends 180 degrees horizontally and 140 degrees vertically, the vertical field being blocked by the nose, cheeks, and eyebrows).

To determine your cone of vision, look directly forward, and then raise your arms on either side of your body to shoulder height. Your arms should be just out of your peripheral vision. Slowly bring your arms forward until they frame the limits of all you can see clearly. You should see both arms without moving your head. Your eyes cannot shift left or right to define your cone of vision. Your arms are most likely framing a 60-degree view.

PICTURE PLANE

The picture plane is an imaginary, transparent vertical plane that sits between you and the subject of the drawing. In the Renaissance the picture plane was thought of as a window that you looked back through to fix the composition on your paper. Dürer's woodcut (fig. 5.3) shows an artist looking through a glass picture plane. The drawing surface is then the virtual equivalent of the picture plane.

Establish the picture plane on your drawing paper before you start with four border lines. These lines create a beginning and an end for the drawing. These will be the first four lines of your composition, and they set up the frame for your cone of vision. Notice how the border line in Sabrina Benson's drawing (fig. 5.4) frames her still life.

HORIZON

The horizon is where the earth meets the sky. When you are drawing in a room, the horizon is your personal eye level. From where you stand or sit, look across the room to the wall and mentally note where your eye level is on the wall. The horizon line may be drawn lightly across the drawing surface to remind you of its location in your drawing. Lines below the horizon vanish up to the horizon, whereas lines above the horizon vanish down to the horizon.

BASELINE

The baseline is a line that vanishes up to the horizon. All objects in a row sit on one baseline. As the objects recede into the background, the base of each one is higher up the paper than the one in front of it. Forms or objects do not need to sit on the same baseline—each may have its own. As objects recede to the horizon, the base level rises up the paper. Benson's drawing (fig. 5.4) illustrates the receding bases placed one behind the other as

FIGURE 5.4
Sabrina Benson, still life objects constructed from the inside to the outside contour with ellipses, student drawing, (1999).

If you are far away from home

FIGURE 5.5
Donald Sultan, *If You are Far Away from Home,* (1985), from the children's book *Warm and Cold* by David Mamet, lithograph and pochoir and letterpress, 18 in. × 22 in. Published by Pawbush Editions and Solo Press, NY.

overlapping shapes they move up the paper indicating they are moving back in space. The front pillars in Donald Sultan's *Warm and Cold* (fig. 5.5) frame the receding baseline of the pier. They get smaller as they move back in the space of the picture plane. Sultan has framed the picture plane in a bold, black, thick line increases the percpetion of looking back into space. The hazy background or paled light only increases the sense of spatial depth.

VANISHING POINT AND THE FOCAL POINT

The vanishing point is an imaginary point on the horizon line, toward which all parallel lines defining a plane, the side of a house for example, recede and

Ground Plane

FIGURE 5.6
Ground Plane in one point perspective.

meet. The vanishing point is determined by the angle of the receding lines. It can be located anywhere on the horizon. In Donald Sultan's *Warm and Cold* (fig. 5.5), the vanishing point can be located by drawing a receding diagonal, line from the top of the front post to the top of the back one, and by drawing a receding line from the bottom post to the bottom of the last post. There may be multiple vanishing points in a drawing. Each house, car, or row of trees in a landscape can vanish to a different point.

The focal point is different from the vanishing point. When an artist employs emphasis in order to draw the viewer's attention to one area of the work, it is referred to as the focal point of the composition. Emphasis can be established through the manipulation of scale, light, and color.

DRAWING EXERCISE 5.1
Drawing in Perspective

Tape a piece of tracing paper across the surface of a window, and using a fine point marker, trace the contour of the trees and buildings where you see them on the paper through the window. Try to maintain one viewpoint, and keep your head in one position. When you finish, place the tracing on a white wall. The drawing of the space will appear drawn in perspective. You will notice the bases of the trees receding back, one behind the other. You should see the tops of trees receding and dropping, one below the other, to the horizon. Try to pick a view you can frame on your paper.

GROUND PLANE

The ground plane and the floor plane are the same. The ground plane is a flat, horizontal plane that extends to the horizon from the front of the picture plane. It may also be called the "table plane" in still life drawing. A ground plane is shown in fig. 5.6. This ground plane is in one-point perspective. Two lines recede from the front edge toward the horizon, and we know that they will meet eventually. They are cut off by the back line to form the ground plane.

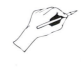

DRAWING EXERCISE 5.2
Studying Relationships in a Still Life

Set a number of bottles on a table covering the surface, from the front to the back, spacing some bottles far apart with oth-

ers close together. Frame the picture plane on the paper, using a border of four lines. Looking straight ahead, locate the horizon line by finding your eye level on the wall across from you. Notice where the horizon intersects the bottles on the table, and mark a light line on your paper. Start with the bottle in the front. Draw the bottle starting at the bottom with an ellipse for the base, then follow the contour of one side to the top, go across the top, and then continue the line back down the other side. Without lifting your pencil, draw a line from the baseline of this first bottle to the baseline of the next bottle. The next bottle may be sitting beside the first one or behind it. Make a mark where the base of bottle number 2 intersects bottle number 1. Make a mark now for the height of the second bottle. Look at where it is, compared with your first bottle—it could be taller or shorter. Draw the second bottle with a continuous contour line to define the outline of the second bottle. Move to a third bottle, draw a line for its base and top compared with the other bottles. Fill your paper by first determining where the base is as compared with the first bottle and where the top is as compared with the first bottle.

PARALLEL BASELINES

In a composition when objects share the same baseline or have parallel baselines space or depth may be achieved from scale changes, small to large, large to small and overlapping forms. The baselines of the buildings in Christo's early preparatory drawing for the *Wrapped Reichstag*, (fig. 5.7) are parallel to the front of the picture plane. They do not recede. Christo has seemingly flattened the Reichstag to the picture plane. He creates the illusion of space by changing the scale from a small row of trees in front of the larger Reichstag and by placing a small temple to the right. There are no diagonal lines receding from the front into the picture plane to push the Reichstag back into the picture plane. All the elements remain on the front plane. Above the drawing he adds a fabric sample of the material he will wrap the Reichstag with and line drawings of the Reichstag's façade, also a parallel baseline to the Reichstag.

FIGURE 5.7
Christo, *Wrapped Reichstag Project For Berlin,* preparatory drawing (1995), in two parts: 15 in. × 96 in. and 42 in. × 96 in., (38 cm. × 244 cm. and 106.6 cm. × 244 cm.), pastel, charcoal, pencil, crayon, technical data and fabric sample. Wolfgang Volz © Christo 1995. Photo Courtesy of Christo and Jeanne-Claude.

FIGURE 5.8a
Francesco Guardi, Italian, (1712–1793), *An Arched Passageway in Venice,* pen and wash in brown ink, with traces of red chalk, on cream laid paper, 220 mm. × 290 mm. Gift of Mortimer C. Leventritt. Iris and B. Gerald Cantor Center of Visual Arts at Stanford University. 1941.271.

ONE-POINT PERSPECTIVE

Francesco Guardi's drawing *An Arched Passageway in Venice* (fig. 5.8a) is so loosely composed it appears to be a sketch from observation. The sponta-

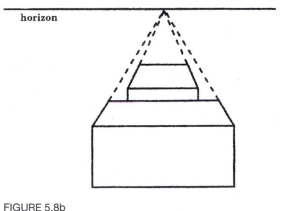

FIGURE 5.8b
Horizon vanishing point.

neous execution, with irregular, slashing pen strokes, comes together in spatial coherence with the play of shadows. The light feels accurate, but it may well be a creation of the artist's imagination. The nervous speed and energy in execution creates an air of drama in the otherwise unremarkable site, apparently a back alley in the labyrinthine byways of Venice.

This is a one-point perspective. To find the vanishing point, extend the lines at the bottom of the walls back to the small door. These ground lines being below the horizon will vanish, moving up to the vanishing point. The lines above the horizon drop down through the corners of the top arches. They end just left of center, in the small door. It is at the back of the alley, in the door that both the top lines and the receding ground plane lines meet.

In one-point perspective, parallel lines appear to converge at a common vanishing point

on the horizon (see fig. 5.8b). As two parallel lines recede into the distance, the space between them appears to diminish. The lines do not need to actually meet on the paper. They need only recede in the same direction with the distance between them continuing to reduce as they move to the horizon.

The rules of perspective drawing assume that if two parallel lines were extended to infinity, they would eventually meet at one point, which is what we call the vanishing point. We mostly think of lines meeting on the horizon because that is much easier to imagine. In addition, each set of vanishing parallel lines can have their own vanishing point. Therefore, the lines of objects in a still life or a landscape, or objects in an interior space, may recede to different vanishing points. Although these parallel lines could go to infinity, for drawing purposes you can place the vanishing point (VP) on the horizon on your paper. When you first begin to work with perspective drawing, it is easier to draw to an exact point to correctly determine the direction and angle of the receding lines. In perspective, lines above the horizon vanish down to the horizon, and lines below the horizon vanish up to the horizon. Edward Hopper, *High Road* (fig. 5.9) is a perfect example of lines vanishing to the horizon. The road and the telephone poles are in a one-point perspective. As you follow the tops of the poles you find each one drops down and ovelaps the one in front of it. The houses are in two-point perspective. You know this as you can see one side of the house facing our view and the other side of the house turned to vanish to a second vanishing point on the horizon. The placement of the road with a light side of the road is meant to create high contrast in the drawing as it is placed against the dark houses dropping down the hill into the dark hill behind them. Hopper than pushes this contrast one more time adding a light sky above them. The use of value and perspective in this combination makes a strong composition.

Architects will often place their vanishing points when drawing a building off their paper on their drawing board. If the vanishing point is placed too close to the sides of the form being rendered, distortion may occur when the receding lines are drawn too steeply. Likewise, if the vanishing point is placed directly over a form, you will be able only to draw the front and top planes—the side planes can't be drawn. This effect explains why sometimes you may not be able draw to an exact vanishing point on the horizon, but once you determine the angle of the baseline, you will be able to draw the receding lines back, adjusting them with your knowledge of perspective knowing that eventually they will meet on the horizon at a vanishing point.

FIGURE 5.9
Edward Hopper, (1882–1967), *High Road,* (1931), watercolor on paper, 20 in. × 28 in. (50.8 cm. × 71.1 cm.). Josephine N. Hopper Bequest. The Whitney Museum of American Art, New York, NY. 70.1163.

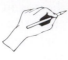

DRAWING EXERCISE 5.3
Drawing Front to Back in Perspective

Stack cardboard boxes up on a model stand or a low table. When the front plane of any box is placed so that you can see one side and the top, it is a one-point perspective. When a box is set at 45 degrees to your line of sight and you can see two sides plus the top, it is in two-point perspective. Since you can see the top it is below the horizon. When you can no longer see the top of a box, it is above the horizon. Locate the horizon line by establishing the location of your eye level. Start by drawing the front plane of the box with horizontal and vertical lines. If you can see the right side of the box, the lines will recede to a vanishing point on your right, which is also the right side of the horizon line. The same is true if you can see the left side of the box. Each box can have a different vanishing point from the others. The lines do not need to actually meet at a point on the horizon, but the distance between them as they recede must decrease. Lili Xu's drawing (fig. 5.10) illustrates drawing boxes in different perspectives.

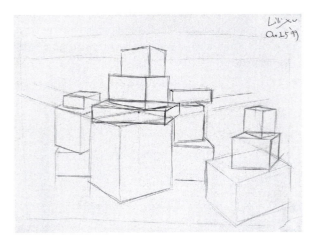
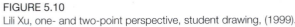

FIGURE 5.10
Lili Xu, one- and two-point perspective, student drawing, (1999).

SIGHTING

In Dürer's print of the artist and his model (fig. 5.3), at the beginning of this chapter, the grid placed between the subject and the drawing guides the artist in transferring specific points and lines that define the shape of the subject onto the drawing surface.

Another device that can be used is a viewfinder. A viewfinder is a rectangle 8 × 11 inches with a rectangle of 3 × 4 inches cut out of the middle. The opening needs to be divided by a grid. Use two black threads secured with tape to bisect the opening, dividing it into equal quadrants. Hold the viewfinder in front of your eye to frame your composition, define the picture plane with this rectangle, and compose your drawing. Frame the picture plane on your paper, and bisect it also into quadrants. Look through the viewfinder, and transfer the shapes you see corresponding from the quadrant in the viewfinder to the same quadrant on your paper.

A second device for measuring is your drawing pencil. By holding the shaft of a pencil at arm's length, directly in your line of sight, you can gauge relative lengths and angles of lines. To make a measurement with a pencil, align the pencil tip with one short section of the object to be drawn, and place your thumb on your pencil where the line on your subject ends (fig. 5.11). Once you have the first measurement, use it to determine the relative length of all other lines. Close one eye to measure, and count the number of lengths it will take to construct the next length by holding the pencil at the measured length and moving down the form (fig. 5.10). This is a relative measurement, and it is controlled by the distance that you are sitting back from the subject.

To determine the angle that an object rests at, close one eye, and then line up the pencil with a receding bottom edge, and holding the pencil at the gauged angle, drop your arm to the paper. This technique will give you the angle at which the object should be drawn on the paper.

Man Ray's surrealistic *Étude pour La Fortune* (fig. 5.12) is a distorted perspective of a pool table in a landscape. He wanted the table to look as big as a lawn, a visual that he achieved by manipulating the scale of the table against the small mountains he drew to the left. The horizon would be just to the right of the base of the mountains, thereby increasing the distortion and the scale of table now hovering over the landscape. For Man Ray, challenging all accepted rules and developing his idea behind the drawing were of the most importance for all his work.

FIGURE 5.11
Chandra Allison, pencil, one-point
perspective, student drawing,
(1999).

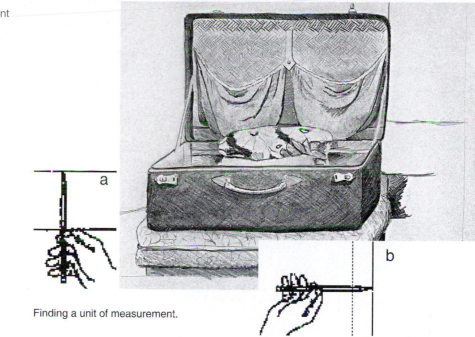

a

Finding a unit of measurement.

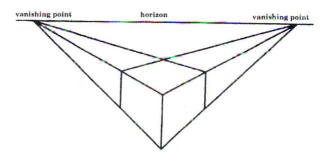

b

Using the unit of measurement to find
the relative length of the case.

TWO-POINT PERSPECTIVE

When the subject sits at an angle to the picture
plane, obliquely rather than square to the front of
the picture plane, the object is in two-point per-
spective. If you look at the subject and you can see
planes receding to the right and to the left, it is
two-point perspective.

When you draw a two-point perspective, first
locate the horizon line, and lightly draw it on the
paper. This step will help you with the direction of
the lines. The vertical line for the front corner, be-
tween the two side planes, establishes the scale for
the drawing, and it is drawn first. All proportions of
the drawing depend on this measurement.

The diagram (fig. 5.13) is a box in two-point
perspective drawn below the horizon. When you
can see the top of an object, it is below your eye
level and also below the horizon. When you cannot
see the top of an object, it is above your eye level
and also above the horizon.

Perspective depends on the fixed eye. You cal-
culate the angle of the object's baseline by using

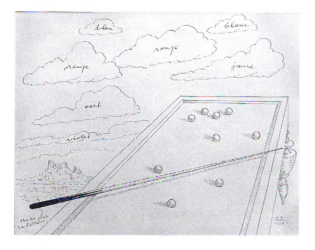

FIGURE 5.12
Man Ray, (1890–1976), *Étude pour La Fortune,* (1938), ink on
paper, 10¼ in. × 13¼ in. (26 cm. × 33.7 cm.). Collection of the
Whitney Museum of American Art, New York, NY. Purchased
with funds from the Simon Foundation, Inc. © 2007 Artists
Rights Society (ARS), New York, NY. 74.81.

vanishing point horizon vanishing point

FIGURE 5.13
Two-point perspective. Horizon vanishing points.

FIGURE 5.14
Frank Moore, (1953–2002), *Legacy,* (1999), gouache on paper.
sheet, 22¼ in. × 16⅝ in., (56.5 cm. × 42.2 cm.). Gift of Beth
Rudin DeWoody in honor of David W. Kiehl. Photograph by
Sheldan C. Collins. Collection of the Whitney Museum of Ameri-
can Art, New York, NY. 2004.13.

receding plane. It is the same on the left, using your left arm. The angle at which you are holding your arm is exactly the angle at which you can draw the lines on your paper to represent the direction and angle of those planes.

Frank Moore, in his drawing, *Legacy,* (fig. 5.14) expands his life concept in a simple two-point perspective. The tree is cut down to a coffin, a box with sides receding to two different vanishing points. Where one life ends another begins, the branches provide a home for the birds, and new life seems to spring from previous. The human arms protruding serve two purposes; one is the formal affirmation that this box is three-dimensional with four sides and the other that a human may well be inside the box transforming before our eyes.

your own body. Use your arms to follow the direction of the baseline for both the left and the right planes. If a plane is located on your right, raise your right arm, and line it up with the baseline of the

FIGURE 5.15
Sabrina Benson, two-point suitcase, with value changes, student drawing, (1999).

INCLINED PLANES

The top of the suitcase (fig. 5.15), is an inclined ascending plane. An inclined plane is not parallel to the ground plane or to the floor. The lines forming inclined planes may not all vanish to the horizon. Vanishing points for ascending planes will be above the horizon; descending planes vanish below the horizon. It is the vertical lines of the lid that are inclined and will converge above the horizon. The lines forming the interior space of the lid are not inclined, and they vanish down to vanishing points on the horizon. The side plane of the suitcase on the right also vanishes down to a vanishing point on the horizon. Take a ruler and follow the direction of the lines to better understand where they vanish.

Wayne Thiebaud in *Study for 24th Street Intersection*, 1978 fig. 5.16 used the inclined plane creating tension and a sense of drama in his drawing. You enter the drawing at the front edge driving down the hill into the intersection. The street continues in front of you, but it seems you will drive down a very steep hill that you cannot see before you drive up the very steep street out in front of you. Thiebaud began his cityscapes by sitting on an actual corner in San Francisco and drawing

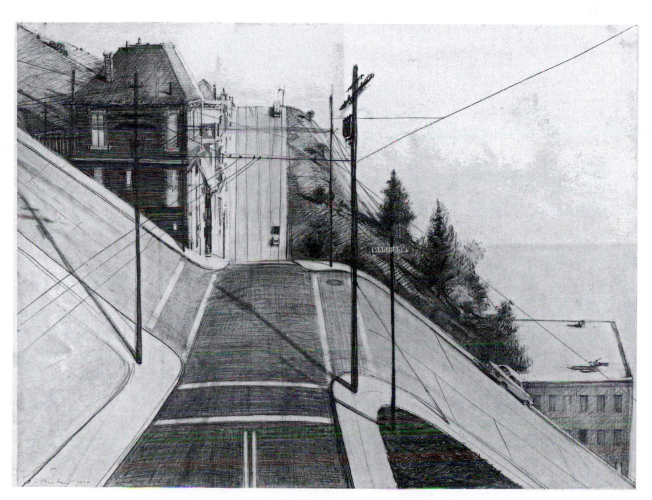

FIGURE 5.16
Wayne Thiebaud, *(1920–), Study for 24th Street Intersection*, (1978), graphite on paper, 22⅛ in. × 29⅞ in. Collection of the Whitney Museum of American Art, New York, NY. © Wayne Thiebaud/Licenced by VAGA, New York, NY.

the streets that just seemed to vanish. He soon discovered that no one view caught the sense of the space where planes disappear. At that point he determined he needed to make the pictures up, reorient them to reflect what he was seeing. He began to compose in doors from memory and sketches. Unsatisfied by the results he returned to direct observation. In these drawings, his goal is to flatten out the planes and play around with the abstract notion of the edge. So what seems to be in perspective may not actually be.

Leonardo da Vinci's, *Architectural Perspective and Background Figures for the Adoration of the Magi*, (fig. 5.17) is a grand example of the perspective grid being applied to a drawing. You can see the receding lines from the front of the picture plane establishing the ground plane, along with the wall plane to the left. Look through the drawing and note the scale of the figures as well as the vanishing point. This drawing should help you understand the application of the grid.

PERSPECTIVE GRID

The Renaissance system for determining the exact size and scale of figures and objects in a space is based on a highly detailed grid with very specific guidelines. To construct this grid, follow these directions, and look over fig. 5.18 stage 1, fig. 5.19 stage 2, and fig. 5.20.

1. Draw the horizon line on your paper slightly more than half of the way from the top (fig. 5.18 stage 1).
2. Draw a vertical line to the right for scale and measurements (fig. 5.18 stage 1).
3. Draw a ground line below the horizon line. Place it one-quarter of the way up from the bottom of the paper (fig. 5.18 stage 1).
4. Establish the center of vision or the vanishing point on the horizon (fig. 5.18 stage 1).
5. Mark off equal increments of one inch on both the vertical and the front ground line from the corner (fig. 5.18) where they meet.

FIGURE 5.17
Leonardo da Vinci, (1452–1519), *Architectual Study for the Background of the Adoration of the Magi*, (c. 1481), pen and ink wash and white, 6½ in. × 11½ in. (16.5 cm. × 29.5 cm.). The Museum of Modern Art/Licensed by SCALA/Art Resource NY. Gabinetto dei Disegni Stampe, Galleria degli Uffizi, Florence, Italy.

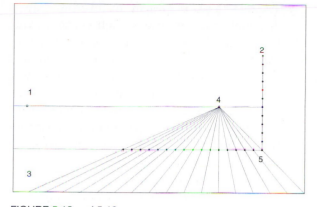

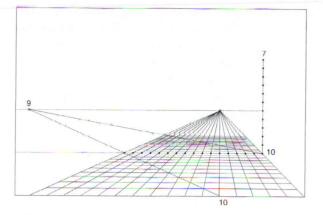

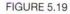

FIGURE 5.18 and 5.19
Christian Gladu, Architect-Designer of The Bungalow Company,
Bend, Oregon, perspective illustrations, (2000). Drawings used
courtesy of the artist.

FIGURE 5.19

6. Draw a line from each one inch mark on the ground line back to the vanishing point. The front points of this first ground plane are called the end points (fig. 5.19).
7. Draw a line from each one inch mark on the vertical back to the vanishing point (fig. 5.18).
8. Extend both sets of lines (on the ground line and the vertical) from their measured marks forward to the paper's edge (fig. 5.19).
9. Establish another point on the horizon that is equal to or greater than the width of the space

(fig. 5.19). From this point, draw two diagonal lines: (a) from the new point, draw the first line to the front corner of the first ground plane grid; and (b) from the new point, draw a second diagonal through the opposite corner of the first ground plane, extending the line into the ground.

10. The diagonal line of (a) crosses the receding lines of the ground plane drawn to the vanishing point. The point where the diagonal intersects the receding line is the mark through which you draw the horizontal line, completing the grid of the ground plane.

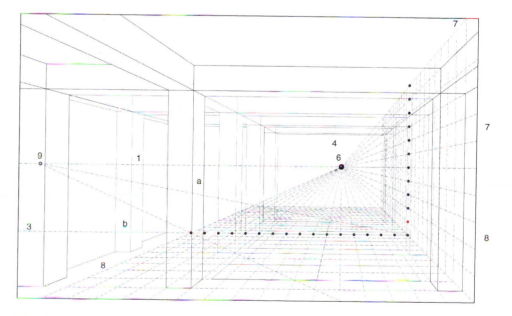

FIGURE 5.20
Christian Gladu, Architect-Designer of The Bungalow Company, Bend, Oregon, *One-Point Perspective both Floor and Wall Planes,* (2000). Drawing used courtesy of the artist.

11. This is now a grid in perspective. The addition of the horizontal lines divides the ground or floor plane into squares that get smaller as they recede.

12. The receding lines on the wall can now be dissected by drawing a straight vertical line up from the ground plane, where the horizontals of the ground plane meet the wall.

DETERMINING SPACING WITH REPEATED INTERVALS

The logical systems of perspective are invaluable in creating a proportioned scale. You may use repeated units based on a mathematical formula used to divide both the ground planes and the receding side planes.

1. In fig. 5.21 the square #1 is square to you constructed with horizontal and vertical lines. This square is easily divided in equal parts by drawing two diagonals across the square from corner to corner, and a horizontal line through the center where the diagonals cross. To create a row of squares, extend the baseline and the top lines horizontally the distance of three more equally sized squares.

2. To create a second square in this row, draw a diagonal line from the top left corner of the first square through the midpoint of the vertical side line on the opposite side of the first square, diagram # 2 continue drawing to the baseline. When this diagonal line meets the baseline, use a 90° plastic angle to draw a vertical line from the meeting point upward to the top line. (Fig. 5.21 #2), illustrates a row of squares constructed with this process.

3a. To draw a wall in a one-point perspective like fig. 5.20 #3, start by drawing a horizon line on the paper. Establish the front edge for the row for the receding planes with a vertical line. The height of this first line establishes the size and scale of the following planes. Draw two lines receding from this first vertical one from the top and one from the bottom to the vanishing point (fig. 5.21 #3c).

3b. Find the midpoint on the first vertical of the first square, and draw a line from that midpoint to the vanishing point (fig. 5.21 #3B).

3c. To complete the first square and locate the back line of this square draw a diagonal line from the front top corner of the first square through the center line to the baseline. Where the diagonal line meets the baseline, draw a vertical line to the top line. This establishes

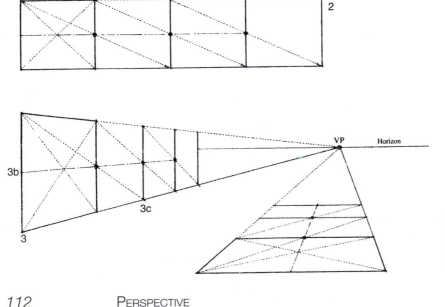

FIGURE 5.21
Christian Gladu, Architect-Designer of The Bungalow Company, Bend, Oregon, *Receding Planes,* (2000). Drawing courtesy of the artist.

the first square in perspective (fig. 5.21 #3). To create square number two, draw a diagonal line from the top front corner of the first square through the mid-point on the back vertical where the center line intersected this vertical. Continue the line to the baseline. Where this diagonal meets the baseline, draw a vertical line upward to form the second square. Continue with this process to create receding squares in perspective.

4. To establish the ground plane (fig. 5.21 #4), draw a horizon line at the top to middle of your paper. Then draw another horizontal line some distance forward from the horizon, which will be the length for the front edge of the ground plane. Draw two lines receding to a vanishing point that you select on the horizon from either end of this front line. Measure to find the midpoint on the front horizontal line, and draw a line from it to the vanishing point. Draw two diagonal lines across the square from the front corners crossing the center receding line at its center point. The points at which these two diagonals meet the receding side lines is where you draw a horizontal line from one to the other completing your square with a backline. Expand the floor plane by drawing a diagonal line from the left front corner

through the midpoint on the back horizontal line of the first square; This diagonal lines continues until it meets the original vanishing side line on the right side. Where the diagonal meets the side line is the point to draw a horizontal line, establishing the end of the second square. (fig. 5.21 #4).

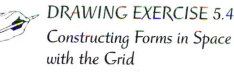

DRAWING EXERCISE 5.4
Constructing Forms in Space with the Grid

To construct three-dimensional solids in one-point perspective, review the perspective grids (figs. 5.18, 5.19, and 5.20).

1. Start by drawing a ground plane and a wall plane (fig. 5.20) in perspective with the grid divisions.
2. You should always draw front to back in perspective. Select a place on the ground plane grid where you want a box to be drawn. Outline the base in the ground plane, following the horizontal and vertical grid lines (fig. 5.22).
3. Draw two vertical lines up from the two ends of the front edge.

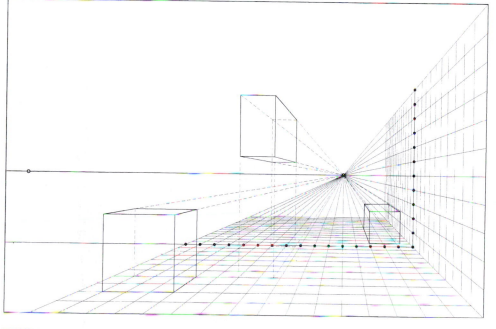

FIGURE 5.22
Christian Gladu, Architect-Designer of The Bungalow Company, Bend, Oregon, *One-Point Perspective*, (2000). Drawing courtesy of the artist.

4. From the top point of these first two verticals, draw diagonal lines that recede to the vanishing point. These receding lines determine the height of the back verticals of the box. (fig. 5.22).

5. Select the depth of your box by locating two verticals on the same baseline as the front verticals in the grid. The back verticals end at the top of the receding lines from the front verticals. The verticals for any given side must align on the same receding baseline.

6. Practice making cubes in one-point perspective. Think of the grids (both the ground and the side planes) as an interior of a room. Using the grid, remember to draw the front planes first. You can then construct bookcases, chairs, tables, and more. When you locate the front plane first, you can easily construct a table, by extending the lines to the vanishing point constructing the top plane of the table. Find the back legs drawing two vertical lines from those receding lines for the top of the table at a distance you choose. See whether you can design and draw an imaginary living room or kitchen in the space.

FIGURES IN PERSPECTIVE

The columns in (fig. 5.23), are drawn in scale. The top line of the column recedes to the vanishing point, as does the baseline. The columns then fit in between those two lines. By adding a ground plane, you can determine the correct location of each receding column. Establishing the size and the proportions of figures in a drawing is accomplished in the same manner. You draw a line from the top or the head of the front figure and a second line from the feet to the vanishing point. Each of the receding figures in the drawing are drawn in between these first two lines, thereby positioning all the figures in perspective. The scale of the figures depends on the first front figure. A figure can be located at any place within the picture plane first by moving across the ground plane and then sizing the figure within the receding lines of the front figure. The eye level of figures in proportion to each other will be on the horizon.

We often define space as it fits the needs of humans. When the space dwarfs the figures, we say

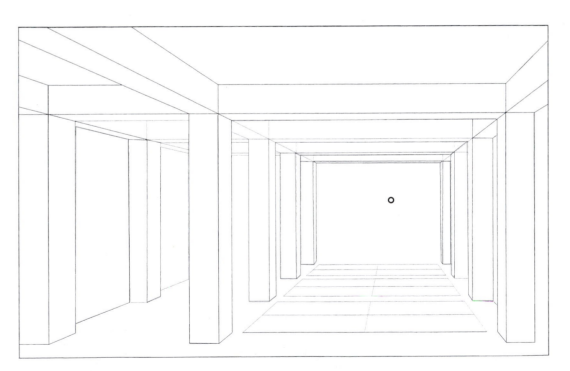

FIGURE 5.23
Christian Gladu, Architect-Designer of The Bungalow Company, Bend, Oregon, *One-Point Perspective*, (2000). Drawing used courtesy of the artist.

that the space is bigger than human scale, whereas if the figures fit the space well, we say that the space is human scale.

DRAWING EXERCISE 5.5
Drawing in Proportion

Before you start, frame your picture plane by creating a border on your paper with four lines. The border lines create a frame to look through in order to locate images in the foreground and the background. Make a simple contour drawing of a real street with the horizon noted, and place the outline of a person in the foreground of the drawing. Draw a line from the top of the first person's head to the vanishing point, and draw a second line from this person's feet to the vanishing point. Continue to draw people in between the two vanishing lines to the horizon. To practice, you can copy the space of a street from a photograph. Copying brings both familiarity and improved hand-eye coordination into your future drawings.

Try different public spaces, using the size of the figures as measuring devices to establish the scale of the space. Draw a space of monumental scale in which the space dwarfs the figures, and another space where the figures fit into a space that is of human scale. For example, a figure under the Eiffel Tower is in monumental space, whereas a person sitting at a café table is much more in proportion with the person's environment.

CONTEMPORARY INTERIOR DRAWING

William Wiley's drawing *Nothing Conforms* (fig. 5.24) is a vision of his studio interior, which contains traditional Wiley icons, visual puns, comic-book lore, and signs and symbols of West Coast drug and funk cultures. He has used one-point perspective but not in the traditional manner. There is a room in front of the canvas drawn as if it is on the back wall of the room. There is one receding baseline on the bottom of left wall. The columnlike

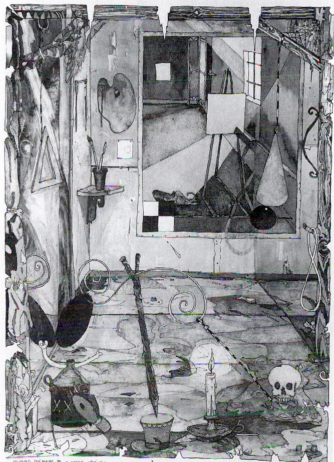

FIGURE 5.24
William T. Wiley, (1937–), *Nothing Conforms*, (1978), watercolor on paper, 29½ in. × 22½ in., (74.93 cm. × 57.15 cm.). Neysa McMein Purchase Award. Collection of the Whitney Museum of American Art, New York, NY.

form in the front does not line up with the back molding on the left. On the back wall, in the large rectangle he has placed a receding baseline for the right wall that is vanishing into the white square further back. Look over this drawing carefully in order to discover all Wiley's plays on perspective. You seem to be looking around his studio including looking at one of his drawings on the wall. The lines in the drawing are pretending to be in perspective. His work with symbols in this still-life interior is fascinating. The symbol of infinity hangs from the branch of a tree, whereas its shadow is incorporated into the drawing on the back wall. Wiley transforms, informs, and misinforms in a pantechnicon—which in the arts is a bazaar where all kinds of things were sold—of images and visual tricks all manipulated through the artist's wonderful handling of graphic devices.

EXPRESSION AND PERSPECTIVE

The Funnel (*The Modern Man's Guide to Life by Denis Boyles, Alan Rose, Alan Wellikoff*) (fig. 5.25) is a one-point perspective of a natural funnel by Robert Beck. In Beck's contemporary approach, contour line plays an important role, but modeling or chiaroscuro in its traditional sense of recording falling light does not. Nevertheless Beck's use of light and dark controls and creates the space. The

light foreground path recedes into a dark shadow in the background. The black in between the trees helps to accent the suspended circle in the center of the trees. The box at the upper left contains an aerial diagram of the funnel. In the diagram the circle is the center line. You are apparently looking through this circle to the ground on the other side. Here, drawing has been freed from the hard rules of linear perspective using the concepts of old space and reinventing a new space.

FORESHORTENING

In foreshortening, spatial relationships are compressed rather than extended. In a foreshortened view, distance is represented with shorter lengths of line, often only an inch or less long, to render a form that you may know to be three feet long. In drawing the figure, one body part may be drawn overlapping the one behind it. You have to intellectually overcome your knowledge that a leg is two or three feet long in order to draw a figure such as Giovanni Tiepolo's *Drunken Punchinello* (fig. 5.26). In foreshortening, shapes generally get smaller as they recede, but Tiepolo has reversed the scale of the shapes. The feet are small, and the nose is enormous. Our view of Punchinello is not from his feet up but from his chest down. We are standing over him, looking down on this figure. Line and value separations between receding body parts are crucial in foreshortening. In Tiepolo's *Drunken Punchinello*, the line for the waist and the dark value under the coat are deliberately used to separate one area of the body from the next. Sighting is helpful in foreshortening. Try to draw what you see, not what you know. The chest behind the nose is a perfect example. Tiepolo did not draw the neck or the head, just the chest directly in front of the nose. The figure lies on a diagonal, receding baseline, increasing our perception that he is back in the space of the picture plane.

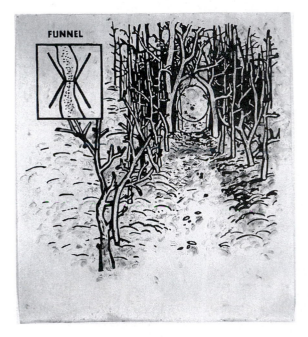

FIGURE 5.25
Robert Beck, (1959–), *The Funnel (The Modern Man's Guide to Life* by Denis Boyles, Alan Rose, Alan Wellikoff), (2000), charcoal on paper 120 in. × 107 in. (304.8 cm. × 271.8 cm.). Collection of the Whitney Museum of American Art, New York, NY. Purchase, with funds from the Drawing Committee. 2000.252.

FIGURE 5.26
Giambattista Tiepolo, (1696–1770), *Drunken Punchinello,* pen and brown ink, brown wash over black chalk, 6¼ in. × 6 in. Photograph: Joseph Zehavi. The Pierpont Morgan Library/Art Resource, New York, NY. Thaw 1, No. 48.

In George Segal's drawing *Untitled* (fig. 5.27), he has compressed the figure and flattened it to the picture plane. The figure sits at the surface or on the surface of the picture plane. There is no opening into the space of the ground; and there is no background. Visually, you are stopped at the surface with one-half of a drawn figure. It is hard to feel personally involved or attracted to a figure without a head. The notion of "inner life" has effectively been removed. Instead, we have a hollow figure without a personality. The Pop Artists and Minimalists of the 1960s took the emotion and feeling out of the artwork. There was a sense that art could be only what it was and that it did

FIGURE 5.27
George Segal, (1924–2000), *Untitled,* (1965), pastel on red paper, 17¾ in. × 11¾ in., (44.7 cm. × 29.6 cm.), Washington Art Consortium Photographer: Paul McCapia. Art © Estate of George Segal/Licensed by VAGA, New York, NY.

not need to allude to some other metaphor or emotion.

DRAWING EXERCISE 5.6
Challenging Perspective

Challenge your understanding of linear perspective by selecting an interior space such as that of William Wiley's fig. 5.25 one that holds some intrigue for you visually. Determine the area that is most visually appealing to you, and start with it. Place the baselines freely, moving parts closer or stretching them farther apart. Use bold shadows and strict value changes in the space. Work to achieve a new representation of this space by the placement of the architecture. Depend on empirical perspective more than on linear perspective; in other words, make judgments from observation and from looking at the space.

In a second drawing, try looking down on an object. Sit on a chair, place an object at your feet, and then looking down through your arms and legs, draw your body parts with the object. This is similar to an aerial perspective.

Manipulate the perspective of space to find your own expressive solution. You will often need to make ten or twenty sketches until you free yourself of preconceived ideas and directions.

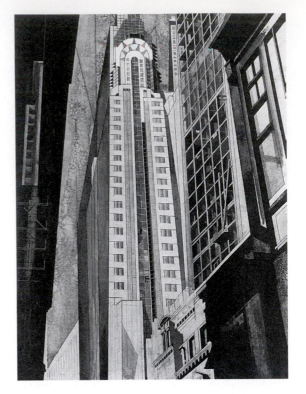

FIGURE 5.28
Earl Horter, (1881–1940), *The Chrysler Building Under Construction,* (1931), ink and watercolor on paper, sheet: 21½ in. × 16 in., (54.6 cm. × 40.6 cm.), image: 20½ in. × 14¹¹⁄₁₆ in., (52.1 cm. × 37.3 cm.). Collection of the Whitney Museum of American Art, New York, NY. Purchase, with funds from Mrs. William A. Marsteller. 78.17.

THREE-POINT PERSPECTIVE

Three-point perspective is what is used to draw a tall building when your view is from the sidewalk looking up. The vertical lines of the building that are related to the height of the building are perpendicular to the ground, and the lines converge into a third point above the top of the building. The side planes of the building are in a two-point perspective, and they vanish to two points on either side of the horizon. Earle Horter's *Chrysler Building* (fig. 5.28) races upward, with the lines of the building vanishing somewhere above the building. You can see that the building is getting smaller as it goes up.

DRAWING EXERCISE 5.7
Three-Point Perspective

Select a building of three or more stories. Sitting where you can see the top and at least one side of the building, draw the horizon line on your paper. Locate the sides of

the building in a two-point perspective, and establish the large side planes. Add the lines for the top of the building, drawing them up and moving together toward one point above the top of the building. When the major planes are established, return to the sides and add the smaller planes and protrusions. Add a dark value on one side of the building to separate the planes, and add any shadows you observe or feel you need. If you are uncomfortable drawing out on the street, take a camera and then photograph the building from one viewpoint. You may also take photos from different viewpoints as you are looking up, and then may choose later which view to draw.

CIRCLES

In perspective the circle becomes an ellipse. The ellipse is the essential shape of all cylinders and other circular forms such as arches. Fig. 5.29 is an illustration of circles in perspective. The circles in

FIGURE 5.29
Circles in perspective.

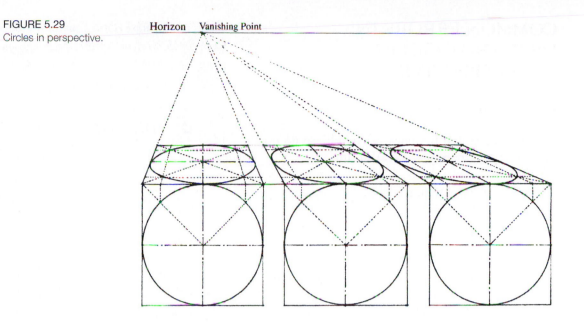

Horizon Vanishing Point

the front boxes remain round circles because they are not receding. It is the circles in the receding boxes on the top planes that have become elliptical. The square surrounding the circle in the top plane is a helpful device to draw the circle in perspective. This is a one-point perspective with the lines for the sides of the square on either side receding to a vanishing point. The area of the circle at the front of the square is larger than at the back. This arrangement follows the rules of perspective that states that things get smaller as they recede. Knowing how to draw the circle in perspective by using the ellipse is very helpful when you need to draw plates and platters sitting on a table in a still life. You should use a receding square and should inscribe the ellipse in it to make sure that you get the back half of the ellipse smaller than the front.

The diagram of the circle (fig. 5.30) illustrates how to construct a perfect circle using a square, with diagonals dividing it. In the diagram in fig. 5.31, the circle is shown in perspective from the horizon up and from the horizon down to where it once again becomes a full circle. Your eye level determines how open the ellipses you are looking at will be. At the horizon, the circle is virtually a straight line: as it moves away from the horizon, the circumference widens. Only when you are looking directly down on a cylinder sitting at your feet or looking directly up at the underside of a can or cylinder can it be round; otherwise, it is elliptical.

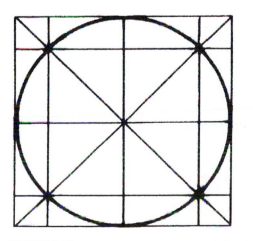

FIGURE 5.30
Diagram of a circle.

FIGURE 5.31
Circles from the horizon up and down in perspective.

COMMON ERRORS IN DRAWING CIRCLES IN PERSPECTIVE

Figure 5.32 demonstrates the following errors:

1. The front and the back of the ellipse do not meet at a sharp point on the rim.
2. The front and the back ellipse should be the same curve. Do not flatten the curve of the front and the back of the ellipse.
3. The ellipse at the top of a cylinder cannot be fuller than the ellipse for the bottom of the cylinder. The circumference of the ellipse opening is determined by the view that you have of the cylinder in terms of where the cylinder sits and where the horizon is located.

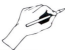 **DRAWING EXERCISE 5.8**
Ellipse Practice

Practice making columns of ellipses at first that are the same size, and then that are different sizes on a sheet of newsprint. To construct an ellipse, draw the front curve of the ellipse first, and then draw a matching curve for the back of the ellipse. Join the corners with a curved line. Don't try to make the ellipse in one rotation with your pencil because it will be lopsided. Draw a column of ellipses one on top of another, and try to make them all exactly the same in circumference and size. Draw another column of ellipses in which every two ellipses are the same size. In this column, draw two small ellipses, and then draw two larger ellipses below them. Draw ellipses on their sides as a vertical ellipse, not a horizontal one as you have been drawing them. After filling the page with columns of ellipses, connect any two ellipses of the same size with a vertical line on your paper. Next connect these two same-sized

ellipses to the larger ellipses, and use a diagonal line. Lili Xu in fig. 5.33 demonstrates practicing making ellipses and joining them together to create cylinders.

 DRAWING EXERCISE 5.9
A Circle in Perspective

To practice drawing a circle in perspective, review the circle diagram (fig. 5.28), showing a circle inscribed in a square. The arcs of the circle are more easily constructed and correctly curved when the square is divided into quarters. Each arc is drawn across one-quarter to complete the whole. In addition, the diagonals drawn through the center help guide the curve of the arc. Practice drawing cubes in one-point perspective (fig. 5.28), and then inscribe the circle in the top receding plane as well as in the front plane using diagonal lines to dissect the space of the square.

 DRAWING EXERCISE 5.10
Analyze Cylinders

Use a sharp HB pencil or a Sharpie marker to test your understanding of the circle in perspective. Select a cylinder whose shape changes from a narrow neck to a round base or from a curved neck to a larger base. Analyze the shape, determining the size of the ellipse needed to represent each section, and then draw a vertical column of ellipses from top to bottom that reflect the change in the cylinder's shape. Change the size of the ellipse as the cylinder's shape changes. Cover a piece of paper in cylinders; draw a coffee pot, a flowerpot, vases, pitchers, and wine bottles. When you draw the ellipse first, you are basically creating the skeleton over which you will form the outside contour.

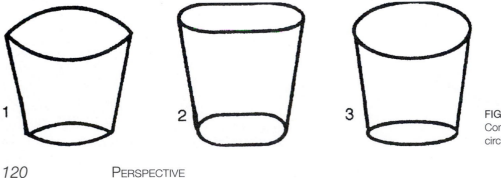

FIGURE 5.32
Common errors in drawing circles in perspective.

FIGURE 5.33
Lili Xu, *Ellipse Practice and Cylinder Studies*, (1999), student drawing. Oregon State University.

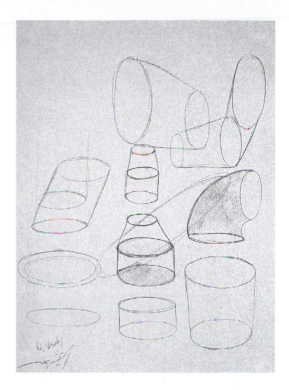

 ## DRAWING EXERCISE 5.11
Deconstruct a Machine

Jan Reaves has expanded the function of the ellipse and the circle in her drawing Form (fig. 5.34). She has pulled the figure apart to reconstruct an abstracted figure. Experiment with the circle and the ellipse in configurations that deconstruct the automobile, the human figure, a bicycle, or a large machine. Consider the value of each part. Where should you use black and gray, or where can you leave it white? Experiment with drawing tools, and use ink and a brush, or compressed charcoal and a brush with charcoal pencils or chalks.

FIGURE 5.34
Jan Reaves, *Form,* (2005), Xerox toner on aluminum, 30 in. × 22 in. Courtesy of the Artist.

AERIAL PERSPECTIVE

The nuclear reactors at Three Mile Island are cylinders. In Yvonne Jacquette's drawing *Three Mile Island, Night I* (fig. 5.35), they have been drawn from an aerial perspective. This perspective has become a powerful tool. From this vantage point you perceive the threatening nature of Three Mile Island, and it is further enhanced by the use of night light. Drawn from this perspective, the image thrusts out into the viewer's space. The drawing seems to have a pulse.

The hatched lines in the drawing create a gray value on the ground that contrasts with the black towers. The space between the cylinder-shaped nuclear reactors is equally important to the reading of this drawing. The contrast of the black planes ending in light planes at the ground increases the stunning light quality of the drawing before you think about the purpose of the towers. The original drawing was made in daylight as Jacquette flew over Three Mile Island in a small plane. She determined that the drawing would have more impact if she changed it to a night drawing—and it is definitely more powerful illuminated in the night.

FIGURE 5.35
Yvonne Jacquette, *Three Mile Island, Night I,* (1982), charcoal on laminated tracing paper, 48⅜ in. × 38 in., Hirshhorn Museum and Sculpture Garden, Smithsonian Institution, Washington, D.C. Museum purchase, (1983).

ATMOSPHERIC PERSPECTIVE

Atmospheric perspective has much in common with aerial perspective. "Aerial" comes from the Latin word *aerius*, meaning "air," whereas "atmosphere" comes from the Latin word *atmosphaera: atmos* is vapor, and *sphaira* is sphere. Both refer to the air surrounding the earth. In an atmospheric perspective, illusion is created with light to dark, but it is not necessarily drawn from above, whereas aerial perspectives may be thought of as being drawn from an "aerial" position above the subject. Atmospheric perspective relates more to one's perception of color, value, shape, texture, and size that can all be altered by the weather conditions. Artists create deep space and other spatial illusions by depicting the effects of atmospheric conditions, such as a haze, a drizzle, or the wind. This depiction is done with value and value changes that will create a sense of depth in either atmospheric or aerial perspective drawings. In an atmospheric perspective, the values in the drawing are manipulated to create various effects and disturbances in the condition of the air in the drawing. This manipulation not only controls the space in the picture plane but also allows the artist to generate certain moods or feelings.

Gaetano Gandolfi's drawing *Italian Seated Turbaned Prophet* (fig. 5.36) is an atmospheric perspective with a field of changing light running throughout the picture plane. The prophet sits in the foreground modeled in dark values with a sharply defined surface from the high contrast application of light to dark. The rocks that he sits between are dark. His foot rests on the rock in the dark foreground, and his left hand sits on top of the large rock, which is illuminated to draw your attention to it. His body turns from the darkness into the light, his hand reaching out like a question.

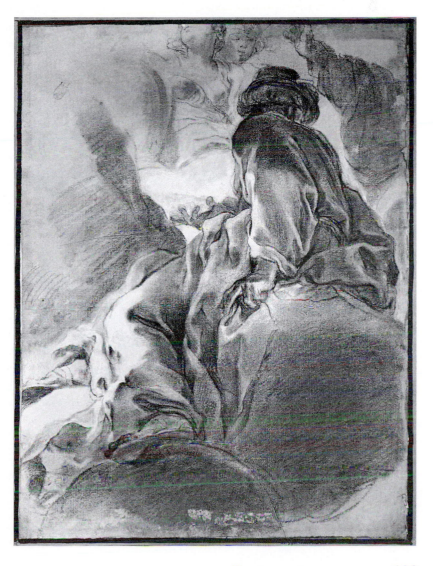

FIGURE 5.36
Gaetano Gandolfi, Italian, (1734–1802), *Seated Turbaned Prophet,* black chalk, stumped, gray wash, heightened with white, on beige paper, 16⅝ in. × 12⁵⁄₁₆ in., (42.2 cm. × 31.2 cm.). Gift of Jacob Bean, in memory of Donald P. Gurney, (1989). The Metropolitan Museum of Art, New York, NY. 1989.108.1.

What is he looking at in this illuminated background where the light has been diffused and in which the background seems mysterious? There are no specific forms in the background, only an atmospheric haze that the artist has used over the distant forms. Gandolfi has suspended dust in the air, reducing the distinctness of the distant forms.

Both atmospheric and aerial perspectives may employ the same technical devices from the drawing toolbox—high-contrast use of values, linear elements, or textural changes. Both perspectives generally make dramatic statements. It is the view that is different in each of them; aerial perspective is drawn looking down on the subject, whereas the atmospheric perspective does not need to be from above.

SHADOWS

Shadows are important elements in composition. They create drama, mysterious space, and volume. Shadows may be introduced arbitrarily by an artist, or an artist may adhere to a graphic method of accuracy controlled by observing actual light. The following factors govern the drawing of shadows and cast shadows determined by the rules of perspective.

1. Consider the source of light. Is it natural or artificial? Natural light falls in parallel rays, whereas artificial light creates radiating rays.
2. Consider the direction in which the light is falling. The direction of the light determines the direction of the shadows. Shadows are cast opposite from the source and direction of the light. Backlighting occurs when the subject is blocking the light, creating either a very dark front plane or illuminated edges on the subject.
3. Consider the angle of light. The angle determines the length of the shadow. At noon, when the sun is directly overhead, there are no long shadows although a small shadow may occur directly under a form. The rays of the sun are at their steepest angle to the earth at approximately 10 A.M. and 3 P.M. At those times, the shadows are the longest.

When you are drawing shadows, the shadow begins exactly where the form ends on the same line or edge. To ensure that the shadow is correctly placed, hatch through the bottom of any form that is casting a shadow. You can also hatch back onto the form from the shadow, guaranteeing that the one flows into the other.

Dempsey through the Ropes (fig. 5.37) by George Bellows is a dramatic drawing. Bellows's expert use of the shadow sets the scene both technically and emotionally. Firpol, the Bull—the fighter in the ring—is illuminated against a very dark background. The white of the mat in the ring is contrasted to black gloves and shoes. Dempsey is

FIGURE 5.37
George Bellows, American, (1882–1924), *Dempsey Through the Ropes,* (1923), black crayon on paper, 30 in. × 22½ in. (76.2 cm. × 57.2 cm.). The Metropolitan Museum of Art, Rogers Fund, (1925). The Metropolitan Museum of Art, New York, NY. 25.107.1.

shown in light tones with light modeling as he falls into a dark mass of spectators. The focal point is the two fighters, and the rest of the arena is darkened to strongly accent this fight. In addition to the technical aspects, the high contrast between light and dark values enhances the impact of the punch and the fall of Dempsey, who had been the champ.

In Lili Xu's drawing (fig. 5.38) the light source is falling from the right. The stacked cylinder on the right of the drawing is casting a shadow on the cylinder in the background. There is also a cast shadow from the base. Forms moving in and out of dark grounds create a beautiful subtlety in a drawing.

FIGURE 5.38
Lili Xu, *Value Study in Charcoal*, (1999), student drawing. Oregon State University.

![pencil icon] *DRAWING EXERCISE 5.12*
Studying Light Changes

Select one piece of fruit such as an apple or a pear. Set it on a white piece of paper on a table. Use a clamp-on light attached to an easel to direct light on the fruit. Make three drawings, changing the direction of the light each time. Direct the light from the front, then from the side, and finally from the back. In the third drawing, angle the light down so that it is not in your eyes. Hang up the three drawings, and examine the shadow treatments. How did the light changes affect your perception of the fruit?

LANDSCAPE LIGHT AND SHADOW

The shadows and light in Heinrich Bürkel's *Italian Farmhouse among Ancient Ruins* (fig. 5.39) were manufactured by the artist; it is not a record of the actual light falling on the farmhouse. He has carefully rotated from light to dark planes. No two planes or areas of the drawing blend together. The balance of the light to dark separates one form from another so that nothing gets lost.

The planes on the buildings or the plants determine where it will be light and where dark. As light falls, the tops of the trees will catch the light, while the areas underneath, in back, and behind will slip into shadow.

The shadows in this drawing, although inventions of the artist create a balanced space in the drawing. They reflect his knowledge of chiaroscuro.

FIGURE 5.39
Heinrich Bürkel, German, (1802–1869), *Italian Farmhouse among Ancient Ruins*, gray wash over pencil on cream wove paper, 247 mm. × 360 mm. Committee for Art Acquisitions Fund. Iris and B. Gerald Cantor Center of Visual Arts at Stanford University. 1984.247.

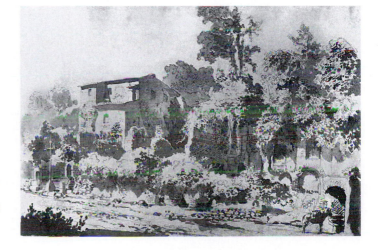

He is not guessing where to put light and dark; rather, he knows that illuminating the building on the front planes will put the side planes in shadow in order to separate the planes and create a volume. The bushes pick up the light on the top planes, and the bottom planes are in shadow. The shadows hold the spaces in between the trees, allowing the tree trunks to show through. This drawing is a balance of light and dark that Heinrich Burkel executed perfectly.

STRATEGIES FOR PERSPECTIVE DRAWING ●▶

1. To use linear perspective, frame the picture plane with four border lines, establish the horizon, and then decide whether your subject is a one-point, two-point, or three-point perspective.
2. In a still life, study the relationships of the forms by checking the baselines and the height of each object compared with the others, locate the horizon, and plan where to use light and dark values. Use your knowledge of the ellipse to construct all cylinders.
3. To draw a landscape, find the horizon, study your subjects, draw from front to back, and then determine where to add light and dark values to create volume and space.
4. Use sighting without a grid to approximate the angle at which your subject is placed in the picture plane, and consider the other forms equally in your view. Don't worry about proportions and scale. Lightly sketch a scene, using lines as textures or organizational lines to locate forms in your view. Think about what will be the focal point.
5. To make a drawing challenging perspective. You may choose to distort your vanishing lines, use even values of light and dark throughout the drawing, keeping the space flat. Cylinders are distorted when the top opening is a different circumference than the base.
6. Perspective drawings can be either tightly controlled with the grid or loosely constructed with empirical perspective. In contemporary drawings there can be a disregard for the rules in order to make a drawing to fit your idea.

ART CRITIQUE: EDWARD RUSCHA AND CHRISTO

The great draftsman Henri Matisse once said, "What I am after, above all is expression." For Matisse, expression was neither an emotion or emotional. It was the whole arrangement of his picture from the figure to the empty spaces around it. Drawing was thinking for Matisse, and he might make one hundred drawings of one face to get the lines he desired.

Drawing is thinking for both Christo and Ruscha. In fig. 5.40, *Pico and Sepulveda*, Ruscha has used an aerial perspective in which you are

FIGURE 5.40
Edward Ruscha, (1937–), *Pico and Sepulveda*, (1999), synthetic polymer on paper, 40⅛ in. × 60¹/₁₆ in., (101.9 cm. × 152.6 cm.). Gift of The American Contemporary Art Foundation, Inc., Leonard A. Lauder, President. Collection of the Whitney Museum of American Art, New York, NY. 2005.58.

FIGURE 5.41
Christo, (1935–), *The Gates,
Central Park, Project for New
York City,* (2003), graphite, char-
coal, pastel, wax crayon, enamel
paint, fabric sample, aerial pho-
tograph, hand drawn technical
data, and tape, in 2 parts: 15 in.
× 96 in., (38 cm. × 244 cm.),
and 42 in. × 96 in., (106.6 cm.
× 244 cm.). Collection of the
Whitney Museum of American
Art, New York, NY. Purchase,
with funds from Melva Bucks-
baum, Raymond J. Learsy and
the Martin Bucksbaum Family
Foundation. © Christo (2003).
2004.419a-b.

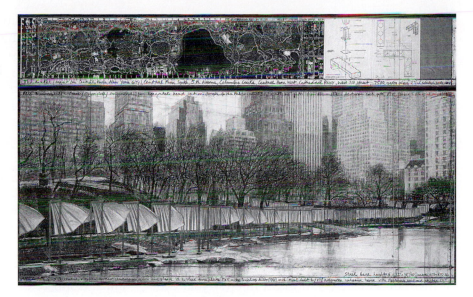

looking down on an intersection in Los Angeles. The streets form an X or a cross in the picture plane. Ruscha has used layers of synthetic polymer to build this surface most likely applied with an airbrush layer on layer. The image plays the formal simplicity of a two-dimensional design, the X-form, against its representation of three-dimensional space, and this play is one of Ruscha's favorite themes.

Christo's drawings are composed of a combination of materials and views. The drawings crystallize Christo and Jeanne-Claude's ideas through the months and years it takes for one of their projects to be completed. During the planning and preparation period, drawings are a source of reality for them, encouraging them so that they will be able to stay with and finish the project. When Christo is drawing, he works alone in his studio. When one of their projects materializes, he and Jeanne-Claude will switch from their private solo lives to work with hundreds of people. Finally, the drawings are their source of revenue; they finance all their projects by selling his drawings as well as other drawings from their early works of the fifties, sixties, and seventies. On any given project, he will make 300 to 600 drawings and collages. In the preparatory drawing fig. 5.41 for *The Gates,* Christo used different perspectives, an uneven grid, a piece of actual fabric, and pencil, charcoal, pastel, wax crayon, tape, and technical data of the base pieces which would secure each Gate to the ground. This view of the *The Gates in Central Park* was drawn in one-point perspective. The drawing was then extended with other drawings into a

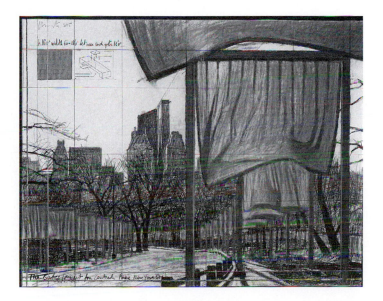

FIGURE 5.42
Christo, (1935–), *The Gates, Project for Central
Park, New York City,* (2003), pencil, charcoal,
wax crayon, tape and technical data, 22 in. ×
28 in,, (55.9 cm. × 71.1 cm.). Photo: Wolfgang
Volz. © Christo (2004). Photo Courtesy of
Christo and Jeanne-Claude.

collage. Above this drawing placed in the bottom of the grid, Christo used an aerial photograph of the park and beside the main drawing he added hand drawn technical data. In fig. 5.42 Christo drew *The Gates, Project for Central Park, New York City* in a one-point perspective that strongly represents what this installation looked like when you walked through it. Ruscha and Christo differ in their choice of materials. While Ruscha stayed with one material, Christo used graphite, charcoal, pastel, wax crayon, enamel paint, tape, and fabric samples pasted to the top corner of the drawing fig. 5.40.

All three drawings are elegant. All three drawings use perspective to their own ends. These drawings are adventuresome with the material or materials used to create them. They are different but equal.

JOURNAL FOCUS •▶

A hallway provides an excellent test for creating an interior space in perspective. Sit in the middle of the hall. Locate the horizon line (at your eye level), and draw a light line on the paper where the line falls. Keep your head in one position. Determine the vanishing point: it will be at the end of the hallway where all the floor lines and ceiling lines converge. Mark your vanishing point on the horizon line. The vanishing point is often through the middle of the doorway at the end of the hall. Toba Khedoori's (fig. 5.43) *Untitled (rooms)* expands the simple hall drawing conceptually adding a quiet mystery.

Using a ruler, draw a ground line at the front of the picture plane, and mark it off in one-inch units. Connect each unit to the vanishing point, and then extend the units forward to create a larger forward floor plan. Draw a vertical line at the end of the horizontal ground line. Mark off one-inch units on this vertical line for the wall. The vertical line is near the front of the picture plane. Draw lines through each point on the vertical line to the vanishing point. Construct the details of the walls and the floor using your horizontal and vertical grid. If you need help, refer to the Perspective Grid section earlier in this chapter.

FIGURE 5.43
Toba Khedoori, *Untitled (Rooms),* (2001), oil and wax on paper, 144 in. × 144 in., (365.76 cm. × 365.76 cm.). San Francisco Museum of Modern Art. Accessions Committee Fund: gift of Shawn and Brook Byers, the Modern Art Council, Elaine McKeon, Christine and Michael Murry, Lenore Pereira-Niles and Richard Niles, and Robin Wright. © Toba Khedoori. 2002.46.A-B.

TEXTURE AND PATTERN

"When you look at a wall spotted with stains, you may discover a resemblance to various landscapes, beautified with mountains, rivers, rocks, trees . . . Or again you may see battles and figures in action, or strange faces and costumes and an endless variety of objects which you could reduce to complete and well-know forms . . . And these appear on such walls confusedly, like the sound of bells in whose jangle you may find any name or word you choose to imagine."
—*Leonardo da Vinci*

This quote from Leonardo speaks to our ability to imagine. Here, textures and patterns off a stained and spotted wall trigger new thoughts and possibilities in drawing. Richard Serra's drawing, *Untitled*, (fig. 6.1) is actually 4 triangles. Most predominantly, a black triangle, surrounded by three white ones. The subtlest one is the sliver of a triangle behind the black triangle's right side. By placing this black triangle in the picture plane on a diagonal line, Serra creates a triangle that seems to recede into deep space. The triangle itself is constructed with lithographic crayon, a crayon that is very greasy and thick bodied. This crayon raises the image off the paper, giving it a sense of sculptural relief and real texture. The edges have been rubbed to create the blurring gray texture on both the top and bottom edges. Serra may very well have used a little paint thinner to create the washed look on both sides working it into the crayon at the edge of the form. The lines drawn for a right angle can still be seen faintly in the gray wash below the triangle. If he had placed the black triangle at right angles to the picture plane, it would have been flat to the picture plane and pushing forward instead of receding back into space like his sculptures do in nature.

FIGURE 6.1
Richard Serra, (1939–), *Untitled,* (1972–1973), lithographic crayon on paper, 37¾ in. × 49¾ in. (95.89 cm. × 126.37 cm.). Purchase, with funds from Susan Morse Hilles. Collection of the Whitney Museum of American Art, New York, NY. © 2007 Richard Serra/Artists Rights Society (ARS), New York, NY. 74.10.

RUBBING AND RENDERING

Texture is one of the formal elements of drawing. Texture contributes to the expressiveness of the drawing. The character of texture in a drawing is dependent on your choice of drawing tools and papers.

Rubbing was used by Chandra Allison (fig. 6.2) in *Study of a Walnut*, to create the texture in the space around the walnut as well as on the walnut's shell. To create this texture, she placed her paper on top of a black, rough portfolio and used her pencil to transfer the portfolio's texture while at the same time she manipulated the value changes on the ground by alternating from light to firm pressure.

The surface of the walnut was drawn with a range of light to dark tonal values. The shell of a walnut poses exactly the same problem as in drawing drapery: its surface rolls from the top plane into a groove or back plane. These planes are much smaller than the ones on the drapery, but the process is the same: light rests on the top planes, gray forms the side planes, and dark fills the inside of the grooves. The handling of light and dark in the drawings of the interior of the walnut demonstrates the effectiveness light and dark have to create space and depth. By leaving the rim of the shell in light values and the nut in the same value, the artist creates a struggle for the same visual space. The small darkening of the areas behind the nut accents the two areas pushing on each other.

The rubbing technique Allison used is called *frottage*. It was invented by Max Ernst, a German surrealist of the 1930s, an early pioneer of alternative processes to create art. He used rubbing as a drawing itself; he also added rubbings into his drawings. Ernst preferred an image that resulted from a natural pattern, one actually taken from a weathered plank rather than rendering the wood grain in drawing media. The rendering or drawing of the "Green Pepper" (fig. 6.3) was made by using the side of a graphite pencil.

INVENTED TEXTURE

Invented textures are textures created from the imagination. It is your knowledge of drawing techniques and the use of various tools that will help you create new textures. Tools such as pen and ink, graphite pencils, and charcoal pencils can be used to create texture. There are several basic techniques: layering wash, cross-hatching, hatching, stippling, dripping, and scribbling. Each of these techniques requires a gradual buildup of marks or careful side-by-side placement. Each mark or stroke has its own nature or quality. Tonal value is expressed through the relative proportion of light to dark, spacing, and the density of lines or marks in a drawing. The direction of the stroke adds to the viewer's understanding and perception of the rendering. William Duffy (fig. 6.4) in-

FIGURE 6.2
Chandra Allison, *Study of a Walnut,* pencil, (1999), student drawing.

FIGURE 6.3
Chandra Allison, pencil rendering of a green pepper, (1999), student drawing.

FIGURE 6.4
William Duffy, invented texture, ink line, (1999), student drawing.

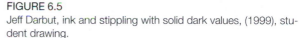
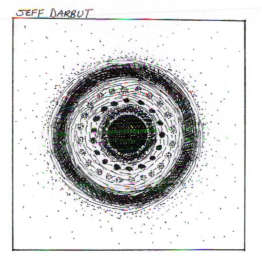

FIGURE 6.5
Jeff Darbut, ink and stippling with solid dark values, (1999), student drawing.

vented the lines and marks in his drawing to render a push pin. Jeff Darbut (fig. 6.5) combines line texture and stippling in his drawing of a sink stopper.

LINE

Sirakus (fig. 6.6), by Richard Tuttle, surprises you with how much can be done with so little. Here, elegantly, wavering lines form "U" shapes of simple curves, something like a descending row of test tubes. The quality of these lines is reminiscent of the edges in his early sculptures, where he placed two congruent plywood shapes an inch apart to create just such a wavy line. Both his drawings and sculptures are characterized by a seemingly casual touch and use of modest materials. In *Sirakus* you sense a sculpture, perhaps the profile of a volume or aerial view of one of his linear sculptures. Tuttle's sculptures, in fact, are often linear, three-dimensional realizations of drawings such as this one, and line is consistently a main tool for his work.

FIGURE 6.6
Richard Tuttle, (1941–), *Sirakus,* (1974), ink on paper mounted on board, board: 19¼ in. × 14½ in., (48.9 cm. × 36.8 cm.), sheet: 14 in. × 11 in., (35.6 cm. × 27.9 cm.). Purchase, with funds from the Albert A. List Family. Collection of the Whitney Museum of American Art, New York, NY. 74.21

FIGURE 6.7
Andrea Hellwege, *Scissors,* ink and stippling, student drawing, (1999). Oregon State University.

STIPPLING

Andrea Hellwege's scissor drawing (fig. 6.7) is an example of stippling, which is a technique that uses very fine dots. Stippling is made with a fine-tipped ink pen on a smooth paper such as plate Bristol. The dots are painstakingly placed side by side, one at a time. You need patience to build the value dot by dot. Tightly spaced dots define sharp, distinct edges, and looser groups of dots create a softer contour or surface. The density of dots controls the value. The farther apart the dots are, the lighter the value. The closer the dots are placed, the darker the value. Large dots result in a coarse texture. Even spacing of dots creates a light value. The darkest areas may have dots placed on top of each other.

DRAWING EXERCISE 6.1
Interpreting Forms in Marks

The three student drawings (figs. 6.4, 6.5, and 6.7) were the creative solutions for the following assignment:

Select a simple object to render without using an outline. Use only line, marks, or stippling to form the shape and surface of the object. On a 10 × 10 inch illustration board center a 5 × 5 inch square to place the drawing. The drawing by Jeff Darbut (fig. 6.5) is a combination of lines and stippling that he used to interpret a rubber sink stopper. William Duffy (fig. 6.4) invented a textured look for a push pin by employing a strict, clean set of vertical lines for the pin's point. Horizontal hatching lines establish both ends of the pin. A grid of x's forms the pin's shaft, and very close stippling points form the head or top of the pin.

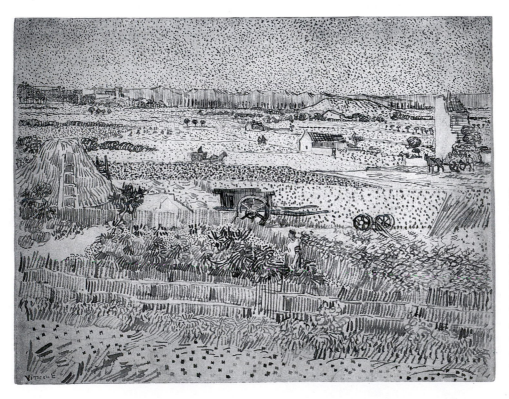

FIGURE 6.8
Vincent van Gogh, Dutch, (1853–1890), *Harvest— The Plain of La Crau,* (1888), reed pen and brown ink over graphite on wove paper, 9½ in. × 12⁹⁄₁₆ in., (242 mm. × 319 mm.). Photograph © Board of Trustees, Collection of Mr. and Mrs. Paul Mellon, in Honor of the 50th Anniversary of the National Gallery of Art, Washington, D.C. 1992.51.10.

HATCHING

Hatching is a series of parallel lines. The lines can be long or short, ruled or drawn freehand. The spacing, density, thickness, and thinness of the lines control the value they reflect. Thin lines with white space between them read as a light value, whereas thick, close lines read as a dark value. The pen is the natural tool for hatching.

Vincent van Gogh's drawing *Harvest—The Plain of LaCrau* (fig. 6.8) is constructed with hatching lines. Van Gogh began with a pattern of ink dots. The absence of outline loosens and activates the drawing. Cross-hatching darkens the value when overlapping strokes are laid horizontally, diagonally, and vertically on top of each other in order to define the planes in the drawing. Dense hatching creates solid volumes. Open hatching is used for water reflections, the light of the sky, and grass covering the ground. The ends of hatching lines feather out like the tips of tall grasses. This hatching technique—of changing the lines from thick to feathery thin—is dependent on the pressure you put on your drawing tool. In van Gogh's *Harvest—The Plain of La Crau*, (fig 6.8) the planes without any marks create a resting place for the eye. Without such empty planes the hatching and stippling would be over powering.

TROMPE L'OEIL AND ACTUAL TEXTURE

Texture may be "actual," duplicating the tactile surface of an object. In drawing, "actual texture" is a photographic representation, whereas invented textures are not based on any real or natural form. Both types create a tactile sense on the surface of the drawing. To re-create a natural surface, an artist examines the subject very closely. The term Trompe l'oeil is a French term meaning, "to fool the eye." When forms and their surfaces are rendered so realistically that you believe that the drawing is a real form because it is so photographically reproduced, it is called trompe l'oeil.

Cy Twombly's collage drawing (fig. 6.9) combines photos of real objects with forms he has drawn. He mixes an abstract scribble with a realistic rendering of a mushroom. The grid, tracing paper, and

FIGURE 6.9
Cy Twombly, *Natural History, Part 1 Mushrooms*. © 2005 Tate, London, England. © Artists Rights Society (ARS), New York, NY.

label at the bottom come together with the photos, creating a trompe l'oeil effect against his invented textures. Twombly's drawing is a contemporary the Van Gogin use of invented and actual textures.

The drawings by Robin Seloover (figs. 6.10 and 6.11) are constructed with thread, which is used as a line. The needle is her drawing tool. She twists the thread around the needle, making knots that are then laid out in a grid format. The grid signals a nontraditional use of thread. This process is no longer sewing. The stitched drawing seems to be fields of sameness, but there are subtleties, differences existing within a given group of stitches. Certain relationships, postures, and positions change in the accumulation of the stitches on and through the paper. Some changes soften it to make it more cloth-like, whereas others tighten in geometric firmness.

In *Untitled (Map 1)* (fig. 6.11), Seloover is drawing with thread, pencil, and a brush. The various media unite in a space that is active, while including

FIGURE 6.10
Robin Seloover, *Untitled (Courtyard)*, (2002), cotton thread on paper, 5⅞ in. × 8 in. Courtesy of the Artist.

FIGURE 6.11
Robin Seloover, *Untitled (Map 1)*, (2003), thread (linen, cotton, sewing), graphite, gesso, enamel, mulberry paper, 10⅜ in. × 14⅞ in. Courtesy of the Artist.

pathways or resting spots. In *Untitled (Courtyard)* (fig. 6.10), she has broken the sameness, introducing torsion, a twisting or rotating motion. She is now setting imperfect, loopy French knots next to tight, conventional ones. The spaces that are created become architectural in this geometric grid.

 DRAWING EXERCISE 6.2
Mixed Media

Collage is not the mere cutting out of magazine photos and pasting them down in some form of organization. Mixed media collage is a form of layering different materials together.

For this exercise you will be assembling images and real textures, as well as invented textures, into a new composition. Use the grid as the foundation. The grid may expand and shrink as needed. Start with thin papers such as rice paper or tracing paper. Get textures, by making rubbings stones, pavement, sewer covers, brick walls, trees, furnace grids. A lead stick is a good tool to make rubbings with because it has a large surface to rub over the ground. In addition, you may use camera photos, drawings, newspaper text or photos, string, thread, cardboard, or rope.

Select one image to direct the composition. For example, shapes like the circle can be repeated. The mushroom expands and contracts in Twombly's assembled drawing (fig. 6.9). Place images on the ground without attaching them at first until you see the composition coming together. You may draw on another paper, repeating the image in color or in black and white, and then place that image in the field. You may find a photo of your image and rub pastel into it lightly. This photo can be added, cut out, and overlapped into your field. You may make Xerox copies of photos in order to work on the paper with pastel, charcoal, colored pencil, or ink. You may use an ink wash and draw into the wash when it is wet or dry. Your linear elements, such as string and thread, may be woven into the paper or may be used as line across the paper. If you have a photograph with a linear element, you may extend that line with a real thread into or across your ground.

Postage stamps and labels offer another material to alter the meaning of your composition.

You may write on the drawings or add numbers. In this work you first make a start, and then you respond to your first images. All decisions are made according to your intuition in placing images.

Maria Sibylla Merian (1647–1717) was an incredible illustrator. Her work demonstrates meticulous rendering. Since there are only a few women artists recognized today who worked prior to the nineteenth century, we are fortunate to have a record of Merian's work.

Merian was both a naturalist and an artist. She was the daughter of Mattheus Merian, the owner of a publishing company. Her first engravings were published at the age of twenty-two. Her father was very supportive of her developing an art career and provided her with instruction in painting and engraving while she was young. Women who became artists in the late 1600s and early 1700s generally were supported by their fathers or came from painting families.

Merian's marriage to the painter Johann Andreas Graff was unhappy. In 1699, after twenty years of marriage in which she had two daughters, she declared herself a widow prematurely and sailed to the tropics, an unthinkable act for a woman in 1699. She spent two years in Surinam with her daughter Dorothea, making drawings and renderings of butterflies. When she returned to Amsterdam, her book *Metamorphosis Insectorum Surinamensium* was published. The sixty engravings of butterflies, banana plants, and pea pods were so correctly rendered that they were often referenced by botanists in her day. Her *Studies from Nature* (fig. 6.12) is an elegant and delicate drawing. Particularly well detailed are the moth and the butterfly wings. The precise accuracy of these drawings is so fine that botanists reproduce and reference her work today. This is a pristine example of "actual texture and trompe l'oeil." You believe that you could reach in and grab the strawberry. The top of the pea pod turns back in a little wrinkle, and the stem is broken, making it even more believable.

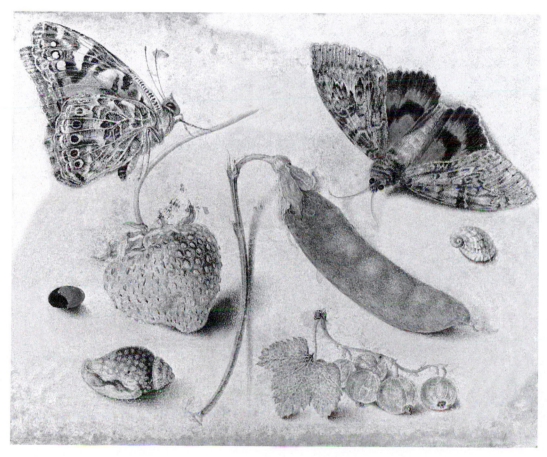

FIGURE 6.12
Maria Sibylla Merian, German, (1647–1717), *Studies from Nature: butterfly, moth, strawberry, pea pod, white currants, shells*, watercolor on vellum, 3⅝ in × 4⁷⁄₁₆ in. (9.2 cm. × 11.3 cm.). The Metropolitan Museum of Art, Fletcher Fund (1939). The Metropolitan Museum of Art, New York, NY. 39.12.

VISUAL TEXTURE

Visual textures are invented to simulate either the smoothness or the roughness of surfaces. These visual textures are not necessarily a real surface or accurate representation. Such invented textures serve the artist's vision and purpose. Texture and pattern are devices in drawing to organize the space, creating visual interest and rhythm. Visual textures have a range of expressive possibilities.

The drawing *Phil/Fingerprint II* (fig. 6.13) is of Phillip Glass, the contemporary composer, Chuck Close created the drawing with fingerprints. Close took a photograph and enlarged it in to a closely spaced grid. He used a single, repeated mark made by his finger covered in ink pressing into a stamp pad. Each square of the grid has one fingerprint filling it. The values, tones, and textures, both light and dark, were all accomplished by the artist's controlling the ink from the stamp pad. In this series of fingerprint drawings, the round fingerprints placed in one square of the grid reestablished the tonal variations of the photograph. At a distance, the eye blends the rounded tessera, the small square of this mosaic, into the surface shapes and patterns of the face. After this series of drawings, Close continued creating variations of the fingerprints: he made square prints butted up against each other in the grid forming the face; and he threw the grid away entirely and put fingerprints on at random.

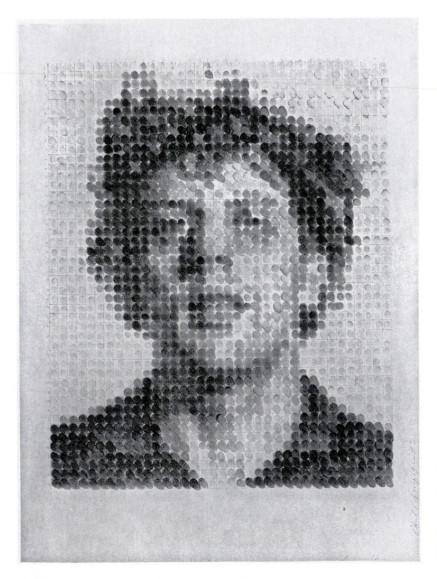

FIGURE 6.13
Chuck Close, (1940–), *Phil/Fingerprint II,* (1978), stamp-pad ink and graphite on paper, 29¾ in. × 22¼ in., (75.57 cm. × 56.52 cm.). Collection of the Whitney Museum of American Art, New York, NY. Purchase, with funds from Peggy and Richard Danziger. 78.55.

DRAWING EXERCISE 6.3
Creating Texture and Pattern

Students Tom Breeden and Betsy Backlund created drawings using invented textures. Their textures are abstract and decorative textures that are based on repetition, patterns, lines, dots, and planar divisions. In fig. 6.14, Tom selected one vegetable, repeating the outline by overlapping the one before it across a 10 × 15 inch illustration board. For fig. 6.15), Betsy drew three apples across the picture plane and expanded the design, using textured grounds. She never outlined her apples. Instead, she changed the texture and size of the pattern to form the edge of the fruit. The change in the pattern guides your eye through the design.

For this drawing exercise, select one fruit or vegetable as your subject. Draw a simple outline of the form, repeating it across a 10 × 15 inch illustration board. Each outline should overlap the one before it in the layout. Create or imitate textures and patterns to redefine the surface of the form. Draw lightly in pencil, and then use ink for the final solution.

FIGURE 6.14
Tom Breeden, *Invented Textures*, (1999), student drawing, Oregon State University.

FIGURE 6.15
Ben Turner, ink pen and charcoal, (1999), student drawing, Oregon State University.

SURFACE TEXTURES AND EXPRESSION: SIMULATED TEXTURES

The term *simulated texture* means to reproduce a surface either from or like nature. A textural effect, which may be rough or smooth, is created from the use of lines and tonal values. Texture-like color or value must be integrated into a drawing. Well-conceived textures harmoniously balanced in the picture plane create a unified vibration in the drawing. Texture, through the various kinds of marks, creates light in a drawing and can indicate planes in space. Different kinds of marks create different textures. The choice of a form of applied texture is up to the artist, and it supports the artist's idea.

To re-create a natural surface, you should examine the subject very closely. Seeing and touching the surface first provides your imagination with invaluable information about the subject. You must determine the shape, depth, contour, and color, and then interpret the information into marks.

Giovanni Tiepolo's drawing *Lying Deer and Head of Crocodile* (fig. 6.16) contains two unrelated subjects in one picture, both drawn from different perspectives—perhaps it is a study for a larger work. The juxtaposition and incompatibility of these two animals in contemporary drawing could be an intentional composition by a modern artist. In examining the material makeup of the deer's hide, you see that it is composed of value changes in pen and ink. Hatched strokes on the stag convey a feeling of surface hair. In this foreshortened view of the deer, the hindquarter is darkened, and there is a contour line dividing the hindquarter from the deer's stomach. A partial contour line and a light value on the shoulder together create a visual distance between the stomach and the shoulder. The dark to light changes create volume and a spatial distance. The ground under the deer is a smooth wash without texture except for the marks indicating foliage at the front corner.

In contrast, the use of pen and ink for the alligator is rough compared with the treatment of the stag. The alligator is modeled with short light to dark strokes, creating a rough surface. It appears to have been drawn from a description rather than from life.

The textural character of the drawing and the nature of the surface are determined by a choice of materials. Tiepolo's ink wash creates both a rough

FIGURE 6.16
Giovanni Domenico Tiepolo, Italian,
(1727–1804), *Lying Deer and Head of a
Crocodile,* (after 1770), pen and bistre
with sepia wash, 11¼ in. × 7⅞ in. (28.5
cm. × 20 cm.). Robert Lehman Collec-
tion, (1975). The Metropolitan Museum of
Art, New York, NY. 1975.1.521.

and a smooth surface. The inventiveness of the artist controls the expression.

SPACE AND TEXTURE

Pierre Bonnard, in his drawing *The Goatherd* (fig. 6.17), used texture to create both planes and light. Beginning students associate line with outline or contour only, but line in this drawing defines air, space, light, and natural forms without the outline. Bonnard's lines reflect what he saw and transcribed through scribbles, marks, hatching, and cross-hatching to define the space of the garden. Later he would translate these marks into a painting with brush strokes and color. Losing the outline frees the artist to interpret space. Bonnard's expressive use of line as texture was influenced by the light in the landscape, the character of the forms, and his drawing tools.

The activity of drawing develops an increased sharpness in perception. Your awareness evolves and expands as you learn to see in new ways, developing a new understanding of the things around you.

FIGURE 6.17
Pierre Bonnard, French,
(1867–1947), *The Goatherd
(recto)*, (1945–1946), pencil
and black and red chalk on
cream wove paper, 10⅝ in. ×
8¼ in., (26.7 cm. × 21 cm.).
Robert Lehman Collection,
(1975), The Metropolitan Mu-
seum of Art, New York, NY. ©
2007 Artists Rights Society
(ARS), New York/ADAGP,
Paris. 1975.1.570.

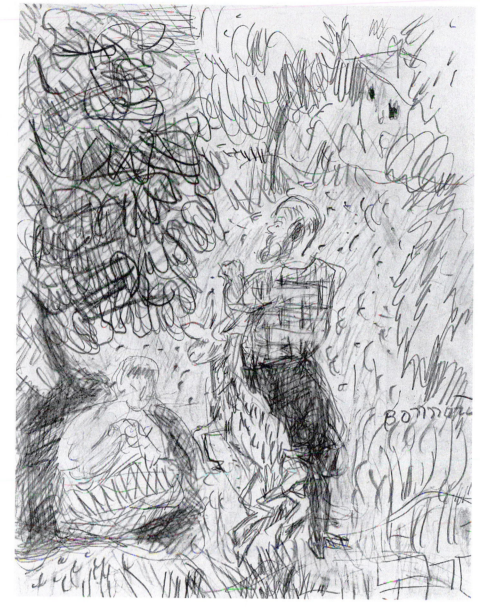

 DRAWING EXERCISE 6.4
Scribble Line Landscape

In a small sketchbook or on loose sheets of paper that are lap size, work outdoors directly from nature. Select a part of the landscape, and draw with a pen. Use various lines — hatched, scribbled, light to dark — to record the location of trees and plants in the space you have selected. Draw the space from front to back by starting with the space of the foreground and adding the receding grounds to it. Scribble and hatch in the direction in which the forms grow. Reverse your visualization, and start with the background, adding the ground, trees, and plants as you draw to the foreground.

Manipulate the values in your drawing with layers of line and by varying the pressure on the pen. Make a dozen sketches of the same area from different sitting positions or angles. Layout all the drawings on a wall, and look at them when you are done. You are looking at a record of your perception, and you will see how, without realizing it, you saw things differently in the same space in each drawing.

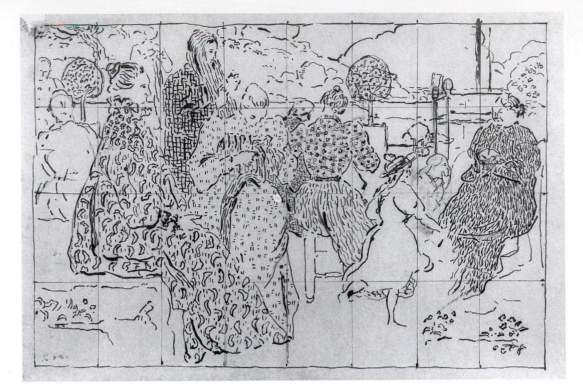

FIGURE 6.18
Ker-Xavier Roussel, (1867–1944), *Women and Children in a Park,* (c. 1892–1893), pen and brown ink, with touches of pencil, on tracing paper, 200 mm. × 305 mm. Museum Purchase Fund. Iris & B. Gerald Cantor Center of Visual Arts at Stanford University. © 2007 Artists Rights Society (ARS), New York/ADAGP, Paris. 1971.32.

PATTERN

In the sketch *Women and Children in a Park* (fig. 6.18) Ker-Xavier Roussell constructed the patterns creating textures on the women's dresses out of different invented marks. The marks are close in size and scale, keeping the picture plane flat. The Nabis Bonnard Vuillard and Roussell were particularly fond of graphic design and flatness. In the 1890s, they contributed striking Art-Nouveau-flavored designs for *La Revue Blanche,* the leading avant-garde Symbolist magazine in Paris. By 1894, Bonnard and Vuillard were producing distinctive designs for book illustrations, posters, and as well as decorations for stage designs. The study in (fig. 6.18) was intended as an advanced stage drawing by Roussel, a compositional plan for a future painting. The grid divides the drawing proportionally for the transfer to the canvas.

For the Nabis the flatness and simplicity of Primitive Art and the ornamental, geometric patterns of Byzantine art with its curves and stylized figures proved to be inspirational.

In the student series (figs. 6.19 and 6.20), images were made from lead and graphite rubbings off actual surfaces. The student then interpreted the rubbings into stylized patterns creating invented textures (fig. 6.21).

Nicole Stowers (fig. 6.22) selected and cut four two-inch squares out of a series of rubbings she had made. She then reassembled them into one four-inch square. After constructing this collage, she interpreted the actual rubbings into a new design, creating a rendering in ink wash and charcoal pencil (fig. 6.23).

AMBIGUOUS PATTERNS

An ambiguous pattern is a design that is balanced evenly between the amount of both positive and negative space. The pattern is equal and exactly the same shape and size, in both the black and white shapes. In Jeff Darbit's student drawing (fig. 6.24), the black pattern and the white pattern are symmetrical. If you look at the white pattern, it

FIGURE 6.19
Nicole Stowers, rubbing, (1999), student drawing, Oregon State University.

FIGURE 6.20
Nicole Stowers, rubbing, (1999), student drawing, Oregon State University.

FIGURE 6.21
Nicole Stowers, invented texture, (1999), student drawing, Oregon State University.

FIGURE 6.22
Nicole Stowers, rubbing, (1999), student drawing, Oregon State University.

FIGURE 6.23
Nicole Stowers, ink translation of rubbings, (1999), student drawing, Oregon State University.

FIGURE 6.24
Jeff Darbit, ambiguous pattern, (1998), student design, Oregon State University.

seems dominant, but if you switch your eyes to the black pattern, then that one seems dominant. The key to this pattern is the contour edges of the form. The white edge must match the black edge, so the form that you select in a drawing exercise is important. In Darbit's drawing, he used the same leaf reversed so that the contour edge matched.

✒ ## DRAWING EXERCISE 6.5
Ambiguous Pattern

Select a symmetrical figure, a form that is the same on both contour edges, to create an ambiguous pattern using only black and white. The design is composed by repeating the figures in rows side by side, and by reversing the figures. The figures will be arranged in a grid of alternating rows, each row facing a different direction. If two different figures are used, they must have similar shape characteristics and must share a common contour line. Selecting and manipulating the symbol takes concentration. The resulting visual should be a balanced composition that fluctuates between the white pattern dominating and then the black dominating. It will be a totally reversible design.

PROFILE OF AN ARTIST: *VINCENT VAN GOGH 1853–1890*

Vincent van Gogh was born on March 30, 1853. His father was a clergyman in Zundert, a small town in a poor region of southern Holland. In the van Gogh family there were two daughters and another son, Theodorus, or "Theo." Theo was to play an important role in Vincent's life, supporting him both financially and emotionally.

Van Gogh was an extremely emotional child given to sudden and violent outbursts of rage. His mother could never understand him, but he was able to talk with both his father and Theo. His education began in public school, where he was briefly enrolled, but his parents thought the contact with the other boys was making him too rough. As a result, they took all their children out of school, and a governess was hired to teach the children at home. Vincent's contact with nature during this time developed his love of the country, the local peasants, the earth, animals, and all other living things. These times provided him with his happiest boyhood memories.

Vincent experienced terrible seizures followed by long periods of calm and mental clarity. His illness may have been caused by a traumatic childhood experience, or he may have had a form of epilepsy.

Vincent's first drawings at the age of ten were conventional studies of flowers in pencil and watercolor, which he copied from illustrations that he found in books. A good deal of whimsical humor and playfulness mark these drawings. The sketches were of dogs' heads, rabbits, birds, butterflies, and kittens, including a sketch of a dog wearing a hat and smoking a pipe. This drawing would fit easily into the primitive imaging by the neo-Expressionists in New York in the 1980s. In Chapter 10 on Color and Modern Art, there is a drawing by Roy de Forest (fig. 10.11) with just such a personified dog. Both de Forest and van Gogh's drawings ignore proportion and perspective but reflect a real interest in landscape.

At age eleven, van Gogh went to a small private boarding school, staying until he was sixteen. He left to take a job with Goupil Gallery in The Hague, and he never finished school. In May 1873, he was transferred to the London Gallery of Goupil, a time that become possibly the happiest of his life. He had enough money to live on and the opportunity to visit the museums and to study the great masters, admiring the work of Corot, Millet, and most of the Victorian artists. The portrayal of the human condition and the focus on human interests attracted him to the work of Corot and Millet. This happy time ended when he fell in love with Ursula Loyer, his landlady's daughter. She, however, rejected him. His unhappiness caused him to neglect his job, and as a result, he was fired. During the next three years he worked as a bookseller's clerk and then studied to be a lay preacher, but he was dismissed by his superiors for "excessive zeal."

In 1880, he turned to art. Millet's *Sower of the Fields* had become a symbol of life to him. He studied anatomy and perspective in Brussels, thinking that he might be destined to be a "peasant painter" like Millet. His work was dark during this period. During a short stay in Antwerp, van Gogh saw the work of Rubens, whose portrayal of vitality and rich color appealed to him. At the same time, he saw the prints of Hokusai, the Japanese printmaker. In 1886, he

joined his brother, Theo, in Paris. Impressionism was everywhere. Van Gogh left the dark and somber paintings of his Dutch period and began painting views of the Seine, the boulevards, and other favorite Impressionist subjects. He met Monet, Pissarro, Degas, Seurat, Signac, Toulouse-Lautrec, and Gauguin. Van Gogh's work had a different emotional quality from that of the Impressionist paintings—it was more forceful. Becoming dissatisfied with Paris, in 1888 he moved to Arles in the south of France. The hot sun of Provence thrilled him. He felt that he could start over.

The Composition of his drawings, became a personal graphic like "handwriting." The broad reed pen he used to cover the paper in overlapping, often dense strokes—but not heavy strokes—created a texture unique to van Gogh. His vivid sense of texture evolved through the use of dots, dashes, whirling strokes, hatching, and cross-hatching—lines forming the space of his landscapes. *Landscape with Pollard Willows* (fig. 6.25) is such a pen and ink drawing. Van Gogh made diagrammatic sketches in his letters to Theo in order to share with his brother his ideas for paintings. He also made complete line studies for paintings with precise color notations. Painting and drawing for him were not about creating luxury objects; rather, they were an extension of life, a part of his environment.

Dreaming of an artists' cooperative in the south of France, van Gogh invited artists to join him, but Gauguin was the only artist to respond. Gauguin came to work with van Gogh, and their relationship was pleasant and mutually stimulating at first. Gauguin's personality, which was domineering and

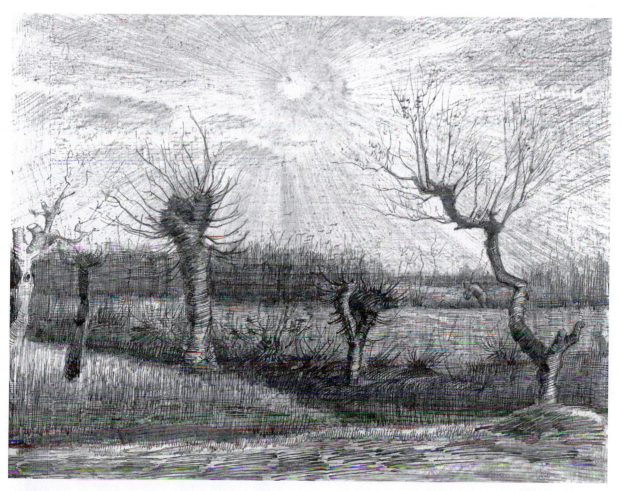

FIGURE 6.25
Vincent van Gogh, Dutch, (1853–1890), *Landscape with Pollard Windows*, (1884), pen and brown ink graphite on over ivory laid paper, 34 cm. × 44 cm. © 1995, Robert Allerton Fund. The Art Institute of Chicago, all rights reserved. 1969.268.

egocentric, soon became intolerable for the high-strung van Gogh. The friction between them brought on a terrible attack of madness. Van Gogh attacked Gauguin in a state of frenzy during which he cut off his own ear. Theo became concerned and got Vincent to agree in February 1889 to enter the asylum at nearby Saint-Rémy. At the asylum he was allowed to paint and to wander outside the walls, but there his life ended tragically when he committed suicide in 1890 by shooting himself. Because his aim was poor, he lived another day before dying in Theo's arms.

During his one year in the south of France, he made approximately two hundred paintings and one hundred drawings, and he wrote some two hundred letters to Theo and Émile Bernard. He lived his life with a burning intensity and dedication to his art. Contrary to the popular belief that he worked during bouts of insanity, his letters to Theo and Émile Bernard reveal great lucidity about his artistic aims. He was one of the most articulate of painters, and his intentions are clearly expressed in his strong, elegant drawings. In this last year of his life, the ideas for each painting came vividly to his mind.

STRATEGIES FOR TEXTURE DRAWINGS

1. Examine the space you intend to include in your drawing by considering the textures.
2. In landscape drawings make a practice scribble drawing to place the grass, trees, rocks, and ground textures. Doing this will increase your understanding of the complexities of the space.
3. Choose the size and shape of the lines you will use. Note the direction in which the forms in your drawing move. Is the wind involved?
4. If you choose to make an abstract texture drawing, experiment with large and small marks and the space between them. Consider the placement of your marks in the picture plane.
5. Consider what tool will be best for your drawing.

ART CRITIQUE

Terry Winters and Richard Serra

Terry Winter's drawing, *#3*, (fig. 6.26) at first glance, is abstract organic shapes, but when you take a closer look the lines evoke the figure of a woman. In fact, the drawing seems to be two women overlapped. The circles for the breasts are repeated, the figure's contour is repeated and reflected in the long curved lines framing the figure from top to bottom. These outside lines may represent the shoulders and the arms of the figure or, radiating as they do from the top of the head, they may be strands of hair, even possibly that of the serpents who sprang from the head of Medusa, the mythical Greek monster who turned to stone anyone who looked at her. The gray ground works against the black lines of the fig-

FIGURE 6.26
Terry Winters, (1949–), *#3,* (1989), charcoal on paper, 30⁹⁄₁₆ in. × 22½ in., (76.99 cm. × 57.15 cm.). Purchase, with funds from the Drawing Committee in honor of Tom Armstrong. Collection of the Whitney Museum of American Art, New York, NY. 90.13.

ure, in that the ground has its own spatial qualities, mostly unrelated to the bold black lines except for the small mark on a white ground that reads as the figure's belly button. The process of rubbed and erased charcoal creates a soft ground behind the bold curves of the line. The hat-like shape resting at the top of the drawing seems to be covering the figure, and creates a foreshortened space even as the overlapping circles present a frontal view.

Richard Serra's drawings are generally formal, their meaning attached only to the materials he uses to make the drawing. *Clifton Chenier* (fig. 6.27) is part of a series of rounds, images of a circle celebrating the masters of American jazz, including Al Green, Billie Holliday, Brownie McGhee, and John Coltrane. Clifton Chenier was a Louisiana accordionist, born in 1925, and often seen as the most influential musician in zydeco history. Formally, each of the drawings in the series plays an ovoid circle set off against the square shape of the canvas. The surface is built up so dramatically with oil stick that the drawings approach being sculpture on paper, a depth of surface almost impossible to see in a photographic reproduction. Notice that Serra did not center this circle, nor is it perfectly rounded, something he is perfectly capable of doing, but rolling toward the right edge.

By tilting his drawing, Serra creates, out of a seemingly formal drawing, a narrative about jazz, and possibly the explosion of sound jazz creates. Winters, on the other hand, draws very organic shapes that suggest a woman's figure, although his title, #3, gives us no hint of his intentions. Serra's texture possesses a kind of physical body protruding into the viewer's space while Winter's drawing of a body, half the size of Serra's, seems to evaporate in the space of abstract drawing.

FIGURE 6.27
Richard Serra, (1939–), *Clifton Chenier,* (1997), from the series *Rounds,* oil stick on paper, 54½ in. × 59¾ in., (138.43 cm. × 151.77 cm.). Purchase, with funds from the Painting and Sculpture Committee. Collection of the Whitney Museum of American Art, New York, NY. © 2007 Richard Serra/Artists Rights Society (ARS), New York, NY. 98.4.2.

Achieving a textural effect in a drawing depends on how you manipulate your drawing tools. A rubbed and an erased drawing provides you with an opportunity to work the surface in many ways. Nature is a good subject with which to test your ability to re-create textures. Select an area outdoors in which to draw. Make a light sketch to locate a few trees, rocks, and grasses. Using a 6B on its side, place a layer of graphite on the darkest planes in your sketch. Once you have dark planes throughout the sketch, rub the graphite with a tissue across the entire surface of the sketch, covering the paper in a light layer of graphite. Using a plastic eraser, remove the white planes from the rubbed surface. You may create textures by the way you remove the graphite. By using the kneaded eraser twisted to a point, you can remove small or finer lines, perhaps for grass or leaves. Small stripes and other marks made with the eraser will show through the next layer of graphite that you apply lightly. Change to a 3B pencil, and with light pressure, put a second or third layer of graphite over the marks. These layers will reduce the whiteness of the erased marks and will change their value.

If you prefer, powdered graphite may be rubbed across the surface, creating a very smooth layer of graphite. A third option is to place an ink wash down on the paper first, and then to use layers of charcoal pencil, graphite pencil, or compressed charcoal on top of your wash. You can still erase the pencils and charcoal as long as the wash is dry. In any of these drawings, let the light and dark of the marks create the image. Don't draw a contour line.

COMPOSITION

SPACE

Composition is a sense of order, calm or chaotic, that brings to life the subjects in a drawing. The components of composition are line, shape, value, texture, pattern perspective, and color, the formal elements that are arranged according to the traditional or the modern principles of design; balance, either symmetrical asymmetrical, or radial; harmony; rhythm; repetition; unity and variety; scale and proportion; emphasis; and focal point. When the elements of art render the intent and vision of the artist, the composition has a sense of unity. The last part of this equation is the theme. A well-designed drawing is not enough. It is your ability to transform the theme or content through the principles of design that makes a good drawing. A drawing is said to be complete when nothing either can be added or can be taken away without unbalancing the whole.

The picture plane and the space of the paper on which you draw are the same. The picture plane frames the space of the drawing. **Space** refers to the area within the picture plane. One-, two-, and three-point perspectives are techniques used to arrange the space of the picture plane. The space of a drawing may also be flattened and pushed forward in the picture plane rather than set back into it. The elements in a composition may be structured and balanced in a harmonious arrangement: symmetrically, asymmetrically, or radially. **Symmetrical** compositions have the same amount of visual weight on either side of the center. The sides are a mirror image of each other. In **asymmetrical** compositions, the sides of the composition are not equal—one side is heavier than the other. In radial balance, everything radiates outward from a central point. The center is surrounded by symbols or figures in a outer ring.

Your ability to use the elements or the principles of design and the way that you choose to compose a drawing are based in your mind-set. The mind-set is your own perception of the world; everyone sees things differently. Your perception of space and your ability to translate from three-dimensional space to two-dimensional space are rarely genetic. Seeing is controlled and conditioned by your previous cultural and social experiences that have blocked a level of spatial understanding in your brain. If you have a definition for a cup, wall, table, or floor, you no longer need to look at the object—you know what it is. However, to draw the room you must look at it differently and much more specifically, since your eyes have not yet been trained to coordinate what you see in order to draw it.

An example of not seeing is when in the beginning, students draw a space in miniature placing the objects of the room in separate parts of the drawing paper. There is a resistance to overlapping the forms because students have no previous experience with this concept, so the mind has no stored information to tell them otherwise.

Perception and seeing are developed through drawing exercises. The act of drawing is a great teacher. Let yourself complete a drawing even if you feel that it is wrong. When you do the next drawing, you will have improved. Not only must you be willing to erase and draw over your first lines, but also to achieve a satisfying composition, you must be willing to redraw the drawing over and over. One approach is to measure with organizational lines. Alberto Giacometti used such organizational lines in his drawing *The Artist's Mother* (fig. 7.1). This drawing technique improves your understanding of spatial relationships. Notice that Giacometti's drawing is a one-point perspective and a symmetrical composition. His process of horizontal and vertical lines locating the objects in the space of his drawing provides a frame of reference within which each object is drawn in terms of its relationship to the other forms in the space.

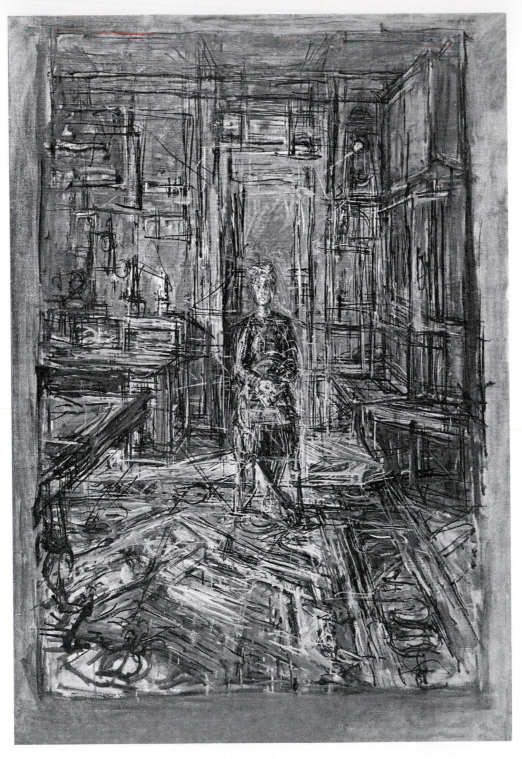

FIGURE 7.1
Alberto Giacometti, Swiss, (1901–1966), *The Artist's Mother,* (1950), oil on canvas, 35⅜″ × 24″, (89.9 cm. × 61 cm.). Acquired through the Lillie P. Bliss Bequest. The Museum of Modern Art/Licensed by SCALA/Art Resource, New York, NY. © 2007 Artists Rights Society (ARS), New York/ADAGP, Paris. Photograph © 1995 The Museum of Modern Art, New York, NY.

Alberto Giacometti's lines define space and the relationships of the forms or objects in that space. In his work he focused on the relationship of the figure to its enveloping space. "To render what the eye really sees is impossible," he said. Giacometti's goal was to discover the accurate visual appearance of his subject and to render it with precision. Giacometti doesn't use line to decorate the surface. Nothing is placed or removed without careful consideration for the composition as a whole. *The Artist's Mother* (fig. 7.1) gives you a good idea of how his line defines the floor plane and the back plane. The lines cross the space to find a form across the room, and then he wipes those lines out and adds white lines into the black lines in order not to lose the space.

He had determined that if he sat 9 feet from the model's eye, he could organize the space as a whole—drawing both the space and the object. It is interesting that he chose 9 feet because when you shoot a portrait with a camera, you sit back one-and-a-half times the height of your subject. If the subject is 6 feet tall, you are taking the picture at 9 feet if you want to fill the picture frame.

Giacometti was not interested in the reflection of light, as were the Impressionists, nor in the camera, which offered a distorted view by failing to register the distance from the artist to the subject. Also, the camera is limited in what it can register by the light source. Space changes when seen by the human eye because we can change both the size and placement of objects in the viewed space. Giacometti, sees his subjects as thin, surrounded by enormous slices of space.

Giacometti's tend toward figures such as standing females with hands on hips, walking men, portraits drawn with an organizational line, (fig. 7.2) and sculptures of male heads. The work *Two Sculptures in the Studio: "Bust of a Man" and "Standing Woman* (fig. 7.3) are just such figures." His sculptures deliberately lack individuality; nothing interested

FIGURE 7.2

Alberto Giacometti, Swiss, (1901–1966), *Portrait of Jean-Paul Sartre,* (c. 1946–1949), pencil on paper, 11½ in. × 8¾ in., (29.2 cm. × 22.3 cm.). Hirshhorn Museum and Sculpture Garden, Smithsonian Institution, Washington, D.C. The Joseph H. Hirshhorn Bequest, (1981). © 2007 Artists Rights Society (ARS), New York/ADAGP, Paris. HMSG 86.2215.

FIGURE 7.3

Alberto Giacometti, Swiss, (1901–1966), *Two Sculptures in the Studio: Bust of a Man and Standing Woman, (*1950), pencil on paper, 21¼ in. × 14¾ in. Hirshhorn Museum and Sculpture Garden, Smithsonian Institution, Washington, D.C. © 2007 Artists Rights Society (ARS), New York/ADAGP, Paris. 66.2026.A-B.

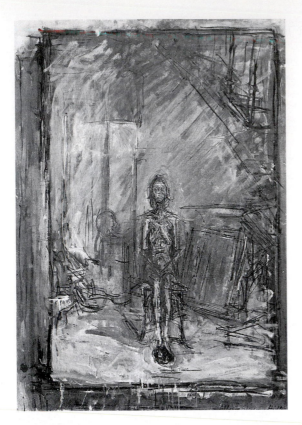

FIGURE 7.4
Alberto Giacometti, Swiss (1901–1966), *Annette Seated in the Studio,* oil on linen, (1954). 36⅜ in. × 25¾ in., (92.2 cm. × 63.3 cm.). Hirshhorn Museum and Sculpture Garden, Smithsonian Institution, Washington, D.C. Joseph H. Hirshhorn Purchase Fund, (1996). © 2007 Artists Rights Society (ARS), New York/ADAGP, Paris. 96.18.

forces at work at the same time your conscious efforts are being applied. This is a limitation in the arts that helps to explain the anguish that is an unavoidable component of the art experience. Giacometti worked for "the moment" when just once he would succeed in representing what he saw. He strove to convey tangible and the intangible sensations of a visual perception of reality—an impossible task and the very measure of his creative drive. The many lines in his work record his struggle to achieve a likeness of his model. In fig. 7.2, he worked to draw the likeness of Jean-Paul Sartre. The lines show the struggle and the search. Part of his coming back into the drawing over and over was his search for the location of his subject in the drawing and his quest for truth.

At one point in his career, Alberto Giacometti and his brother Diego were designing vases, lamps, chairs, and tables for a fashionable Paris decorator. Alberto realized that he was working on the vases in the same way that he worked on his sculpture. Feeling that he had to separate the two pursuits, he returned to the studio expecting that he would work from life for a couple of weeks. During this time, he produced paintings like *Annette Seated in The Studio* (fig. 7.4) and a sculpture on one human form no larger than a pin: he had reduced it to the ultimate minimum. He was to work all day for the next five years without returning to the designer's studio and without noticing the amount of time that passed. During this time, he worked on sculptures of five human heads that in the end were the size of a pin.

As Giacometti drew, changing, adding, or subtracting, each step of the drawing, painting, or sculpture became a study for a new or future artwork. He moved from drawing to painting to sculpture without really separating them. The uneven, rough, heavily worked surfaces of his paintings, sculptures, and drawings bear witness to the artist's struggle with his vision.

Giacometti's art recalls the Egyptian figure, standing stiffly looking off to the distance. The whole of his work is elevated into the sublime, where time ceases to exist. *Annette Seated in The Studio* (fig. 7.4) is just such an Egyptian figure. She sits stiffly alone, surrounded by an immense studio dwarfing her.

Giacometti less than making a psychological interpretation of the individual. It is not the individuality, but the universality of the human being that he sought. Some have said that his figures seem lonely, even alienated. The severity of their appearance is a result of the intensity with which he worked his materials to reach the visual representation he saw.

He worked and reworked both paper and clay until feeling that the piece could go no further he stopped, hoping to achieve his goal in the next piece. Nothing was ever finished for him.

Giacometti has been described as an "existential" artist because of his unrelenting singleness of purpose, both in his life and in his work. In his work, he felt the fundamental contradiction arising from the hopeless discrepancy between conception and realization, both necessary components in all artistic creation. You may well experience such frustration in your drawings. You will have a vision, and you will begin working on it, only to find in the end that "your drawing is not the vision you had." There are invisible

LEARNING TO SEE SPACE

The amount of time you are willing to spend on a drawing along with your openness to making a number of changes directly controls the quality of

FIGURE 7.5
Ron Graff, *Box, Steamer, and Shell*,
(2001), charcoal on paper, 24 in. × 26 in.
Courtesy of the Artist.

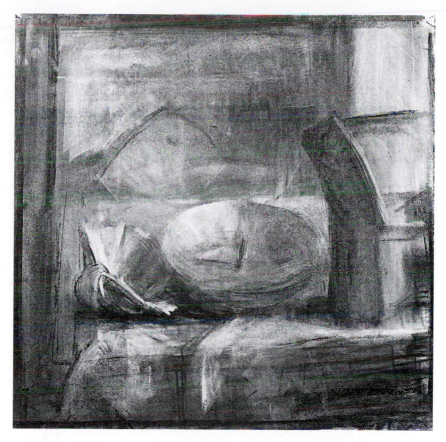

the drawing you will be able to produce. In both Graff's *Box, Steamer and Shell* drawing fig. 7.5 and Giacometti's, still life, fig. 7.6 you see the artists' close examination of the space and all the relationships involved in that space.

In Ron Graff's drawing *Box, Steamer, and Shell* (fig. 7.5) the absence of outline and hard edges al-

ters your perception of the space in the drawing. The close values and predominance of gray makes it difficult to calculate the depth of the space. The space is pushed forward to the front of the picture plane. A haze seems to lie between you and the objects. The atmospheric fog and diffused light keep us from seeing this space clearly. The drapery, under

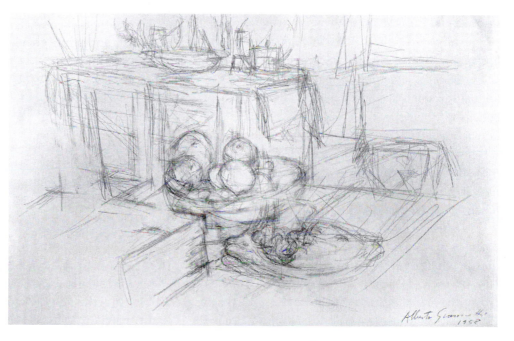

FIGURE 7.6
Alberto Giacometti, Swiss,
(1901–1966), *Still-Life*,
(1958). The Thaw Collection, The Pierpont Morgan
Library/Art Resource, New
York, NY, © 2007 Artists
Rights Society (ARS), New
York/ ADAGP, Paris.
SO156457.

the steamer and the shell, is mysterious. The left side reflects a table underneath, but the right corner is flat; there is no table underneath it.

Graff never accepts his first attempt at a drawing. The traces of Graff's many attempts to construct this drawing are evident starting with the front right corner, where ambiguous lines protrude under the top layer of value changes. He draws and then wipes off, draws again, and wipes off, and so on—for hours. He often wipes away all the work he does in a day because he doesn't feel that it was successful. This reworking a drawing for hours is what you should expect to do to make a quality drawing.

Alberto Giacometti's *Still Life* (fig. 7.6) was drawn with his loose organizational gesture lines that establish the relationship of the fruit bowl to the space surrounding it. He has made a careful examination of each plane in the picture plane, considering where one plane intersects another. This loose line process enabled Giacometti to check each relationship in his drawing.

DRAWING EXERCISE 7.1
Drawing a Spatial Analysis

To develop a better understanding of an interior space, set up a still life, using three objects of three different heights. Select a spot where you can sit to draw the still life and the space of the room around it. Hold your head in one position, keeping it level and at the same angle through the entire drawing. Draw only what you can see from where you are standing or sitting. If you move your head, the perspective of the drawing and all the relationships change.

Start with an object in the front of your view, and lightly draw its shape. From this first object, draw lines across the paper. Draw with a light gesture line to establish the location of the first forms. Avoid making a hard outline; use an unconnected line. Keep the line loose in defining the forms. Draw diagonal, horizontal, and vertical lines, from the base of your still life objects out into the room. Notice where the other objects in the room intersect those lines. Mark off on these lines where the forms behind the still life intersect them.

The lines in your drawing are to measure the distance, the size, and the location of all the forms and objects to be placed in your picture plane. These first lines have nothing to do with the outline of the objects and the forms. The first lines crisscross the surface of the paper horizontally and vertically, seeking to establish the location,

height, and width of the objects in the room. For example, where is the ceiling in comparison with the location of the still life objects? Can you see a wall, window, or chair in the space of the room, behind one of the still life objects? Your loose gesture lines establish the comparative location of all objects in the room in terms of their relationship to the still life objects. The forms in your space should be overlapping.

Draw a vertical line from the tabletop to the floor. From the bottom of the table leg, draw a diagonal line to the front edge of the picture plane to establish the floor plane. Let the lines wrap around the forms, crossing the planes on the forms, as a way to help you draw the space. If the lines become confusing, use your kneaded eraser and lightly remove some lines.

POSITIVE AND NEGATIVE SPACE

The balance of positive and negative spaces is crucial to composition. In David Park's drawing *Four o'clock in the Afternoon* (fig. 7.7), the negative spaces are the black and gray bodies of the figures. Generally a figure would be a positive space, and the space between it and the other figures would be a negative space or inner space. In Park's drawing, the figures are tightly packed together with no space between them. The white heads stand out from the field of gray and black. Park reverses his direction in the background where gray negative space surrounds the white figures. The floor plane on the left in a black-and-white checkerboard serves as a negative space under the white figures. Park's drawing is so well balanced between the black and the white areas that it borders on being an ambiguous space. At that point, your eye becomes unsure of what is foreground and what is background.

In addition, identifying and seeing the positive spaces is easier than seeing the negative spaces. Positive spaces translate to positive shapes. They are the "nouns" of the composition. They stand out like the faces in Park's drawing. You look at the drawing, starting with the large head on the right and moving through a diagonal of smaller heads to the back of the drawing. The heads look to the right, to the left, and occasionally straight at the viewer. It is the negative space of the figures' suits and sweaters that provides a visual gap that sepa-

FIGURE 7.7
David Park, (1911–1960), *Four O'Clock in the Afternoon,* (1953), collage with colored and India ink mounted on brown Kraft paper, 81½ in. × 91 in., (207 mm. × 231 mm.). Estate of Olive C. Frieseke, Jr. Iris & B. Gerald Cantor Center of Visual Arts at Stanford University. 1965.128.

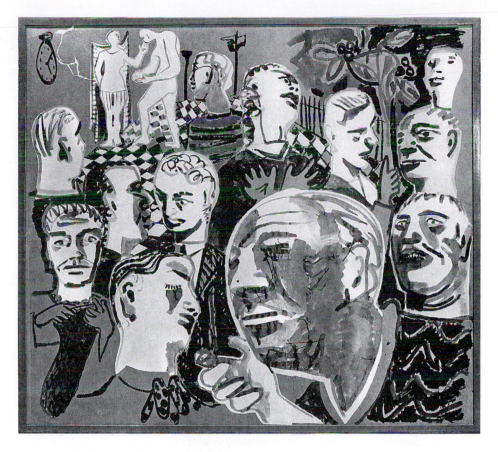

rates the positive spaces of the white heads, allowing you to see each one individually.

Park has manipulated the scale of this drawing by using overlapping shapes to create a sense of deep space. The large head in the foreground seems to press forward, moving away from the group, insinuating that there is more space between the two heads than he has drawn. The sense of space in the drawing results from the reduced size of each overlapping shape. Park has flattened the images to the picture plane and at the same time alluded to the presence of a deep space in the drawing.

Jennifer Borg's drawing (fig. 7.8) is of negative space. The space in between the table legs and chair rungs was drawn, leaving the positive area of the chairs and stools as the white of the paper. The negative space becomes negative shapes. At first glance, the drawing seems flat until you look more closely at the diagonal seats on the chairs. This diagonal turns your view back into the picture plane, and you sense a shallow space.

Negative space is the inner space, or that space between the signs and symbols in a drawing,

FIGURE 7.8
Jennifer Borg, *Negative Space Drawing,* (1999), Conté, student drawing.

FIGURE 7.9
Carroll Dunham, (1949—), *Untitled, (5/18/99)*, (1999),
ink and wash on paper, 24 in. × 32 in., (61.0 cm. ×
81.3 cm.). Purchase, with funds from the Drawing
Committee. Collection of the Whitney Museum of
American Art, New York, NY. 2000.255.

such as in Carroll Dunham's, *Untitled 5/18/99* (fig. 7.9). Over the years Dunham has developed a personal set of linear marks, signs, and symbols and then joined them with cartoon drawings, creating a new approach to drawing. Here the *Shootist*, an earlier drawing, is reused within an abstract composition. Dunham has synthesized abstraction with representation. Negative space provides the balance to the positive objects in the drawing, keeping the composition open to the viewer's reading. Because it was reproduced in black and white, you can't see that the bar on the left is a black to white gradation beside a color bar of both primary and secondary colors, somewhat like what TVs and computers use for color balance. There is something odd about the left edge of this drawing; after close examination it seems to be the barrel of a gun from the top edge down to the color bars, which could be covering the pump on a shotgun. The handle is hidden at the bottom behind a cream covered square. The drawing is more aggressive than passive.

DRAWING EXERCISE 7.2
Negative Space

The subject of this drawing exercise is a stack of chairs, stools, ladders, and tables. Carefully build a tall pile of this furniture, leaving space between each piece. Frame the picture plane by drawing a one-inch border on your paper.

Hold a piece of black Conté between your thumb, forefinger, and middle finger, so that you can twist and turn it. Conté can be used on its side to create the shape as well as on its end to outline the space. Start with the spaces at the bottom of the pile, draw the space between the legs of the table, leaving the positive space of legs. Draw in between the rungs of the ladder and the chairs—to virtually draw the air. Fill these spaces in with black as you draw them. Darkening the space as you draw will help you keep track of your location in the drawing. Resist the temptation to draw a positive outline of any object.

The drawing may not be completely accurate—you may miss a shape or get out of proportion. Such a possibility is to be expected. This exercise is about learning to see, not about accurately proportioning the space.

Filled the paper top to bottom, side to side. Concentrating on the negative spaces is an entirely different drawing experience that trains your eyes to see both negative space and positive space.

American Primitives, They Say Water Represents the Subconscious in Dreams (fig. 7.10) by Kara Walker manipulates the viewer's sense of positive and negative space. The riverboat floats as if on a river of dreams. There is no horizon, no separation of the foreground and background. The Riverboat's windows are negative spaces darkened against the white boat. The figures are black silhouettes cut out and pasted over the painted ground. At a distance, the black figures can read as a negative space, but that is contradicted by the fact that they are not a dark inner space but are human beings. The figure is a positive space, a volume, that is rarely a negative space. Kara Walker is reworking the clichés associated with the South before and after the Civil

FIGURE 7.10
Kara Walker, *They Say Water Represents the Subconscious in Dreams,* (2001), mixed media and paper on board, 8 in. × 11 in. Courtesy of Sikkema Jenkins, Inc., New York, NY.

War. The boy wears oversized boots and the girl has the petite feet of a plantation owner's child. Seemingly, a young African-American boy and a white southern belle romp across the front of the boat while a silhouette of a slave hangs upside down in front of them or perhaps behind them. It is impossible to say for sure. It is no accident that a long flagpole, or the pole used to move the boat off a sand bar, projects from the front of the boat directly into the silhouette of the slave as if hanging her out there. Walker generally confronts and confounds the viewers of her work.

FIGURE-GROUND RELATIONSHIPS

The placement of the objects in a drawing determines the figure-ground relationship. In addition, the placement of each object affects that of the others. Beginning students tend to concentrate on the object itself, more than on where it should be placed in the picture plane. The integration of the object into the space around it is crucial in achiev-ing a balanced drawing. The relationship between the object and the space depends on line, value, texture, point of view, perspective, and especially scale. Diebenkorn's *Still Life/Cigarette Butts* (fig. 7.11) was drawn from his viewpoint above the table. The drawing was balanced with high contrast in the large white shapes against the black ground. At the same time, other areas were created with subtle relationships of black on black or white on white. The shape and value changes balance the space, creating seamless figure-ground relationships. The objects flow across the table. The scale of each object balanced with the others—in terms of the amount of space each one occupies. The positive and the negative spaces are perfectly balanced neither taking priority over the other.

PLACEMENT IN THE PICTURE PLANE

The placement of objects in the picture plane has no hard-and-fast rules. Compositional tradition, however, warns against placing the main event in

FIGURE 7.11
Richard Diebenkorn, American, (1922–1993), *Still Life/Cigarette Butts and Glasses,* (1967). Ink, conté crayon, charcoal, and ball-point pen on wove paper, 13¹⁵⁄₁₆ in. × 16¾ in., (35.6 cm. × 43.2 cm.). Photograph © 2005 Board of Trustees, National Gallery of Art, Washington, D.C. © Artemis Greenberg Van Doren Gallery for the Estate of Richard Diebenkorn. 1990.101.1.

the center, but it is up to the artist to direct the placement of the subjects, depending on the purpose of the drawing. The picture plane may serve to create the illusion of three dimensions, or it can be treated as a flat surface. The tradition from the Renaissance forward was to use the picture plane like a window through which you look back into space.

The procession of the three figures in *Trieste Ledger Series (6)* (fig. 7.12) provides one part of a Kentridge production, the animation. They are all walking across the stage of the ledger. The space is shallow, with a baseline at their ankles separating the background and the foreground. The ledger sheet has been folded to create a ledge for the figures to walk upon. The ledger is an actual ledger of plantation accounts. A record from the years of apartheid which accounts for things like the cost of corn and hay and the low value placed on people's lives. The title, *Trieste,* is the name a provin-

cial city at the edge of the Austrian empire. Kentridge discovered it in reading Italo Svevo's, *Confessions of Zeno,* and was fascinated by the relationship of this town in 1920 that was so far away from the center of the real world to how it felt to be in Johannesburg in the 1980s. Kentridge found this book to be a beacon or a shared vision for his new work, which would incorporate theatrical performance, animation, and projection. He considers the figures to be actors and may draw them as part-puppet, part-costumed performers. His drawing style starts with a charcoal figure and then he rubs it out only to redraw it in the same space as the first drawing. Two things happen with this process; by layering the charcoal, he can get a darker black quality out of his vine charcoal, and he can get a certain gray only erasing creates. The horn on the right has light areas that are created by leaving erased charcoal. The erasing and rubbing brings the figures into a closer relationship with the ground. The woman's

FIGURE 7.12
William Kentridge, *Trieste Ledger Series (6),* (2002), charcoal on book pages, 9⅞ in. × 15⅜ in., (25 cm. × 39 cm.). Courtesy of Marian Goodman Gallery, New York, NY. Inv. #8277 TL 11.

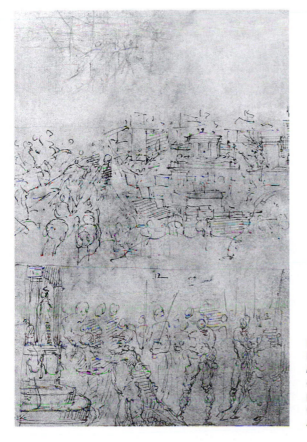

FIGURE 7.13
Domenico Beccafumi, Italian, (1486 (?)–1551), *Page from a Sketchbook,* verso, (1520's), pen and light brown ink, some figures redrawn in dark brown ink, 8⁹⁄₁₆ in. × 5¹³⁄₁₆ in., (21.8 cm. × 14.7 cm.). The Metropolitan Museum of Art, New York, NY. Robert Lehman Collection, (1975). Photograph, all rights reserved, The Metropolitan Museum of Art. 1975.1.272v.

legs on the left are reminiscent of the guard towers in South Africa during the apartheid years. The horn may also be a reminder of the bull horns used by the police, or perhaps the man carrying it is the messenger, and the man in a suit is like Kentridge's character, Soho, who was part of the old white ruling class.

The drawing *Page from a Sketchbook* (fig. 7.13), by Domenico Beccafumi, is a 16th Century pen-and-ink sketch that he made to plan the space of a future painting. This type of drawing calculates the relationships and scale of the figures for a future work. The top of the sketch shows one idea, and the bottom shows a second idea. Planning the composition in a thumbnail sketch can help you avoid the pitfalls of unbalanced compositions.

DRAWING EXERCISE 7.3
The Odd-Shaped Picture Plane

Take a sheet of white drawing paper, 18 × 24 inches, and rip it into different sizes and shapes. Set up a still life for a subject. Select one piece of ripped paper, and make a drawing from the still life. Consciously calculate which part of your still life might fit best on this shaped paper. Not having the traditional rectangle will force you to consider the space of the picture plane in relationship to your subject. Take the shape of the paper into consideration, and decide how best to utilize it.

Consider the placement, scale, and figure/ground relationships of the objects in the picture plane. Look at where the objects are sitting (in the foreground, middle ground, or background). You may want to lightly sketch your first thoughts in HB pencil, using light pressure on the pencil. You can rub these first lines into the paper with a scrap of newsprint and easily draw over them. Expand your study by taking a few pieces of ripped paper outdoors to draw the landscape.

FIGURE 7.15
Richard Tuttle, (1941–), *Sparrow,* (1965), from the book *Sparrow,* gouache and graphite on paper, 3³⁄₁₆ in. × 3⁵⁄₁₆ in., (8.1 cm. × 8.41 cm.). Purchase, with funds from the Wilfred P. and Rose J. Cohen Purchase Fund. Collection of the Whitney Museum of American Art, New York. 84.35.9.

SHAPE

Shape, in the pure sense, is a flat form, a contour, or an outline without volume or recognizable planes. Richard Tuttle's *Sparrow* (fig. 7.14) is one of nine drawings in the sparrow series made of gouache and graphite on paper. This drawing is the second in the sequence. In each drawing he reduces the shapes forming the circle by one until in the last drawing only one shape is drawn. In fig. 7.15 the image has been reduced to 3³⁄₁₆ × 3⁵⁄₁₆ inches from the original circle of 4¹⁄₈ × 4³⁄₁₆ inches. Shape or shapes have become the composition. Arshile Gorky, fig. 7.17 used organic shapes, whereas Ed Ruscha (fig. 7.16) and Josef Albers (fig. 7.18) used shapes that are geometric.

Motor (fig. 7.16) is a drawing made from gunpowder rubbed on paper. Ruscha made a model for this ribbon drawing that he constructed of cut paper, shaped, and held in place with straight pins. He then drew from the model. Ed Ruscha once remarked that he could contend with the reality of his

FIGURE 7.14
Richard Tuttle, (1941–), *Sparrow, (*1965), from the book *Sparrow,* gouache and graphite on paper, 4¹⁄₈ in × 4³⁄₁₆ in., (10.48 cm. × 10.64 cm.). Purchase with funds from the Wilfred P. and Rose J. Cohen Purchase Fund. Collection of the Whitney Museum of American Art, New York, NY. 84.35.5.

FIGURE 7.16
Ed Ruscha, American, (1937–), *Motor*, (1970), gunpowder and pastel on paper, sheet: 23 1/16 in. × 29 in., framed: 25⅝ in. × 31⅜ in., (65.1 cm. × 80.2 cm.) (58.6 cm. × 73.7 cm.). Purchase, with funds from The Lauder Foundation. Drawing Fund. Collection of the Whitney Museum of American Art, New York, NY. 77.78.

subjects only in their original scale. He uses words because "words are the only things that do not have a recognizable size, so I can operate in that world of 'no size.'" The size of this drawing is 23 × 29 inches relatively close to your 18 × 20 in. drawing pads. The planes and surfaces in *Motor* are defined by the subtle use of tone. Darkened tonal values create shadows, and the transition between light and dark insinuates a line. The darkened center of the letter "O" shifts the spatial depth to inside the picture plane. The drawing is ambiguous in terms of its lo-

cation. Is it a still life on a table top, a landscape, or a billboard?

Arshile Gorky drew from nature and from the memory of his father's garden in Armenia. The drawing *Untitled* (fig. 7.17) was constructed using overlapping organic forms. The repetition of the elliptical shapes creates balance and rhythm; the forms seem to move around the paper. In this open composition, there are many things happening at once. In this open system, the forms flow off the borders of the paper, unrestricted by the edge.

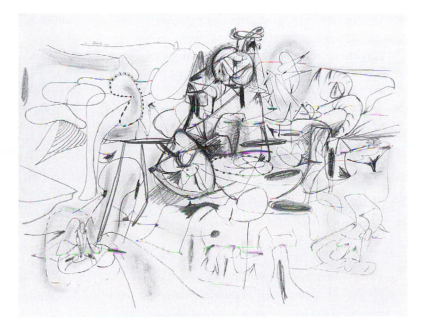

FIGURE 7.17
Arshile Gorky, American, b. Khorkom, Armenia, (1904–1948), *Untitled*, (1944), pencil and crayon on paper, 23 in. × 29 1/8 in., (58.4 cm. 3 73.9 om.). © 2007 Estate of Arshile Gorky/Artists Rights Society (ARS), New York, NY.

FIGURE 7.18
Josef Albers, (1888–1976), *Reverse + Obverse,* (1962), ink on paper, 22½ in. × 14 in., (57.2 cm. × 35.6 cm.). Gift of the Ford Foundation Purchase Program. Photograph: Geoffrey Clements. Collection of the Whitney Museum of American Art, New York, NY. © 2007 The Josef and Ann Albers Foundation/Artists Rights Society (ARS)/New York, NY. 63.13.

Josef Albers's drawing *Reverse + Obverse* (fig. 7.18) is a closed composition. The geometric forms remain stationary in the picture plane. Although they create an optical illusion, they create one that always leads back into the drawing, never out of the picture plane.

DRAWING EXERCISE 7.4
Shapes

This drawing exercise is a study of the function of shapes in terms of value, size, and scale changes.

1. *Select the shape of a fruit or vegetable. Draw a simple contour of it on your paper, and darken it in. Using the same shape, place a second and a third shape on the paper. Consider size, scale, and place-*

ment in arranging your shapes. Did you create harmonious balance or tension?

2. *Select the shape of a bird, an insect, or an animal. Draw the contour on one edge of your paper, working from side to side, draw the image first upright and then draw it reversed. The amount of space you leave between the images will affect the way you perceive the final arrangement. You may place the forms so that they frame the space between them. Or you may bring the forms together with no space between them, and let the tip of the wings or other body parts connect.*

ABSTRACT SHAPES

Jean Arp's collage *In Memory of 1929* (fig. 7.19) is very refined with delicate washes and gently tapered cutouts. Arp composed the collage "according to the laws of chance." When you use chance operations, you do not design or directly lay out the composition. The artist's hand and conscious control is replaced by a process. Arp placed the black shapes on the ground by dropping them down on the surface. Most likely he placed them where they landed on the paper. Unfortunately, we do not know the exact definition of his process or from what heigh the dropped the shapes, but Arp designed it so that the forms found their own location.

Arp's placement, even if by chance, moves the eye across the surface. You are uncertain as to the artist's point of view. Are you looking down on shapes as you stand above them? Or are you looking at shapes floating on a surface far way? If you think about it in another way, you could be looking directly at pollywogs swimming by in a glass aquarium.

Jean Arp was attracted to biomorphic forms, that is, organic forms, such as leaves, trees, roots, and torsos. For this collage, the shapes were trimmed and cut into rounded shapes of paper. These flat, black shapes sit on a ground that was first worked with both pencil lines and washes of varying intensity, some of which appear as shadows along the rocklike black paper cutouts. The black shapes are like rocks rising above the tide pools of uneven pale-pinkish white gouache.

This collage challenges your ability to read it, to determine the figure-ground relationship, to understand its meaning, or to simply locate the forms

FIGURE 7.19
Jean Arp, French, (1886–1966), *In Memory of 1929: Collage Arranged according to the Laws of Chance,* (1955), collage with pencil and pinkish white gouache on blue-gray laid paper with black cutouts, 312 mm. × 455 mm. Bequest of Dr. and Mrs. Harold C. Torbert. Iris and B. Gerald Cantor Center for Visual Arts at Stanford University. © 2007 Artists Rights Society (ARS), New York, NY. 1984.502.

in the picture plane. By arranging the pieces automatically, without imposing his will and according to the laws of chance, Arp felt that he was creating life. By following the laws of chance, he was following the same laws from which all life arises.

Max Ernst, a surrealist artist, designed a chance process in which he dropped forms from a certain height above the surface, and the place where they landed is where they stayed. His second chance process involved a can with a hole in the bottom, suspended on a string, and filled with ink that he let swing like a pendulum across a canvas on the floor under it. Whatever amount of ink came out and wherever it landed completed the composition.

AMBIGUOUS SPACE

Space that has no strictly defined figure-ground relationship, is considered **ambiguous space.** In an ambiguous space drawing, the space of the background and the space of the foreground interchange. The figure and the ground move back and forth between each other. As a result, it is difficult to decide what is positive space and what is negative space. This is ambiguous space.

Willem de Kooning virtually invented ambiguous space in drawing. In his drawing *Composition–Attic Series* (fig. 7.20), the lines glide across the surface, expanding and contracting

FIGURE 7.20
Willem de Kooning, (1904–1997), *Composition Attic Series,* (1950–1951). ink on paper, 75 cm. × 90 cm., Washington Art Consortium. Virginia Wright Fund. Photograph: Paul Brower. © 2007 Willem de Kooning Foundation/Artists Rights Society (ARS), New York, NY. 76.1 VWF.

without defining any forms, glancing off the edges of the objects. There are no specific contours and no closure. It is an open composition. The only forms you can place in the space of the drawing are a window in the upper right-hand corner, and the ladder in the lower right. The window orients the spectator that this could be an interior space by indicating that there is a back wall with a window, but you cannot traverse through the space. The foreground and the illusionistic background shift. The line constantly changes, preventing you from ordering the forms. His lines that were created with a long, thin hair brush allude to planes in the space, but without closure they remain undefined. Areas of the drawing push forward, and areas pull back, into the flat ground at the same time. Without closed forms in a fixed figure-ground relationship, the drawing becomes ambiguous. Arshile Gorky was de Kooning's mentor. In fig. 7.17 *Untitled* you see Gorky leading in developing the ambiguous space of drawing.

DRAWING EXERCISE 7.5
Continuous Line

Your drawing tool should be a black Sharpie marker or a flowing pen. Select an interior room to draw. Do not outline any form in the room, but start your line on an object, drawing any shape on the surface or any contour as long as the contour lines do not connect. Keeping the pen on the paper, draw a line to the next object in the room, and very briefly select a few lines to indicate its presence. Lift the drawing tool, moving to another form, or draw a diagonal line to the next form in the room. Shift from the tip of the sharpie to the side to change the thickness of the line. Let the lines representing the objects overlap. Draw a second drawing of the same space—this time with a brush dipped in ink. Reduce the number of lines in the first drawing.

Place tracing paper over your first drawing, and using a Sharpie, trace only the lines you think to be most essential. Repeat the tracing paper drawing on your second drawing. Now compare all four drawings. Determine which drawing you find to be the most ambiguous.

AMBIGUOUS RELATIONSHIPS

Robert Rauschenberg's drawing *Untitled* (fig. 7.21) is a combine drawing. This drawing redefines your previous understanding of positive and negative space, as well as the possibilities of figure-ground relationships. Gravity seems absent. His ordering devices are rhythm and repetition. One organizing element is the shape of the V. At the top of the drawing, two black legs or trees begin to shape a V. This V is repeated in a piece of architecture, the ram's horns, the deer's horns, and the gate for the fence. There are directionals in the drawing, images intended to guide your eye: the arrow on the bottle cap points up, whereas the column below it points down. The compositional device of repetition is evident in the fence in the middle of the drawing as it mirrors the columns of the building on the left.

An especially confusing rubbing is the one farthest to the right. At first glance it appears to be black, white, and gray forms. A closer look reveals that it is a man and a woman walking. They have been placed sideways adding to your visual confusion. The amounts of black, white, and gray are equal in this photo and without a border; the open sides allow the eye to flip back and forth, you are unable at first to distinguish the figures from the ground.

Rauschenberg has redefined not only space but also drawing. None of the images were drawn by him; they were found, manipulated, and transferred by him. Rauschenberg's rubbings are taken from newsprint or magazine photos soaked with lighter fluid. When the image is placed face down on paper and then rubbed across the back, the image transfers off the photo onto the paper. But this process reverses the images, positioning them backwards in the drawing. Rauschenberg's drawing space does not imitate real space. Instead, it is a space in which these real-world fragments have fallen into a loose organization. The logic of the drawing may escape you, since Rauschenberg works without logic; instead, the drawing reflects his will, intention, memory, attention, and associations. The meaning is what you get, what you take from this experience.

In the 1980s Carroll Dunham developed a fluid gesture and iconography of shapes and signs with bristling, hairy protrusions often suggesting teeth and lips. Dunham's #8 (fig. 7.22) from 1988 is just such a fluid gesture. This invented shape challenges you to define it. This drawing is a result of his independence from the prevailing stylistic norms of the 80s, and his idiosyncratic combination of biomorphism, cartooning, and

FIGURE 7.21
Robert Rauschenberg,
(1925–), *Untitled,* (1965),
combine drawing on paper,
39.4 cm. × 57.8 cm. Wash-
ington Consortium. Virginia
Wright Fund. Photography:
Paul Brower. Art © Robert
Rauschenberg/Licensed by
VAGA, New York, NY. 76.10.

abstraction expanded the vocabulary of Ameri-
can drawing. He has played a pivotal role in
synthesizing abstraction and representation. His
career parallels that of Rauschenberg, but only in
time not in purpose or direction. The two are as
different as night and day and yet equally impor-
tant in the development of new directions in
drawing. His influences, like Rauschenberg's
were the Abstract Expressionists, the Surrealists,
and modernism. While Rauschenberg dug
through the garbage cans of American culture
finding photos to combine, Dunham looked at
Minimalism, Mayan art, and then pop culture.
Dunham is unique and that is perhaps a result
of the range of artists he admired. There are
70 degrees of difference between the work of
Hieronymus Bosch and that of Brice Marden
or Robert Ryman, but those are the artists he
looked at. His line swells or narrows, gracefully
and simply.

FIGURE 7.22
Carroll Dunham, (1949–), *#8*
(1988), graphite, wax crayon,
and carbon on paper, 27¹⁵⁄₁₆
in. × 41⁷⁄₁₆ in. (70.96 cm. ×
105.25 cm.). Purchase, with
funds from the Drawing Com-
mittee in memory of Victor W.
Ganz. Photo by Geoffrey
Clements. Collection of the
Whitney Museum of American
Art, New York, NY. 89.2.

DRAWING EXERCISE 7.6
Photo Transfer Drawings

Using Citra-Solv, an organic cleaning product, you can make newspaper transfers onto rag paper. BFK by Arches or Arches 88 are both work well. A bristol board will work, but not as well. Brush the concentrated Citra-Solv on the surface of a color photo from the newspaper, lay it facedown on your paper, and rub the back with a pencil, a stick, or a credit card. Rub firmly but not so hard as to rip the paper. A picture can be used twice, and you may want to put the actual rubbed photo in your composition. Pastels can be rubbed into the transferred images, and you can also use watercolors. Magazine photos will not transfer with Citra-Solv. Practice the process first, and then select images for a composition in which you will combine rubbings, rubbed chalk into black and white photos, text, the rubbed photo itself, and some drawing of your own.

CONTEMPORARY COMPOSITION

Planning a drawing requires thinking about the entire picture plane. Robert Rauschenberg developed his technique of "combine" drawing between 1951 and 1953. The combine *Drawings for Dante's 700 Birthday, IIB* (fig. 7.23) is integrated with gestural strokes and blotches of paint with mass produced elements such as newspaper, photographs, and common objects. In other combines, his objects ranged from more three dimensional objects such as clocks, stuffed birds, ladders, and fans. *In Drawings for Dante's 700 Birthday, IIB,* some of his appropriated images have been applied with the technique of solvent transfers. The order of this work is seemingly random. No attempt was made on his part to organize the composition through any traditional system of design, nor was it arranged by "chance." The drawing is arranged in rows, based on a formal grid and yet not perfect rows and that providing Rauschenberg a loose compositional order with in which he places his chosen images. This chaotic work employs violent images to illustrate the dangerous aspects of technological and industrial development in the twentieth century. The images range from John F. Kennedy's Cadillac in the crosshairs of a rifle scope through the Ku Klux Klan cross-burnings that overlap images of Adolf Hilter and Nazi concentration camps with mushroom clouds. Rauschenberg appropriated these images for their formal qualities as well as for their references. For him

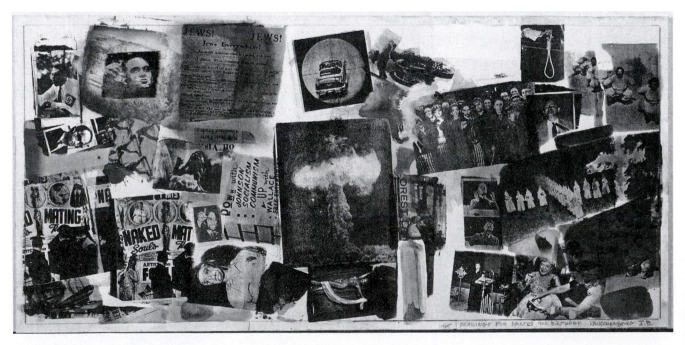

FIGURE 7.23
Robert Rauschenberg, (1925–), *Drawings for Dante's 700 Birthday, #1,* (1965), graphite, watercolor, and gouache over photolithograph paperboard, 15 in. × 31 7/16 in., (382 mm. × 800 mm.). Gift of the Woodward Foundation, Washington, D.C. Art © Robert Rauschenberg/lLicensed by VAGA, New York, NY. © Board of Trustees, The National Gallery of Art, Washington, D.C. 1976.56.193. (B-28927.)

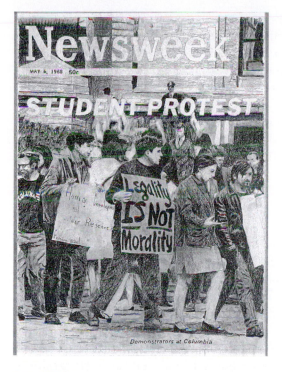

FIGURE 7.24
Samuel Durant, (1960–), *Legality is not Morality (index),* (2004), graphite on paper, 29½ in. × 22 in., (74.9 cm. × 55.9 cm.). Purchase, with funds from the Painting and Sculpture Committee. Collection of the Whitney Museum of American Art, New York, NY. 2004.44.

they suggest the dissociated consciousness of a modern urban dweller.

The external world can provide the basis for our imagination to interpret our experience into art at which point drawing is more than technique.

THE CONTEMPORARY APPLICATION OF RHYTHM AND REPETITION

Rhythm may be thought of as the repetition of similarly directed movements in lines, shapes, or volumetric forms. In Durant's drawing you read the overlapping figures in motion as a form of rhythm. They are walking through the picture frame, moving in and off the edge of the drawing. These figures are volumetric forms in motion.

Samuel Durant's, *Legality is not Morality (index)* (fig. 7.24) investigates the political activism of the 1960s and 1970s in order to consider its relevance for contemporary culture. This photo-realistic drawing in graphite depicts the 1968 multipurpose uprising that protested Columbia University's ties to the Pentagon and its real estate expansion into Harlem, while also calling for the university to grant amnesty to student activists who had participated in previous campus demonstrations; thus the title, "Legality is not Morality." In this drawing Durant is not promoting the idealism of a previous generation or longing for a return to those times nor making a political statement. Instead his drawing looks critically at nostalgic constructions of a romanticized past. His drawings examine little-known or misrepresented histories in order to better understand contemporary situations.

The repetition and recurrence of similar lines in Cy Twombly's drawing, *Untitled,* (fig. 7.25)

FIGURE 7.25
Cy Twombly, (1929–), *Untitled,* (1971), chalk and gouache, 70 cm. × 99.5 cm. Works for Paper: 1945–1975. University of Washington, Seattle, Museum of Art, Virginia Wright Fund. © Cy Twombly/Artists Rights Society (ARS), New York, NY. 75.12.

creates rhythm. The lines create a discernible pattern in a high-contrast figure-ground relationship that is enhanced by the density of these diagonal lines. The lines returning from the bottom and crossing the falling diagonals add an additional element of texture to the drawing. The consecutively flowing lines are balanced by the interval between them, creating a sense of unity and an overall composition.

In Twombly's drawing the rules of composition have been dramatically altered. Twombly has made many changes to the space of the picture plane. The picture plane is now flat. There are no objects distributed in the space, and depth has been abandoned, but possibilities of space have increased. Value and modeling have been exchanged for a textured surface.

The diagonal lines, loosely drawn, create motion and a resulting rhythm. The lines continue to bounce around the drawing, pushing forward only to slide back. The use of overlapping lines creates space but not depth. It is an ambiguous space without a horizon or a baseline. In this abstract drawing Cy Twombly challenges the notion of 'style,' disrupting and questioning conventional thinking about drawing and representation. In so doing he creates a new direction and model of drawing.

Willem de Kooning's drawing, *Untitled* (fig. 7.26) is composed in rhythmic lines. De Kooning was the master at drawing loose, free lines like these that circle the breasts and bounce out to create mis-shapened arms. The thick to thin line allows one shape to flow into another. De Kooning's shifting line creates movement in the drawing. Without hard and fast contour lines engulfing the figure, it seems more active and even in motion within the ground. The traces left in the background are from de Kooning rubbing and erasing previous lines.

BALANCE IN COMPOSITION

When a drawing is in balance, the eye is drawn through the composition effortlessly. Balance has two major categories, **symmetrical** and **asymmetrical.** There is also **radial** balance, but it is rarely used. *Blind Time* (Chapter 3, fig. 3.19) by Robert Morris is a radial balance.

Symmetrical balance is achieved by dividing the picture plane in half, either horizontally or vertically. The visual elements are then identical on either side of the dividing line. Rauschenberg's *Drawing for Dante's 700th Birthday* (see fig. 7.23) seems to be symmetrical. Both sides of center have the same visual weight. The linear elements have the same weight on both sides of center de Kooning's (fig. 7.26) making it symmetrical.

Asymmetrical compositions have more visual weight on one side or on the other. An example of

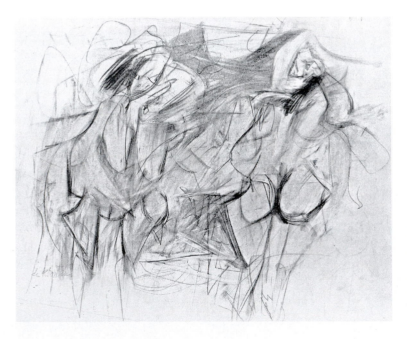

FIGURE 7.26
Willem de Kooning, (1904–1997), *Two Women III,* (1952), pastel, charcoal, and graphite pencils on paper, 14¾ in. × 18½ in. Allen Memorial Art Museum, Oberlin College, Ohio. Friends of Art Fund. © 2007 The Willem de Kooning Foundation/ Artists Rights Society (ARS), New York, NY. 1957.11.

FIGURE 7.27
Jean Antoine Watteau, French,
(1684–1721), *Study of a Nude Man
Holding Two Bottles*, (c. 1715–1716),
black, white, and red chalk, lined. A
strip of paper 3.3 cm. wide has been
added at right margin and the draw-
ing continued in the artist's hand,
10⅞ in. × 8⅞ in., (27.2 cm. × 22.6
cm.). The Metropolitan Museum of
Art, New York, NY. Bequest of Walter
C. Baker, (1971). 1972.118.238.

asymmetry is Antoine Watteau's drawing *Study of a Nude Man Holding Two Bottles* (fig. 7.27). Watteau has placed the figure on the right side of the picture plane. The paper has been ripped through the figure's left arm. It is possible that, in the first draft, the arm was off the paper, outside the picture plane. This arrangement may have felt compositionally unbalanced to Watteau. To change the balance, he added another piece of paper on the right to draw in the arm completely. Revision is a tool of drawing that allows the artist to change the balance of a drawing. Artists constantly rub out parts and move them over, leaving the traces of the first lines visible through the second lines. The addition of the arm and the other bottle completely changes the drawing.

DRAWING EXERCISE 7.7
Using Balance

Select a subject such as an apple, and set it on a table. Cut or rip one piece of 18 × 24 inch white drawing paper into fourths. Divide each of the four papers into quarters. This grid on the paper is to help you size the objects you will draw.

On the first paper, draw the contour of the apple, filling one-half of the paper horizontally. Take a 6B pencil, and hatch the entire shape with a dark value. On the second paper, draw two apples of the same size and value, side by side on either side of the center line. On the third paper, draw one apple in the bottom right-hand corner and one apple in the top left-hand corner. Cover one apple with a dark value, and leave the other one in the white of

the paper. On the fourth paper, draw two apples on the left side of the paper, each one approximately 3 × 3 inches. Darken the value of each outline.

Hang up all four drawings, and consider what happens to the balance in the space of the picture plane, depending on the value and location of the apples.

REVISING A DRAWING

Drawings can be planned out very carefully, but you can never anticipate everything. When a form looks wrong in the space, change it. Draw your first lines lightly, and leave them so that you can draw from them. With the first lines in place, it is easier to make changes and to move things. If the first lines seem in error or misplaced leave them on your drawing to guide your correction.

Jean-Auguste-Dominique Ingres in the drawing *Study of a Seated Nude Male* (fig. 7.28) was experimenting with the angle and location of the model's arms and legs. Drawing and redrawing the arm helped him to see the placement he preferred. He shifted the angle of the thigh, knee, and the leg into new positions. First he tried the hand behind the hip, and then he drew it resting on the thigh. The modeling on the side plane of the figure's chest along with the construction of the knees gives you an excellent insight into the complexities of creating the volume of the figure.

The student drawings in (fig. 7.29 and fig. 7.30), began with a drawn border on the paper to frame the picture plane. The shapes were mapped

FIGURE 7.28
Jean Auguste Dominique Ingres, French, (1780–1867), *Study of a Seated Nude Male,* black chalk, 29.2 cm. × 38 cm. The Metropolitan Museum of Art, New York, NY. Rogers Fund, (1961). 61.128.

FIGURE 7.29
Megan Brown, ink and wash, (1999), student drawing, Oregon
State University.

Changes in a drawing should be made during the drawing process as often as you need to. Drawing represents critical and visual thinking that changes all through the drawing. A drawing is a record of thinking, revising, and seeing. One of the great benefits of drawing is how quickly you can change it with the media. Even ink, if the first layers are diluted with water, can be covered with darker lines, changing the position of the objects in the drawing. Nothing should be too precious to change. The writer William Faulkner once said, "Throw away your darlings," meaning that if you are hanging on to some part of the composition, that part may be wreaking havoc with the rest of the composition. Your ability to draw improves the more you draw; and as your sense of proportion and scale improves, the way you see, will also change.

STRUCTURAL AND PLANAR CONSIDERATIONS IN COMPOSITION

Composition in a drawing depends on an overall consideration of the relationships among all the forms in the drawing in terms of their planar structure location in the picture plane, value changes on the planes.

Louis Lozowick's drawing *New York* (fig. 7.31) reshapes the bridges and skyscrapers into rhythmic patterns reflecting the energy of city life. This drawing was made from memory, from the artist's impression of the architecture, bridges, and streets of New York. The planes of the buildings rise in

out, and then overlapping ink washes were laid down to build up the values. A quick review of the first drawing (fig. 7.29) revealed that the skull did not fit in the picture. Megan Brown determined that the space felt crowded and unbalanced. She corrected these places by opening the space in the drawing (fig. 7.30). Notice she turned the paper to a horizontal format, feeling that there was not enough space in the vertical format. To make the drawing stronger, she increased the dark values in it.

FIGURE 7.30
Megan Brown, ink, (1999) student drawing, Oregon State
University.

FIGURE 7.31
Louis Lozowick, Russian, (1892–1973), *New York,* (c. 1923), carbon pencil on paper, 17$^{15}/_{16}$ in. × 12$^{1}/_{16}$ in., (45.6 cm. × 30.6 cm.). Purchase, with funds from The Richard and Dorothy Rodgers Fund. Collection of the Whitney Museum of American Art, New York, NY. 77.15.

vertical forms representing the city's towers. He introduces a range of light to dark tones to define the light, space, and depth in his composition. He structured this composition with repeated planes, circular forms in the ramps, and the overlapping buildings. He then increased the dramatic appearance of the city with high-contrast value changes. These compositional choices all create rhythm.

Your first analysis of your subject guides the structural dynamics and controls the compositional order of the drawing. Lozowick chose to keep the planes flat overlapping them and separating them with shadows. Whether you draw from observation or from memory, your expression is dependent on structural essentials, as well as the rhythmic relationships between them. Structure is a dominant consideration for artists like Cézanne who from the beginning searches for the subject's fundamental structural and spatial conditions. With a solid understanding of the mass of your subject, you have the essential element to interpret your subject. Avoid establishing fixed contours in the beginning, thinking that you can fill in the planes later. Envision the surface planes, contours, and rhythms at the beginning of the drawing.

FIGURE 7.32
Sabrina Benson, *Value Study by Plane*, (1999), student drawing, Oregon State University.

DRAWING EXERCISE 7.8
Planar Analysis and Memory

Color on objects can be confusing when plotting out a planar analysis. To avoid this confusion, select four or five objects — vases, pitchers, small boxes — and spray them completely white. When they are dry, arrange them on a table.

Examine each one first by drawing each object in a precise contour that you fit over an elliptical skeleton. Then divide the surface of each object by plane (fig. 7.32). Note that the bottle has a horizontal plane at the bottom of the neck. Plane lines are reflected in the outside contour line of any object.

Determine the direction of the light and assign values from light to dark on each plane and on the ground (fig. 7.33). When you change planes, change the value. There should be a vertical change in light as well as a horizontal change across the surface of the objects. The background and the foreground will also change in value. Consider the entire mass and relationship on one form to another, plus their relationship to the table and the walls. Remove the still life and draw the still life again, only this time from memory.

FIGURE 7.33
Debra Finch, *Study of the Planes of Cylinders*, (1999), student drawing, Oregon State University.

ORGANIZING A COMPOSITION WITH THE GRID

The grid is a compositional device to proportion the space of drawing. The grid provides a measuring system in which the proportions of the figures and objects can be correctly determined within the picture plane.

When the drawing paper is divided into equal increments an underlying visual order is created for the drawing. This geometric division can be used to transfer a drawing, either enlarging it or reducing it. In figure drawing, the head is used as the unit of measurement to determine the size of the figure. A standing figure is between seven-and-a-half to eight heads tall. A sitting figure measures only approximately six heads tall. Once you have drawn a grid, using the measurement of the head, you can mark off the area that your figure should fit into.

The grid for Jacques-Louis David was an organizing tool; he used it to locate and proportion the drawing *Study for the Figure of Crito* in *The Death of Socrates* (fig. 7.34). In David's formative study, the figure is rendered in a seamless manner. You are unaware of one part fitting into another. The drapery seems to be the focus, as you notice that the right arm and hand are undeveloped. David's use of value is dramatic. The drapery rolls off the top of the knee into dark grooves and then turns into grays across Crito's back.

For the Modernists, the grid became a standard format announcing the flatness of the picture plane. The grid provided a structure to arrange and present the subject matter of the work, as well as

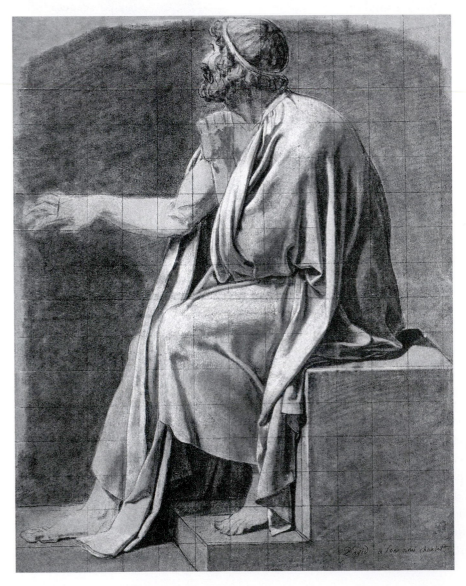

FIGURE 7.34
Jacques Louis David, French, (1748–1825), *Study for the figure of Citro* in *The Death of Socrates,* (c. 1787), black chalk, gray wash, heightened with white on brownish paper, squared off in black chalk, 31 1/16 in. × 16 5/16 in. The Metropolitan Museum of Art, New York, NY. Rogers Fund, (1961). 61.161.1.

FIGURE 7.35
Theresa Chong, (1979–), *P.E. #73, No. 1 and No. 2, V.2 and V.4,* (1999), woodcut drawing on Korean rice paper, 20½ in. × 23⅜ in., (52.07 cm. × 59.37 cm.). © 2000, Collection of the Whitney Museum of American Art, New York, NY. Purchase, with funds from the Drawing Committee. 2000.50.

an infrastructure for a series of repeated marks. In Contemporary Art the grid is used to flatten the picture plane instead of proportioning it.

The grid is a format in drawing that avoids the associations and problems of foreground and background. These compositional issues are dissolved. Theresa Chong's geometric field (fig. 7.35) is full of subtle movement from the irregularities in the lines composing the grid. The carved lines, fluctuate and the grid is shifted in the center where the lines no longer match up. Unless you look carefully you will not notice this shift. What seems symmetrical and minimal is actually a visual correlative to the feelings that nature elicits. Here, Theresa Chong (fig. 7.35) renders in concrete form what is inherently impossible to objectify—a clarity of vision and feeling from nature in a purely abstract rendering. Explaining this Agnes Martin wrote in her book *Writings*, "Works of art have successfully represented our response to reality from the beginning. Reality, the truth about life and the mystery of beauty are all the same . . . The manipulation of materials in artwork is a result of this state of mind. The artist works by awareness of their own state of mind."

Adolf Gottlieb's drawing *Structure* (fig. 7.36) was drawn intentionally flat to the picture plane. There is no background or middle ground. There

FIGURE 7.36
Adolph Gottlieb, (1903–1974), *Structure,* (1956), gouache on paper, 20.5 in. × 28.75 in. (52 cm. × 73 cm.). Art © Adolph and Esther Gottlieb Foundation/Licensed by VAGA, New York, NY. Photo: The Washington Art Consortium.

is only the drawing in the front of the picture plane, with parts of the drawing pushing out into the viewer's space. Look closely; there are black calligraphic marks in the center, on top of what seems to be a black outline of white shapes. Once you see the black marks, the front outline becomes a dark gray by comparison.

This is an open composition, in which the drawing continues beyond the edges of the paper. The drawing is contained neither by the size of the paper nor by the end of the paper. The lines lead your eyes off the edge.

DRAWING EXERCISE 7.9
Drawing in Layers

Cover a piece of drawing paper with white gesso, and let it dry. The gesso will protect the paper from ripping when you tape it off. Use vine and compressed charcoal to make a drawing from a landscape. Keep it simple and on the impressionistic side, drawing loosely defined forms. Rub and erase the charcoal. Before your next step you may choose to lightly spray-fix the surface to save the taped-off areas. Tape a grid over your drawing with masking tape, gently rubbing the tape to stick it on the surface. The units may be one, two, or three inches apart. Continue drawing on top of the tape and the first drawing. You may change scenes, draw the same scene larger or smaller, or even select another image to draw. Use the technique of rubbing and erasing to balance the drawing. When you feel finished, use lo-odor reworkable spray-fix on the drawing, and take the tape off. You may leave it, or you may continue to work areas, moving them in and out of the grid. You may retape, redraw, and spray-fix for another couple of layers.

PROFILE OF AN ARTIST: RICHARD DIEBENKORN (1922–1993)

Richard Diebenkorn was born in Portland, Oregon, in 1922. The family moved from Portland to San Francisco, where Richard grew up. His father, who was a sales executive for Dohrmann Hotel Supplies, brought home the slick, shiny-surfaced paper used by the company for shirt cardboards. The papers would become Richard's first drawing surfaces. He continued to draw on glossy-coated paper throughout his career, even though this kind of paper was seldom used for artists' drawings.

Diebenkorn began his art career under the influence of the French moderns (Paul Cézanne, Henri Matisse, and Pablo Picasso) and the New York School, later called the Abstract Expressionists. Diebenkorn's work was abstract until about 1955, when he suddenly shifted to representational work (fig. 7.37). This change from the abstract style of the avant garde—along with his refusal to leave California for New York—caused him to be ignored for many years by art critics and galleries. To be a West Coast artist was to be forgotten by the art world.

Diebenkorn changed from abstraction to realism because abstraction no longer challenged him. Realism, however, provided a visual challenge for him in which he could do more problem solving. He wanted his ideas to be altered by nature, changed by what he saw in the world. For him drawing was essentially an exercise in seeing. Drawing from life created resistance from his imagination. Confronting this resistance was the challenge he needed to continue working.

There seems to be tension beneath the calm in his work. He composes his drawing by ordering the shapes. Forms are overlapped by other forms to weld everything together. Each shape in the drawing is given consideration. Value is assigned and determined by the location of the shape in the ground. Most of his figures seem self-absorbed. They don't look at you—they look to the side or down.

There is a sense of multiplicity in the layers of his work. In *Woman by Window* (fig. 7.37), you enter the space with the gleaming white of her blouse. Your eye is immediately pulled to the dark back wall, then out the window, and finally pulled back to her skirt. The balance of gray, black, and white pushes you through the entire composition. He has balanced the drawing with light and dark. The scale of the drawing is established by having the figure occupy over three-quarters of the vertical in the picture plane. She is drawn overlapping the window frames behind her, indicating space. The absence of modeling in this drawing creates a flat or shallow space.

Diebenkorn's drawings record actual observations, quietly but intensely, without sentimentality. They embody discovery rather than arbitrary construction. His economy of pen, pencil, and mono-

FIGURE 7.37
Richard Diebenkorn, American, (1922–1993), *Woman by Window,* (1957), gouache on paper, 17 in. × 13⁷/₈ in., (43.1 cm. × 35.3 cm.). Hirshhorn Museum and Sculpture Garden, Smithsonian Institution, Washington, D.C. Gift of Joseph H. Hirshhorn, (1966).

chrome washes suggests the shape and character of matter. The precise use of the visual effects achieves a complexity of mood.

Diebenkorn is a master of rendering spatial relationships using the artist's tools, such as perspective, and **chiaroscuro.** Chiaroscuro you will remember is a word coined in the Renaissance that describes "light into dark," or value change. When we refer to **perspective,** we mean the process of translating three-dimensional space into two-dimensional space with the traditional technique of linear perspective. In Diebenkorn's work, the placement of the figure follows the rules of perspective, and the use of value changes moves the viewer's eyes through the drawn space, creating a sense of space and volume.

The artist has reworked the drawing *Seated Woman* (fig. 7.38), first starting, then changing his mind, rubbing the first charcoal lines out and

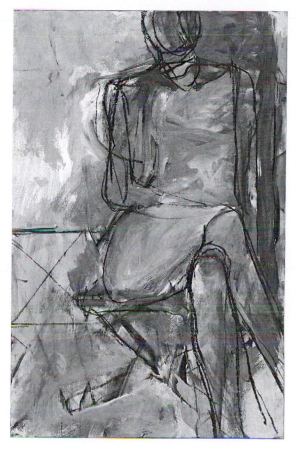

FIGURE 7.38
Richard Diebenkorn, (1922–1993), *Seated Woman,* (1966), synthetic polymer paint and charcoal on board, 31 in. × 19⁷/₈ in. Gift of the Artist, The Museum of Modern Art, New York, NY. Digital image © The Museum of Modern Art, licensed by SCALA/Art Resource, New York, NY. 253.1990.

COMPOSITION 175

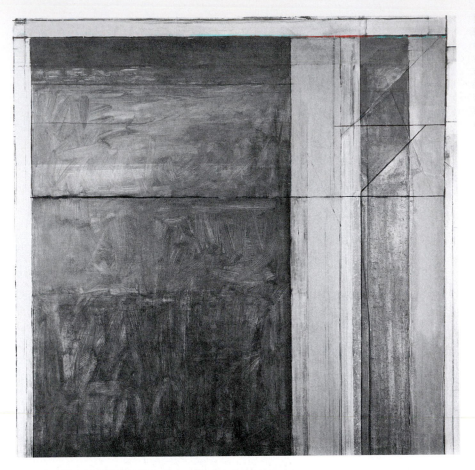

FIGURE 7.39
Richard Diebenkorn, American,
(1922–1993), *Ocean Park #111,*
(1978), oil and charcoal on canvas,
93⅛ in. × 93¼ in. Hirshhorn
Museum and Sculpture Garden,
Smithsonian Institution, Washing-
ton, D.C. Museum purchase,
(1979). HMSG 79.235.

redrawing the figure in the chair. In this drawing he has used acrylic white over the charcoal creating a rich gray. Beginning students should take heart and feel no sense of failure when the first lines drawn don't accurately describe the form. Redrawing instead of starting over is the way you learn and improve.

Diebenkorn's drawings are a record of move-ment in time, a network of recorded movements, and a direct record of the movement of his hand. He doesn't conceal that his drawing is a result of trial and error. He leaves the traces that allow you to fol-low his thought process. Drawing from external sources provided Diebenkorn with a knowledge that he converted to internal relationships that, once processed, are integral to his painting. Diebenkorn returned to abstraction around 1968 when he started the *Ocean Park Series* (fig. 7.39). He worked on this series through 1986, each painting advancing the geometric structure of the series.

Diebenkorn worked his entire career from a moral imperative of achieving "rightness" in his work—something that was impossible to define but that was recognizable when he had created it. Mil-ton Resnick once summed up this feeling of know-ing when your work is complete: "It feels like you feel when you come home." Both men were serious artists with a deeply rooted sense of ethics about their art.

1. What is the theme, purpose, or intent of your drawing? What do you want to express?
2. What elements, forms, or photos do you need to support the subject that you chose? Collect the images you need to work from.
3. How will you balance the composition? Is there a focal point? Is balance not an issue? Will you use chance or intuition to compose your work?
4. Choose your materials. Will you use color, black and white, a mixed media, or other materials?
5. Make a presketch of the arrangement you think may work, and then make adjustments to your composition.
6. Think of your subject as a series of drawings rather than as one to help you develop your idea. Make four to six drawings on one theme.

ART CRITIQUE •▶

Kiki Smith and William Kentridge

The *Pieta* drawings, one of which is shown in fig. 7.40, are self-portraits of Smith with her dead cat. She sits in the posture of the grieving Virgin Mary. Smith is attracted to archetypes of women who populate cultural mythology, from the Virgin Mary to Little Red Riding Hood. Not to be trapped in mythology, her figures extend beyond the cultural context of their day to encompass universal psyche, and physical pain becomes symbolic of the suffering endured by all humans. These drawings, relatively recent in Smith's work, further explore her earlier ideas about representing the human body. Her creations convey her devout belief in the intimate connection between humanity and the environment. She addresses both the balance and the imbalance between humans and the natural world. Basically a sculptor, Kiki Smith began exploring the possibilities of paper in the 1990s. In this large, life-size drawing, 57 × 31 inches, Smith not only works at a sculptural scale, but stacks the sheets of Nepalese Paper—a light, translucent, paper—one upon the other to build the drawing. In addition the choice of this paper makes a reference to the fragility and translucence of human skin. The ink drawing with the graphite layered on translucent paper takes on a ghostly appearance. We grieve with her. The drawing has embedded the sadness of losing a good friend through both appearance and process.

William Kentridge lives and works in South Africa, where he grew up under its Apartheid government. While apartheid has influenced the content of his work, it is the transformation of drawing into film that most distinguishes his new work. His drawings, made of rough-hewn charcoal or pastel, successively chronicle the rise and fall of a white Johannesburg magnate, Soho Eckstein. The process for the film is to make a drawing, photograph it with a 16 mm camera, erase parts, photograph it again so that the same drawing is used over and over one

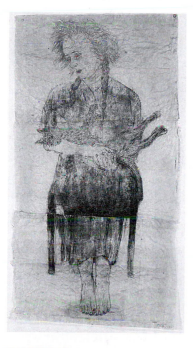

FIGURE 7.40
Kiki Smith, (1954–), *Pieta*, (1999), Ink and graphite on Nepalese paper, 57 in. × 31 in., (144.78 cm. × 78.74 cm.). Collection of the Whitney Museum of American Art, New York, NY. Purchase, with funds from the Drawing Committee. 2001.151.

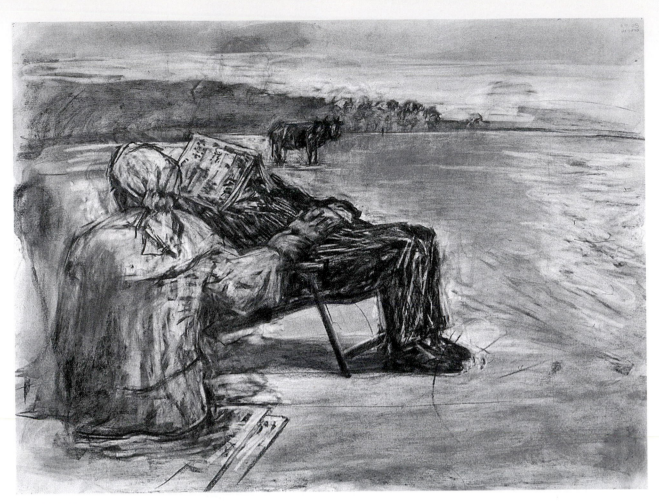

FIGURE 7.41
William Kentridge, drawing from *Tide Table: Soho Sleeping,* (2003), TT33, charcoal on paper, 48 in. ×
63 in., (121.92 cm. × 160.02 cm.). Courtesy: Marion Goodman Gallery, New York, NY. Inv. #9201.

frame at a time, evolving through hundreds of movements and moments, one frame at a time, as it is erased and redrawn. This technique of erasure engenders a time-based, open form of "process" drawing, a work in a constant condition of revision and becoming. The erasure leaves imperfect surfaces where traces of preceding stages can still be seen. These smudges and shadows reflect the way in which events are layered in life, how the past lingers in the mind and affects the present through memory. In his film, *Tide Table,* the drawing *Soho Sleeping* (fig. 7.41) appears. Kentridge drew a series of elements for *Tide Table,* that started to affect each other as he reviewed them. For Kentridge, each film is a series of possibilities, each drawing is waiting to see which drawing will be the center of the film and which drawings will stay at the edges. For *Tide Table,* he started by drawing the beach hotel with Soho on a balcony looking out over the beach. On

the floor below him three Generals stand looking at the beach through binoculars. Next we find Soho on the beach in his deckchair and the generals are no longer central. The deckchair life seems more important. Although with the end of apartheid Soho's life is now changed forever, we don't feel sorry for him in this drawing. Only the figure with her back to us feels sorry for him. The cast of characters that Kentridge will bring together in one journey for the film *Tide Table,* is a boy on the beach (a young Soho?), a choir, some cows, and a row of beach huts. This may be more about Soho and his young self. The film may be asking the question of our relation to our young selves—are we the same? is our young-self someone completely other whom one hopes not to meet? whom one is protective of or contemptuous of?

Both Smith and Kentridge are dealing with human suffering and pain. Their content is similar,

their process different. Smith's use of a thin paper and translucent wash transforms her medium into the a tragic statement of life's fragility. Kentridge's drawing is bold and rugged, as if under his paper, dressed in a suit on the beach, Soho hides from the landscape of his native land, himself, and the pain of apartheid. It seems hardly coincidental that Soho's chair is a lounge chair, Smith's a straight-back, forthright and erect.

JOURNAL FOCUS

To follow William Kentridge's example, select a subject, perhaps a man eating or a woman walking, and use charcoal to draw the subject.

Make the first drawing, and then using a disposable camera or a digital camera, if you have one, take one picture straight on of the drawing. Erase the hands or legs, and move their position in your drawing, and then take a second picture. Make another change, and take a picture of the new drawing.

A disposable camera has twenty-four shots, so you can get a series of drawings fairly well developed in these shots. Develop the film, or put it up on your computer, if it is digital, and check your sequence. Do your figures act or move?

THE PORTRAIT, THE FIGURE, AND DRAPERY

THE PORTRAIT

The **portrait,** or likeness of the human face, has been drawn, painted, or sculpted by artists from earliest times. The Egyptians drew and painted the likeness of both human figures and human faces. Stone sculptures from Mesopotamia depict the full-size likeness of kings engaged in military victories. In 7000 B.C., in Jericho, artists made molds of the heads of deceased people by putting plaster on their skulls, which gave them a perfect likeness to work with. The popes, the nobility, and later the emerging class of wealthy industrialists and merchant princes all had their portraits painted by artists. One of the most famous portraits is the *Mona Lisa,* painted by Leonardo da Vinci in the sixteenth century. In Spain, in the seventeenth century, the court artist Diego Velázquez painted the entire royal Spanish family; of these paintings, *Las Meninas* is the most famous. Napoleon had the great neoclassical painter Jacques-Louis David paint his portrait over and over. There are rooms at Versailles with nothing but huge paintings of Napoleon on horseback leading his men to war.

It was the camera that made portraiture affordable for everyone, not just the rich. This technical change freed the painters to experiment with the portrait—to go beyond rendering a person's features to expressing other feelings and sensibilities in the portrait. The accurately drawn portrait demands precise observation skills and measuring. A portrait can convey tension, strain, peace, thoughtfulness, or anxiety as well as being a psychological study.

In drawing the head or in making a portrait, it is important to make careful measurements for the placement of the features. Close and careful observation will reveal that the shapes of the eyes, the nose, and the lips are never constant or the same between any two people. You need to look closely and carefully at each facial feature, scrutinizing its shape. Think of the skull as a round globe with the features sitting across the curved surface. Facial features are neither symmetrical nor perfectly horizontal. In addition to understanding and locating the the facial features, it is crucial to understand the planes of the face in order to interpret the volume of the head.

Baccio Bandinelli's *Three Male Heads* (fig. 8.1) was constructed following the planes of the skull. There is nothing arbitrary in his decision of where to darken the head and where to leave it white. Cross-hatching was used to model the heads, and the location of the hatching on the side plane of the front head was determined by where the plane changed from the front plane to the side plane. The value of the hatching strokes darkens at the point where the skull turns to the side plane, which is near the middle of the eyebrow. The dark hatching in the eye sockets sets the eyes back in the skull. To create volume, the top plane of the nose on all three figures was left white with the side planes of the nose hatched into a shadow. Look carefully at each mouth. The top lip is generally darker. In these three heads the area between the lips has also been darkened. Each head is modeled differently. The head of the youth to the left has large, white frontal planes supported by darkened side planes. In contrast, the front head is heavily modeled with the creases in the face deepened and the beard modeled light to dark. The man's head to the right has lines across the top of the head, suggesting hair, and some of the creases in his face were darkened. You create volume in a portrait using light to dark values assigned to the planes of the head with additional consideration to where the features either recede or protrude.

FIGURE 8.1

Baccio Bandinelli, (Bartoloimeo Brandini), Italian, (1493–1560), *Three Male Heads,* pen and brown ink, 12⅝ in. × 8 in., (32.1 cm. × 20.7 cm.). The Metropolitan Museum of Art, New York, NY. Rogers Fund, (1963). Photograph, all rights reserved. 63.125.

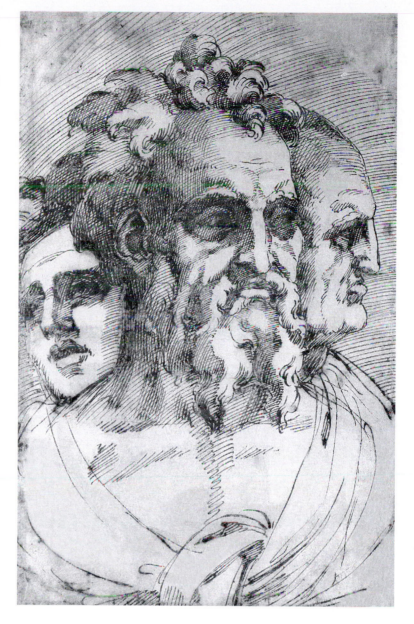

PLANAR ANALYSIS OF THE HEAD

The plane is the basic structural unit for all figure drawing. A plane can be defined as a flat or curved surface. The boundaries of a plane are where the terrain of the form changes. The cube is the easiest form to use as an example of plane and plane changes. The cube is composed of a top plane and four side planes that sit on the bottom plane.

The use of lines to identify plane changes is a graphic convention helpful in mapping out a form in terms of its planes. But lines don't exist in nature. What we think of as a line is a plane

change. There are no lines on the face, which is why it is so important to understand the planes of the head.

Julio Gonzalez created *Screaming Head* (fig. 8.2) with strict and simple plane changes depicting the planes of the head. The strictness of the drawing does not allow for any small planes that can become busy. His Cubist style is direct and he used only major plane divisions.

To understand and locate where the planes change, begin by studying your own face. Move your hand across your forehead to where your skull curves back. At the middle of the eyebrow, move back to the top of your ears. Next follow the bridge

FIGURE 8.2
Julio Gonzalez, Spanish, (1876–1942),
Screaming Head, (1940), pen and black ink,
with brush and gray wash, over graphite, on
off-white laid paper, 31.6 cm. × 24 cm.
McKee Fund. Photograph © 2001, The Art In-
stitute of Chicago. All rights reserved. © 2007
Artists Rights Society (ARS), New York/
ADAGP, Paris. 1957.358.

of your nose, moving down the side planes to where they meet your cheeks. Go to the bottom of your ears, and follow your jaw line down to your chin. From the chin, move up to the lips and then the bottom of the nose. Touching your own face will help you understand the plane changes on the head.

DRAWING EXERCISE 8.1
Analyzing Planes in a Self-Portrait

In drawing the face, you will be challenged by many problems to create a believable volume. It is easiest to start with the large planes and to search out the smaller attached planes. To locate and draw all the small planes first would result in a weak drawing because the form would be obliterated by all the little details.

Stand in front of a mirror with a sketch pad 8 × 11 inches in your hand. Study your face, and using a 3B pencil line, lightly outline and define the large planes of your face. Draw your forehead and the sides of the forehead, the top of the nose, adding the side planes of the nose, the cheeks, the chin, the side of the head, and so on. Add a value change

with hatching to one of the side planes of the head. Hatch the side plane to separate it from the front plane. In a separate study, try making one- and two-minute sketches of your family—without having them sit still. In this way you will be making very fast decisions about the planes of the face, and you will be unable to get picky with the details.

Drawing the Skull Animal skulls are good subjects for studying the structure of the skull. By studying the basic structure, the connections of the planes, and the way that the planes fit together as well as how the planes overlap on a large cow skull, you gain familiarity with the skull's structure (fig. 8.3). In addition, some art departments have plastic human-skull replicas to draw (fig. 8.5). By studying the underlying structure of the head, you have a stronger idea of when and where the planes of the head change.

Untitled (Head Drawing), fig. 8.4 by Kiki Smith, is a hovering presence void of personality, a generic experience of the body with no intention of becoming specific or relating to any specific people. *Head,* for Kiki Smith is an effort to alert the

FIGURE 8.3
Chandra Allison, *Cow Skull,* (1999), ink wash, student drawing, Oregon State University.

viewer to reclaim your body from society as an individual. The image, a floating head, represents separating yourself from the ideologies with which your head is packed full. It is Smith's hope that something in the work resonates with the viewer in terms of their own life. In her work she expects people to examine their personal philosophies and ideologies in every aspect of their lives—religion, government, health, gender and all the other social contributors to our lives. Part of what she does in her work is to find her subject through a basic fascination with the subject and in fact any one of her biological pieces, the stomach made out of glass for example, may start without some absolute significance, intention, meaning, or reason behind the work, but the viewer may find the significance on their own. In the current world of art, the artist may choose not to explain the meaning of their work nor the materials they use. It is fortunate for us to have Kiki Smith's statement as it guides our thoughts in the direction she intended for work to be understood.

PROPORTIONS OF THE FACE AND HEAD

Like most of the subjects we draw, the human face is very familiar to us. We recognize it immediately, but we need to study and carefully observe the

FIGURE 8.4
Kiki Smith, (1954–), *Untitled (Head Drawing),* (1994), ink and collage on Japanese paper, 30 in. × 18½ in. (76.2 cm. × 46.99 cm.). Gift of Anne and Joel Ehrenkranz. Collection of the Whitney Museum of American Art, New York, NY. 98.54.3.

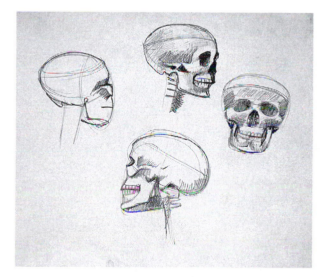

FIGURE 8.5
Lili Xu, Skull Studies, (1999), student drawing, Oregon State University.

anatomical structure in order to draw a portrait. You'll want to make a careful analysis of the head before you start drawing. Use your pencil as a sighting tool. When mapping out the face and head, follow these general guidelines to help you draw accurately:

Front View

1. Draw a vertical line on your paper. This line is for aligning the top of the head with the chin in a frontal pose. Make a mark for the top of head, and make a line for the chin down the line (fig. 8.6a).
2. The eyes lie halfway between the top of the skull and the chin. Draw a curved horizontal line across the vertical to locate the eyes (fig. 8.6a).
3. Divide the face in thirds from the hairline to the chin. Locate the eyebrows one-third of the way down, and place a mark for the base of the nose two-thirds of the way down.
4. The center line of the lips is one-third of the way between the nose and the chin.
5. The ears sit on the side of the head between the top of the eyes and the bottom of the nose.
6. The width of the eye is an important measurement. The head is five eyes wide. The distance between the eyes is one eye length; the distance from the corner of the eye to the side of the head is one eye length.
7. The distance between the eyes is the same as the width of the nostrils.

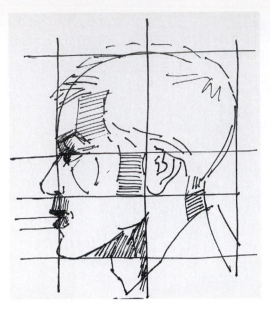

FIGURE 8.6B

8. Remember that the features remain at right angles to the center vertical line no matter how you tip your head from front to back.

Profile View

9. In a profile pose, the distance from the chin to the eyebrows is equal to the distance from the ear hole to the top of the nose (fig. 8.6b).
10. The distance from the back corner of the eye to the back edge of the ear is equal to one-half the height of the head in profile (fig. 8.6b).
11. In a side view, the head is divided in front of the ear, creating equal parts on both sides of the line (fig. 8.6b).

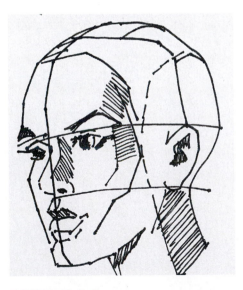

FIGURE 8.6A, B, C
Three Illustrations of the *Proportions of the Face and Head,* (author's illustrations).

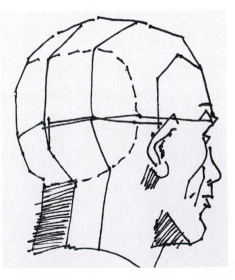

FIGURE 8.6C

12. Fig. 8.6c diagrams the view of the back of the head. The eyes are on the same curve where the roundness of the skull changes.

FACIAL FEATURES

The isolated fragments from different compositions by Giovanni Battista Tiepolo, seen in fig. 8.7, were made for a large canvas he worked on with his two sons, Domenico and Lorenzo, between 1751 and 1753. The work was done for Prince-Archbishop Greiffenklau in the Imperial Hall at Würzburg in Franconia. These studies were originally thought to be rapid notations of individual details, but some historians think that they may have been drawn during the course of the painting, as exploratory drawings rather than as preparatory studies. The fragments of the design in the drawing seem more painterly than graphic, and when they reappear in the finished painting, little has been changed. The drawings parallel the finished work so closely that still other scholars believe that they were done after the work was finished, as a way of keeping a record. *The Fall of the Rebel Angels*, which was painted for the palace chapel, is a large canvas rather than a fresco. In addition to completing the large painting, Tiepolo and his sons executed vast frescoes and a large altarpiece at the same time. It is to their

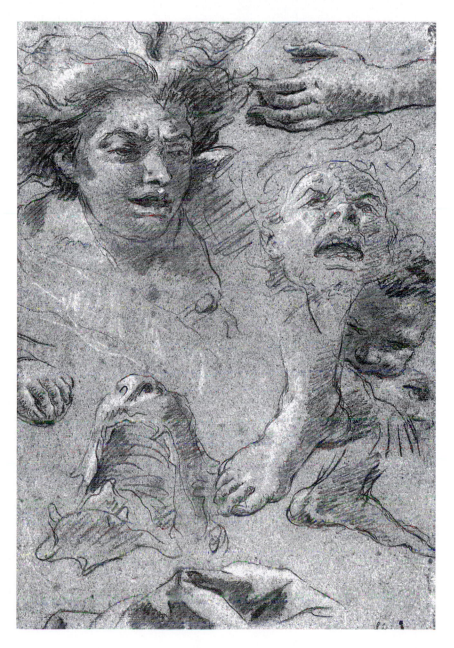

FIGURE 8.7
Giovanni Battista Tiepolo, Italian, (1696–1770), studies for *The Fall of the Rebel Angels*, in the Chapel of Würzburg Residenz, (c. 1751–1752), red chalk, heightened with white, 394 mm. × 272 mm. Committee for Art Acquisitions Fund. Iris and B. Gerald Cantor Center of Visual Arts at Stanford University. 1982.170.

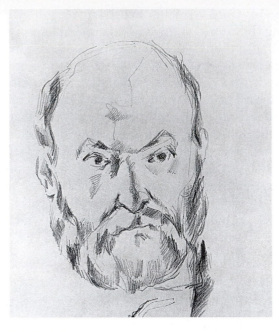

FIGURE 8.8
Paul Cézanne, French, (1839–1906), *detail from Sketchbook No. 2 (L'Estaque), 1875–1886,* graphite and pen and ink drawings on paper bound into a book, 124 mm. × 217 mm. (max.). Arthur Henn Purchase Fund, The Art Institute of Chicago, Photograph © The Art Institute of Chicago. All rights reserved. 1951.1.

credit, and to history's amazement, that the Tiepolos completed a huge number of various projects for the archbishop in only two years, a very short time for this amount of work.

To familiarize yourself with drawing techniques used in creating a face, carefully examine the facial features in Tiepolo's drawing. Look closely at the thickness of the eyelid; note that the eyes are not almond-shaped and how the lower lid slides under the corners of the upper lid. The iris of the eye seems to rest on the lower lid. Follow the curved line shaping the top lid and the bottom lid of the eye. In Tiepolo's drawings, the lips are not outlined. The line between the lips gives them their shape, along with the shadow under the bottom lip, and a little shading on the upper lip to give the lips form.

DRAWING EXERCISE 8.2
Studying the Facial Features

Practice drawing lips, eyes, ears, and noses of models seen in photos from fashion magazines. Models have extreme, well-definned features that make them very photogenic and that

will also help you see the various qualitites of the eyes and nose especially. Practice looking carefully at each feature.

Study the shape of the eye, the eyelid, and the eyebrow. Carefully map out the curve of the eye, the curve of the mouth, and the shape of the lips. The nose is difficult. Remember to draw a top plane and a side plane to get the volume of the nose.

SELF-PORTRAIT

Drawing a self-protrait will be both difficult and revealing—difficult in that you must look back and forth between your paper and your face in the mirror. Achieving a good likeness of yourself depends on the accuracy of your observation and on how well your translation skills have developed.

Paul Cézanne once said that all of nature could be thought of in terms of a sphere, a cone, and a cylinder, the universal geometry that he found in nature. In his self-portrait (fig. 8.8) he has addressed the face in terms of the planes of the head. You can see the plane change in the sharp division between the bottom of the cheek line and his beard. Look carefully at the hatching strokes in the beard. His strokes turn down from the large, white cheek planes. On the left, as you look at the portrait, the beard is formed with vertical strokes, whereas on the right, he used diagonal strokes in addition to the vertical strokes. Notice how he used a dark value under the nose and under the bottom lip to create the volume of both the nose and the lip. These dark values recede, whereas the light values lift up off the surface of the face. The value changes on the face are relative to each other in their amount and degree of darkness to lightness. Cézanne doesn't use black; instead, as his dark, he uses a light to medium gray value, which is sufficient to form the volume of the head when placed against the white planes.

The gaze of the person in a portrait is an important consideration. In a modern work, the gaze may be directed at the viewer or past the viewer. Cézanne, in his self-portrait (fig. 8.8), looks past the viewer, his gaze averted.

The portrait of Cézanne's son, Chappuis, (fig. 8.9) was drawn with the gaze directed down and to our left, but the eyes do not look at the same spot. The eye on our left is "day dreaming," it looks inward not outward.

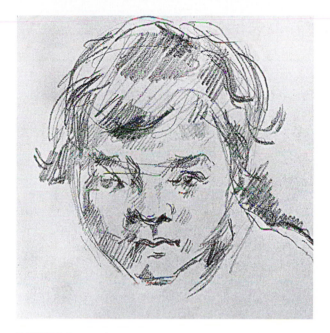

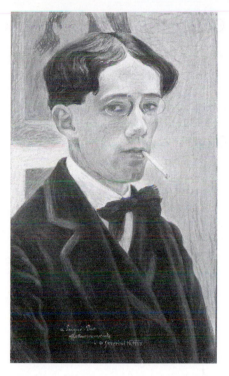

FIGURE 8.9
Paul Cézanne, French (1839–1906), *detail from Sketchbook: No. 2 (L'Estaque) (the Artist's Son, Chappuis) 1875–1886*, graphite and pen and ink drawings on paper bound into a book, 124 mm. × 217 mm. (max.). Arthur Henn Purchase Fund, The Art Institute of Chicago. Photograph © The Art Institute of Chicago. All rights reserved. 1951.1.

FIGURE 8.10
Gino Severini, Italian, (1883–1966). *Self-Portrait*, (1909), pastel on paper, 48.5 cm. × 28.8 cm. Ada Turnbull Hertle Fund, The Art Institute of Chicago © 1969. Photograph © The Art Institute of Chicago. All rights reserved. 1969.376.

Gino Severini, a Futurist painter, in 1909, drew a realistic—and what could be considered as a traditional—self-portrait (fig. 8.10) of himself smoking. His handling of the modeling of the face and figure reflected a very modern approach. Looking at the drawing, you see that the value change from the top white plane of Severini's nose to the gray side plane is slight. His jacket is formed with a few simple value changes on the top of the folds, and the white piping on the lapel forms the edge. In 1912, in *Self-Portrait with Straw Boater* (fig. 8.11), Severini has adopted the Futuristic style of drawing, fracturing and shifting the planes of the face, creating movement and rhythm. Like the Cubists, the Futurists used modeling as texture. It was another way to visually separate the planes. A white plane is next to a gray plane; a black plane is surrounded by gray planes constructing this shifted view. The background now reflects the shifting planes and shifts to a diagonal or a diamond shape, which increases the sense of movement and lends a rhythmic character to this portrait. These two drawings accurately reflect the change in the world of art from 1909 to 1912. Modernism opened up to include Cubism, Futurism, Surrealism, and Expressionism.

FIGURE 8.11
Gino Severini, Italian, (1883–1966). *Self-Portrait with Straw Boater,* (c. 1912), black chalk on ivory laid paper, 55.1 cm. × 45.2 cm. Margaret Day Blake Collection, The Art Institute of Chicago. Photograph © 1912, The Art Institute of Chicago. All rights reserved. 1965.171.

Élisabeth Vigée-Lebrun was born in 1755, the daughter of an artist, Louis Vigée, a portraitist who worked in the style of Jean-Antoine Watteau (fig. 8.28). We know more about her than about any other woman painter of this period because she wrote and published her memoirs.

She began to study painting at the age of eleven, under a painter named Davesne. Later her childhood friend Anne Bocquet Filleu began to study along with her but was persuaded by her husband to quit. Vigée-Lebrun considered this a great loss. The early death of her beloved father brought confusion and melancholy into her life, but these emotions soon turned into an ironclad resolve to become a serious painter. To her credit, she was able to support her mother with her painting, something unique for a woman painter of her time. When her mother remarried, her stepfather insisted that Élisabeth turn all her painting fees over to him. At the same time, her mother thought that her daughter would be secure in a marriage to a wealthy man, and she urged her to marry Lebrun, an art dealer. At the time Vigée-Lebrun was twenty years old and earning a good deal of money. She felt no desire to get married, but in order to escape the torment from her stepfather, she agreed. In her memoirs she says that on the way to the church she kept saying to herself, "Shall I say yes? Shall I say no? Alas, I said 'yes' and changed my old troubles for new ones." Her husband, Lebrun, was likable enough, but he had a passion for gambling. His extravagant habits drained her receipts from her portrait commissions.

Neither marriage nor maternity stopped Vigée-Lebrun from painting. She took her pregnancy lightly, making absolutely no preparation for the birth of her daughter during the entire nine months. On the day that her labor started, she continued, in between contractions, to work on the painting *Venus Tying the Wings of Love.* Madame de Verdun, her oldest friend, happened to come into the studio and seeing this situation, asked her if she had provided all that would be necessary for birth. Vigée-Lebrun looked astonished and said that she didn't even know at all what was necessary. De Verdun responded, "That's just like you; you are a real boy." When Vigée-Lebrun was told she needed to go to bed, since the birth was near, she exclaimed, "No, no, I have a sitting tomorrow. I will not go to bed today."

However, she did go to bed and gave birth to her daughter, Julie. The resulting portraits of her with her daughter are stunning in their perfection.

Vigée-Lebrun was a court painter to Louis XVI and Marie Antoinette. The painting *Portrait of Marie Antoinette with Her Children,* completed in 1787, was a splendid painting of the queen with her children around her. The painting, which measures 108¼ × 84⅝ inches, was intended to be a historical statement portraying the vitality and health of the royal family, but it was criticized by some who thought it was too large and extravagant. The queen having lost one child prior to this painting, and with the young Dauphin, her son, dying after the painting was finished, it became too painful for the queen to look at the painting, and she had it put in storage. During the French Revolution, when the palaces were sacked and works of art were destroyed or stolen by the people, the fact that this painting was in storage saved it from destruction.

Vigée-Lebrun's salon, was the social event to be invited to in Paris. It was frequented by so many guests that she once bragged that the marshals of France had to sit on the floor. She arranged musical evenings, witty conversations, and elaborate costume parties. Her popularity as a society hostess and fame as a painter made her the center of gossip. Some of the most jealous speculated that her paintings were done by a man and not by her. She wrote in her memoirs, "Has one ever known a great reputation, in whatever matter, that failed to arouse envy?" The Académie Royale, the organization that officially recognized the artists in France, on May 31, 1783, admitted Vigée-Lebrun, ending all rumors she had not painted the works attributed to her. Vigée-Lebrun had been devoted to the royal family and thus had to flee France on the eve of the Revolution. She spent twelve years in exile, but wherever she went, she was treated as a celebrity and made a member of the local Academy. She painted dozens of portrait commissions during her exile, and later she returned to France as a portrait painter to Napoléon Bonaparte. In her lifetime she completed 660 portraits. She made her subjects look glamorous but at the same time encouraged them to come in an informal attire so that the portraits would have a sense of intimacy and spontaneity. The drawing in fig. 8.12 is a self-portrait, more than likely a sketch for a future painting.

FIGURE 8.12
Marie-Louise-Élisabeth Vigée-Lebrun, (1755–1842), *Self Portrait*, (1955,8). The Pierpont Morgan Library,
New York, NY. Photo Credit: The Pierpont Morgan Library/Art Resource, New York, NY. ART 151295.

Upon returning to Paris, she set about enter-
taining the survivors of the Revolution. In her mem-
oirs she recounts an incident during one of her
parties of a man who did her horoscope. He said
that "I should live a long while and become a lovable
old woman, because I was not coquettish. Now that
I have lived a long while, am I a lovable old woman?
I doubt it."

EXPRESSIVE PORTRAITS

The art of drawing is almost infinite in its expressive
range, as well as the range of techniques and media
that are available to the artist. Through technique
and media, an artist works the surface of a drawing
to give a personal vision to a graphic expression.
Part of graphic expression is the way the forms are

FIGURE 8.13
Alberto Giacometti, *Annette,* (1961), oil on canvas, 21⅝ in. × 18⅛ in., (54.8 cm. × 46.0 cm.). Hirshhorn Museum and Sculpture Garden. Smithsonian Institution, Washington, D.C. Gift of Joseph H. Hirshhorn, (1966). Photograph by Lee Stalsworth. © 2007 Artists Rights Society (ARS), New York/ADAGP, Paris.

organized and their spatial relationships. Alberto Giacometti, in the drawing of his wife, Annette (fig. 8.13), overlapped and wrapped the head in lines to define the planes of the face. His technique, created a rich volume, Expressive and Gestural at the same time. Giacometti drew with three to five brushes in his hand at once. He drew with black lines until he had almost obliterated the face and then he would come back into the drawing with white oil paint, lifting the planes of the face out of the blackground. Using rubbing and wiping, he created gray planes on the face. It was this balance between white, black, and gray that he worked with back and forth for days. He relied on his own intuitive sense of what was finished, what was not, and when to stop.

DRAWING EXERCISE 8.3
Photo Realism and the Grid Transfer

The student portrait drawings in figs. 8.14, 8.15, and 8.16 are grid transfers that illustrate not only a photorealistic but also an Expressive syle. McDonal's (fig. 8.16) is pho-

FIGURE 8.14
Kevin Cunningham, pencil, grid transfer portrait, (1999), 18 in. × 24 in., student drawing, Oregon State University.

torealistic, whereas Cunningham's (fig. 8.14) is more Expressive, leaving the formal realism behind for a veiled effect. All three drawings, were taken from magazine photographs. To do this exercise select a photo 8 × 10 inches. Divide the photo into a grid of one-inch squares. A second grid is then constructed on a piece of 18 × 24 inch white drawing paper, using two inches for each unit of the grid. In both grids there are the same number of units vertically and horizontally, but of course the two inch grid is larger.

Both grids have eight squares across the top and ten squares down the side. The grid on the white paper doubled the size of the small photo to a 16 × 20 inch format.

Once you have both grids, transfer the information in terms of shapes, lines, marks, and value changes from each unit of the small photo to the matching unit on the larger drawing paper. The imagery in the top right unit of the small grid will be drawn and expanded in the top right unit of the larger grid on the white paper. Continue transferring lines, values, and shapes square by square.

FIGURE 8.16
Matt McDonal, pencil, grid transfer portrait, (1999), 18 in. × 24 in., student drawing, Oregon State University.

FIGURE 8.15
Andrea Galluzzo, pencil, grid transfer portrait, (1999), 18 in. × 24 in., student drawing, Oregon State University.

PHOTOGRAPHIC REALISM

A clear photographic likeness of your model is realised in photographic realism. It is often painstaking to execute because you can't rush to finish. In Matt McDonal's drawing (fig. 8.16), he has buried the marks and any strokes that would take away from a very photographic, polished surface. He worked for two weeks to complete this drawing by adding one layer of rubbed value changes in pencil over another. When the pencil is used on its side, you avoid linear marks. The side of the pencil lays down a soft, flat layer of graphic. By rubbing the graphite with newsprint, a chamois, or a tissue, you can spread a thin, soft layer, creating an even surface. Do not use your fingers, since the oil in your skin interacts with the paper and discoloration may occur.

Understanding the expressive means of drawing, the formal elements, (texture, line, perspective, value, and composition), as well as the tools you use, is essential to the development of your individual style. Galluzzo fig. 8.15 drew the model as a strict form. The individual styles of each of these three artists comes through as completely different interpretations.

Elaine de Kooning was both a talented painter and an astute art critic. De Kooning, along with Tom Hess, Meyer Schapiro, Eugene Goossen, and Harold Rosenberg, were the first art critics to see the intellectual and emotional depth of the art being done in New York in the 1940s, by Milton Resnick, Mark Rothko, Willem de Kooning, Robert Motherwell, Helen Frankenthaler, Jackson Pollock, Lee Krassner, Pat Passlof, Hans Hofmann, and many others. In the 1950's she wrote art criticism for *Art News,* in which she created a series called " 'So and So' Makes a Painting," as in "Jackson Pollock Makes a Painting," or de Kooning makes a painting. Her articles focused on individual artists. She wrote about Mark Rothko, Franz Kline, Willem de Kooning, and Jackson Pollock, those articles discussing the artists and their work in formal terms.

Her writing was greatly informed by her life as a painter she understood the new art culture of New York. In 1943, she married Willem de Kooning, and they lived in New York in the center of it all. She had access to artists' studios and was taken into their confidence. She learned their thoughts and techniques, information that artists usually share only with each other, but she was one of them.

Like the work of many other painters in New York during the 1940s and 1950s, Elaine de Kooning's painting was inspired by Arshile Gorky. In 1948, she attended Black Mountain College near Asheville, North Carolina. She drew constantly and worked both abstractly and realistically. Her portraits were characterized by how well she established the stance of the body, capturing the sitter in a way to make the portrait more than just an illustration. She painted her wide circle of friends, including Harold Rosenberg, Joseph Hirshhorn (fig. 8.17), the poets Frank O'Hara and John Ashbery, the painter Fairfield Porter,

FIGURE 8.17
Elaine Marie Catherine de Kooning, American, (1920–1989), *Hirshhorn,* J. H., Portrait of a Painting (1963), oil on canvas, 72 in. × 48 in. Hirshhorn Museum and Sculpture Garden, Smithsonian Institution, Washington, D.C. Gift of Joseph H. Hirshhorn, (1966). 66.1182.

and her most famous subject, President John F. Kennedy.

Along with Grace Hartigan and Pat Passlof, Elaine de Kooning was one of the few women admitted to "The Club," which was formed by the artists in the New York School. Starting in 1949, The Club would convene to discuss current problems in the arts; it was the only place in which sophisticated artists in New York could find companionship with people of like minds. Previously, the artists got together in a café to have a cup of coffee and to discuss the meaning of art, but the longshoremen also frequented these cafés and one night the longshoremen got into a fight that ended when one of them threw another one out the front window of the café. This was the turning point, and the artists decided to rent a loft in which to meet. No one had much money. It was Philip Pavia who put the money up for the rent out of his savings to cast one of his sculptures in bronze—a truly generous and unselfish action.

Women artists have always had trouble getting recognized, but with her husband's support, Elaine de Kooning managed to maintain her professional position and her personal relationship with her husband. To the art world, however, she was first a wife, then a painter. Being the wife of one of the most admired artists in the world did not help her career. Dealers walked right by her work without noticing it to get to Willem de Kooning's. Her situation was typical: most artist-wives during the forties and fifties, although strong artists in their own right, gave their unquestioning support to their artist husbands, making major sacrifices such as giving up motherhood to put their husbands' careers first. Esther Gottlieb, Annalee Newman, Musa Guston, and Lee Krasner were among those women.

Elaine de Kooning separated from Willem in 1956 after thirteen years of marriage and left New York in 1957 to teach at the University of New Mexico. In 1977, however, she returned to live near her husband at their house and studio on Long Island because he was ill. Although they maintained separate houses and studios, she was only five minutes away, and she joined him every night.

She did not receive real recognition for her work until a few years before she died. Elaine de Kooning said of painting, "When I do something I didn't expect or consciously intend to be doing, it's not an accident." When asked how she made decisions while painting, she said, "When you're dancing, you don't stop to think: now I'll take this step. It just flows."

FIGURE DRAWING

Odalisque with Slave (fig. 8.18), by J. A. D. Ingres, was executed in Rome in 1839. Ingres had a lifelong fascination with the subject of the **odalisque,** using it often in paintings and drawings. The pose for the odalisque was set as early as 1809 in another of his studies. The painting resulting from this drawing is now in the Fogg Art Museum at Harvard University. A replica was commissioned by Charles Marcotte d'Argenteuil and painted in 1842.

FIGURE 8.18
Jean Auguste Dominique Ingres, (1780–1867), *Odalisque with Slave,* (1839), pencil, black and white chalk, white gouache, gray and brown wash, especially on the moor's face, hands, and cuffs; surface scratched in places to produce highlights; on cream-colored wove paper. Design area: 13³/₁₆ in. × 18¼ in., (335 mm. × 462 mm.), on sheet measuring 19¼ in. × 24¼ in., (488 mm. × 616 mm.). The Thaw Collection. Photo Credit: The Pierpont Morgan Library, New York/Art Resource, New York, NY.

Originally, as the story goes, this replica shows the Odalisque resting in a landscape rather than a room. Marcotte d'Argenteuil had the painting hung in the smoking room of his house, a room used only by the men after dinner. The painting was hidden behind a curtain that was opened for viewing while the men sat with brandy and smoked cigars. This painting is now at the Walters Art Gallery in Baltimore.

The painstaking labor in this drawing, which is of photorealistic or lithographic quality, indicates that Ingres intended it to be an independent work. **Lithographic** quality means that an artist goes to great lengths to prepare a drawing for a lithograph that can then be reproduced some two hundred times. In a business sense, a lithograph gives the artist a better return for the work.

The meticulous finish of this drawing is another indication that Ingres spent a great deal of time working on it. The balance of wash, pencil, chalk with gouache, with the highlights, is perfect. The drawing seems fused in a soft light. It is a peaceful, quiet, and relaxed scene. Hours of work go into making a drawing of this caliber.

A drawing made in this manner might be called "mixed media," although a mixed-media drawing today is generally more active, bolder, and marked more heavily. Today the artists make the media evident on the surface of a mixed media drawing and often make the media the subject of the drawing. The media are not the "handmaiden" of the subject, as they are here, in Ingres's drawing, where you are unaware of the media. The drawing is completely tonal and resembles a photograph in its absence of line. This approach is relatively rare. It is pure sensual luxury.

BEGINNING FIGURE STUDIES

The human figure is one of the greatest challenges in drawing. It is large, complicated, angular, round, and structured by connecting small and large planes that twist and shift. Problems abound in determining scale, proportion, perspective, and space, and if the figure is clothed, drapery must then be dealt with.

The figure is difficult to define. When you look at it carefully, you see that any contour line you follow shifts. The contour will change at the knee, the elbows, and the wrists, most notably. Early in figure drawing studies you will tend to be preoc-

cupied with an outline representing contour, surface conditions, and minor details. If your figure drawing is to be convincing, it must address the basic structural nature of the figure; it must be a volume in space.

GESTURE IN FIGURE DRAWING

Gesture depends on a rhythmic line. The drawing in fig. 8.20 is a gesture drawing following the planes of the figure, including the invisible back planes as well as the front planes. The line follows—and crosses—the planes of each body part, hinging them together at the elbows, knees, ankles, and wrists. The line also wraps around the back and the chest, and envelops the entire figure. In this way, it communicates volume or a sense of volume.

The drawing in fig. 8.19 is a gesture drawing that was drawn overlapping itself three times. The

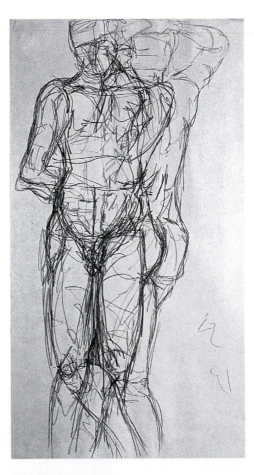

FIGURE 8.19
Eric Bailey, pen, overlapping figure, gesture drawing, (1999), student drawing, Oregon State University.

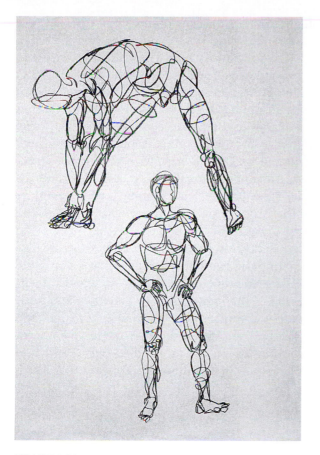

FIGURE 8.20
Sabrina Benson, figure study, gesture drawing, (1999), student drawing, Oregon State University.

and you draw it round at the top and at the bottom, you can then do the same for the torso, each arm, and each leg. When drawing the arm, draw by section, the shoulder to the elbow, then the elbow to the wrist. Do the same for the legs. These cylinders for the arms and legs are tapered, not straight tubes. They are tubes with a narrow end and a wider end. Drawing the figure as a series of cylinders describes the changing contour on both the outside and the inside contours. With the torso drawn first, you can find where the legs slot in and then the arms off the shoulders (fig. 8.21). Studying how the parts are connected sensitizes your visual awareness to the specific shapes of the body's contour, replacing your previously generalized version.

model struck a pose, holding it for eight minutes. She then turned a quarter turn, leaving one leg in the same position. After eight minutes, the model turned again. The figure was redrawn over itself each time the model turned. The resulting drawings increase your understanding of the figure's volume, shape, and proportions. The overlapping lines add movement to the drawing of the figure.

The gesture drawing in fig. 8.20 shows two different poses done in five minutes using continuous line. The goal was to create a line that enveloped the figure crossing the planes but that did not become a contour outline.

The Figure as a Cylinder One way to think of the figure is as a series of connected cylinders. The best drawing instructor I ever had, Professor Ron Graff, called it "the garbage can theory of figure drawing, where one can fits or slides into another." If you think of the neck as a cylinder

FIGURE 8.21
Mandy Reeves, cylinder study of the figure, pencil, (1999), student drawing, Oregon State University.

THE PORTRAIT, THE FIGURE, AND DRAPERY

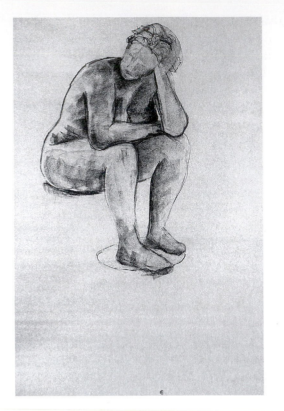

Light and Planar Analysis of the Figure

Contour drawing alone cannot describe the structural nature of the figure. The volume of the figure is established and revealed through value and plane. Value is often misunderstood. The value is not a mere recording of the way the actual light falls on the planes of the figure, because actual light patterns can destroy structure. Actual light strikes any object in its path, sometimes revealing the structure, sometimes camouflaging it, and sometimes totally destroying it. For example, a figure standing in the cast shadows of a fence will be lost in the light patterns of the fence. Another example is overhead lighting, which spreads out, brightly illuminating the figure from all angles and flattening it. Understanding **chiaroscuro**—in which the direction of the light falls both vertically and horizontally, covering a cylinder from light to dark, top to bottom—provides you with a model to follow in determining where you need to place light and dark. In Larkin Schollmeyer's drawing (fig. 8.23),

FIGURE 8.22
Peter Meyer, *Figure Study,* (2001), 24 in. × 36 in., charcoal, courtesy of the artist.

Peter Meyer's *Figure Study* (fig. 8.22) is a fine example of the roundness achieved in figure drawing when you think of the figure as a cylinder, not an outline. The modeling on the figure shifts you from the geometry of the cylinders to a sensibility of skin on the figure. The volume seems more real.

DRAWING EXERCISE 8.4
The Figure as Connected Cylinders

Have the model strike a standing pose, leaning on one leg, with arms free in space. Begin with a torso, constructing it with ellipses. Use one ellipse for the waist, one for the chest, and one for the base of the neck. Connect them with light, curved, diagonal lines. From this, add an ellipse for the top of the neck. Place the head on the neck, checking the angle of the head. Sight over from the neck to the shoulders, and locate the arms off the shoulders. Use ellipses drawn vertically for connecting the hips to the torso (fig. 8.21). Draw the legs one cylinder at a time, from joint to joint. For each finger of the hand, create a series of small cylinders to fit into the palm and on the top of the hand.

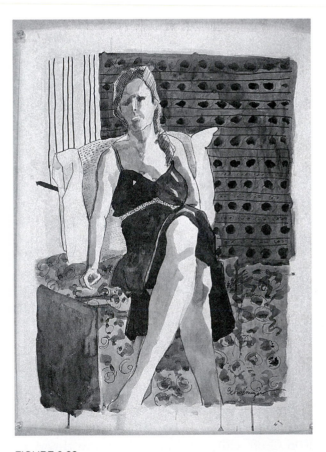

FIGURE 8.23
Larkin Schollmeyer, *Sarah,* (2004), 18 in. × 24 in., ink and wash, courtesy of the artist.

FIGURE 8.24

Isabel Bishop, (1902–1988), *Waiting*, (1935), Ink on paper, 7⅛ in. × 6 in., (18.1 cm. × 15.2 cm.). Collection of the Whitney Museum of American Art, New York, NY. Purchase. 36.31.

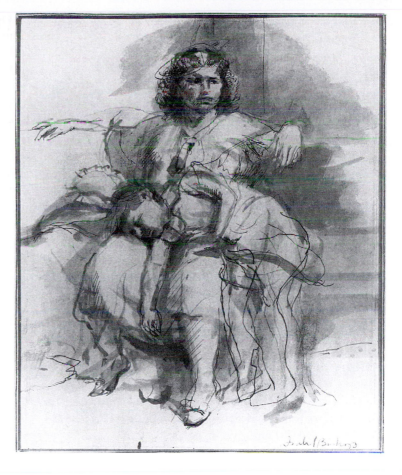

she determined the placement of all the values from the front to the back of the picture plane, and on the figure. Falling light was not considered.

The plane is the basic structural unit of the figure. In nature, planes may be clearly identified with a change of value, color, or texture. Analyze the structure of the figure by first locating the large planes of the head, chest, pelvis, hip, knees, thighs, calves, and arms. The small planes hinge the large planes together. In fig. 8.23 Schollmeyer dealt mainly with the large planes, ignoring the small planes.

DRAWING EXERCISE 8.5
Rubbed and Erased Values in Planar Analysis

Start by using the cylinder approach to draw a seated figure. Study the figure by analyzing each limb, from joint to joint. Draw a cylinder for each body part. Next, divide the cylinders into planes. The curve of the cylinder will guide you in finding the planes. When the cylinder curves and turns down or back, the planes change.

Add value using a 6B pencil on its side. Apply a layer of lead to all the darkest planes on the figure. Take a tissue or paper towel, and rub the lead across the entire figure. Rub firmly to cover the entire paper.

Using a white plastic eraser, remove the rubbed gray value off the lightest planes. Shape them boldly with the eraser, and then gently use the tissue at the edge of each plane to clean up the edge. To change an area, rub over it again with a tissue, and then erase the planes or add value to darken them. Go back into the dark planes, use the 6B pencil now to add another layer of graphic to further darken the dark planes.

Foreshortening All the planes are foreshortened on a figure, except those at a right angle to, or centered in, the viewer's line of sight. The less you can see of the plane of a body part, the more foreshortened it is. In fig. 8.24, Isabel Bishop's *Waiting*, the woman's head and torso are centered in the viewer's line of sight and therefore not foreshortened. In foreshortening, the fact that an arm or a leg has length is negated by its position in the space of the drawing. You cannot draw the figure using

remembered size and shape notations about the form of the arm or leg when it is projecting out at you. The woman's left foot in Bishop's drawing projects forward and is foreshortened.

In *Waiting* (fig. 8.24), the woman's left hand (on the viewer's right) hangs in midair with no visible arm supporting it. This is a foreshortened view; her arm is actually over the back of the bench. The use of overlapping shapes is a major technique in foreshortening to create volume. Bishop's use of two figures that are overlapped increases the sense of space. The child's legs are drawn with gesture strokes, whereas her left hand rests on her mother's leg. This is the only indication that the top of the leg exists—we do not see it. It is implied.

Look at your subject, starting with the front forms. Next look at the relationships between the parts of the figure. You need to draw by adding each section to the one in front of it; in other words you will draw from front to back. For example, the woman's legs are the farthest forward in Bishop's drawing. The top of her legs are covered by the sleeping child, blocking your view of the woman's waist. The woman's torso rises out of the little girl's back. The woman's left hand overlaps her shoulder with no arm shown. In looking at your subject, visually make these connections. You look at how one form relates to another, not for a view of the entire body. It is the visual location of one body part to the one behind it that guides you in foreshortening the figure.

Bishop draws a woman during the depression, who is clearly tired but vigilant, waiting seated on a bench with a sleeping child. Bishop's concern with "the nobility of life" is stated through her skills as a draftsperson. The exploratory lines barely sketching these two figures suggest a condition of life. We feel the tranquillity of the woman and at the same time we feel sympathy for the woman and her child.

DRAWING THE FIGURE IN PROPORTION

The traditional unit of measure for the figure is the head or skull. Leonardo da Vinci determined the adult figure to be eight heads high. When measuring the figure, you will find that each head measurement falls between major parts of the body. The figure chart in fig. 8.26 has been divided into the eight parts to illustrate the proportions of the human figure. Note where the unit divisions intersect the male and female figures. The hip is generally considered midpoint for the male figure; the pubic bone is the halfway mark for the female figure.

When establishing proportions for a figure, first use sighting to determine the size of the head. The head measurement can be established by lining up the end of your pencil with the top of the head and then placing your thumb where the chin line intersects the pencil's shaft. This measurement constitutes one unit. Mark your paper with this unit repeating it eight times down your paper. Alternatively, you can simply start a figure drawing by dividing the paper into eight units into which you will fit the figure.

Once a figure takes a pose, some part of it will be foreshortened. In the beginning, you might make the body parts too long. It takes practice to adjust what you know with what you are seeing.

Taddeo Zuccaro's drawing (fig. 8.25) is a good example of how a standing figure is foreshortened.

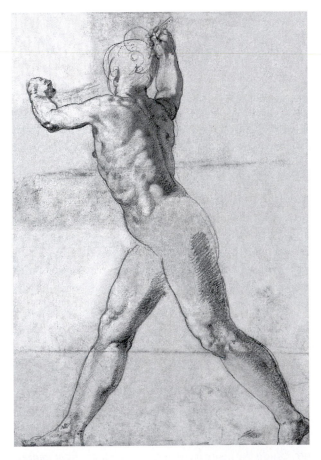

FIGURE 8.25
Taddeo Zuccaro (Zuccari), (1529–1566), *Standing Nude Man*, red chalk, heightened with traces of white gouache, 16⅝ in. × 11⅜ in., (42 cm. × 28.7 cm.). The Metropolitan Museum of Art, New York, NY, Rogers Fund, (1968). Photograph, all rights reserved. (68.113).

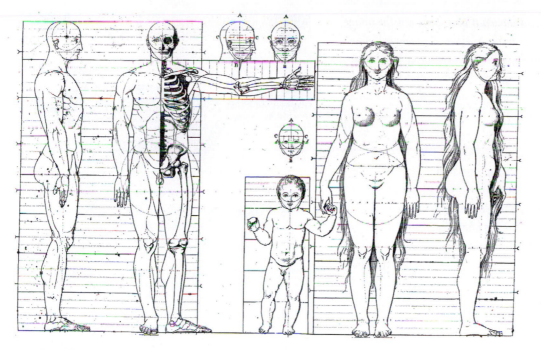

FIGURE 8.26

Borghese, from Savage's *Anatomie du Gladiateur Combattant,* Plate 19. Courtesy of the Library of Congress.

The chest, arms, and head of Zuccaro's figure turn back into the ground, thereby making them visually farther away from us than the legs in the foreground. Foreshortening increases as the figure turns into space which reduces the size of the upper torso and increases the size of the legs in relation to the head, arms, and torso. Zuccaro's arms are a good example of an artist's drawing what he sees, instead of his drawing the length of the arms that he knows them to really be. The arms seem to be completely in scale, but look at the contour line for each section from the shoulder to the wrist. It is constructed with the correct contour of the muscles of the arm, but the lines are shortened. The large legs in the front push forward in the space. Notice the placement of the feet, the angle of the knees, and the beautiful contour line running from the chest through the knee and ending at the front foot.

DRAWING EXERCISE 8.6
Copying a Master Drawing

For women, the top of the pubic bone is the midpoint of the figure, measuring from the soles of the feet to the top of the head. The knees are halfway between the pubic

bone and the feet. The point just at the bottom of the breasts is halfway between the pubic bone and the top of head. For men, these measurements are a bit lower—see fig. 8.26.

With these divisions in mind, mark off eight equal parts on a piece of transparent paper using the head of Zuccaro's figure as your unit size. Copy the drawing by Taddeo Zuccaro. When you have drawn the figure place the transparent measuring paper over your drawing. Because it is foreshortened, the parts of the figure will not need eight units.

DRAWING EXERCISE 8.7
Drawing the Nude Model

It is best to warm up with a number of one- to five-minute gesture drawings when you first start studying the figure. Use newsprint and pens or 6B pencils. If your school has a plaster cast of the figure, work from it in the beginning; it will be helpful in getting you accustomed to the intricacies of the human form.

At first, don't concentrate on making the figure look correct. Concentrate on uniting all the parts of the figure and noticing the relationships of one part to the others.

Each time you draw, draw what you see—not the image you have stored in your brain. Gesture drawing will allow your line to flow from the leg to the arm through the torso. Look carefully at the angle of the body and then at the angle of the arms and legs in relation to the body. Draw a line that reflects the angle of the torso and legs, and then start with the front planes. Add the rest of the body by using overlapping forms if necessary. One technique for locating the parts of the body is to draw first the front leg, the arm, or the head. Then drop a vertical line down from the nose or top of the shoulder, and note where and what other body parts intersect this line. If you have drawn the front knee, you can draw a second line across the body to locate the other knee or other leg. Horizontal and vertical lines drawn across the drawing from one body part to another will help you locate the body parts. Fig. 8.26 illustrates the true proportions of the figure when it is square to your line of vision.

PLACING THE FIGURE IN SPACE

Correctly locating the figure in space is just as important to drawing as proportioning the figure itself.

When you draw a figure in space, carefully consider the relationship of the figure to the other objects in the drawing. The size of both the figure and the objects is important to consider. You have value, texture, line, and scale in your toolbox to use.

To locate and place the forms in a drawing artists work by moving their eyes between the model and the paper. In contrast, Rodin developed a different process. He focused entirely on the model, his hand moving without any visual monitoring. He drew his models without ever looking at his paper or worrying about any technical problems with line, value, scale, or texture. Nothing came between his sight and his feeling about the model's stance. Once he dropped his eyes from the model, he found that the energy flow stopped.

Rodin's drawings were Expressionistic, in which the technical measurements or perfect proportions either did not apply or were stretched to fit the artist's vision.

Mary Cassatt, in *La Lampe* (fig. 8.27), balanced the space of the picture plane in the manner of a Japanese print. The figure and the objects in the picture are without modeling and would seem flat but for the contour lines shaping the fig-

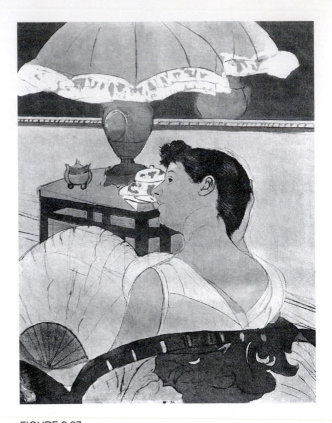

FIGURE 8.27
Mary Cassatt, American, (1845–1926), *La Lampe,* dry-point and aquatint printed in color. The Metropolitan Museum of Art, gift of Paul J. Sachs, (1916). Photograph, all rights reserved, The Metropolitan Museum of Art, © 2001 Artists Rights Society (ARS) New York/ADAGP, Paris.

ure and other forms. The rotation from light to dark values directs our feeling about the space of the room. The most important aspect of this print is how Cassatt balances the size of each form in the drawing. The woman occupies over one-half of the picture plane. The chair she sits in fills the entire front of the picture plane. The scale of the table is reduced and located in the back of the space, which follows the rule of perspective that things get smaller as they move away from us. The beautiful overlap of the figure's tilted head against the table insinuates that there is space in the room between the figure and the table. Cassatt also handled the lamp in an interesting manner. The lamp is at the back of the picture plane, but by adding the mirror with a reflection of the lamp, she has increased its presence, not decreased it. The balance of the space is controlled by the rotation of light to dark values from front to back, along with the fact that the chair, the fan, lamp, and mirror flow out of the picture plane off the edge. Thereby not closing the composition but creating an open composition.

Jean-Antoine Watteau was born in 1684 to a very poor family in Valenciennes, which had been annexed to France six years earlier. Watteau trained in studios that developed theater set designs and ornamental panels for Paris residences, using fashionable *chinoiserie* (Chinese motifs and qualities) and *singerie* (monkey and rustic motifs). His graceful, silken-clad figures appear to exist in a world somewhere between reality and make-believe.

Inspired by high society and theater, his work using elegant motifs for interior design precedes the Rococo. Watteau should be considered a prophet of the Rococo rather than a representative, for the Rococo movement as it reached its height in 1730, nine years after his death.

Watteau began his career by drawing from life in the public square. He would go to the square to draw the actors and performers, and like the artists Rembrandt, Daumier, and Toulouse-Lautrec, he recorded this small view of life removed from reality, capturing the essence in his drawings. Known as a "painter's painter," he was most appreciated by a small circle of close friends. Watteau broke with the classical tradition of Nicolas Poussin and Claude Lorrain by working out his compositions directly on the canvas—a method unheard of at the time. It was the Neoclassicists of the Davidian School whose scorn pushed Watteau's work into almost total oblivion. However, in 1712, he was elected an associate of the French Academy, an organization that officially recognized artists. He became a full member five years later, but in his lifetime he was not famous.

He drew constantly from nature. His practice was to keep his studies in a bound notebook. In addition to his nature studies, he had many elegant fancy-dress costumes in his studio and would dress up his friends to model for him. The use of costumes gave a more poetic dimension to reality for Watteau.

His deep love of music influenced his personal vision in his compositions. You get the feeling that the drawings were made for the sheer delight of drawing them.

It was from these studio sketches that Watteau would compose his paintings. He would select figures from the sketches and then place the figures in a landscape or background that he imagined. Rarely would he compose the entire composition in a sketch before painting it. His studies are usually detached figures or parts of figures, heads, hands, or details of costumes. The high quality of his finished work is a tribute to his extraordinarily sensitive perception (fig. 8.28).

In drawing, Watteau preferred to use the white of the paper for lightness and highlight rather than

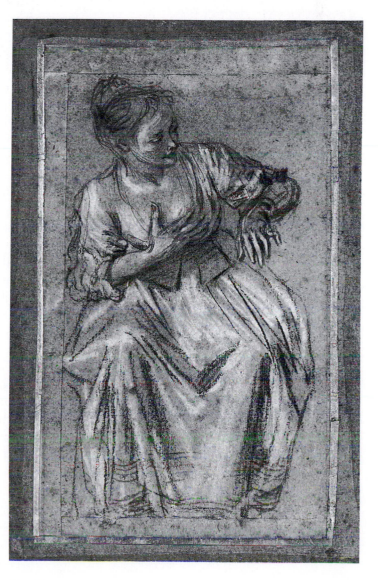

FIGURE 8.28
Jean Antoine Watteau, French, (1684–1721), *Seated Woman*, (1716–1717), black, red and white chalk, 9⁷⁄₁₆ in. × 5⁷⁄₁₆ in., (24 cm. × 13.8 cm.). The Metropolitan Museum of Art, Robert Lehman Collection, (1975). Photograph, all rights reserved, The Metropolitan Museum of Art, New York, NY. 1975.1.763.

touching up with white crayon, although sometimes the white crayon was necessary. He combined black and red chalk using pastel or gouache, but never pen and ink. As in fig. 8.28 he preferred drawing to painting, feeling that he could express the spirit and truth of the subject with his crayon better than with the oils. In the drawings there is a sudden turn of a charming head, the tip of a nose, or the rustle of drapery, which he communicated better through the directness of drawing.

Antoine Watteau's work had many of the qualities that we think of as French — subtlety, sensitivity, an awareness of the ironies and contradictions of life, all combined with elegance. To these you can add a complex, high-strung personality and a deeply poetic imagination.

DRAWING DRAPERY

There is a formula you can use to address the problems of rendering drapery. At first looking at drapery is overwhelming, but once you direct your study of the drape to a study of the planes, it is easier to draw drapery. When drapery is held against a wall with a pin, the folds radiate from that pinpoint, flowing out in a triangular shape as they drop to the floor. On the figure, drapery will radiate from the knee or the elbow in much the same way.

To draw a cloth, first follow the folds with a simple line drawing from the pin down. The folds can be mapped out in three planes, as seen in fig. 8.29. Your first decision is to determine where the top plane ends and the side plane begins. Imagine the palm of your hand lying on the top surface of a fold. When you must turn your hand to follow the drape back towards the wall, you have changed from the top plane to the side plane. The back plane begins when the drape touches the wall. When the top plane is white, the side plane is a gray value, and the back plane is a dark or black value. It is the rotation of light to dark values that creates the sense of volume in drapery.

Lili Xu's drawing in fig. 8.29 is a good example of how value changes create volume in a drawing of drapery. The white top planes radiate from the top narrow pin. The folds widen as they fall. Folds can turn under abruptly; when this happens, the side plane is eliminated, resulting in a white plane directly against a black back plane. It is hard to see where the folds in the drapery change planes. You must look carefully at the drape, and decide where to make the division: where to stop the top plane and to begin the side plane, and where the drapery rests on the wall. The light falling on the drapery does not always reveal gray and black. It is up to you, the artist, to translate the light into the grey and black planes to create the illusion of rolling folds on your paper. You decide where one plane ends and another begins.

Pirro Ligorio's *Seated Sibyl and Attendant Genius* (fig. 8.30) illustrates drapery following the planes of the figure in a clearly defined, almost exaggerated, way. The light falls first on the back of her dress, which is predominantly white with gray grooves. Value changes occur, from white to gray, where the back plane of the

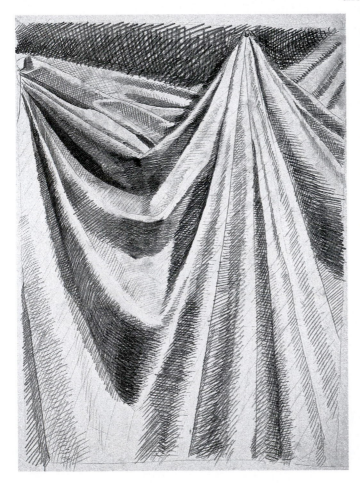

FIGURE 8.29
Lili Xu, black and white Conté on gray paper, still life (1999), student drawing, Oregon State University.

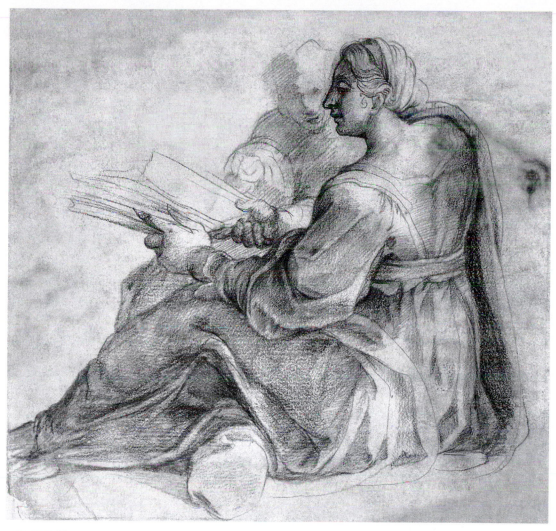

FIGURE 8.30
Pirro Ligorio, Italian, (1513–1583), *Seated Sibyl and Attendant Genius*, red chalk on beige paper. 9⅝ in. × 10⁷⁄₁₆ in., (24.5 cm. × 26.5 cm.). The Metropolitan Museum of Art, Gustavus A. Pfeiffer Fund, (1962). Photograph, all rights reserved, The Metropolitan Museum of Art, New York, NY. 62.120.7.

figure turns into the left side plane. The right side of the figure is rendered in dark planes under the cape. The top of the left arm which turns away from where the first light struck, is thus darkened. The folded drapery of the dress under the legs to the left has been darkened, creating a recessed space, that is set back.

Ligorio was a painter, an architect, and an antiquarian. He was the architect who followed Michelangelo in finishing St. Peters's Church in Rome. Noted for his highly plastic treatment of forms, which are reminiscent of Michelangelo's treatment, he created ponderous figures with monstrous hands clumsily attached to arms with grotesquely deformed wrists.

DRAWING EXERCISE 8.8
The Clothed Figure

For the first practice, draw clothed figures. Sit outside in a park or inside at a café, and sketch people sitting with their backs to you or walking by. Use value changes to define the shapes. Darken the undercuts and sides of the drapery, turning back or into the body. Leave the top planes white.

For the second practice, ask a friend to wear a white shirt and dark pants and then to sit for you. Make five- and ten-minute drawings, using a continuous line. Follow the folds and curves of the drapery, drawing with a free-flowing line. Let your eyes move up and down across the

shirt, taking in its shape. In a long pose, map out the figure and the major folds of the drapery on the shirt and the pants first. Follow with value changes added to the side and back planes.

For the third practice, place a glove on your hand, and draw your gloved hand. It will help you to understand drapery and underlying structure. First, draw a relaxed hand; then, draw a tense hand.

STRATEGIES FOR PORTRAIT, FIGURE, AND DRAPERY DRAWING

1. Warm up your hand and your eyes first with loose gesture drawings.
2. In figure drawing, draw from front to back by establishing the body part closest to you, and then add the other parts of the body onto the first by measuring where they intercept this first part.
3. Rub out and erase, leaving traces of the first lines to help you change the proportions.
4. In drapery, begin by mapping out the folds in terms of the planes they create as they fall. Divide the top plane from the side plane, and locate all back planes. Start with light hatching that flows from the side plane to the back plane, and then add another layer over the back plane.
5. In both portrait and figure drawings, the use of vertical and horizontal lines across the face or figure will be helpful in locating all the parts. In figure drawing, to find the actual location of the arms and legs, use vertical and horizontal lines drawn from the first established part, the nose, shoulder or knee. Drop a vertical line from the nose or chin, place a horizontal at the top of the front knee, and then sight across or down to where the other limbs and the chest align or intersect with these guidelines.
6. In portrait drawing, the first horizontal is halfway down the skull for the the placement of the eyes. The vertical line runs down the face through the nose to the chin and establishes a guideline to work from, locating and spacing the other features correctly.

ART CRITIQUE

Mary Cassatt and Willem de Kooning

In the history of drawing, the figure has clearly evolved from its foundation as pure representation of the human body, to possibilities beyond recognizable forms in modern art. The Impressionist drawing by Mary Cassatt (fig. 8.31) stands in sharp contrast to the Expressionistic drawing by Willem de Kooning (fig. 8.32). The formal elements of color, line, texture, and value changes are applied in both, but with a different concept and technique.

Mary Cassatt's drawing *Mother and Child* (fig. 8.31), which is realistic and softly hatched, is a pastel drawing of the figure in a more traditional composition. These two figures have a beautiful roundness and are locked together in a serpentine balance. You flow from the mother to the child and back to the mother. It is peaceful and tranquil. Cassatt's use of pastels steps out of the tight tradition as she draws through the plane, letting the pastels pass through the outside edges of the figure's form where they can mix in the background as well as on the figure.

In Willem de Kooning's *Two Women in the Country* (fig. 8.32) two women stand boldly side by side and forward in the picture plane. The relationship between the figures and the ground is ambiguous; meaning it is hard to tell where the ground begins and the figure ends. In Cassatt's drawing, the figures occupy most of the picture plane—she does not need a background.

The de Kooning drawing is composed of sharp angles and choppy lines. These figures are barely recognizable. De Kooning once said that he put all the body parts in the artwork but that they were just not in the right order. De Kooning pulled the anatomy apart, flattened it into shapes, and often pushed and changed some shapes to seem heart-shaped. He had a concept about the body that it had interchangeable parts and "intimate propor-

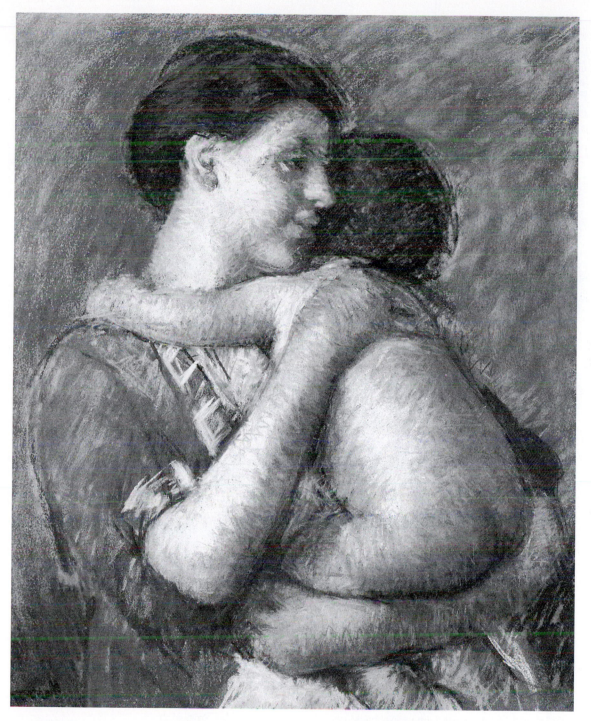

FIGURE 8.31
Mary Cassatt, American, (1845–1926), *Mother and Child,* (1914), pastel on wove paper mounted on canvas, 26⅝ in. × 22½ in., (67.6 cm. × 57.2 cm.). The Metropolitan Museum of Art. Bequest of Mrs. H.O. Havemeyer, (1929). The H. O. Havemeyer Collection. Photograph, all rights reserved, The Metropolitan Museum of Art, © 2001 Artists Rights Society (ARS), New York/ADAGP, Paris. 29.100.50.

tions," as he called them. Each part was given an emphasis that, carried to conclusion, became independent and equal in weight to all other parts, so that the thumb could become a thigh, which could become something else. The part could also become nothing—an abstract element.

Today, there is no one right way to draw. There is only drawing and exploring. It is neither

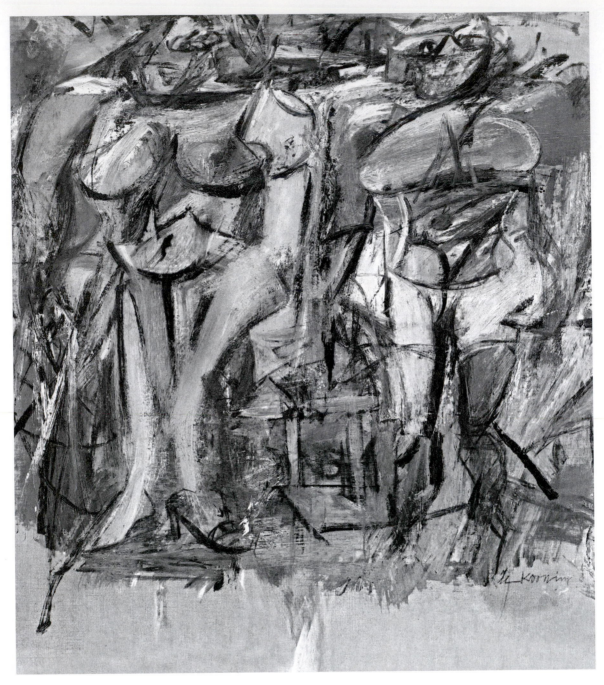

FIGURE 8.32
Willem de Kooning, (1904–1997), *Two Women in the Country,* (1954), oil, enamel and charcoal on canvas, 46⅛ in. × 40¾ in., (117.1 cm. × 103.5 cm.). Hirshhorn Museum and Sculpture Garden, Smithsonian Institution, Washington, D.C. Gift of Joseph H. Hirshhorn, (1966). © 2007 Willem de Kooning Revocable Trust/Artists Rights Society (ARS), New York, NY.

the formal elements nor the principles of design that determine the quality of the drawing. Cassatt used soft pastels to create drawings of women and children, whereas de Kooning used paint and oil sticks to deconstruct the figure and reveal a new way to see the figure. Drawing is the personal direction and expression of the artist. The ability of the artist to see a composition and develop it effectively has always relied on the artist's personal view.

Practice drawing figures and portraits in your sketchbook, but don't expect perfection. You are developing a stronger understanding of the figure. While I am in meetings, for instance, I will often make sketches with overlapping lines of the faces of the people across the table. I am relaxed, and I have no investment in the outcome of the drawing, I'm just scribbling. Remember that it is polite not to stare at the person whom you are drawing. Try to work from a quick glance at your subject.

To practice drawing drapery, select some of your heavier clothing, such as a sweatshirt, pair of jeans, sweater, or jacket, and fold and stack them up in a high pile. Using a 6B pencil with light pressure, draw the pile. This exercise is much like draw-ing a box with wavy sides. Let your line go around the contour, across the surface, and then into the stack. Where the fabric rolls into a groove, thicken the line to darken the area. Try hatching lines on the side planes for the gray planes. Rotate the values from a light top plane to a dark bottom plane, and perhaps a gray side plane.

Go out into the street for further figure studies, and let your drawings be as wide open as de Kooning's (see fig. 8.32). Try to get only the basic shapes and the biggest planes. Use the tip and the side of the pencil, or use a large black marker with a flat tip. When you return to your studio, cut up these drawings, and reassemble them into new compositions.

LANDSCAPE

Oscar Wilde once made the comment "nature imitates art." This is a statement that strikes people as backward, but he was referring to the fact that art awakens our perspective of the world around us. The atmospheric paintings of J. M. W. Turner, particularly his sunsets, are fine examples of what Wilde was refering to. It was only after Turner had painted these beautiful and somewhat abstract skies that people were heard to comment on a sunset, "Look, it's a Turner sunset." They may have previously let sunsets go completely unnoticed, but Turner's stunning paintings brought a new awareness to the people of the nineteenth-century improving their observation skills.

The late eighteenth century and early nineteenth century gave rise to the Romantic Landscape painters, John Ruskin, J. M. W. Turner, Thomas Girtin, and John Constable who took different approaches from their respective imaginations drawing and painting from nature. These artists shared a reverence for nature in which they were faithful and respective to the truth of nature. Nature for Constable was the fountain's head, the source from which all originally must spring. The sketch, for Constable, represented one state of mind. Constable's work was done "close to home," the images familiar. Most of his drawings and paintings were done of the English countryside, particularly the area around the valley of the River Stour in his native Suffolk. Turner's work is exotic, remote, and even alienating. Turner explored "the colors of the imagination." He was interested less in "the objects of nature than . . . the medium through which they are seen." It is as if the earth and vegetation dissolve in Turner's paintings into light and water, into the very medium—a gleaming oil or translucent watercolor—with which he paints them. It could be said of Turner that his is a mind that "feeds upon infinity," and that what he finds there is both the "dim" and the "vast."

In *Rhuddlan Castle* (fig. 9.1) Thomas Girtin used broad washes over a light pencil sketch as an under painting. The unevenness in the sky and water was the result of dabbing the wet wash with soft rags to lift it off. Girtin left the white of the paper for the lightest areas in the drawing.

John Ruskin, the nineteenth-century advocate of drawing from nature, was a prominent British aesthete and well-respected critic in the arts in Europe. His book *Elements of Drawing* was an influential manual and treatise for artists that was published in the mid–nineteenth century and read throughout the world of art. Ruskin argued for a kind of drawing for which the purpose was to "set down clearly and usefully, records of such things as cannot be described in words, either to assist your own memory of them or to convey distinct ideas of them to other people." For Ruskin, drawing was never a mere visual record of an object from nature — the drawing was almost that object's equivalent. Ruskin believed that drawing allowed the artist to obtain quicker perceptions of the natural world's beauty and that it preserved a true image of beautiful things that you see and must leave, or that leave you. *View of Bologna* (fig. 9.2) by John Ruskin records his observation of trees in Bologna, but at the same time you see a larger interpretation of the city of Bologna.

LANDSCAPE, WASH, AND WATERCOLOR

Wash is ink or watercolor diluted in water either with a large amount of water for the lightest wash or a small amount of water to maintain more depth in the color, and a darker ink wash. Compressed charcoal may also be diluted with water to make a wash.

FIGURE 9.1
Thomas Girtin, English,
(1775–1802), *Rhuddlan Castle,*
(1799), pencil and watercolor on
ivory laid paper, 287 mm. × 396
mm. Iris and B. Gerald Cantor Cen-
ter of Visual Arts at Stanford Univer-
sity. Museum Purchase Fund.
1971.35.

Watercolor is dependent on layers of wash. The artist Thomas Girtin was a master of wash and watercolor. Thomas Girtin was a contemporary of J. M. W. Turner in England in 1890. Unlike Turner, who belonged to the Royal Academy, headed by Sir Joshua Reynolds, Girtin's training was completed at the informal "academy" known as the Adelphi Terrace, the home of Dr. Thomas Monro. Girtin spent his time copying watercolors by John Robert Cozens from the doctor's collection. In this way, he developed his personal style. It was Girtin's sketching tours in Yorkshire and the Scottish Lowlands that further advanced his painting skills and personal style. The watercolors he brought back from these trips were large and energetic, noteworthy in the painterly handling of color. Instead of underpainting his watercolors in gray monochrome as the tradition dictated, Girtin laid in the main forms and the ground in strong local colors, resulting in an

FIGURE 9.2
John Ruskin, *View of Bologna,* (1845–1846), pen and ink and wash on paper, 343 mm. × 489 mm. © Tate, London, England. NO3507.

overall rich effect. Local color refers to the natural color. For example, most people perceive that apples are red and that trees are green — those would be local colors. There is a unique bond between drawing and watercolor with watercolor, between painting and drawing.

PROFILE OF AN ARTIST: *JOHN CONSTABLE (1776–1837)*

Landscape painting as we know it today emerged in the late-eighteenth and early-nineteenth centuries, culminating in the work of Constable and Turner.

Although landscapes in the seventeenth and eighteenth centuries had been in demand, this trend had particularly to do with wealthy patrons who wanted mere records of their country houses and grounds. For example, Canaletto, an Italian artist, spent nine years in England in the mid–eighteenth century, painting stately homes and gardens which at this time, were made in the studio, not from direct observation from working outside. These imaginary landscapes were based on traditional composition theories from artists such as the French artist Claude Lorrain. The wealthy British art patrons considered landscapes to be serions that were views of the Roman countryside or other Roman motifs by an artist who had an Italian name.

The Industrial Revolution and the growth of the city removed many people from an everyday experience with nature. The English poet William Wordsworth's *Lyrical Ballads* are a reaction against the urbane sophistication of the eighteenth century. Wordsworth promoted simplicity, direct feelings, and contemplation of nature. "The divine spirit is to be found in trees, meadows, flowers, mountains, and valleys," he wrote. This view corresponded with Constable's belief that the painter should "walk in the fields with a humble heart."

Unlike other painters, Constable felt no need to travel abroad for "real" or proper landscape subjects. Flatford Mill (fig. 9.3) was situated in the Stour Valley, a place very familiar to Constable. He refused to make scenes evoking lofty or melancholy sentiments. Instead, Constable declared that his art could be found under every hedge. He preferred to work

FIGURE 9.3
John Constable, English, (1776–1837), *Flatford Mill,* graphite on paper (watermark cropped at edges), 15.6 cm. × 9.5 cm. Acquisition, Sir Robert Clermont Witt, bequest (1952). Courtauld Institute of Art Gallery, London, England. D.1952, RW 2379.

FIGURE 9.4
John Constable, English,
(1776–1837), *Cloud Study,* pencil and
watercolor, 93 mm. × 140 mm. Iris
and B. Gerald Cantor Center of Visual
Arts at Stanford University. Museum
Purchase Fund. 1971.33.

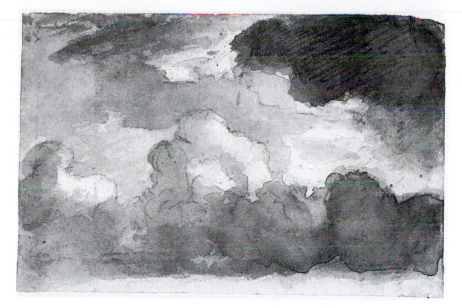

outdoors, following the example of his contemporary John Robert Cozens, whose work Constable felt was all poetry. J. R. Cozens was the watercolorist that Thomas Girtin copied when he was a student.

Constable painted the landscape where he grew up—in the country around East Bergholt in Suffolk, England. In a letter to a friend, Constable wrote of strong memories from his youth, "the sound of water escaping from the mill-dams, willows, old rotten planks, slimy posts and brick work—I love such things . . . They made me a painter, and I am grateful."

Constable developed his own visual language to respond to his passion for nature. He felt oppressed rather than exalted by mountains and preferred to relate his landscapes to the human scale. He drew the barges on the river Stour, the canals, the views of the mill, the church, and the wooded vale of Dedham. He loved the windy skies and made a series cloud studies in 1820. On the back of each sketch, he wrote the exact time it was drawn and the weather conditions at that moment. He called these notations "skying" (fig. 9.4). He did the same in a series of studies about trees (fig. 9.5). The changeability of nature kept him interested in exploring all aspects of his natural surroundings. To balance his drawings, he preferred to use a rich tonal

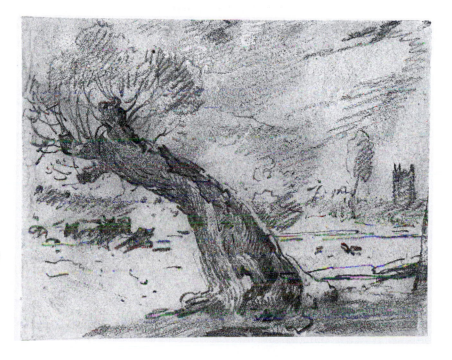

FIGURE 9.5
John Constable, English,
(1776–1837), *Landscape with pollard willow,* graphite on paper (watermarked - J WHA/ 18), 9.4 cm; × 10.9 cm. Acquisition, Sir Robert Clermont Witt bequest (1952). Courtauld Institute of Art Gallery, London, England. D. 1952.RW.4011.

contrast of black and white, an extreme application of chiaroscuro.

He would make small oil sketches on-site, and often before beginning a large six-foot painting, he would draw a full-size sketch in oil on a canvas of equal size. These large oil sketches are now considered some of his best work, yet they were never shown in his lifetime. Constable would exhibit only what he called "finished work." For Constable, the drawing was just a study for his paintings.

In his paintings his combination of rural labor and country life staged in glistening foliage, tremulous reflections in the stream, and the thickening clouds, sent a mixed message to Londoners seeing his work at the Royal Academy in London in 1821. Constable responded that "Londoners, with all their ingenuity as artists, know nothing of the feelings of country life, the essence of landscape." Constable combined an accurate observation of nature with a deep poetic feeling to express the sense he felt of life running through everything in nature. He set out to capture in paint and pencil the wind, the dew, the bloom, and the freshness. "Painting is with me but another word for feeling," he said.

WORKING OUTDOORS

Drawing *en plein air* ("out of doors") involves not only drawing from an ever-changing nature but also braving the elements, where you are subject to changes from hot to cold, plus wind and rain. It is important to set up a comfortable area in which to work. The artist Georgia O'Keeffe painted outdoors in New Mexico. She would load up her Model T car with canvases, paints, and brushes; bring along her maid; and go off painting and camping for three days in the desert. At Giverny, in France, Claude Monet would get up before dawn, have breakfast, and then his boatman would take him out to his painting raft, on his lily pond where four or five canvases stood waiting. Each canvas represented a certain hour of light. He would work on the first one until the light changed, then move to the second one, and so on, until noon when the light is the least interesting, so he went home for lunch. In the afternoon he worked on the large paintings in his studio that are now on display in Paris at Le Orangerie Museum.

For drawing outdoors, you need to prepare a small kit for carrying and storing your array of tools, brushes, pencils, charcoal, and ink. A portable easel

is handy. For wet media, you need a water container and a cup. Loose sheets of paper should be taped down to a board (or you may use watercolor pads where sheets, of paper are glued together on a hard board). These professionally constructed watercolor pads are convenient and easy to use. Bring a folding chair, or sit on the ground. If you plan to draw in charcoal, bring no-odor Blair spray fix, or tape a piece of newsprint over the drawing immediately after you are finished in order to prevent smearing. Don't forget to take some personal accessories, such as a hat, sunglasses, an umbrella, and some food and drink.

DRAWING EXERCISE 9.1
Composing Real Space

Drawing the landscape can be overwhelming at first, because there is too much information to choose from. It is important to focus on the space you plan to draw.

A viewfinder may be a handy tool for you to organize the space of the drawing. A viewfinder is a 12-inch square piece of cardboard with a one-inch rectangle cut out of the center. By looking through the opening, you can select a part of the landscape to work with in your drawing. You may also frame information by using your hands to block a view. Once you know the parameters of the drawing, select a number of different strokes and marks to represent the trees and grasses. Loosely map out the space of the drawing so that you can fill it in later without looking through the viewfinder. In Blechen's drawing (fig. 9.6) he has focused on a group of standing trees with the downed trees laying nearby.

The area behind the trees is very unclear. Black and gray strokes merge with one silhouette of a tree in the back of the picture plane. The vague space is created with value changes of light to dark marks. Plan your landscape drawing with areas in full focus and areas that are very hazy or not in focus.

PICTORIAL ELEMENTS IN LANDSCAPE

The way in which an artist structures space indicates the underlying visual logic of a drawing. Analyzing this logic will help you understand how artists work. As an artist, you want to train yourself to see with greater clarity and to consciously di-

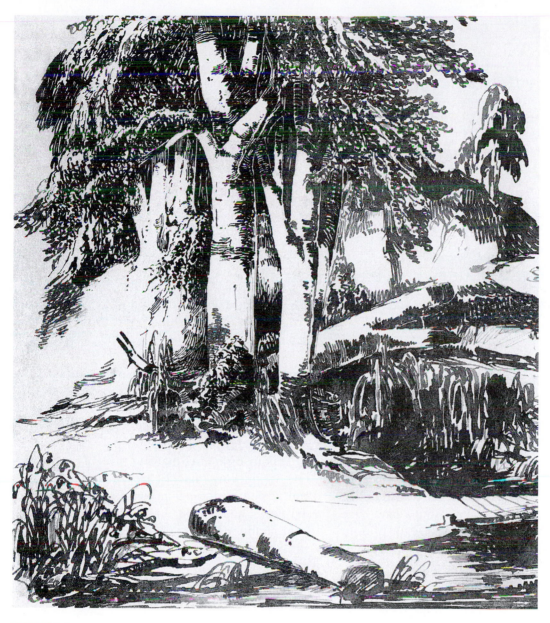

FIGURE 9.6
Karl Blechen, German, (1798–1840), *Birch Trees at a Stream,* (c. 1835) pen and gray and black ink on buff wove paper, 245 mm. × 218 mm. Iris and B. Gerald Cantor Center of Visual Arts at Stanford University. Committee for Art Acquisitions Fund. 1989.62.

rect the placement of all elements in the picture plane.

Karl Blechen's ink drawing *Birch Trees at a Stream* (fig. 9.6) was executed in heavy pen strokes made with a reed pen. Note that the hatching is rounder and softer when made with a reed pen. The marks define the side plane of the trees, leaving large light front planes. Additional painterly pen strokes create the grass and the leaves. His strokes are loose, keeping a sense of airiness in the drawing.

The strokes change size, some thin, some thick, some curved. This change in the size of the mark works to create a sense of space. Marks that are all the same size will flatten space in the picture plane. To create the illusion of light coming through the branches of the trees and the ground grasses, he has left white space between the ink marks. He has balanced the drawing by placing small black marks and dense areas of ink at the top of the drawing, which are juxtaposed against the full white ground below.

FIGURE 9.7
Robert Birmelin, American, (1933–), *Fantastic Mountain Landscape,* (1954), pen and black ink, 5¼ in. × 5 in., (13.3 cm. × 12.7 cm.). Yale University Art Gallery. Transfer from the Yale Art School.

COMPOSITION

When you begin to draw a landscape, pay close attention to the linear details in nature, and look carefully at the size and shape of your subjects. Consider the placement and relationship of each form one to another. The scale of the picture is controlled by the size of the forms in the front, middle, and back of the picture. Composing a landscape means that you must determine where the horizon is placed. The balance of the picture is heavily dependent on the horizon and the vanishing points.

The Rembrandt drawing *Two Cottages* (fig. 9.8) has a completely different quality. Rembrandt creates a quiet, still, and peaceful mood by placing the horizon conventionally in the middle of the page, with the vanishing point to the left. The contour line composing *Two Cottages* is loose and gestural. The forward placement of the cart, loosely described in flowing lines, creates space in the drawing as it sits well in front of the cottages, establishing the plane of a road between it and the cottages. The use of overlapping shapes creates the illusion of space and depth in this drawing.

Both Birmelin's drawing (fig. 9.7) and Rembrandt's drawing (fig. 9.8) are pen and ink, an excellent choice of medium for making a landscape drawing. The ink line can be a single light or dark contour line, or it can be used in overlapping strokes of hatching or gestural strokes to model the forms. For instance, the tree in the middle of Rem-

FIGURE 9.8
Rembrandt Harmensz van Rijn, Dutch, (1606–1669), *Two Cottages,* (c. 1636) pen and brown ink, corrected with white chalk and/or body color, 5⅞ in. × 7½ in., (15 cm. × 19.1 cm.). The Metropolitan Museum of Art, Robert Lehman Collection, (1975). Photograph, all rights reserved, The Metropolitan Museum of Art, New York, NY. 1975.1.801.

brandt's cottages (fig. 9.8), has been framed by a fence. The fence overlaps the tree, visually pushing the tree back into the picture plane a little. Note, too, how the front porch of the cottage on the left has been substantially darkened with hatching lines, but even in that darkness, you still recognize two figures in the doorway. On the roofs, Rembrandt's line is so gentle you can feel the thatched roofs sagging. Line represents much more than an outline in this drawing. It creates weight, mood, value, and space. It is the same in Birmelin's drawing fig. 9.7 *Fantastic Mountain Landscape*, the drawing marks composing the picture plane are not calm, but tense and anxious. The drawing has an overall feeling of nature in action.

VALUE

Value is important in landscape drawing because it directs the viewer's eye through the space of the drawing. Light to dark values are manipulated to balance the picture arbitrarily, or you can decide to record the light as you see it falling on your subject. Rembrandt's drawing is based on his knowledge of light, but it is not a record of actual light. The white roof is balanced against the black roof. The receding spaces are further darkened, to direct the viewer's eye in and out of the picture. Rembrandt's value changes draw the eyes through the composition, with the light and the dark creating space and depth. If you use only one value, it tends to flatten the space of the drawing.

DRAWING EXERCISE 9.2
Working (en Plein Air) in the Open Air

Take a sketch pad outside, with a drawing tool such as a roller ball pen or other kind of pen. Select a group of houses in your neighborhood as your subject. Organize and map out the space of the drawing with a light line sketch. Consider the location of the horizon at the beginning. Draw from front to back, starting with a tree or a house in the front of the picture plane. Continue adding the houses and trees, one behind the other, to the horizon. Once you establish the first form, such as a tree in the foreground, the scale of the drawing follows this first form. You may draw a light line from the top of the first form and from the bottom to the horizon to help with scaling. After you

have established the components in your drawing, separate the planes of the houses, trees, and positive and negative spaces, using light to dark values. Values will be lighter at the horizon and darkest in the foreground. Look at the sky, and determine how to create the texture of the air. Revisit the discussion on Girtin's dabbing (fig. 9.1) to create the clouds. Allow yourself to use gesture lines, especially for the trees and plants. You may prefer to follow using simplicity in organizing the planes (Robert Birmelin in fig. 9.7, Fantastic Mountain Landscape.

TEXTURE AND PATTERN

Landscape at Eragny-sur-Epte (fig. 9.9), by Camille Pissarro, is a watercolor over traces of graphite. Pissarro painted it at a house he lived in with a garden and a field, about two hours from Paris. Pissarro placed great emphasis in his drawings on working from direct observation of nature, studying the weather as well as the changes of light though the day and through the seasons. His work had a certain compositional rigidness, which may be credited to his use of complementary colors (red and green, violet and yellow, and blue and orange). Complements create the greatest vibration when placed side by side, so they can both push each other to vibrate visually, or if they are the same value, they will visually read the same. Pissarro had met the two pointillists Georges Seurat and Paul Signac in 1885. Pointillism is a painting process in which dots of color are placed side by side to build the forms in painting without an outline or solid shapes. In addition, the white ground of the canvas is left, or white is added between the dots to create the shimmering effect of light. The thinking was that if the dots are concentrated, a third color will develop from the relationship and placement of the dots. For example blue, placed next to yellow in pointillist theory will create green. When colored dots are placed far apart, a certain airiness occurs, and color mixing is impossible. This process is related to stippling, the process of drawing with dots. Stippling in color creates an overall texture in the artwork and may graphically describe light.

DRAWING EXERCISE 9.3
Pointillism

Select as your subject a grove of trees in a park or a row of trees on a street or in a yard. Draw a border on your paper to frame the picture plane. Framing the picture plane

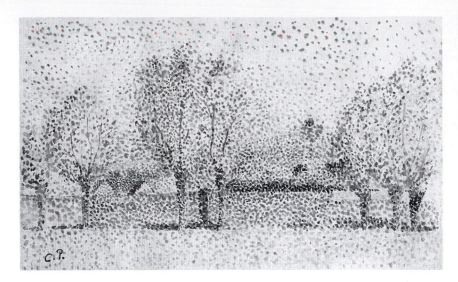

FIGURE 9.9
Camille Pissarro, (1830–1903), *Landscape at Eragny*, watercolor, 7¾ in. × 9⁹⁄₁₆ in., (184 mm. × 230 mm). The Thaw Collection. Pierpont Morgan Library, New York, NY. Photo credit: The Pierpont Morgan Library/Art Resource, New York. ART 149947.

is always a good way to start. In this way, you know where the borders are for your picture. In your mind, frame the area you will draw. After you lightly map the areas of the drawing in graphite, use a pen or fine-point small brush and ink wash to construct a drawing with dots. You may need to use several cups of water, because the more water you mix with the ink, the lighter the value. Begin with a light value in the sky, and place the dots far apart. Work from the background to the foreground, using the ink wash. Then you may want to change to your pen to make smaller, closer dots in the foreground. Use ink dots to develop the entire composition, thinking carefully and experimenting with how you will place and space the dots in the picture plane to create light and dark areas.

DRAWING FROM THE IMAGINATION

To work from your imagination, you must have control of the media. Girtin's drawing (fig. 9.10) is a fine example of his well-developed sense of scale, placement, use of value, and understanding of his media. Thomas Girtin, in 1890, after studying at the Monro Academy at Adelphi Terrace in England, joined a sketching society in London. It was often referred to as Girtin's Sketching Club, because he was the leading artist of the group. The members would meet, choose a topic for the evening, and invent a painting to reflect that topic. They usually selected a "poetick passage," lines of poetry from poets like James Thomson, a Scottish poet who was best known for four poems entitled *The Seasons*,

written in the 1800s. Each of his poems reflected on the sublime power of nature. There, the artists found inspiration for the painting done that night.

On a different evening gathering at the home of Robert Ker Porter, Girtin drew *The Eruption of Mount Vesuvius* (fig. 9.10), confirmed on the back of it by the note "Drawn in the House of R.K.P., 1800." According to the rules of the sketching society, the drawings were given to the host at evening's end. Curiously, the society's records show that this session was held in 1799, so it is possible that Girtin re-created the marvelous work we see here, or that the inscription was added later and the date remembered incorrectly.

Either way, the scale of the drawing is extraordinarily stunning. The large ground plane of a body of water in the foreground is balanced against Mount Vesuvius. In this unique spatial experience, a small village sits at the base of this very large mountain. The powerful explosion does not seem violent, but rather, at this stage, spectacular. Girtin's manipulation of light and dark on and around the mountain is very dramatic. The drawing is concerned with Girtin ultimately expressing his attitude toward form. Always consider what is important about your drawing. What are you trying to say? Think about what to emphasize and what to reduce in the drawing to control the purpose of the drawing.

SEASCAPE

Rendering water is a complex problem. Water is moving and at the same time transparent. The surface of water reveals reflections, and in really clean

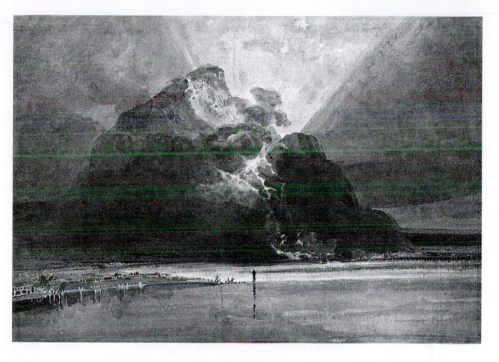

FIGURE 9.10
Thomas Girtin, English,
(1775–1802), *The Eruption of
Mount Vesuvius,* brush and
gray wash over some pencil.
The Thaw Collection. Pierpont
Morgan Library, New York, NY.
Gift of Mr. and Mrs. Eugene
Victor Thaw. Photo credit: The
Pierpont Morgan Library/Art
Resource, New York, NY. ART
149933. (1996.147).

water, you can see the bottom of the river or pond at the same time you are looking at the top of the water.

Marsden Hartley, in *Rocky Coast* (fig. 9.11), uses strokes and gestures to build the mountains that reach out into the ocean, but he leaves the water without embellishment. Seascapes, like other landscapes, utilize textural marks to create the land forms and water areas. The quality of the line, the thin and thickness, are important elements of seascape drawings. Turner's *The Pass at Faido, St. Gotthard* (fig. 9.12) is one way to render water. Vija Celmins modernizes drawing water in *Untitled 1970* (fig. 9.18).

FIGURE 9.11
Marsden Hartley, American,
(1887–1943), *Rocky Coast,* (1941),
crayon on paper, 33.3 cm. × 40.7 cm.
Portland Art Museum, Gift of Suzanne
Vanderwoude. 80.119.

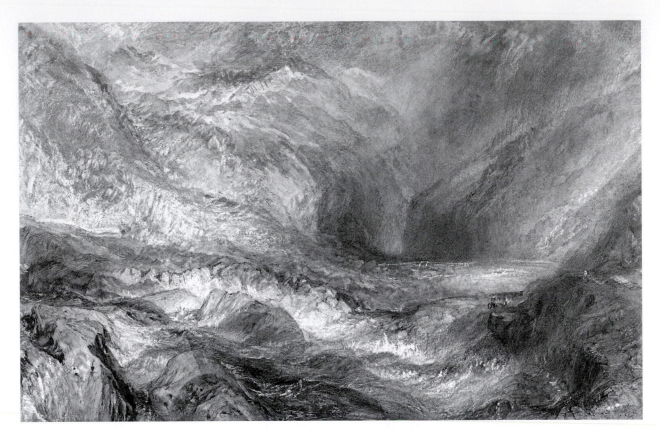

FIGURE 9.12
Joseph Mallord William Turner, (1775–1851), *The Pass at Faido, St. Gotthard,* watercolor, point of brush, scratching out over traces of pencil, 11¹⁵⁄₁₆ in. × 18½ in., (303 mm. × 469 mm.). Pierpont Morgan Library, New York, NY., The Thaw Collection. Photo credit: The Pierpont Morgan Library/Art Resource, New York, NY. Art 149926.

 DRAWING EXERCISE 9.4
Drawing Reflections

Practice drawing reflections by placing objects on a mirror that is lying flat on a table. The reflection appears directly below your subject as it would if the mirror's surface were a water line. The angle at which you view the object will change your perspective. Place the table below your horizon to draw the object and its reflection, and then move your drawing position back, and draw the scene again from a distance. Note the changes in the relationship of the object to its reflection. Draw with an ebony or a 6B pencil to draw with. Once you have established light and dark areas and covered the dark places in graphite rub the surface completely with a piece of newsprint. Then use your eraser to cut horizontal breaks through the outline of the reflection. Rubbing and erasing is a good process for creating the texture of water and reflections.

J. M. W. Turner's drawing (fig. 9.12) is not a seascape, but it is a drawing of a river in the pass at

Faido, St. Gotthard, in Switzerland. Turner made this drawing during one of his six trips to Switzerland, in which he filled many sketchbooks, recording what he saw. At first, he made only monotone notations and drawings in pencil or wash on gray paper. But in 1836, he introduced touches of color to his drawings, and by 1840, he was using watercolor. Turner showed these studies to his dealer, Thomas Griffith, but they generated little interest until his patron, John Ruskin, reproduced this watercolor as an etching in his book *Modern Painters*. Turner used these sketches later as references for larger paintings that he completed in his studio in London.

In *The Pass at Faido, St. Gotthard,* Turner has focused our attention on a rush of water over rocks. The river merges with the sky and the mountains. Here, Turner is at his best, evoking the overwhelming power of nature and giving form to the concept of the sublime, a sense of immensity beyond description or comprehension, suggesting the vast unknow-ability of God. Nature is an awe-inspiring force, and Turner's drawing is as much an

FIGURE 9.13

Giovanni Battista Piranesi, (1720–78), *The Temple of Isis at Pompeii,* quill and reed pen in black and some brown ink, black wash, over black chalk; perspective lines and squaring in graphite; several accidental oil stains, 20½ in. × 30½ in. The Thaw Collection. Pierpont Morgan Library, New York, NY. Gift of Mr. and Mrs. Eugene Victor Thaw. Photo credit: the Pierpont Morgan Library/Art Resource, New York, NY. 1979.4.

invention as it is an accurate rendering of reality. *The Pass at Faido* has been expanded and enhanced. It is so rough that you hardly see the small figures and their carriage at the lower right. Someone dares to travel this route?

 DRAWING EXERCISE 9.5
Drawing Water

Select a body of water to draw—the ocean, a river, a lake, or a pond. Use Bristol board for this exercise because it is slick and smooth. Use a soft graphite pencil of 4B or an ebony pencil. Using light pressure and the side of the pencil, follow the flow of the water, making layers of lead lightly on the Bristol board. Wave the line over the board to reflect the directions in which the water moves. Now, gently rub the surface with newsprint, and use a plastic or kneaded eraser to remove the lighter areas. A stump, a rolled paper stick, can be used to create light and dark marks. With a stick, scratch some texture into the surface; be careful not to rip the paper. Make a light ink wash, and lay it over the darkest areas of the water, using small strokes with a soft, flat brush. Consider the effects you have achieved, and continue experimenting. Water is not drawn so much as it is created by layering the media.

CITYSCAPE AND INDUSTRIAL LANDSCAPE

Giovanni Piranesi's drawing *The Temple of Isis at Pompeii* (fig. 9.13) was done on-site. In the 1770s, Piranesi took a number of trips to the ancient ruins around Naples to study and draw them. He considered publishing them as a series of etchings. With this in mind, Piranesi studied the temple and its sanctuary from every point of view. He used linear perspective and the devices of converging lines to the horizon, diminishing scale, and overlapping forms to create the illusion of this space. He developed the darker values with vertical hatching lines and used horizontal lines for the shadows.

Ludwig Meidner's *Industrial Landscape* (fig. 9.14) is considered an Expressionistic drawing. Meidner worked with the German Expressionists in Berlin. His drawing is a symbolic interpretation of an industrial landscape with the forms exploding virtually out of perspective. Expressionistic drawing grew out of a time in Germany when life was very chaotic and unsettled. *Industrial Landscape* reflects both the artist's emotional temperament and society's anxiety as the prospect of war grew. In the early 1900s, countries such as

FIGURE 9.14
Ludwig Meidner German, (1884–1966), *Industrial Landscape,* (1913), soft pencil with areas of turpentine wash (/?) on ivory wove paper, 465 mm. × 590 mm. Committee for Art Acquisitions Fund. The Iris and B. Gerald Cantor Center of Visual Arts at Stanford University. 1983.87.

Germany, where Meidner lived, saw explosive growth in the cities, as great industrial complexes and mazes of railroad tracks burst on the scene. Meidner believed in the necessity of creating an art of one's own time: "Let's paint what is close to us, our city world! . . . the wild streets, the . . . iron suspension bridges, gas tanks . . . the roaring colors of buses and express locomotives . . . the drama of a factory smokestack." An almost painterly quality results from the rubbed soft pencil, but Meidner often used a reed pen, making the thick lines and heightening the mood of anxiety. His angular, slashing strokes are characteristic of the German Expressionist style.

EXPRESSION AND ABSTRACTION IN LANDSCAPE

Abstraction is a style of drawing that is nonrepresentational. The artists' work often refers to the way that the artists feel about their subjects. The drawing mediums are the same as those used in Realism. The drawing techniques of line, gesture, and chiaroscuro (balance of light and dark) are all used in abstraction. Abstract drawings use a simplification of shape, plane, and space. In Cubism, an early form of Abstraction, the space was flattened, and the objects, which were reorganized as shapes, were placed in the composition in pieces, all shifted off center. The patterns in Cubism could be real or invented. Foremost in early Abstraction was the flattening of the picture plane. Perspective was abandoned, but not space. Space stayed, as shallow space or flat space. Space is created with overlapping strokes and shapes, whose size and relationships to each other and the ground are important to the composition.

Mark Rothko was an Abstract Expressionist, a member of the New York School in the forties and fifties. In Rothko's drawing *Untitled* (fig. 9.15), you see a symbolic representation of landscape. The structure of brushstrokes in the foreground lends itself to a sense of looking through something, perhaps trees and bushes. The three small marks in the white opening have a figurative sense about them, and the wavy lines at the top of the picture seem to imitate clouds. They seem to rest above a hill line. Since the drawing is "Untitled," there is no way to know whether Rothko's forms are from landscape or whether this is a work of pure abstraction, composed of marks that either represent nothing but the marks on white paper or represent an Expressionist gesture by the artist working from memory.

FIGURE 9.15
Mark Rothko, American, (1903–1971), *Untitled*, (1967), acrylic on paper, mounted on masonite, 8 in. × 10 in. Gift of the Mark Rothko Foundation. The Portland Art Museum, Oregon. © 2007 Kate Rothko Prizel and Christopher Rothko/Artists Rights Society (ARS), New York, NY. 85.128.1.

A CONTEMPORARY APPROACH TO LANDSCAPE

Cai guo-Qiang (pronounced si guo chiang) created the large-scale drawing (fig. 9.16) *Bigfoot's Footprints: Project for Extraterrestrials No. 6* by igniting gunpowder on paper. Guo-Qiang's creative process harnesses seemingly destructive forces and challenges the conventions of time and space within which we expect artwork to exist. For *Bigfoot's Footprints: Project for Extraterrestrials No. 6*, he used solute shells embedded with computer chips in the paper. For the Footprints in the sky traveling to-

ward the sculpture Garden. Fig. 9.16 he scheduled the event for dusk on the appointed date of an opening at the Hirshhorn museum, and it was to last three minutes. Starting from the circular courtyard of the Hirshhorn, giant footprints would appear in the sky (fig. 10.1), traveling toward the sculpture garden. They would then circle around the Washington Monument, crossing the sky over the Freer and Sackler Galleries and The National Museum of African Art. Here at their destination, they would disappear into the night. Part of this piece is a strong gesture on the final theme of conversing with the unseen. As an additional piece to

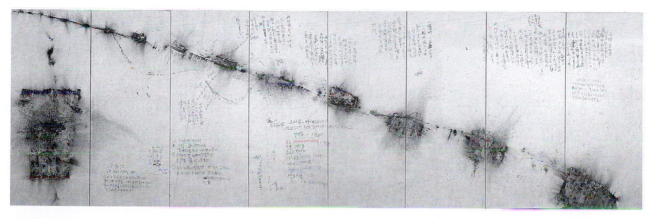

FIGURE 9.16
Cai Guo-Qiang, *Bigfoot's Footprints: Project for Extraterrestrials No. 6*, 200 cm. × 680 cm. 2002 Project proposal for the Hirshhorn Museum and Sculpture Garden, Freer Gallery of Art, Arthur M. Sackler Gallery and National Museum of African Art. Smithsonian Institution, Washington, D.C.

this project he conceived of pyrotechnic displays that he intended to be seen by alien beings occupying a heavenly vantage point. Cai Guo-Qiang wanted to remind people that there are larger questions that they could be asking. Unfortunately, The Footprints in the Sky, fig. 9.18 is an unrealised project. The color photograph of this project is in Chapter 10, fig. 10.1.

Since 1989, the artist has orchestrated explosion events that fill the sky or alter the appearance of architecture and landscapes with fire, sparks, and smoke. He feels that the large scale of his work is part of his heritage. Everything China does is big—for instance, the Great Wall. In addition, the materials drive the scale of the drawing because gunpowder has a volatile nature. A small project or small artwork does not allow this material to be what it has to be. There must be room for it to reach its full potential. Guo-Qiang thinks of the explosion projects as drawing in space—drawing not on a

FIGURE 9.17
Cai Guo-Qiang, the artist, with an assistant.

two-dimensional surface, but in four dimensions, including space and time. His gunpowder drawings act as enduring studies for the ephemeral displays or evocative visualizations of ambitious projects that could not be realized. To date at least eight proposals have been unfunded for various reasons. To create these drawings requires working with a team of assistants. The paper is laid on the ground (fig. 9.17), after which the artist carefully arranges mounds of gunpowder in patterns on the large sheets of paper. To alter the mark and to vary the effects made by the gunpowder, he will add swatches of cardboard or heavy stones on the paper. The stones must be removed quickly after the explosion to prevent them from burning a hole in the paper. The resulting drawing is a scroll covered with striking marks and charcoal streaks. In some ways, it is as delicate as Chinese brush calligraphy and as bold as the action painting from The New York School.

The way that Cai Guo-Qiang moves while working reminds you of Buddhist monks' creating a sand painting or a mandala. He moves quickly, placing patches of colored pigment or gunpowder on the paper's surface (fig. 9.17). This combination of chaos and composition is much like the fusing of traditions—Chinese and Western, Tao and Expressionism—into a work of art illuminating the best of both. His use of gunpowder has a dual role: it reflects both celebrations and warfare. Cai's use of gunpowder and firecrackers is also a reaction to the didactic style of artistic output required during his training under China's Cultural Revolution; this rigid training taught him how sound, light, and special effects can have an impact on an audience. These are the very components that he relies on for the reception of his gunpowder drawings.

He was nominated for the prestigious Hugo Boss Prize by The Guggenhein Museum in 1996, and he won the Golden Lion at the 48th Venice Biennale.

STRATEGIES FOR LANDSCAPE DRAWING

1. Find a comfortable place to sit and work outside.
2. Select a section of the landscape within your view that will be manageable.
3. Try working from the foreground shapes to the background shapes.
4. Manipulate the values in your drawing from dark values in the foreground to light values in the background.
5. In a second drawing, reverse the values to light values in the foreground and dark values in the background.
6. Explore various sizes of marks to indicate the textures in your landscape.

ART CRITIQUE: VIJA CELMINS AND CHRISTO

Vija Celmins' *Untitled 1970* (fig. 9.18) is a drawing of a section of a larger ocean. Her realistic close-up focuses your attention on the surface of the waves and the motion of the water. This is a photo-realistic drawing, but it is at the same time elusive. Your eyes cannot hold on to any one wave; the pattern is so repetitious you can take in the entire surface at one glance, and yet you keep looking into the drawing. She has so perfected her technique that is it difficult to identify the medium she used to create the surface. Celmins' use of value change is subtle. Her range of value is close, not in high contrast or from either end of the value scale. It is more from the middle of the scale. This drawing is pencil on an acrylic ground.

In the drawing, *Wrapped Reichstag, Project for Berlin,* Fig. 9.19, Christo has combined images to create a collage, or narrative about the project. The Reichstag is drawn as he envisions the building will look when it is wrapped. His use of light and dark to create the folds covering the entire surface of the building along with his use of shadow on the side planes of the building, the forms on the roof, and the right tower establishes this building as a volume. It is not flat.

Above the drawing of the Reichstag he has used two aerial photographs, a line drawing and an actual piece of the fabric that he will use to wrap the building. Despite real differences between these

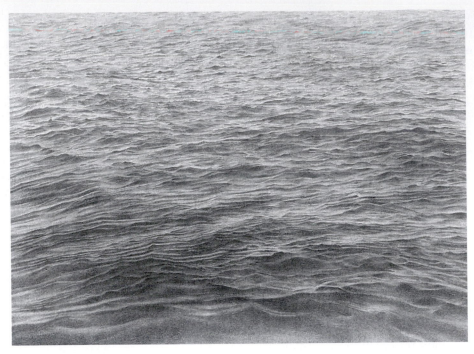

FIGURE 9.18
Vija Celmins, *Untitled,* (1970) pencil and acrylic on paper, 12¾ in. × 17½ in., (32.4 cm. × 44.5 cm.). Collection of the Modern Art Museum of Fort Worth. Museum purchase, The Benjamin J. Tillar Memorial Trust, (1972).

drawings Celmins' has enhanced what at first might have been considered an uninteresting view and Christo has combined aerial photographs, line drawing, and a two-point perspective drawing below the horizon to illustrate the project. Both drawings depend on the use of value and value changes to create the image for the drawings. It is the use of value changes that generates interest for both drawings.

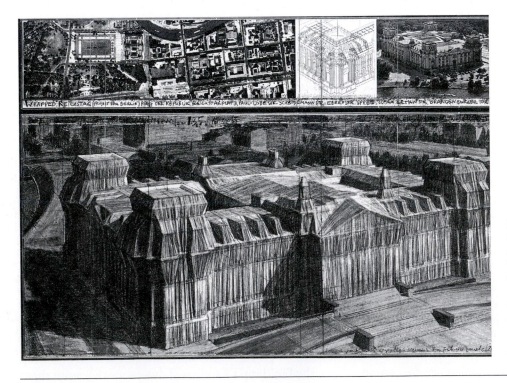

FIGURE 9.19
Christo, *Wrapped Reichstag, Project for Berlin* (1995), in two parts: 15 in. × 96 in. and 42 in. × 96 in., (38 cm. × 244 cm. and 106.6 cm. × 244 cm.), pencil, charcoal, pastel, crayon, fabric sample. Photograph and aerial photograph by Wolfgang Volz. © Christo (1995).

As you can see from these the drawings by Celmins and Christo, one of the most important aspects of landscape drawing is the point of view, or the focal point. Success in landscape drawing depends on how the artist stages the space and the viewpoint. Instead of the horizon in the middle of the paper, it can be at the bottom as you look down on your subject from above. Consciously seek a perspective totally different from the most obvious one. Your point of view expresses your relationship to your drawing and the space you choose to depict.

Try practicing drawing a landscape by looking down on your subject. Try to be loose in establishing the planes of your subject with values, from light to dark. For a second drawing, select a very small, specific area, and create the texture in the space of that area. You may want to start with ink wash, placed lightly over layers of rubbed and erased graphite pencil. For a third drawing, use charcoal pencil, rub it, erase it, and add an ink wash. To start coat your paper with a smooth layer of white acrylic, let it dry, use pencil with rubbing to see whether you can re-create a little of Celmins's water effects.

You should experiment with different media and different layering practices in your sketchbook. Next, experiment with scale in your drawing. Draw a tree from the top to the bottom of the page, and then add in the forms that recede behind it. Reverse that process by drawing the trees or the mountain in the background and coming forward, overlapping the foreground onto the background. These exercises will help you think about the space and ways to manipulate the drawing space.

COLOR AND MODERN ART

Until the end of the nineteenth century, the general consensus was that the basic skills of good drawing were an ability to create lifelike imitations of nature, a technical expertise in controlling the media, and an extensive knowledge of ancient art. The Renaissance art historian Vasari, in his book *Lives of the Artists*, described draftsmanship as "the imitation of the most beautiful parts of nature in all figures." Absolute accuracy, precision, and hand-eye coordination characterized drawing in the High Renaissance. Over the course of the next four centuries, drawing continued to be a process of realistic renderings that served mostly painting as the plan. By the end of the nineteenth century and the beginning of the twentieth century, avant-garde artists cast off the tyranny of this classical tradition. New attitudes toward nature and new approaches to the picture plane, the subject, and the purpose of drawing replaced the long-established techniques and styles of the past. Drawing ceased to be preparation for a large painting. Imitating nature was no longer enough.

Cai Guo-Qiang's *Bigfoot's Footprints: Project for Extraterrestrials No. 6*, (fig. 10.1) would start in the sky from the circular museum courtyard in the Hirshhorn, giant footprints would then appear in the sky above, traveling toward the sculpture garden, above the mall, to the Washington Monument, circling it, then making the sky over Freer, Sackler, and The African Galleries their destination. At this point they would disappear into the night, but not before they united these three galleries. To make the footprints, mortars are grouped together to form the shape of a footprint: 3-inch solutes are loaded into the mortars. When ignited, they will burst open at 150 meters in the air, forming a 100-meter long footprint of light that will last approximately 2–3 seconds. Computer chips are embedded in each solute shell, to ensure precision and safety. The entire journey will be made up of

50–60 footprints, taking place over 3 minutes of time. Cai Guo-Qiang first conceived of this idea in 1990 after the fall of the Berlin Wall. He proposed Giant Footprints take place on the grounds that bordered the two sides of the wall. He imagined that an invisible giant walked across borders without restriction, leaving only his fiery footprints behind. Guo-Qiang's strong gesture follows his idea of conversing with the unseen.

In the 19th and 20th centuries color became a player in drawings. The drawing was no longer just a plan for a painting and the color no longer just a brown sepia tone: red, yellow, and blue began to appear first in Cubist *compositions* followed by modern to contemporary, artists.

Betye Saar's *Mother and Children in Blue*, (fig. 10.2,) appears to be a family portrait from the late 19th century or early 20th century. The photo of the family has been colorized either in the original or by Saar in this drawing. The top torn edge of the photo rests on a faux wallpaper background as well as do the sides of the image where papers have been added. Even with Saar's manipulations the drawing maintains a sense of age, of being old and authentic, not produced as mixed-media collage by a contemporary African-American artist.

SEEING IN COLOR

Color alters the way we see and changes the space more than any other formal element in drawing. It can often overwhelm our senses, causing us not to see clearly. The way our eyes function is extremely complex. Some researchers have expressed a theory that the eye is so powerful that it seems to have its own small brain. We know that when the nerve cells in the retina of the eye are stimulated, we see patterns of light at various intensities, and we see color. Our eyes process these patterns, separating

FIGURE 10.1
Cai-Guo-Qiang = Traveler, Unlucky year = unrealised projects from 2003–2004, *Bigfoot's Footprints: Project for Extraterrestrials No. 6.* Project proposal for the Hirshhorn Museum and Sculpture Garden, Freer Gallery of Art, Arthur M. Sackler Gallery, and National Museum of African Art; Smithosonian Institution, Washington, D.C.

light and dark while also defining edges, contours, and sizes. In this way, we can separate objects in space to perceive the entire space.

In previous chapters, studies of chiaroscuro (the way light falls on the planes of forms) defined for us the interplay of light with objects and surfaces. In color drawings, tone and value will again play an important role. Color and mass can together create the feeling of weight in the drawn image.

FIGURE 10.2
Betye Saar, (1926–), *Mother and Children in Blue,* 1998, mixed media collage on paper, 8¾ in. × 6½ in. (22.23 cm. × 16.51 cm.). Purchase with funds from the Drawing Committee. Collection of the Whitney Museum of American Art, New York, NY. 2000.46.

Elizabeth Murray's, *Cloud 3*, fig. 10.3. is an oversized steaming, blue coffee cup that is sitting on a green tray and floating in a pink cloud. It seems like one of the images you might make up laying on your back watching clouds float by as you find lions, rabbits, people and even a coffee cup in the clouds above you. At over 28 × 44 inches this is a substantial pastel drawing. Her shapes are bold and her colors are vivid. It is a contemporary approach to drawing with the absence of perspective, the large scale, and the unmodeled colors. Murray works somewhere between cartoons and popart.

THE BASIC COLOR VOCABULARY

In 1905, Albert Munsell, a German artist, published one of the first standardized systems of color. Munsell determined that color could be defined by **hue, value,** and **intensity. Hue** is the specific color—red, green, blue, purple, orange, yellow, and so on. Red, blue, and yellow are also known as the **primary** colors. In Munsell's color wheel, the primaries were magenta for the true red, with yellow, and cyan (a green-blue) for the blue. You may choose between the reds and the blues in color mixing. Primaries cannot be created by mixing any other colors together; being primary, they are first. Other colors are created by mixing the primary colors. By mixing any two primary colors together, you will get a **secondary** color. Mixing red and blue creates vio-

let or purple; blue and yellow mixed together creates green; and red and yellow will make orange. Purple, green, and orange are the secondary colors on the color wheel. **Tertiary** hues are created by mixing a primary and its neighboring secondary hue together. On the color wheel, the resulting tertiaries are red-violet, blue-violet, blue-green, yellow-green, red-orange, and yellow-orange.

Jennifer Tavel's study, *Design I* (fig. 10.4), is a value study of single hues, the light to dark of one color. **Value** in color is the light and dark of the hue or the color. To lighten the color, she used white, and to darken the color, she used either black or the complement. Hues that are opposite one another on the color wheel are called **complementary** colors. The complementary color pairs are red and green, yellow and violet, and blue and orange. When you mix together two complementary colors, such as red and green, at a certain point the mix turns black. By adding white to this mixture, you can create a range of grays from light to dark. You then use this gray mixture to change the value of the hue. Add a little light gray to the red, and you can lighten it without turning it to pink. Adding the dark gray to the red turns it to maroon. In Tavel's design the eight monochromes are gradated from a light center to a dark background. In this color gradation, the light center tends to advance, and the darker rings recede.

Intensity describes the strength of a color. Colors directly out of the tube are full-strength and considered bright or a full intensity. To reduce the

FIGURE 10.3
Elizabeth Murray, (1940–), *Cloud 3,* (2001), pastel on paper, sheet (irregular): 28¾ in. × 44½ in., (73 cm. × 113 cm.). Purchase, Photograph and digital Image © The Whitney Museum of American Art, New York, NY. 2003.72.

FIGURE 10.4
Jennifer Tavel, *Color Study*, (1999), from Design I, student work, OSU.

DRAWING EXERCISE 10.1
Gradations of Color Intensities

The format for this exercise is a square or a circle, repeated four times on a background. You should use tagboard or Bristol board with acrylic paints, fig 10.4 is an example. Select and mix any two complements—red and green, blue and orange, or yellow and violet—on a plastic palette to make black. Keep a spray mister bottle nearby to mist the paint to prevent it from drying out. Generally, the mixture needs more of one color than the other. In red and green, for example, you will use more green. To check the mix, add a touch of white at the corner to see if it turns gray. Use only a tiny amount of the complement mix with white to make the light gray. Increase the amount of the complement mix in another pile of white to get a medium gray, and then make a dark gray. Using your complementary colors, decide whether you will start with a dark value in the center or whether you will use a light value. Place your colors in the four circles or the squares moving from a light value at the center to a dark value in the background, reverse the values, starting with a dark center moving to a light background.

intensity, you add a gray, made from the complements which reduces the degree of saturation in the pigment. The gray may come either from a complementary mix or from black and white mixed. The gray made from any complementary colors is easier to control the value changes.

Yellow, orange, and red are **warm hues,** whereas blue, green, and purple are considered **cool hues.** Sherry Holliday's *Design*, (fig. 10.5) is a **triad harmony.** A triad harmony is equidistant colors on the color wheel. If you select one color, there will be three colors between it and the second part of your triad. Holliday has selected red-orange, green, and yellow-green, which is a complementary color scheme. Complementary colors create strong color vibrations in compositions. Color vibrations actively engage the eyes.

COLOR HARMONIES

Visual balance is created with basic harmonies. How you perceive color is controlled by the color's placement, proportion, dimensions, value, and intensity. Color harmonies maybe **monochromes, analogous, complementary,** or a **triad** harmony. Monochrome harmonies are one color. Analogous color relationships are a combination of several hues located adjacent to each other on the color circle. An analogous color harmony with red would include red-orange and red-violet. Blue would

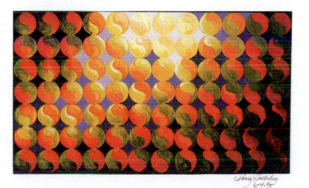

FIGURE 10.5
Sherry Holliday, *Triad Harmony*, (1999), from Design 1, student work, OSU.

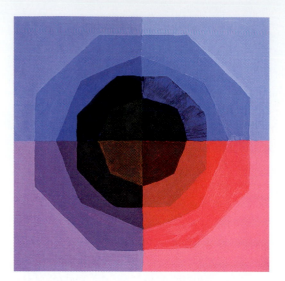

FIGURE 10.6
Edward Cheong, student drawing, (1998).

grayed color you alter how the viewer will perceive your drawing. Sherry Holliday's design (fig. 10.5) is a triad harmony. She used red-orange, yellow-green, and blue-violet for her composition. Holliday's design is also a simultaneous contrast. In Holliday's design, she has a light to dark value change in the background and a saturation change in the colors in the circles that she arranged in a grid. This technique created the visual effects of movement plus the circles do not appear to be attached to the background.

Using the grid for your composition, select your triad of colors from the color wheel. Divide the units in the grid as

include blue-violet and blue-green. Complementary colors are opposites, red is opposite green, blue is opposite orange, and yellow is opposite violet. The triadic harmony was fig 10.5, and see fig 10.7 to determine the colors to use in a triad harmony.

Each quadrant of Edward Cheong's design (fig. 10.6) is **monochromatic,** that is, each quadrant expresses one color, in which the value and intensity of the color changes from a dark center to the light outer shape. When a darker color is placed beside a lighter color, a visual jump occurs that moves the eye backward, forward, or sideways. The placement of color in a composition controls the movement of the spectator's eye through the composition.

DRAWING EXERCISE 10.2
Triad Harmony and Simultaneous Color Contrast

A **triad harmony** is created by using the hues located equidistant from each other on the color wheel. For example, the primary colors red, blue, and yellow are equidistant. By using an equilateral triangle in the center of the wheel (fig. 10.7), you can locate the combinations for triad harmonies. Simultaneous color contrast simply refers to the visual influence of one color on another color when they are placed next to each other. For example two complementary colors side by side creates a vivid, visual vibration. If the value of one color changes from very light *in the front* to very dark in the back or if you put a fully saturated color on top of a

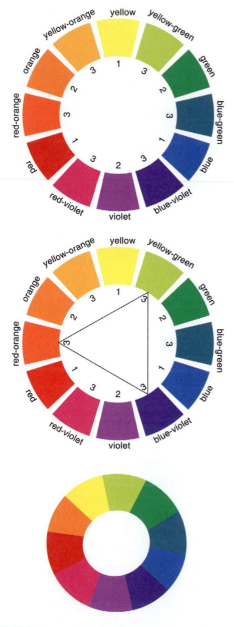

FIGURE 10.7
Top: Conventional Color Wheel; middle: Triad Combination: bottom: Munsell Color Wheel.

you choose; you may use the circle, a triangle or diagonal lines inside each unit of the grid to create a pattern. Ultimately you need three sections, one for each of the colors in the triad. Consider the proportion of each hue in your design. You may use watercolor, acrylic paints, or colored pencils.

COLOR IN CONTEMPORARY ART

Paul Cézanne transformed our reading of space by flattening planes throughout the picture plane. Cézanne created the bridge between painting and drawing. In painting, pigment often covers the entire surface of the canvas, whereas in drawing, the surface of the paper may often remain visible through the drawing. You read drawings as you read text, interpreting signlike marks and gestures into narrative.

In the postmodern world, traditional distinctions between media have broken down, and the distinction among drawing, painting, and sculpture has disappeared. A drawing is defined as any work on paper. Paper has unique qualities: it interacts with the tools used to mark upon it. For instance, it absorbs paint. As Jack Flam has put it in an essay on "Modern Drawing," "When one draws [or paints] on paper one also draws [or paints] into it." By way of contrast, in painting on canvas, images are built up and layered over the surface. When an artist such as Milton Resnick paints on paper, fig. 10.8, *Untitled*, he isn't making studies for other

FIGURE 10.8
Milton Resnick, (1918–2004), *Untitled*, 2000, 22 in. × 30 in., acrylic on paper. Courtesy of Sandy Brooke and Henry Sayre.

work, nor is he drawing. For Resnick, it is all the same. Like Cézanne, he is interested in more than what you see represented here. He said to me, "The idea of a picture is what you are trying to realize. The picture begins when I can feel the emotion and hold on to it. Emotions have a distance. I find the distance with paint. If I have the good luck to understand the paint, I can follow what the paint does." In finding the feeling, the paint and the brush respond better than a pencil for Resnick. It was while working on a very large painting that his sense of his work changed. He discovered that he couldn't focus on it all at once. But when he caught a glimpse of his work from a peripheral point of view, he saw the picture he wanted. The unfocused view had a feeling that the focused view did not. Resnick continued, "When you are concerned with the 'whole,' there is no focal point. The space expands continually. Then at a certain point, the space becomes one whole and you don't see it as focused you see it all." Resnick paints "the whole."

Rick Bartow is a Native American from the Yurok tribe. He lives and works between his indigenous roots and the North American, Anglo-Saxon culture, combining native imagery and the gestures of modern abstraction. *The Trickster*, fig. 10.9, is a drawing for which color is a major part, and animal images interchange with people. He works mostly in pastel, charcoal, and graphite on paper. For Bartow there is a physicality to the paper, which involves the sound of the pastel moving across the paper. He works standing up which allows for a good motion of his hand, keeping gesture in the process. If he puts in a big graphite area in the drawing, it will take hard work to get a line erased back through that area. This is one of the challenges in his work. He acts or draws, then erases as he changes his mind. His process is to draw and draw, erase, and continue drawing. He listens to what is inside and outside of him, then looks at the drawing. While he is looking, a shadow may happen across the paper. He does not know what it is or what it means. He knows it is connected to him, his family and his past. He is willing to make a leap of faith, and follow what might be called his intuition. The fate of animals and humans intertwines in his work. In his images the animals may seem to be people, and the people may seem to be animals. For Bartow, the artist is a carrier bringing forward a story known from an earlier time.

CÉZANNE'S PLANES OF COLOR

Paul Cézanne, before Bartow, drew from what he knew and from what was around him. His life and art were tied

FIGURE 10.9
Rick Bartow, American, (1946–), *Mythic Portrait*, 1998, pastel on paper, 44 in. × 30 in. Collection of Westfälisches Landesmuseum, Munster, Germany. Courtesy Froelick Gallery, Portland, Oregon.

FIGURE 10.10
Paul Cézanne, French, (1839–1906),
Mont Sainte-Victoire, (recto) (1895)
watercolor over graphite on wove
paper, 8⅜ in. × 10¹³⁄₁₆ in. (.211 mm.
× .274 mm.). The Armand Hammer
Image Photograph © 2005 Board
of Trustees National Gallery of
Art, Washington D.C., 1991.217.27
.a/DR.

together. Cezanne created a new interdependence between painting and drawing. He once said to Émile Bernard, "Drawing and color are not at all separate: To the degree that one paints, one also draws; the more harmonious the color, the more precise the drawing" (fig. 10.10).

To Cézanne the whiteness of the field of either the canvas or the paper was perceived as a field for the painter's brush to act on. Cézanne composed with structural planes of color or graphite, defining the landscape not by shape but by plane. His freely drawn lines were linear scaffolding to hold strokes of color now freed from their job of outlining a shape (fig. 10.11). The linear scaffold of the picture plane was opened up with partial erasures in the paintings, creating pentimenti, or traces,

FIGURE 10.11
Paul Cézanne, French, (1839–1906), *Trees Leaning over Rocks,*
(c. 1892), watercolor and black chalk, 18½ in. × 12½ in. (.473 mm.
× .317 mm.). Collection of Mr. and Mrs. Paul Mellon. Photograph ©
2005 Board of Trustees, The National Gallery of Art, Washington,
D.C. 1985.64.86.

revealing sections that were rubbed or painted out but that also remained in the final image. In this way, you see what the artist accepts and what he refuses. It's like looking at the artist's mental process. In *Trees Leaning over Rocks*, fig. 10.10 the white space was increased by Cézanne to where the trees, the rocks, and the riverbank float in an engulfing white space.

By 1910, Cézanne had created a new pictorial language with new conventions for painting and drawing. This new language directing the way pictures were made would affect the process of making art for the next ninety years. His process of not fixing the planes resulted in multiple contours, interpenetrated spaces, and transparent planes. He extended the language of drawing, operating two systems simultaneously; a network of marks seemed to exist independently from the planes of color. The planes separated by white space seem to float free from gravity. Cézanne's goal in flattening the picture plane was his desire to ensure that viewers knew they were looking at a picture, not at an illusion of space. His painting was an extension of drawing.

In Cezanne's work the linear movements, the lines, don't encircle the strokes of color. There is an openness to Cézanne's placement of color. The colors float, and their contours define the white shapes between them. Cézanne was concerned with revealing something hidden. The conventions Cézanne invented—the multiple contours, the transparent planes, the free lines and marks, with the emphasis on the plane and an open picture plane—formed the foundation for the new direction of modern art.

PROFILE OF AN ARTIST: *PAT PASSLOF (1928–)*

In 1946, most colleges and universities did not have studio art departments. Pat Passlof had been studying at Queens College, where they offered only a degree in art history. Determined to be a painter, she left to study at Black Mountain College, where the list of faculty and students read like the *Who's Who in American Art.* Joseph Albers was the director of the college; the faculty was composed of professionals such as Buckminister Fuller, Willem de Kooning, Anni Albers, Merce Cunningham, and his accompanist John Cage. Black Mountain College is often thought of as an art school, but it offered a full complement of course work for a liberal arts education, with poets such as Jonathan Williams and M. C. Richards in residence. When Passlof returned to New York, she found a loft to serve as a studio on Tenth Street. These unpartitioned spaces had no kitchen, no water, no heat, and no bathroom. The toilet was down the hall, a public toilet shared with the workers in the building.

In the fifties, the New York School was emerging. A new energy was developing with a new way of thinking, along with a new painting process. The paintings and drawings became abstract, seeming loosely structured with free-flowing lines. Certain philosophers assumed that if the literary or narrative meaning as they understood it in the tradition of painting was absent, then the subject of the painting must be the artists themselves. This version of what was changing evolved into the assumption that these painters painted from their "guts." It was a misleading oversimplification of a more complicated process. These painters had strong technical skills, and the structure of their paintings was deliberate, with a respect for the unexpected. In fact, these artists held complicated ideas about art and painting. There were intense debates long into the night over the different points of view. Artists such as Milton Resnick, Ad Reinhardt, and Willem de Kooning came together at the now famous Artist's Club. The Club was formed by the artists to provide a space where there could be lengthy discussions about the nature of art, painting, literature, philosophy, and poetry.

Passlof, like other painters in the New York School, has strong, well-developed technical and painterly skills, but she chooses to find ways to work that challenge those skills. Passlof may use overly large or ruined brushes in her painting, because they will make unexpected marks to which she can respond. She likes to work in ways in which the results can surprise her.

Drawing and painting today are closely tied together. In Passlof's *Eighth House #9* (fig. 10.12) the surface is a series of linear, lossely brushed lines made out of oil paint. The linearness of this work says drawing as much as painting.

For Passlof, making a picture is like "making a stab in the dark." You make brush strokes, and "the strokes determine the fate of the painting. When you lose your interaction with the picture you repaint," Passlof said. "Drawing divides and painting brings together." Passlof has said, "What I'm trying to do is

FIGURE 10.12
Pat Passlof, (1928–), *Eighth House #9*, (2002–2003), oil on linen, 48 in. × 60 in. Courtesy of The Elizabeth Harris Gallery, New York, NY.

capture an emotion, whether the work is abstract or figurative. When you paint, the paint multiplies what you do. I don't make studies, because the flexibility of painting in oils doesn't require a plan. I respond spontaneously to what happens on the canvas without being constrained by an arbitrary plan. The signs of calculation are not beautiful."

Passlof doesn't start with images. She starts with the brush and the paint. She finds the images in the paint and pulls them out. In *Eighth House* (fig. 10.12) she is "thinking with a brush," making the invisible visible. The rhythmic strokes lay on an underlying loose grid. Her line is imbedded in the layers of paint. The lines result from the layers of paint placed on the canvas. The subtle changes in the line comes from being able to work back against the wet line. Her color is yellow ochre and blue-black, earth colors that refuse to fight. She feels that the apparent simplicity of the painting belies the steps in its making. In *The Red Horse* (fig 10.13), the horse is held in suspension at the top of a leap, so there is only potential movement. By painting red over a black undercolor on the horse, a bleak and blustery landscape, and the semi-transparent person who

FIGURE 10.13
Pat Passlof, (1928–) *Red Horse*, acrylic on paper. Courtesy of the Elizabeth Harris Gallery, New York, NY.

watches all, contributes to the magic in the painting. Complementary colors and active strokes of paint keep this work active, and vibrant.

Passlof's working process is fluid. She builds up the layers of paint into each other, working wet on wet, holding the forms in suspension. "The painter must be watchful, concentrating and considering what each stroke does and how it changes the painting. Everyone has trouble knowing when to stop. Sometimes it helps if you can 'ambush' your painting to see it from a fresh vantage point," Passlof's said. "The act of painting is not random. Thoughtful moves balance spontaneous outbursts."

Passlof works continuously aware of the stroke under her brush as well as the stroke at the farthest corner of a painting thirteen feet long. The artist leaves herself open to the flow of events. A drip or even a mistake may point to a different direction than the one being pursued. She acknowledges that painting and drawing cannot be strictly controlled. She accepts random elements, like the "lump," for example, in *Red Horse.* She playfully refers to the cloaked figure as a "lump," albeit an eloquent lump—eloquent because a tweak of the brush has given this utterly simple shape an elbow; then another tweak, a head; and then another tweak, boots—all in one stroke. We even know that it faces away from us and toward the leaping horse.

Passlof's process is to work out her ideas in each piece as an end in itself. Even so, she may work from one drawing to the other painting in order to explore and further develop ideas that may seem to be complete in their original context, but she has found can be expanded and transformed in another work. Her work, like that of many other good artists, comes out of the encyclopedia she has built from everything she's learned. It is a reservoir she draws from.

INNOVATIONS IN COLOR

Amy Cutler's drawing, *Pine Fresh Scent*, fig. 10.14 transforms a common scene into a functional fantasy while keeping it on a plane slightly unanchored in time and place. In this drawing women are pictured in aprons with pies sitting on the fresh cut tree trunks. We assume they cut the trees down, as two of the women are holding axes. The situation of women who seem to be farm housewives holding axes in front of a rollercoaster is more surreal than real to us. Women standing in a forest with axes and pies would be very real, but the addition of a rollercoaster behind them with the tops of the cut trees or branches riding in the cars is nonsensical although enchanting in some way. This is a very small drawing, only 8 × 10 inches, done in gouache on paper. The size and scale add an intimate quality to the drawing. Cutler likes to create worlds unfettered by logic and normal codes of behavior. Her characters, particularly the women, subvert the re-

FIGURE 10.14
Amy Cutler, (1974–), *Pine Fresh Scent,* (2004). gouache on paper, sheet (sight): 8 in. × 10 in. (20.3 cm. × 25.4 cm.). Purchase, with funds from Beth Rudin DeWoody and Joanne Leonhardt Cassullo. Photograph and Digital Image © Whitney Museum of American Art, New York, NY. 2005.99.

FIGURE 10.15
Jan Reaves, (1945–), *NUF Series, detail,* (1999–2001), ink, acrylic, Conté pencil, wax, 10 in. × 10½ in. Courtesy of the Artist.

direction is the degree to which they make visible things that cannot be seen—states of mind, ideas, and processes. Drawing ceases to be only about fine technique and narrative. Once the conventional strategies of drawing were rejected in the twentieth century, a new relationship between materials, form, and tools evolved. The second is a change in the concept and purpose of a drawing done with fine technique and narrative. Amy Cutler, fig. 10.14 is such a drawing.

Process and the manipulation of the media were now the purpose for some drawing's where a representational subject was replaced. In *Nuf* (fig. 10.15), the transparent layers of colors—red, white, black, and a blue-gray—seem stacked. You can see the color forms on both the front, and also from the other side of the paper. The fifty *Nuf Drawings* (fig. 10.16), are shapes found in factories and at construction sites. The materials used to make the 10 × 10 inch drawings were gouache, ink, Conté, pencil, and wax. The juxtaposition of the shapes creates meaning by their associations. The series is constructed on paper, using both the back and the front of the paper. If the drawings were bound together, they would make a book with images on both sides of the pages. Reaves's drawings depict no real space. The artist has no direct intention of conveying any precise

strictions of accepted social conventions and critique historically prescribed female roles. She often explores domestic stereotypes that she inverts with a shrewd use of metaphor and a lighthearted sense of humor. Her drawings are often brash renunciations of domestic decorum.

The innovations of twentieth-century drawings revolve around at least two major changes; one

FIGURE 10.16
Jan Reaves, (1945–), *NUF Drawings,* (1999–2001), ink, acrylic, chalk, pencil and wax on paper, 50 in. × 100 in. Courtesy of the Artist.

FIGURE 10.17
Carroll Dunham, (1949–), *Pine Gap,* (1985–1986), mixed media
on wood veneers, 77 in. × 41 in. (195.6 cm. × 104.1 cm.). Pur-
chase, with funds from The Munchin Foundation. Photograph
and Digital Image © The Whitney Museum of American Art, New
York, NY. 86.36.

meaning—for her, the process of making the draw-
ings is the purpose.

Pine Gap by Carroll Dunham, fig. 10.17 is
actually classed as a painting, but it is so much
like a colored drawing that it can be included
here. The representational elements are barely
identifiable, and adrift in a swirling composition
of abstract shapes. In these paintings, Dunham
used panels with wood-veneered surfaces instead
of canvas. This allowed for the natural pattern of
the wood to guide and influence him. His work
combines a combination of biomorphism, car-
tooning, and abstraction which has expanded the
vocabulary of American painting and drawing
playing a pivotal role in synthesizing abstraction
with representation. For Dunham the use of
cartoon-like characters strips away the preten-
sions of the art world revealing a dark truth about
the human condition. In an interview for the
New Museum catalogue in New York, Dunham
says, "I want to make art that feels true, that can
function as a window into realms that aren't part

FIGURE 10.18
Reuben Valdivia, *Tsunami,* colored pencil, 22½
in. × 30 in. Courtesy of the Artist.

of the day to day. I know that my art exists in this kind of tension between irrational, almost goofy, things and extremely tight, formal, organized things. That tension is where I live."

Reuben Valdivia was completely captivated by the destruction of the *Tsunami* in South East Asia in 2005. It was an event he could not imagine happening and could not stop thinking about. The images of the ocean, the waves, the lost people, the destroyed villages played over and over on the TV. His only way through this terror was to make a wave and put everything he had seen in it. The drawing *Tsunami* fig. 10.18 was Reuben's way of paying respect to the ocean and the water as well as the huge loss of life. For Reuben the Ocean, like us is a living thing. The

power of the ocean has helped humankind as well.

Steve DiBenedetto's interest in paranormal phenomena began in his late teens partly inspired by Spielberg's 1977 sci-fi film *Close Encounters of the Third Kind*. UFO's entered into DiBenedetto's artistic vocabulary fifteen years later, and he continues to incorporate outer-space imagery into his work while seeking out new motifs. Over the past five years he has settled on a refined set of subjects including octopi, helicopters, and Ferris wheels. They share a radial quality but each carries a different meaning in the artists' iconography. Helicopters possess the most complex modern technological and spiritual lineage. In the drawing *Deliverance* fig. 10.19 Dibenedetto uses small, iter-

FIGURE 10.19
Steve DiBenedetto, *Deliverance*, (2005), colored pencil on paper, 22½ in. × 30 in. (76 cm. × 57 cm.). Collection of Morris Orden. Courtesy of Nolan Eckman Gallery, New York, NY.

ant strokes of indigo colored pencil to create a ghostly rendering of a hovering helicopter whose whirling propeller blades dissect the marbleized sky above. The orange pencil adds a level of excitement, orange being a hot not cool color. The color increases the tension in this drawing. Meaning can be translated into color and transmitted to the viewer. These two helicopters hover over an abyss whose walls are covered in geometric decorations. The large helicopter casts a shadow on the side of this attractive vortex. You have to wonder if you go down there will you get out.

Technical aspects of the helicopter are important to DiBenedetto. On closer inspection, of the bulbous head of the aircraft it can be identified as that of the famous Bell Model 47 Helicopter. Invented in 1946 by Arthur M. Young for Bell Air-

craft Corporation. Model 47 was a feat of modern design.

DiBenedetto's interest in octopi stems from his reading of Terence McKenna, an occult ethnobotanist who saw the octopus as an advanced species based on its ability to communicate emotion by changing color. He finds the Ferris wheel to be an instrument of disorientation reflecting the centrifugal and chaotic movement that recurs in much of his work.

COLOR GOES PRIMITIVE

This focus on the process and on the emphasis on materials begins with the Cubists, but is intensely examined and thought through by the painters in New York in the late forties and fifties. A drawing

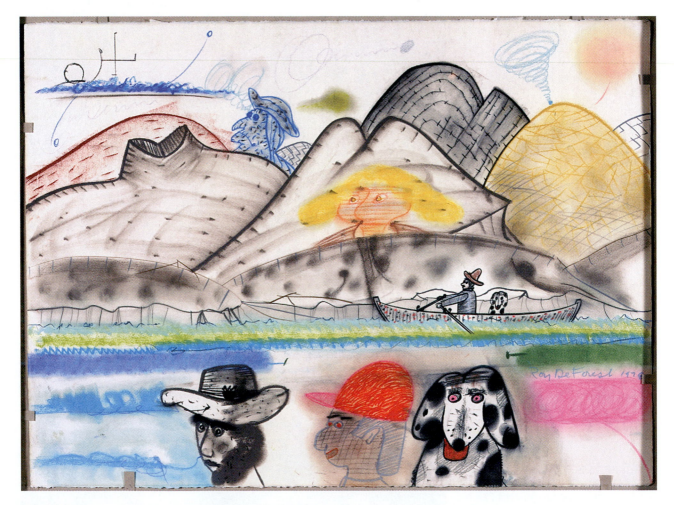

FIGURE 10.20
Roy Dean DeForest American, (1930–), *Untitled (water, mountain, people, dog)*, pastel and crayon, 57 cm. × 76.5 cm. Pratt Fund Purchase. Portland Art Museum, Oregon.

for the New York artists could be made by dragging the pencil or crayon, scratching, smudging, smearing, and scrawling. The drawing might resemble a dirty object instead of a shiny figure, or a shaky stain, rather than a perfect shape. The shiny figure and the perfect shape refer to a traditional style of drawing prior to 1890.

With Modernism came an investigation of the primitive arts of Africa by both the Cubists and the German Expressionists, who relied on quick gesture drawings reflecting the look of primitive art rather than the previous or traditional form of composition. The garish, bright color of the German Expressionists came from the French Fauve painters Henri Matisse and André Derain.

Roy Dean De Forest fig. 10.20 works in a style free of what artists felt to be dead weight from the tradition by drawing. In *Untitled* (water, mountain, people, dog), his color is intended to be garish, harsh, his style is primitive. To understand this illogical composition, you must use your imagination, and what you find in it will depend on your personal experiences in life. His primitive drawings of figures create a dialogue with the viewer. Neo-Expressionism is a manifestation of postmodernism thinking, in which it recognizes that chaos and diversity must exist with order. For the postmodern artist the idea of truth is contingent on place, time, history, and social context. Truth is no longer a universal norm, because the psyche can be constructed or reconstructed by our environment: this means that there is no one truth.

COLOR DRAWING AND PRINTMAKING

Drawing and printmaking are strongly linked. In Yuji Hiratsuka's prints *Allurement* and *Fragrance* (figs. 10.21 and 10.22), He developed a personal technique of Chine Collé, combining it with both a traditional and an innovative etchng process. He makes continuous alterations to a copper plate, printing a sequence of black, yellow, red,

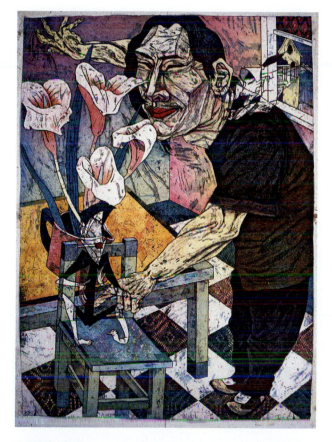

FIGURE 10.21
Yuji Hiratsuka, *Allurement*, (2004), intaglio and relief, 30 in. × 22 in. Courtesy of the Artist.

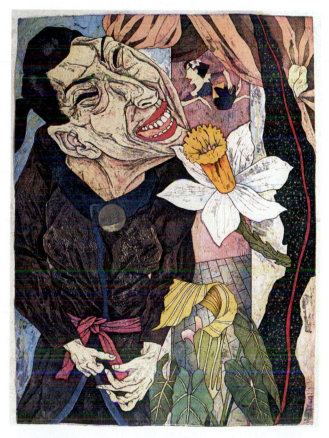

FIGURE 10.22
Yuji Hiratsuka, *Fragrance*, (2004), intaglio and relief, 30 in. × 22 in. Courtesy of the Artist.

and blue. The same plate is passed through the press for each design and color change. He starts with line-etching, drypoint, aquatint, a soft ground, photocopy transfer, or roulette for the first tones on the plate. Line-etching and drypoint are no more than drawing on the copper plate. With these first impressions on the plate, he pulls his first color. He then works back into the plate with a scraper, a burnisher, and an emery paper to enhance the lights and to accent the motif. Here again this is similar to the drawing process where erasing, rubbing, and smearing are used to enhance the drawing. Hiratsuka then continues through a second, third, and fourth print run of color. When this part of the process is completed, he works from the back of the print with a relief process of woodcut or linocut to intensify shapes and colors. He has chosen the Japanese paper known as Owara Mulberry to print on. For the final step, he applies glue to the back of the mulberry print and passes it through the press, adhering it to a heavier rag paper of BFK or Somerset. The final print is a four-color intaglio print saturated with subtle tones of color coming through the back of the Owara Mulberry paper, which is set deep into a rag paper.

Hiratsuka's images bear a slight resemblance to traditional Japanese Ukiyo-e prints, but his intent is to express contemporary aspects of the Western Hemisphere. The representational images are metphors of life for him.

DRAWING EXERCISE 10.3
Multiple Perspectives

One of the innovations of Modernism was multiple points of view in one drawing. We don't see from one single fixed viewpoint as a camera does; we have a wide range of vision. It was Cézanne who first drew a still life from the right side, and then, moving his easel, drew the left side in the same drawing.

Select a subject to draw. Start with light-colored pastels on one side of the paper, and draw part of your subject. Pick up your paper and supplies, and move to another place. Draw part of your subject from your second viewpoint, but do not try to tie the second view to the first. Continue moving and adding parts to your drawing in light chalk. When the paper is full, lay it down on a table, and with another pastel enhance an area that you like. Rub out areas you do not want in your drawing. Chalk pastel can become a wash if you use a wet brush over them. Once that wash is dry, go back to your drawing with other pastels, charcoal, ink, or colored pencils, and begin coordinating and composing a drawing from the various sections now floating on your paper. Try to avoid returning to a one- or two-point perspective. Let each section remain in its own perspective. When you add color, consider the value and hue of the color. Light colors usually push forward, and dark colors move back into the picture plane. Color will enhance and complicate the spatial arrangement. To keep the picture plane flat, keep all colors in the same value.

STRATEGIES FOR DRAWING IN COLOR

1. Consider the space of your composition, and decide where you should use light colors and dark colors.
2. Consider the value of each color in the composition.
3. You may want to use a triad harmony or a tetrad harmony. Fig. 10.5 illustrates both a triad harmony and a tetrad harmony.
4. Consider whether to use bright hues or grayed hues.
5. To create a mood, use warm hues, which tend to feel more light-hearted, or use cool hues, which produce a more subdued mood.
6. Consider layering colors to produce a rich or textured effect in your drawing.

ART CRITIQUE

Kevin Appel and Shahzia Sikander

Prior to 1900, drawing had its conventions, but through the twentieth century and now in the twenty-first century, traditional drawing mediums and subjects have opened up in to many new directions. Kevin Appel in *Light Model: Southeast View 2002* (fig. 10.23) has appropriated the language of architectural

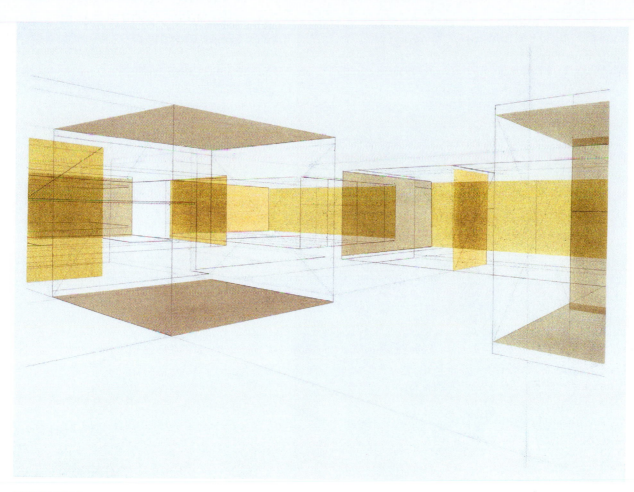

FIGURE 10.23

Kevin Appel, *Light Model: Southeast View,* (2002), liquid acrylic and pencil on paper, 22½ in. × 30 in. (57.2 cm. × 76.2 cm.). Collection of Helen Alameda Lewis. Courtesy of Kevin Appel and Angles Gallery, Santa Monica.

illustration. Appel is not an architect; he is an artist whose work consists of views of imaginary homes he has designed on the computer. These single-story open-plan bungalows are orchestrated compositions of horizontal and vertical planes. He has colored the drawing with semitransparent liquid acrylic, instead of using the architects traditional ink on vellum. His compositions are created in sequential groups of four, each a directional view from a certain compass point. His use of the computer provides him with three-dimensional as well as two-dimensional views. With the computer he can easily manipulate the planes and the dimensions of his drawings.

His drawings are not illustrations in the traditional sense. An illustration is considered a derogatory term in the context of art. Illustrations are images inspired by a text: the artist relies on a source outside the artistic imagination. They are often decorative and commercial, none of which

can be applied to Appel's work—which is a creation of his imagination.

In the drawing, *Dispersion,* fig. 10.24 Shahzia Sikander confronts the stigma of creating an illustration in a well-designed and patterned drawing that comes from a different direction than Kevin Appel's work. She uses traditional methods found in Asian miniature painting, notably small fine details, repeated patterns, and rich colors. A Sultan kneels, draped in a coat designed after the shape of peacock feathers and painted in contrasting colors to the patterns of the clothing he wears beneath the coat. Like miniature painting the scene is complicated with the fine details in the background, and foreground. The pink tile behind him dissolves into a line drawing of the plants on a blue ground, transforming into leaf or bird shapes on the right. The right side is then contradicted by the abstract forms on the left that are much more modern, and

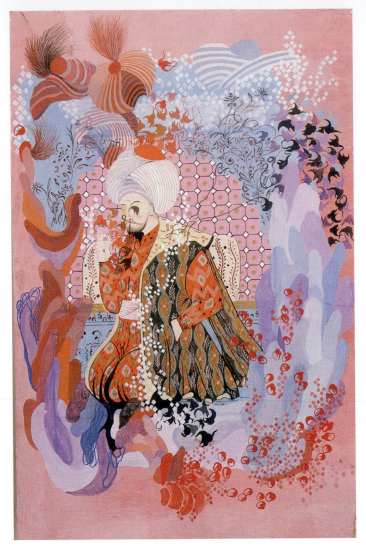

FIGURE 10.24
Shahzia Sikander, *Dispersion,* (2005), ink and gouache on prepared paper, 11 in. × 7 in. Courtesy of Sikkema Jenkins and Co., New York, NY.

organic completely out of the miniature tradition. The battle for Sikander is that miniature painting has long been thought of as stylized work, a craft or technique rather than a genuine expression of the artist. It is to her credit that the content of her work challenges the cultural tradition in miniature painting, in which old stories are retold. If this is from an old story it has been dramatically altered by the color, choice of forms, and the overlapping abstract shapes floating across the surface, which place it more in the realm of contemporary drawing rather than a traditional miniature. Although retaining the materials, techniques, styles, and some of the characters of traditional Asian miniature painting, Sikander has radically altered the form.

Appel's work is formal, based in geometry and without narrative. Sikander's work is based on politics, myth, cultural traditions, and sometimes current quotes from religious leaders, creating a powerful narrative. Sikander's color is from the tradition of Asian miniatures, which are brightly colored. Appel employs a monochrome color scheme with a few value changes but no color changes. Appel's materials are of the most current in modern art, whereas Sikander's materials such as gold leaf and "wasli" paper are part of the miniature tradition. The fact that these two drawings were created in the same era is indicative of the depth and breadth of this postmodern world.

Choose a subject either narrative, geometric, or abstract. Approach your subject by experimenting with mediums. Select one color of watercolor or acrylic paint, place it in a dish, and dilute it with water until it is a very light value. Put that value down on your paper, let it dry, and then add a little more paint to the water to darken the value of the color, and paint that into your drawing. When it is dry, you can draw on top of these areas with pen, pencil, or charcoal. Pastel chalk can be rubbed into the surface to change the value or color. Wipe the chalk on tissue, and gently rub the tissue over and into the surface. Pastels can be used with water to make a wash. Layering media builds complicated surfaces. Cut some images out of the newspaper, and glue them flatly to your journal paper. Try rubbing pastel across one, draw a pattern over one or two, and use watercolor over one. Experiment with other mediums to find a process you can use.

MODERN TO CONTEMPORARY DRAWING

Classical myth tells of how drawing was invented by a Corinthian maid, the daughter of Butades, who, with her hand guided by Cupid, traced the outline of her sleeping lover's shadow on the wall. The myth reminds us of both our fascination and our connection to creating an image that speaks to us. Drawing is another form of language or personal expression that today is multidimensional. Art, like life, has gone beyond the conventional and traditional compositional rules. Chapter 11 is about the possibilities of drawing in terms of the changes in thinking, concepts, techniques, directions, and materials in Modern to contemporary drawings. George Baselitz began making prints in 1964. His early prints were closely related to drawings in scale and conception. The linocut *Female Nude on a Kitchen Chair* (fig. 11.1) has an extraordinary presence and physicality, partly as a result of the process, which is a scratchy line drawing on a linoleum block, and partly of the presentation: it is shown upside down because he wants you to see it differently. Baselitz is a contemporary artist whose early influences were Willem de Kooning and Philip Guston.

CUBISM AND SURREALISM

Two movements formed Modernism's foundation: Cubism, with the invention of the collage, and Surrealism, with a recognition of the dream world. These two movements asked the question "What is the nature of reality?" Is it made of things or of states of mind about things? Are the elements to be perceived as stable or fluid?

Cubism was deeply rooted in a drawing practice that used an underlying geometric structure to compose angular, grid-like spaces. The space of the picture plane was divided with vertical fracturing, a device that forced you to reconstruct the subject in your mind's eye. In Cubism, the nature of reality was altered. However, the work of the Cubists al-

ways referred to some representational space such as a still life (fig. 11.2), a landscape, or the figure. George Braque's *Collage* is composed of charcoal, graphite, oil paint, and watercolor on a variety of cut laid and wove paper elements laid down on dark tan board. Braque's *Collage* combines newspaper and faux textures, while the pictorial structure no longer relies on linear perspective. In the same way, all the formal elements were redefined. In this new order Cubism saw line as the medium of analytic thought, while the Surrealists, line represented the manifestation of the unconscious. Modern drawing began to simultaneously project image and idea.

In the Cubist collage, the character of the ground was altered by pasting elements onto it, whereas the drawing could continue over the paper and the pasted elements. Hatching, a traditional marking process that was traditionally used to create the effects of volume on a two-dimensional surface, now became a texture. The purpose and use of hatching was redefined by Cubism. Hatching was transformed into flat, linear patterns, often reversing the perception of positive and negative spaces. A number of techniques developed in the Cubist and Surrealist drawings found their way into twentieth-century painting. Frottage, decalcomania, drips, spatters, and staining further dissolved the traditional boundaries between drawing and painting.

The Surrealists believed in the objective reality of the dream, subconscious imagery, automatism, hallucinatory and irrational thought associations, and recollected dream images as a means of liberating the psyche from its enslavement to reason. The role of myth played an important part in Surrealism. Automatism was a process of tapping the unconscious in which the artist worked in a trancelike state, letting images tumble out. Surrealists saw line as a manifestation of the unconscious liberated from any descriptive function. The space of the picture might appear as the collection of random linear gestures, signs, and symbols. The artist may have had

FIGURE 11.1
Georg Baselitz, (1938–), *Female Nude on a Kitchen Chair,* (1977–1979), linocut on paper, image: 2021 mm. × 1370 mm. Weiblicher Akt auf Küchenstuhl. © 2005 the Tate, London, England. P77011.

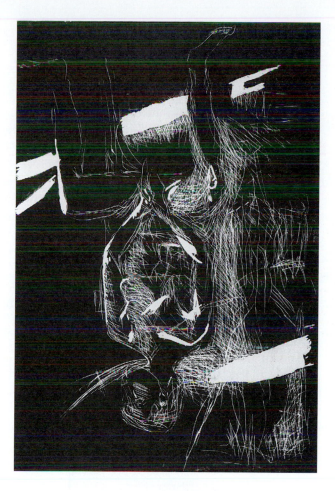

in mind very specific images, but the spectators were left to decipher what they saw. Artists such as Arshile Gorky used flowing curvilinear lines to draw fantastic figures and fragments of naturalistic images. The picture space no longer directly correlated to the space of the real world.

Lucas Samaras was born in Greece in 1936 witnessing first hand the horrors of World War II. He immigrated with his family to the United States in 1946. Since that time it seems as if he has felt compelled to reinvent himself every day since his arrival. Lucas Samaras' favorite subject is himself. In his own words, "Professional self-investigation—

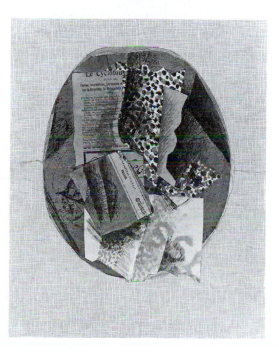

FIGURE 11.2
Georges Braque, French, (1882–1963), *Collage,* (c. 1912), composed of charcoal, graphite, oil paint and watercolor on a variety of cut laid and wove paper elements laid down on dark tan board, 35.1 cm. × 27.9 cm. Gift of Mrs. Gilbert W. Chapman. Photograph © 2001, The Art Institute of Chicago. All rights reserved. 1947.879. © Artists Rights Society (ARS), New York, NY.

which is what a good self-portrait is—is as noble a search as any other, and I have always shared what I have learned with the public." For most of his life as an artist, Samaras has focused upon himself with an intensity that goes well beyond "professional self-investigation." He has made thousands of Polaroids of his face and body. *Untitled*, (fig. 11.3) a self-portrait by Lucas Samaras reflects the cross-hatching in the background from the Cubists forward the hatching being a ground not a form of modeling. You can make the connections to the numbers crossing his face to being an out growth of the words and letters used by the Cubists in their collages, and more currently the numbers used by the pop artist, Jasper Johns as the subject of his compositions. Here the self-portrait evolves into a contemporary drawing out of the formal elements of the past. The face is rendered in a dark value with a surprising blue rainbow across the eyes. At the bridge of the nose there is a yellow inverted triangle, a prism of yellow to red. Thin, small, white letters float across the darkened face. Some call him a narcissist for continually drawing himself, but he sees things and gives

views you don't expect in his portraits. The mythological Narcissus found his image in a pool of water that was clear, still, and cool enough to reflect his perfected countenance. Samaras seems to look into a hot, murky, turbulent cauldron finding as much self-loathing there as self-love. He searches for something beyond the reason of the body.

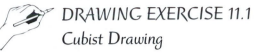

DRAWING EXERCISE 11.1
Cubist Drawing

Set up a large still life. Place the items in different relationships

Make three large shape drawings in which the forms from the still life are drawn as large as your hand—or larger—all over an 18 × 24 inch piece of paper. Use the words, textures, and patterns of the objects in the drawing. Then stop looking at the still life, and cut up the drawings in half or quarters, diagonally or vertically. Take the cut-up shapes, and reassemble pieces on another piece of paper. Use hatching lines arbitrarily on some shapes as texture and between shapes as elements in their own right. The work by Nicole Williams (fig. 11.4) is an example of this cut and reassembled drawing.

Redraw a composition from the drawing you have assembled. Add or subtract shapes and textures as your internal sense of composition dictates.

This process helps you to see shapes and composition in a new way and to make decisions about the placement of shapes in a completely intuitive manner.

FIGURE 11.3
Lucas Samaras, (1936–), *Untitled, May 9, 1982,* colored pencil on paper, 17½ in. × 11½ in. (44.45 cm. × 29.21 cm.). Purchase, with funds from the Drawing Committee. Collection of the Whitney Museum of American Art, New York, NY. 2002.149.

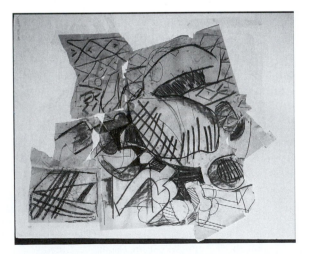

FIGURE 11.4
Nicole Williams, cubist drawing, Painting I, (1999), student drawing, Oregon State University.

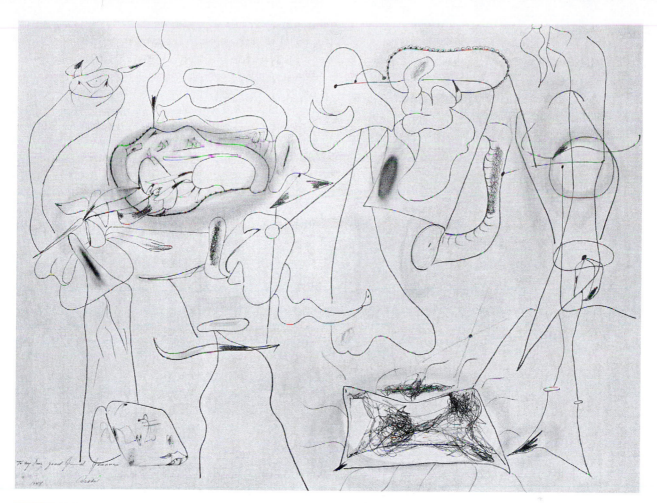

FIGURE 11.5

Arshile Gorky, American, b. Khorkom, Armenia, (1904–1948), *Untitled*, (1944), pencil and crayon on paper, 19¹³⁄₁₆ in. × 25⁷⁄₁₆ in. (50.2 cm. × 64.5 cm.) Gift of Joseph H. Hirshhorn, (1966). Hirshhorn Museum and Sculpture Garden, Smithsonian Institution, Washington, D.C. © 2007 Artists Rights Society (ARS), New York, NY. 662152.

PROFILE OF AN ARTIST: *ARSHILE GORKY (1904–1948)*

Arshile Gorky was the painter instrumental in introducing the concepts and theories of Cubism and Surrealism to America. He believed that the history of art was an unbroken chain in which all art evolved from past to present artists.

Arshile Gorky was born Vosdanik Manuk Adoian in Khorkom, Armenia, in 1904. His mother, Lady Shushanik der Marderosian, and his father owned an extensive rural estate. Gorky based many of his paintings on recollections from his youth of the gardens on this estate. He spoke of the garden near their home: "My father had a little garden. There was a blue rock half buried in the black earth with a few patches of moss placed here and there like fallen clouds." The garden was also considered a source of magical power by the villagers, who would rub their bodies against the rocks in the hope that their wishes might be fulfilled.

When Gorky was four years old, his father fled Armenia a small country beside Turkey to the east to avoid conscription into the Turkish military service, a service in which he would have been forced to fight against fellow Armenians. In 1915, when Akiesdan Armenia came under attack by the Turks, Gorky and his mother, along with his three sisters, fled. They survived a grim hundred-mile journey. Living in exile for three years with no money and little food, Gorky's mother became seriously ill and died of starvation in her son's arms. Gorky was very attached to his mother. It was she who imparted to him high moral standards with a love of nature and beauty that would inform his work forever. Then, fifteen-years-old Arshile

and his thirteen-year-old sister, Vartoosh, made their way to the United States to join their father.

Once in America, Gorky was determined to become an artist. In 1922, he enrolled in the New School of Design in Boston. Shortly thereafter, he became a part-time instructor in the school. Gorky believed that an artist's purpose was to capture both the mood and the formal essence of the subject, which should then be transformed into a timeless, universal image. Gorky felt that Cézanne had done exactly that, and so he studied Cézanne's work carefully.

In 1924, Gorky moved to Greenwich Village in New York City. Determined to develop his career as an artist, he adopted the fictitious name "Arshile Gorky," hiding his Armenian identity with a Russian name. "Arshile" derives from the Armenian royal name "Arshak," which translates to "Achilles" in Russian. Gorky is Russian for "bitter." He fabricated his past, naming his birthplace as Kazan, Russia, and claiming to have studied art at Nizhu-Novgorod.

Gorky was hired to teach art at Grand Central School of Art, a position he held until 1931. At this time, Cubism, Fauvism, and Surrealism were virtually unknown to American students, so it was remarkable that Gorky was able to discuss the complex theories and ideas of these new art styles with his students. He was extremely familiar with the work of Paul Cézanne, Pablo Picasso, Georges Braque, Henri Matisse, and the Surrealist André Breton. His primary sources of information were books and periodicals, such as the avant-garde magazines *Cahiers d'art* and *La Révolution Suréaliste* that he found at the Weyne bookshops in New York. After the Armory show of 1913 in New York, at which Americans were first introduced to modern art from Europe, the Brooklyn Museum showed Braque, Miró, Picasso, and Kandinsky in 1926. Gorky saw every show. There is a story that he went with a group of artists to see a Picasso exhibition, and they noticed a drip on the painting. His friends chided Gorky about Picasso's drip, to which he responded, "If Picasso drips, Gorky drips."

Gorky is the indisputable link between European modern art and the New York School or the Abstract Expressionists. A self-taught artist, he blended elements of Cubism and Surrealism into his paintings and drawings.

The drawing *Waterfalls* (fig. 11.6) could be considered a foundation for the work Gorky did between 1940 and 1944, when he again referenced the waterfalls. Gorky created the same transparency and

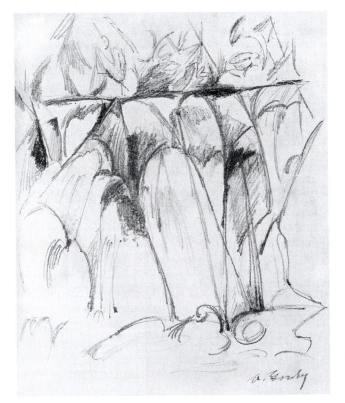

FIGURE 11.6
Arshile Gorky, *Waterfalls,* (1904–1948), pencil and crayon on paper, 14⁹⁄₁₆ in. × 11⅜ in. (36.8 cm. × 28.8 cm.). Gift of Joseph H. Hirshhorn, (1966). Hirshhorn Museum and Sculpture Garden, Smithsonian Institution, Washington, D.C. © 2007 Artists Rights Society (ARS), New York, NY. 66.2152. JH64.160.

translucency that you could achieve in watercolor by diluting his oil paints. The sensation of a rushing cascade of water was created by allowing the paint to drip and run over—and next to—large areas of unpainted white canvas. This technique resulted in an openness in the surface of his paintings, creating a new pictorial vocabulary between painting and drawing.

Gorky desired a timeless quality for his images, a spatial ambiguity in which the forms floated mysteriously. His feelings and memories materialized into a poetic vision, represented by images, shapes, and colors. These spontaneous images, from the unconscious level of his thinking process, were woven into other images based in nature. From the early 1940s until his death in 1948, Gorky approached the working surface as a mental landscape. It was neither flat nor concave but was shallow and covered with forms. In drawing, Gorky used a hairline or thin outline that extended in a fluid manner across the ground. The line was a way to create space, not to separate the objects from the ground or from each other. He once said that he had begun to look into the grass, not at it. Drawing for Gorky was a metaphoric response to nature, allowing for unconscious reactions to simplified forms.

Gorky's mature work *Soft Night* (fig. 11.7) broke with his previous cubist and rigid geometric structure. In *Soft Night,* you see the universal shapes he now preferred, which are nearly impossible to read as either animate or inanimate, natural or manmade.

Gorky's friendship with the Surrealists early in 1939 influenced the direction of his compositions. Shapes hover in unfixed, spatial relationships (fig. 11.7), much like Joan Miró's work. Gorky's biomorphic forms capture the essence of a garden without

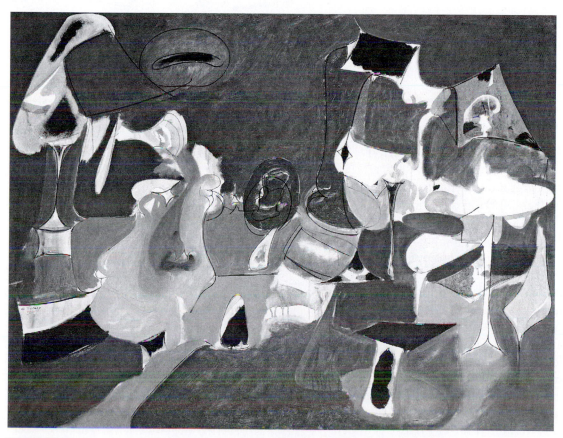

FIGURE 11.7

Arshile Gorky, American, b. Khorkom, Armenia, (1904–1948), *Soft Night,* (1947), oil, India ink, and Conté crayon on canvas, 38⅛ in. × 50⅛ in. (96.7 cm. × 127.1 cm.). The Joseph H. Hirshhorn Bequest, (1981). Hirshhorn Museum and Sculpture Garden, Smithsonian Institution, Washington, D.C. © 2007 Artists Rights Society (ARS), New York, NY. 86.2341.

depicting it literally. The line is nervous, fast-moving, and perhaps "automatic." Automatism was the unconscious drawing process of the Surrealists, in which one draws unfettered by the rules of logic or schooled hand-eye coordination. The imagery flows from the unconscious uncensored by the brain. Gorky used a random line to connect the images into a web in a highly activated space such as in fig. 11.7, *Untitled*.

Once while drawing outdoors, Gorky was observed by his mother-in-law, who commented that she couldn't see what he was drawing in the trees he was looking at. He replied, "I am not drawing the trees—I am drawing the space between the trees." In Gorky's work, color and line seem in constant flux. André Breton, in late 1944, wrote of Gorky that he was the only Surrealist who maintained direct contact with nature, penetrating nature's secrets to discover the "guiding thread" that links together the physical and the mental structures. Gorky later rejected the Surrealist practice of automatism, and he moved away from their theories that ideas surfaced from the unconsciousness to guide the artist's hand. Later, some of the painters in The New York School, (the Abstract Expressionists) would build on that direction, altering it with the idea that consciousness controls with the thinking mind.

THE NEW YORK SCHOOL: ABSTRACT EXPRESSIONISM

The aesthetic criteria of the modern drawings of the New York School bring to mind those of the fifth-century Chinese theorist Hsieh Ho, for whom the intangibles of the spirit, the life force, and the structural use of the brush were more important than representation, color, or composition. For Hsieh Ho, creating depended on inspiration and imagination, not on skill.

To the artists of the New York School, the authenticity of feeling and a moral purpose to creating was preferable to creating mimetic or realistic images of the material world. Each of the artists working in the 1950s invented their own language, creating a personal pictorial syntax of signs. This new attitude materialized into a change of touch and marking in pictorial space. The very nature of pictorial space changed. Whereas Cubism in its early days was founded on scientific truth and created a system to make visible the essential struc-

tures of the world, the New York School moved further into abstraction, leaving the modeled and recognizable forms behind. Like Cubist works, de Kooning's figure drawings refer to a recognizable image of the figure. In a departure from Cubism, he may have drawn the figure *Untitled* (fig. 11.8) with his eyes closed, depending on chance and the unconscious to guide his hand. De Kooning leaves himself open to the flow of energy; he doesn't try to control or structure the drawing: he relies on the spontaneity of the act in making the art. Most of these painters in the 1950s rejected any labels categorizing them into a single, united group. The diversity in the work does not reflect any one style but many individual styles.

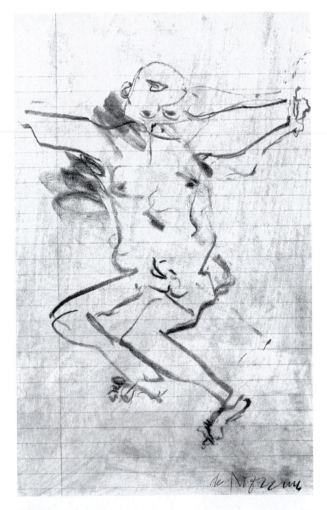

FIGURE 11.8
Willem de Kooning, American, b. Rotterdam, The Netherlands (1904–1997), *Standing Woman with Knees Bent*, (1964–1966), pencil on colored paper, mounted on paper, 12½ in. × 8⁷⁄₁₆ in. The Joseph H. Hirshhorn Bequest, (1981). Hirshhorn Museum and Sculpture Garden, Smithsonian Institution, Washington, D.C. © 2006 Willem de Kooning Foundation/Artists Rights Society (ARS), New York, NY. D395.74.

Drawing became an internal investigation of the process itself, rather than a drawing process to render objects. Fragments of objects floated and pulsed in drawings,

With the outbreak of World War II, Hans Hofmann was forced to leave Germany. An accomplished artist who had worked in Paris with the Cubists, Hofmann opened one of the first art schools in New York. He developed many theories of art and was fond of telling students, "Depth in a pictorial, plastic sense, is not created by the arrangement of objects, placed one after another toward a vanishing point, in the sense of the Renaissance perspective, but on the contrary by the creation of forces in the sense of push and pull." In other words, in real space, depth results from objects placed "here" and "there." Pictorially—or on the surface of the paper—"here" and "there" are two points on a flat plane that are connected by a lateral, horizontal, or vertical line.

Jackson Pollock's work *Untitled* 1951, (fig. 11.9) reflects the drawing concept of all-overness. "The Abstract Expressionists" were noted for inventing all-overness, an articulation of flatness through a repeated network of similar marks. The act of drawing is the subject of the drawing. Artistic integrity was equated with the medium and the truth of the artist's hand. The lines or marks making up the picture are equated with certain psychic and ethical states of being. In the 1950s, artists developed an entire vocabulary of gestures out of multiple lines, erasures, smudges, flows, spills, splatters, and scratches, building a drawing or painting and holding it in suspension. Pollock's work is associated with spontaneity and dreams. He was attracted to the Surrealist notion of psychic automatism and of using unconscious sources to create form.

The pictorial field opens, expanding the sheet of paper conceptually and physically into a space with a huge range of possibilities. Characteristic of

FIGURE 11.9

Jackson Pollock, (1912–1956), *Untitled,* (1951), black and sepia ink on mulberry paper, 25 in. × 38¾ in. Gift of Lee Krasner in memory of Jackson Pollock. © The Museum of Modern Art/Licensed by SCALA/Art Resource, New York, NY. © 2007 The Pollock–Krasner Foundation/Artists Rights Society (ARS, New York, NY. The Museum of Modern Art, New York, U.S.A. (666.1983).

works on paper by the artists in New York in the 1950s was the sense of all-overness and flatness holding illusionism at bay, forestalling the reading of space except through the shapes on the surface. The images are arbitrary, a pictorial syntax from artists inventing their own language.

Pollock's line, which is blotchy and bleeding across the surface while being absorbed by the paper, influenced a new wave of young artists.

DRAWING EXERCISE 11.2
The Process as the Art

You may make a drawing by looking and recording or by using your imagination to create new forms. In this drawing, you will use chance, dripping, and responding to the drips. Using rice paper, make a stack of papers ten deep. Use paper that you have ripped to 8 × 11 inches or even smaller, 6 × 8 inches. You can choose any size within this range. Dip a small brush in ink and then hold the brush over your stack of paper and let it drip. Don't shake the brush. If the ink is too thick, add a little water to it. You can try other tools, such as a stick or rolled-up fabric. When the tool drips, watch where the drip lands, and pour a little more ink on the paper to create a shape. Pour slowly.

Watch the pattern, and choose where next to direct the ink. When you are done, lift each piece of paper off the stack, and let it dry on a plastic sheet or a piece of wax paper. The ink will have gone through the sheets, but each one will look different. Arrange the sheets in a grid, pinning them to a piece of foam core to display them.

Helen Frankenthaler saw that she could expand the deposit of pigment onto a field by staining the paper or canvas. The staining process removed her hand from directly making the art. She pushed the paint around with a squeegee to form the field, removing any brush marks. The stained shape remained two-dimensional, spreading across the flat ground of the paper. Her first works on canvas were done with oil paint. Oil on raw canvas creates a ring outside the color field, and then the oil will eventually rot the canvas. It was the invention of acrylics that allowed Frankenthaler to expand the possibilities of stain paintings. Her abstract style was derived from Hans Hofmann and Arshile Gorky. Like them, she took her inspi-

ration from nature. Her stained color was luminous and radiant, a thin transparent film with the quality of light. *Study IX, 1971* (fig. 11.10) is a field expanding into an endless space. Her color is sensuous on this flat field, possibly implying texture. The sensuous surface reflects references to natural sensations that we associate with touch—like the feel of velvet, silk, sand, or wet grass. There is no actual depiction of such things, and she doesn't intend for us to find textures in her work.

Other painters followed her, using the stain technique. Morris Louis and Kenneth Noland visited her studio, asking her advice for their own work. Later Mark Rothko would develop a process to stain canvas creating luminous surfaces.

Barbara Hepworth lived and worked in England at the same time that the artists in New York were developing a new abstraction. She first investigated adding color to her sculpture in 1938, but World War II interrupted her work. She pursued the addition of color in her drawings but not in her sculpture. By 1940, she knew Arp, Brancusi, and Mondrian, whose abstractions she respected. She began to think in more elliptical than prismatic shapes. Living in Cornwall with her husband and three small children, she found time to work only late at night. She wrote, "I did innumerable drawings in gouache and pencil—all of them abstract, and all of them my own way of exploring the particular tensions and relationships of form and colour which were to occupy me in sculpture during the later years of the war."

Hepworth's drawing *Curved Forms with Blue 1946* (fig. 11.11) is constructed of concentric curves that surround a deep hole in the center. The areas outside the blue center are gray, neutral surfaces that are delicately textured. The texture results from small parallel strokes scratched in a chalky, white impasto creating a surface reminiscent of the beach. This series of drawings is as close as she could come to carving in a two-dimensional medium. Inspired by the pagan landscape that lies within St. Ives, Penzance, and Lands' End, in England, her ideas formed regarding the relationship between the figure and the landscape. She felt that the human figure was formed out of landscape; a rocky island was an eye, another island was an arm, and so on. Color gave her linear constructions, a sense of three-dimensionality. The influence of nature is evident in her titles from 1940: *Crystal, Pebbles, Spiral with Red,* and *Form with Yellow on a White Ground.*

FIGURE 11.10
Helen Frankenthaler, (1928–), *Study IX,* (1971), acrylic on paper, 45.5 cm. × 54 cm. Washington Art Consortium Virginia Wright Fund. Photographer: Paul Brower.

POP ART

The New York School became the target for a new wave of New York artists in the late 1950s and into the 1960s. The content of Pop Art was focused on three directions: first, they used images from commercial culture, raising the value of a soup can from common to a high art status; second, they attacked artistic traditions, which had been holding the value of art at lofty heights; and finally, they removed the personal touch from making art. The interaction between the hand and the finished work could be eliminated. The painting or drawing was now directed by a preconceived plan. Andy Warhol, for

FIGURE 11.11
Barbara Hepworth, (1903–1975), *Curved Forms with Blue,* (1946), pencil and white gouache and oil (?) over a prepared ground on laid paper. 233 mm. × 290 mm. Iris & B. Gerald Cantor Center of Visual Arts at Stanford University, Bequest of Dr. and Mrs. Harold C. Torbert. 1984.521.

example, established the Factory in New York, a place in which his work is reproduced through a printmaking process, that he had no hand in.

Sentiment was removed from drawing. Roy Lichtenstein's *Mural Drawing* (fig. 11.12) makes a skeptical attack on both the working process and the values of Abstract-Expressionist painters. Brushstrokes for the Abstract-Expressionist painters had been spontaneous and authentic, and made with commitment. These artists of the 1950s discussed Existentialism and the moral position of humans in society, statements such as "A man 'condemned to freedom' is free only to choose, and the significance of his life is the sum of those choices." In the same way, the spontaneous, uncorrected brushstroke had meaning: the brushstroke was related to the painter's personality. Lichtenstein composed his drawing as an imitation of spontaneity by preplanning the composition in a calculated manner. He submits the brushstroke to ironic scrutiny. The grid of dots making up the ground of his drawing (fig. 11.12) refer to the mechanical process used in photo reproduction for printing large paper billboards. Photo reproduction, reduced the distinctiveness of a single drawing or canvas, from its previous ethical values determined in the making. Drawings such as Lichtensteins' converted the images into a flat field, where the printer's plate then turned the image into multiple images eliminating its uniqueness.

One of the more famous stories of an interaction between these two schools of painting is Robert Rauschenberg's visit to Willem de Kooning's studio to ask for a drawing that he could erase. De Kooning was agreeable and gave him a rich ink drawing, thinking that it would be very difficult to erase. Rauschenberg, however, did erase all the ink marks of de Kooning's drawing. In a way, this act was like the passing of the torch from one generation to another, although it was in no way the end of the New York School. Still, it marked the entrance of a new group of artists.

One of the new artists was Jasper Johns who often worked with serial imaginary. During the years of 1959 to 1962 he used the alphabet and numbers as his subjects. He might use scribbling and hatching around and over the numbers that were organized in a grid of anywhere from two rows long to 10 rows. The grid and row composition of serial imaginary abandons the traditions of composition replacing the foreground and the background with the infinite possibility of endless rows of forms. In Fig. 11.13, *0 through 9*, he has stacked the numbers 0 through 9 one on top of the other. This stacking creates rhythm and space without depth. The outline of each number is clean helping you look through the stack and pick out the shape of each number. The line gets thick when two numbers or more use the same space. So the 3, the 0 and the 8 curve at exactly the same place their outlines overlapping darkening the line. This is a print rather than a drawing but it was first drawn to create the image for the print. Johns chooses images for his work that are based on a concept devoid of the per-

FIGURE 11.12
Roy Lichtenstein, (1923–1997), *Mural Drawing*, (1969), crayon and gouache, 52.5 cm. × 206.5 cm. Washington Art Consortium Virginia Wright Fund. Photographer: Paul Brower.

FIGURE 11.13
Jasper Johns, American, *O through 9,* (1960), lithograph
(stone) in black on Arches paper, (Field 1970 4). Rosenwald
Collection. Photograph © Board of Trustees, National Gallery
of Art, Washington, D.C. Art © Jasper Johns/Licensed by
VAGA, New York, NY. 1964.8.1129. (PR).

sonal and the narrative. Rather, the content of any
given artwork derives its existence from the over-
all structure of the work. The qualities that inter-
est Johns are literalness, repetition, an obsessive
quality in the image, order with dumbness, and the
possibility of a complete lack of meaning.

James Rosenquist, in his drawing *Circles of
Confusion, 1965* (fig. 11.14), employed the trans-
parency of rubbed pastel to create aureoles of color
upon which he penciled the General Electric logo
as if you are looking at the top of the lightbulb. The
flat insignia of GE reinforces your sense of a flat
field. He mocks the light of nature, replacing it with

FIGURE 11.14
James Rosenquist, (1933–). *Circles of Confu-
sion,* (1965), pencil and pastel on paper, 22 in.
× 18.25 in. (56 cm. × 46.5 cm.). Works On
Paper: 1945–1975 © James Rosenquist/Li-
censed by VAGA, New York, NY. Washington
Art Consortium Photographer: Paul Macapia.
75.4.

the light from a lightbulb, claiming that this light is more valid.

PARODY

In the 1970s and 1980s, marginalized artists moved into the mainstream as active participants. This change can be credited to the growing public recognition that the work of ethnic minorities—Chinese Americans, African Americans, Latinos, and women, as well as the cultural production of the Third World cultures—spoke powerfully to the social and political issues of the day. The civil rights movement, the feminist movement, the sexual revolution, and the Vietnam War opened a new awareness in the world of art. A new consciousness developed, one much more pluralistic in its understanding of life. The theoretical manifestation of this new thought was deconstruction, which not only attacked the very possibility of a dominant mainstream discourse but also challenged the finality of meaning. In the mainstream, white male artists had once dominated the shows in the museums and galleries. Now the deconstruction artists, once considered part of the "other"—other than white male—moved into the mainstream of the arts. For the last thirty years, their work has gained more and more authority.

When the African-American artist Robert Colescott was chosen to represent the United States at the 1997 Venice Biennale exhibition, the art of these marginalized voices could be said to have finally arrived. Colescott's work was informed by a trip to Egypt in 1964, where he discovered the 3,000-year-old history of African narrative art. In light of this knowledge, he began to analyze his own identity and to consider the complexities of his own situation. Colescott studied in Paris at the Atelier, a French art school, of Fernand Léger, from 1949 to 1950. Colescott combines his knowledge of Cubism and other modern movements, as well as his love of cartoons, into his compositions. He mixes anecdotal humor and painterly invention. As he often does, he has taken his subject from the mainstream tradition of art, which he intentionally parodies. *Suzanna and the Elders* (fig. 11.15) is based on a story that was painted first by Tintoretto in 1555, then by Artemisia Gentileschi in 1610, by Guercino in 1617, and finally by Rembrandt in 1647. As the story goes, the traditional Susannah

was a beautiful young woman who was married to a very rich man. The elders of the community visited the husband often for his counsel. Seeing Susannah, they became obsessed with her beauty and determined to hide themselves in her garden where she went to bathe. They surprised her and sought sexual favors, which she denied them. Angry with being rebuked, they falsely accused her to Daniel, her husband, of lying with a young man. They fabricated a complete lie about a sordid affair with this young man, for which she was brought to court. There she was sentenced to death for this supposed adultery. When the sentence was announced, she cried out to God for justice, knowing that she was not guilty. God spoke through Daniel questioning the story of the elders, who had no proof but their word. The people listened and then questioned the elders. In his wisdom, Daniel separated the two elders and asked each one, "Under which tree in the garden did you see this act?" One elder said that it was the oak tree, and the other named the evergreen tree. They were found out in their lie, and both received the death sentence.

In both Rembrandt's and Tintoretto's versions of the story, the tension of the bath scene is reflected in the paintings' sharp contrasts of light and dark, and in the way that Susannah's dazzling, feminine beauty is contrasted to the caricatured ugliness of the elders. The same tensions inform Colescott's composition, but he has translated the scene into his own world, a modern bathroom in Harlem. The tension between light and dark skin tones, and the traditional treatments of chiaroscuro are transformed into a treatise on race and class in the contrast between the white woman and the black janitor behind the bath. Where the tension between beauty and terror punctuated the original works, the tension of Colescott's work depends on the contrast between Suzanna's slipping in the tub and the watching men, including Colescott, whose face is in the window at the top of the drawing on the left. In this modern version, Colescott has changed the spelling of the name from Susannah to Suzanna, as in the song "Ole Suzanna, Don't You Cry for Me," increasing the humor of his parody.

Colescott's work turns the tables on the European tradition, relegating it to the category of "the other" by replacing it with a new interpretation of the biblical story in his drawing taken from modern life and seen from an African-American point of view.

FIGURE 11.15
Robert Colescott, (1925–), *Suzanna and the Elders,* (1980), colored pencil and pencil on paper, 30 in. × 22½ in., (76.2 cm. × 57.2 cm.). Signed, dated, and titled R. Colescott 80. Courtesy of Phyllis Kind Gallery, New York, NY. 1982.153.1.

DRAWING EXERCISE 11.3
Drawing from Culture

Focus on a story you know from myth, fairy tales or other literature. Rework this story in a drawing putting a modern twist on it. Bring elements together to interpret the story in terms of how you see life around you now. Feel free to use photography, rubbings, textures and real textures.

MINIMALISM

In both Minimalism and Pop Art, the surface of the picture did not imitate the spatial logic of the real world or a picture plane. Depicted as flat and opaque, drawings in Minimalism were made to remain on the surface. There was no intent to move the viewer beyond or through the surface. This style is consistent in the work of Brice Marden (fig. 11.16), Frank Stella (figs. 11.17 and 11.18), Agnes Martin (fig. 11.19), Robert Ryman (fig. 11.20), and Larry Poons (fig. 11.21). The idea of expressive content had been eliminated in Minimalism. There were no hidden psychological meanings to the work. As Stella once said, "What you see is what you see." The idea of the imagination as the force behind the mark was replaced with "the process" being the important force in the work. Materials gained new importance. There was no interaction between the marks and what the artist did next. There are "no accidents" in Minimalism, the

FIGURE 11.17 and 11.18
Frank Stella, (1936), *Eccentric Polygons,* (1974), a portfolio of 11 lithograph/silkscreen prints, editions of 100, 56.5 cm. × 43.8 cm. Virginia Wright Fund. Washington Art Consortium. Photographer: Paul Brower. © 2005 Frank Stella/Artists Rights Society (ARS), New York, NY. 76.19.

FIGURE 11.16
Brice Marden, b., *Untitled,* 1964. Graphite pencil on brown paper, 41 cm. × 51 cm. (16⅛ in. × 20⅛ in.). Works on Paper: 1945–1975 © 2005 Brice Marden Artists Rights society (ARS), New York. 76.11. Washington Art Consortium. Photo Paul Brower.

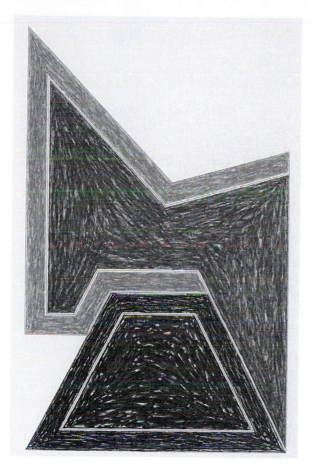

FIGURE 11.18

painter Frank Okada told me. The artist planned the approach with a choice of materials, marks, and colors to fill the surface of the picture from start to finish.

Brice Marden employed the grid in *Untitled, 1964* (fig. 11.16) like a scaffold for the drawing. The grid, which holds the graphite marks, is an underlying structure that organizes and orders the space. The graphite laid over the grid takes on an extreme physical presence. The drawing is about the quality of graphite, and the quality of the graphite is determined in its application. Minimalism strongly investigated the properties and possibilities of the materials of art and brought to art new materials such as plastic, roplex (an early form of a plastic gel that hardens), and vacuforming (a process in which a plastic form is made in a mold). Virtually anything that could be used to make a mark could be appropriated as an art material.

Minimalism gravitated toward geometric forms, repetition, and modular sequences that created endless and real space. It sought ways to reveal itself to the spectator in a physical sense that was literal, not metaphoric and not representational of something else.

FIGURE 11.19
Agnes Martin, (1912–), *Untitled,* (1965), pencil on paper, 9 in. × 9 in. (23 cm. × 23 cm.). Works on Paper 1945–1975. Washington Art Consortium Virginia Wright Fund. Photographer: Paul McCapia. 74.1.

FIGURE 11.20
Robert Ryman, (1930), *Yellow Drawing #5,* (1963), charcoal, pencil and white pastel on ochre paper, 37.5 × 38 cm. Works on Paper 1945–1975. Gift of Virginia and Bagley Wright. Washington Art Consortium. Photographer: Paul Brower. 76.16.

Frank Stella eliminated the rectangle as the definitive shape of painting. In so doing, he eliminated any possible reference to the picture plane as a window into the space. The Renaissance concept of a window was abandoned for the flat surface of a shaped canvas. Now the exterior shape reflected the internal divisions. *Eccentric Polygons* (figs. 11.17 and 11.18) are shaped prints in which the edge of the print no longer contains the pictorial elements. "The whole was the sum of its parts," Stella once said in an interview. He called the work a "deductive structure." Stella worked in series, a process that allowed him to make one piece after another from the same set of defining principles. Organizing his work as a series established a mechanism for him, a director, which was external to the work and shaped its contents. He set the parameters of each series by first assigning a family of shapes, predetermining the color or colors, and determining the other variables, such as the thickness of line and the lines for the general divisions. This process with predetermined compositional elements generated the individual works in the series.

FIGURE 11.21
Larry Poons, (1937), *Untitled,* (c. 1963), pencil, 20 cm. × 40 cm. Gift of Charles Cowles. Washington Art Consortium. Photographer: Paul Brower. Art © Larry Poons/Licensed by VAGA, New York, NY. 76.15.

The images were deprived of content or meaning. The geometric structure found no metaphor in the viewers' consciousness that would make them think or say, "Oh, that reminds me of . . ." Minimalism wasn't cold—it was indifferent, ironic, and sarcastic. It was intellectually, not emotionally, based. The subject matter was removed, as were the brush marks, thus eliminating content. The visual reality of the painting, once it was a shaped object, included the space of the walls around it as it undermined the convention of the rectangular format.

The division between the means and the ends vanished with the art of this period. In the 1960s and 1970s, Minimalism rejected the conventional strategies of drawing. The relationship between artistic tools and materials was reevaluated, and Minimalist artists refused to rely on technique or composition as a way to judge a drawing.

Agnes Martin's *Untitled, 1965* (fig. 11.19) is about perfection as her mind defines perfection. Her feeling is that in spite of this desire for perfection, the drawings are never perfect. In her work, all literary allusions or representations have vanished. Her work seems calm, but the calmness is a result of an intensive drawing process. This intensity is not expressed by gestural brushwork but by pursuing the idea for the drawing day after day. She rejects most of her drawings, reworking them until only a few are left. In her work she creates a space for perception line by line: "My drawings have neither object nor space nor anything—no forms. They are light, lightness, about merging, about formlessness, breaking down form. A world without objects, without interruption, making a work without interruption or obstacle. It is to accept the necessity of the simple, the direct going into a field of vision as you would cross an empty beach to look at the ocean." Her drawings and paintings are timeless. As you sit in the middle of her series of white paintings and look at them, they begin moving off the surface of the canvas into the space between you and the surface. Her drawings and paintings seem to expand as you look at them. The lines in her work are perfect lines of high quality. It is hard to imagine that they were made by the human hand rather than by a machine. In an exhibition, you experience her work more than look at it.

In her writings, Agnes Martin addresses the unity of truth and beauty in a work of art. She says in her book *Writings,* "Works of art have success-

fully represented our response to reality from the beginning. Reality, the truth about life and the mystery of beauty are all the same. The manipulation of materials in artwork is a result of this state of mind. The artist works by awareness of their own state of mind."

Robert Ryman's *Yellow Drawing #5, 1963* (fig. 11.20) concentrated on the nuances of the abstract mark. He restricted himself to an all-white palette from the beginning of the 1960s. This technique heightened the "pure" reading of each component in the drawing or painting—the mark, the surface, the support, and the way that the support is attached to the wall. His work is subtle: there are no metaphors, and he is defining the mark. The grid provides a structure to arrange and present the matter of the work. For Ryman, the grid is the infrastructure for a series of repeated marks.

For Larry Poons, in *Untitled, ca. 1963* (fig. 11.21), the grid serves to methodically organize what he might call a visual incident. The organization of the lines creates an optical illusion that can be perceived to move endlessly through space. It has not been framed or bordered. The edges are open—these lines could be drawn into infinity. Unlike minimal sculpture, in which a sense of endless space can be physically constructed, painting and drawings must rely on illusion to create the sense that the space is expanding and infinite.

SERIAL IMAGERY AND PROCESS ART

The organization of serial work was derived by means of a predetermined process. In contrast to thematic work, such as Monet's *Haystacks,* in which the work developed during its execution, serial work tended to be anti-Expressionistic and antisubjective.

The relationship between process, material, and a serial image could be the works, subject, or theme. Nontraditional materials in art practice characterized Process Art. Non-art materials—such as feathers, rubber hosing, neon, lettuce, and felt—were combined with other materials and objects, and then placed in unusual arrangements or broken into pieces and rearranged. In general, Process work emphasized the temporality, rather than the presumed permanence of the art object. It meant to draw attention to the process of its construction

more than the final product or result, which sometimes changed according to the installation or the effects of time. Process Art can result from a particular act of expression resulting from an activity of the body, such as grasping, touching, placing, and reaching. Robert Morris often used materials considered impoverished in the tradition of art such as in his work *Blind Time XIX* (fig. 3.17). His use of indiscriminate gestures and random acts such as hanging, rolling, scattering, and splashing moved making art into a new realm. Drawing was a very compatible medium for Process art, since drawing can record the process of the artist's making the strokes. A drawing made by the artist's hand speaks to the hand's decisions. In Process art, drawing is no longer object-based work but is redefined as representing something else. Now "drawing" is the subject.

EARTHWORKS AND SITE-SPECIFIC ART

Michael Heizer pioneered the new genre of site-specific art, that is, art that defines itself in its precise interaction with the particular place for which

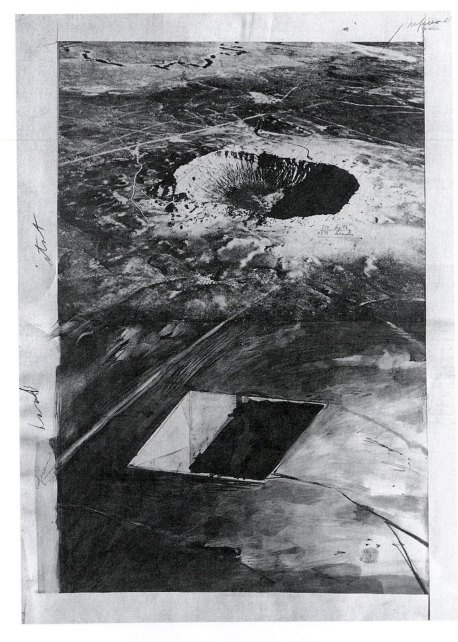

FIGURE 11.22
Michael Heizer, (1944), *Untitled,* (1969), photograph, graphite and watercolor on paper, 39 in. × 30 in., (99.06 cm. × 76.2 cm). Collection of the Whitney Museum of American Art, New York, NY. Gift of Norman Dubrow. 80.26.1.

it was conceived. This is Process Art taken outside and into the physical world. Heizer grew up in a family of geologists and archaeologists in Northern California. His affinity for the landscape grew into doing "dirtwork." One of his drawings was made by driving his motorcycle over a site in Nevada, the tracks of the wheels were his lines. Once again, illusionism is rejected by focusing on the actual mass and weight of real cuts into the ground or into real walls. The idea of art as a portable object was attacked, along with the institutions that showcased art. In 1969, many Process and Conceptual artists rejected the museum and the gallery; after all, these were places that could neither show nor sell their major works. *Untitled, 1969* (fig. 11.22) is a drawing used as a rough, annotated working presentation of an artist's idea. Heizer's drawing combines a photograph of Arizona's meteor crater with a proposal for a revised square shape. The artist's image mirrors and reforms the crater's shape with a painterly wash. The Earthwork artists considered

the earth a raw art material. They cut, sliced, dug, or "drew" on a variety of the earth's surfaces. Heizer's work can be seen completely only from the air or from afar; close-up, it can be experienced only part by part.

Process Art was continuing and evolving into the 1980s, with artists like Anselm Kiefer, Joseph Beuys, and Donald Sultan, all of whom expanded the list of materials that could be used in painting and drawing. Kiefer (fig. 11.23) works in the German romantic tradition. Unlike Pop Art and Minimal Art of the late 1960s and 1970s, his work has emotional meaning and makes direct references to historical themes. It parallels mythology, including that of the Greek, Egyptian, early Christian, Jewish Cabbala, and Nordic cultures. Feeling that science does not provide the answers to the questions that he has about life and the universe, Kiefer has researched the major world religions. He is no longer a Process Artist; instead, he is an artist who has expanded the possibilities of materials in art but who

FIGURE 11.23
Anselm Kiefer, German, (1945), *The Staff (Der Stab),* (1984), melted lead, acrylic, charcoal, photographic emulsion, and leaves on photograph, mounted on paperboard, 27¹¹⁄₁₆ in. × 39½ in., (70.3 cm. × 103.0 cm.). Hirshhorn Museum and Sculpture Garden.Smithsonian Institution, Washington, D.C. © Artists Rights Society (ARS), New York, NY.

has returned to a narrative. Glass and straw are woven together in a new narrative.

Kiefer admired the materiality of Joseph Beuys's work, plus the work of the American Minimalists, and the work of the Process artists of the 1960s. He was attracted to real materials for his work, for their presence and symbolism. He has made books of lead and paintings with straw, both of which change with oxidation and exposure during their time on exhibition.

Tam Van Tran was born in 1966 in Kontum, Vietnam and now lives in Redondo Beach, California. Tran's artworks extend the boundaries of both painting and drawing, using a range of materials and techniques to create abstract compositions whose references sweep from the microscopic to infinity. His early work was inspired by traditional Chinese landscape painting yet evoked computer networks, city plans, and futuristic architectural structures. In the series, Beetle Manifesto (fig. 11.24), there are references of an intimate focus on organic matter, conjuring forests, leaves and microscopic views of cells. Beetle Manifesto IV is composed of chlorophyll, spirulina, pigment, staples, binder, aluminum foil, and paper. This large-scale, sculptural drawing is from a series Tam Van Tran calls the "beetle manifestos". To make them, the artist draws and paints on immense swaths of paper which he then cuts into thin strips. Next, he punches holes in the strips and sutures the pieces back together with thousands of staples. Finally, he adds white inserts which warp the paper, giving it a three-dimensional shape. To create the various shades of verdant green, Van Tran often uses natural pigments normally not intended for artmaking, such as plant chlorophyll and spirulina algae, creating an effect that recalls dense vegetation or the teeming life of pond water as seen under a microscope. His almost obsessive, labor-intensive process and unusual combination of materials allude to tensions between the natural and the man-made, representation and abstraction. The use of natural materials provides Tran an opportunity to make natural references, while his art remains engaged with issues of abstract painting. He sees that the filigreed lines of connectors on a computer chip are visually similar to human veins or those of leaves. He shifts back and forth between the industrial and

FIGURE 11.24
Tam Van Tran, (1966–), *Beetle Manifesto IV,* (2002), chlorophyll, spirulina, pigment, staples, binder, aluminum foil, and paper. Unframed: 92 in. × 91 in. × 12 in. (233.7 cm. × 231.1 cm. × 30.5 cm). Photograph and Digital Image © The Whitney Museum of American Art, New York, NY. 2004.45.

FIGURE 11.25

Donald Sultan, American, (1951–), *Plant, May 29, 1985,* latex, tar and fabric on vinyl tile mounted on fiberboard, 96 in. × 96 in. (243.9 cm. × 243.9 cm.). Hirshhorn Museum and Sculpture Garden, Smithsonian Institution, Washington, D.C. Thomas M. Evans, Jerome L. Greene, Joseph H. Hirshhorn, and Sydney and Frances Lewis Purchase Fund, (1985). 85.30.

the organic, the abstract and the representational, the delicate and the roughly handmade, holding them all in a productive tension.

Donald Sultan grew up when Minimalism and geometric abstraction were the dominant styles. He inherited the grid, which is the underlying structure of the tiles he uses to compose his large works such as *Plant* (fig. 11.25). Like moderns before him, he maintains a sense of flatness to his work by using the silhouettes of shapes. The tarred surface and the extensive structure he builds to physically support his work reference the material advances of the 1960s and 1970s. Sultan draws from a range of images he finds through time. His work might reflect the Baroque, Impressionism, or Abstract Expressionism.

Sultan's recognizable objects are defined with sharp figure-ground contrasts and sometimes atmospheric grounds. For Donald Sultan, paintings and drawings are in a continuous state of formulation. He will take a theme and try out variations, watching where the work takes him (this direction emerge, out of Abstract Expressionism). Sultan takes his ideas from the world around him. His sub-

jects may be the industrial landscape, chimney stacks, street lamps, explosions, or shapes of fruits and flowers. He uses modern life—the world of common objects (relating directly back to Pop Art)—as his subjects. He looks for experiences that distinguish life today from what has gone before. His choice of materials gives his work a strong physical appearance. The things that characterize his work as contemporary are the following three things: its visual and stylistic level, the use of nonart materials, and the choice of subject matter as well as the source of his subject. Often Sultan's paintings look like drawings.

DRAWING EXERCISE 11.4
Drawing with Black

Use wax as your drawing tool. It can be wax from a candle, crayons, or paraffin. Try drawing a section of a landscape by wiping strokes of wax on a piece of paper. Once you have a drawing, cover the drawing in ink. The wax will bead and show through, creating the effect of night

light. You can use raw canvas instead of paper. Canvas has texture that will contribute to the broken light effects in your drawing. You can try to remove some of the ink with a flat razor blade which will give you another value in the drawing.

POSTMODERNISM

Until the 1960s, the term "modern and contemporary art" covered the new Abstract art, Cubism, Surrealism, and other modern movements. The term "postmodern" was first applied to architecture in the 1960s, and by the 1970s it referred to a change in the studio arts as well. There is no well-defined line between the end of modernism and the beginning of postmodernism. It was more a change in thinking, not a change in an art style.

Phillip Guston was one of the leading New York School painters, who in his youth wanted to

FIGURE 11.27
Phillip Guston, (1913–1980), *Untitled,* (1971), oil on paper 22¼ in. × 28⅛ in. (56.5 cm. × 71.5 cm.). Hirshhorn Museum and Sculpture Garden, Smithsonian Institution, Washington, D.C. Bequest of Musa Guston, (1992). 92.19.

be a cartoonist and studied at home through a correspondence course. A rebel from the beginning, he was expelled from high school, along with Jackson Pollock, for publishing and distributing a leaflet against the faculty for emphasizing sports. He never went back to school; instead, he read art journals like *Transition* and *The Dial*, and began working with other intellectuals and artists. Guston's *Inscapes: Words and Images, print, 1976* (fig. 11.26) announces a new realism. By 1980, through the use of cartoons and transformed images as in *Untitled* (fig. 11.27), his style was based on fully blown cartoon images.

Guston was a self-taught painter. His association with the Mexican muralists José Clemente Orozco and David Alfaro Siqueiros in Los Angeles altered both his politics and his painting style. In 1931, Guston completed two paintings, one of Ku Klux Klansmen whipping a roped black man and one of hooded Klansmen armed with crude weapons, huddled in front of a gallows. He left these paintings in a friend's bookstore in San Francisco. One morning, a group of Klansmen and American Legionnaires carrying lead pipes and guns broke into the bookstore and shot the eyes and genitals out of the figures in the paintings. There were eyewitnesses, Guston sued the Klan & Legionnaires and but the judge in the case disliked Guston's leftist politics and dismissed the case. This was a lesson about "justice" that he never forgot.

Guston's early paintings and drawings in the 1950's evolved from the artist's interaction with the paint and the surface. His palette was reduced to black, red, and white. For him, touch rather than

FIGURE 11.26
Phillip Guston, (1913–1980), *Inscapes: Words and Images,* (1976), print, color serigraph on paper, 44 in. × 32¹⁵⁄₁₆ in., (111.7 cm. × 83.7 cm.). Hirshhorn Museum and Sculpture Garden, Smithsonian Institution, Washington, D.C. Gift of Smithsonian Resident Associate Program, Washington, D.C. (November 30), 1978. 78.97.

gesture was important. He painted a sensual surface, rich and saturated, until the end of the 1950s when he felt that it was "too easy to elicit a response" with his sensuous abstractions. He moved through a gray-and-black abstract period into the 1960s. Then he made the move to cartoon-like figurative work. Drawing always played an important role for him, allowing him to move between the figurative and the abstract. In the early abstract ink drawings, structure was important (fig. 3.23, Chapter 3). He struggled with self-doubt during the transition from Abstraction to figurative work. At first he was doing the "pure" drawings—drawings without objects—but the drawings of objects, books, shoes, buildings, hands, heads, and cigars (fig. 11.28) finally won out, and he began to create a private iconography, a pictorial language that influenced the German artists Georg Baselitz and Anselm Kiefer. Other artists in the 1980s and 1990s would return to the figure and narrative in art, encouraged by his lead.

Georg Baselitz began making prints in 1964. His early prints were closely related to drawings in scale and conception. In the print *Drinker* (fig. 11.28), Baselitz expanded the linear quality of draw-

FIGURE 11.29

Joan Brown, American, (1938–1990), *Woman Resting*, (1961), gouache and fabric on paperboard, 30 in. × 31⅝ in. (76.2 cm. × 80.3 cm.). Hirshhorn Museum and Sculpture Garden, Smithsonian Institution, Washington, D.C. Gift of Joseph H. Hirshhorn, (1966). JH61.522.

ing by eliminating chiaroscuro and concentrating on networks of lines. Baselitz intentionally presents the print upside down. In this way he asks you to reexamine what you know about the figure and the space it is in. He offers you a new image.

FUNK

In 1957 in California, Joan Brown worked with the Funk collage-makers who used the process of assemblage. Funk attacked the boundary between the art forms and the clarity of communication in art. Artists working in the Funk style might cut underground film clips together, reassembling them in a random order that made no sense, or build assemblages out of materials at hand, using an intuitive process of construction. Preconception was eliminated, and the spontaneous was celebrated. The work was often humorous and usually threatened the perimeters of "good taste." Joan Brown's funky paint surface in *Woman Resting* (fig. 11.29) comes out of the beat or hip assemblage aesthetic. The densely painted expressionistic surfaces are characteristic of her work, perhaps resulting from the influence of William de Kooning and then Elmer Bischoff who she studied with in 1956.

FIGURE 11.28

Georg Baselitz, *Drinker*, (1981), woodcut and monoprint on paper, 798 mm. × 593 mm. Tate, London, England. P78016.

DRAWING EXERCISE 11.5
Shaped Picture Planes and Repetition

First establish a picture plane that is not a rectangle. Take a piece of paper, and rip it into a shape that is not a rectangle. Select one object: your glasses, a cube, a toy, a small animal, or a pair of sunglasses to be your subject. Make a drawing of this object on your new-sized paper. On another piece of paper draw the object as a dark one, overlap the drawing with a second drawing rub some of the drawing out, leave the rubbed-out area, and draw on top of it. Have you changed your perception of this object? Does it have a new identity? The goal is to reinvent a form.

PROFILE OF ARTISTS: *GOAT ISLAND, 1987–2005*

The purpose, use, and function of drawing by the 1960s and 1970s was dramatically altered. It was no longer abstraction, representation, or imitation. Drawing and writing for this new generation of artists became intertwined. There was—and is now—a kinship among drawing, writing, and thinking. Leonardo, in his sketchbooks, reflected his idea of pictorial art as a *cosa mentale,* an activity of mental invention. Thinking draws; it constructs and manipulates images. Drawing is the basis for rendering structure visible, allowing for the manipulation and formalization of order. As Plato realized, drawing is at the basis of spatial visualization and literacy.

Goat Island was founded in 1987. It is a nonprofit organization formed to produce collaborative performance works that are developed by its members. The Chicago-based group seen in performance in fig 11.30 consists of Karen Christopher,

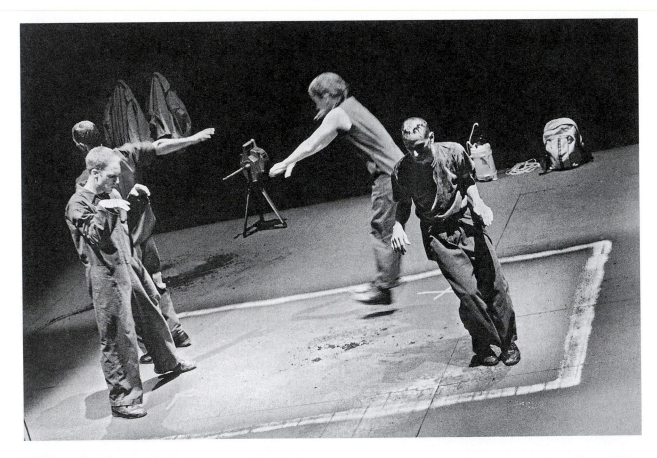

FIGURE 11.30
Goat Island performing, *The Sea and Poison,* (1998), directed by Lin Hixson; performers from front left: Mark Jeffery, Bryan Saner, Karen Christopher and Matthew Goulish. Photograph courtesy of Goat Island.

Matthew Goulish, Mark Jeffery, Bryan Saner, C. J. Mitchell, the manager, and Lin Hixson, the director. All members contribute to the conception or idea for the work, research, writing, choreography, documentation, and educational demands of the work.

Lin Hixson, the director of Goat Island, began her career in the studio arts in college. Drawing is a natural tool for her to communicate her ideas regarding the various stages that a Goat Island performance will go through. Lin Hixson is comfortable with drawing as a planning tool and uses drawing to describe movement. What is two-dimensional in Hixson's drawings becomes three-dimensional in performance. Drawing provides her the first avenue for mapping out what will be a one- to two-hour performance in which she must coordinate four performers, the performance space, and the space of the audience.

Lin Hixson describes Goat Island as follows:

Characteristically we attempt to establish a spatial relationship with audiences, other than the usual proscenium theater situation, which may suggest a concept, such as sporting arena or parade ground or may create a setting for which there is no everyday comparison. We perform a personal vocabulary of movement, both dance-like and pedestrian that often makes extreme physical demands on the performers, and attention demands on the audience. We incorporate historical and contemporary issues through text and movement. We create visual/spatial images to encapsulate thematic concerns. We place our performances in non-theatrical sites when possible. We research and write collaborative lectures for public events, and often publish either our own artists' books, or in professional journals.

In the drawing for *The Sea and Poison* (fig. 11.31), Lin Hixson has choreographed the section called "Dead Red Buttons." The marks indicate where each performer starts and in which direction the performer will move. The text below the drawings is a diagram for the performance and more text directing the movements and interactions between the performers.

The work *The Sea and Poison* investigates the effects of poison on the body and landscape, including the pollution of time and space. The company focused their research on personal, historical, and popular culture poisonings. The research ranged from the medieval choreographic epidemics known as Saint Vitus' Dance—believed to have been caused by the mass consumption of contaminated

DEAD RED BUTTONS

Sequence following 5 impossible dances

(ending of 5th impossible dance)

K, B, MO go to star spots

M goes to new spot

all 4 do roll ending

B, K, MG, M go right into solos with B counting (no jumps or M's)

B, K, MG do solos exactly the same except they go back to star position and begin solos again right away

M does solos exactly the same except he is going counter direction to B, K, MG

End of solos everyone goes to original Impossible Dance spots at M site. Everyone does roll.

M, Mg, K go put on backpacks and stand in a line

B goes to middle (George spot)

Music starts

B dances

Siren. Music stops.

M, MG, K go to Impossible dance spots

Put money on B

FIGURE 11.31

Illustrations by Lin Hixson directing the movements of Goat Island in their performance of *The Sea and Poison*.

bread—to the poisoning of U.S. troops and Iraqi civilians in the Persian Gulf War.

Goat Island has six completed works to date including the following: *Soldier, Child Tortured Man* (1987), *We Got a Date* (1989), *Can't Take Johnny to the Funeral* (1991), *It's Shifting, Hank* (1993), *How Dear to Me the Hour When Daylight Dies* (1996), and *The Sea and Poison* (1998). There is a video on their working process called *Goat Island, Works in Progress*. It was produced by Annenberg CPB and can be seen on PBS or purchased by calling 1–800–LEARNER.

CONCEPTUAL ART AND INSTALLATION

In the middle of the 1960s, artists moved their creativity off paper and canvas onto the walls of the gallery, creating a new art called Installation Art.

Jonathan Borofsky graduated from Yale in 1966. He had stopped making objects and turned to Conceptual Art. In 1968, he started a piece that involved counting. He would write one number on a sheet of paper followed by the next number on a second sheet of paper. After counting for a few hours, he began scribbling and drawing little figures on his paper. This step led him to using both the numbers and the figures in a painting. As of 1973, he had reached the number 2,208,287. The counting continues today.

In his show at the Paula Cooper Gallery in 1975, Borofsky filled the walls, installing all the drawings he had been doing for the last year. He showed self-portraits, sketches on scraps of paper, and dreams he had written down. He censored nothing in an attempt to give people a sense of being inside his mind. Next, he started drawing directly on the floor and walls of his studio. To transfer his drawings from the studio to the gallery, he would use an opaque projector to project and trace the drawing onto the wall. Rather than arriving at the gallery with a number of objects to hang, Borofsky arrived with a briefcase containing drawings he would project. His purpose in drawing directly on the walls was to eliminate any sale of his work. He reasoned that if you couldn't buy the work, then you would come to interact with the work only out of a genuine interest in the experience.

His work, which is pictured in *Blimp* (fig. 11.32) and the *Details* from the installation (fig. 11.33), was installed at the University of California, Irvine, in 1977. In this installation, the drawing *Blimp* was projected through a doorway and drawn on four separate surfaces, which involved three walls and the edge of one wall. As installed, the drawing invites the viewer to walk through it. In this installation, Borofsky activates the entire space, not allowing the viewer to focus on a single point. The viewer feels inside the work. Borofsky works as painters work on a canvas, moving around the space, placing images in one part and balancing them with images in the other rooms or on other walls. He creates an en-

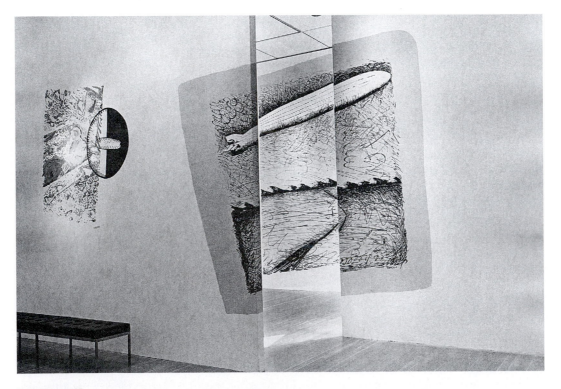

FIGURE 11.32
Jonathan Borofsky, *Blimp,* (1977), ink on wall, installation, approximately 96 in. × 84 in. University of California, Irvine. Courtesy Paula Cooper Gallery, New York, NY.

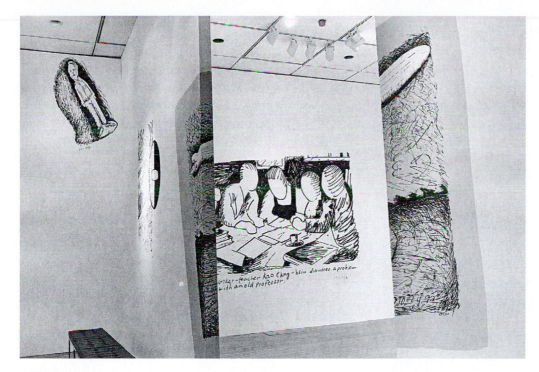

FIGURE 11.33
Jonathan Borofsky, *Blimp,* installation at the Ink, (1977), ink, day glow paint on wall. Courtesy Paula Cooper Gallery, New York, NY.

ergy in the space. In this installation, he used four walls, the ceiling, and the floor, which were colored green, pink, and yellow, to create a three-dimensional effect. As Borofsky explains, "I would find the key point of the three-dimensional architectural interest in a room, the one I could do the most with, and play with the two-dimensional possibilities of a painting, trying to bring the two together."

Laura Vandenburgh's works are pencil and silverpoint drawings on wood panels and books. The units are hung as arrangements with other materials or in groups across the wall or across the corners. The photo of *Lacunae* (fig. 11.34) shows the piece installed on the wall. As with other Installation Art, the viewer must make visual adjustments depending on the space between themselves and the wall. Some of the drawings on

FIGURE 11.34
Laura Vandenburgh, *Lacunae,* graphite, silverpoint, gouache, wood and book, 15.5 in. × 50 in. Courtesy of the Artist.

FIGURE 11.35
Laura Vandenburgh, *Still,* (1999), graphite, gouache, mirrors, and wood, 8 in. × 5.5 in. Courtesy of the Artist.

the prepared panels are derived from photographs in science books or textbooks. *Lacunae* is composed from drawings of tangled hair on each pale orange tile. The tiles are approximately four- to five-inch squares and rectangles. The drawing is light and visible only from a certain viewing distance. The hair reminds you of the drawing by Leonardo called *Deluge.* These hair piles are ambiguous—they could be clouds or a storm just as well as hair.

Vandenburgh constructs the drawing out of birch panels that are gessoed and sanded. She then paints layers of white gouache on the surface. The drawing is done in either graphite or silverpoint. The silverpoint drawings are done with various types of metal wires mounted in a dowel. The images are rubbed back into the surface by sanding and then returned with another layer of drawing. This is a slow process and rather like meditation; it takes patience.

The piece *Still* (fig. 11.35) is graphite on a 5.5 × 5.5 inch primed or prepared birch panel. The two small squares placed above it are mirrors. When you look at the drawing, you see yourself at the same time, but you see only your eye, or a part of your face. The artist has made you part of her piece.

STRATEGIES FOR CRITIQUING AND THINKING ABOUT CONTEMPORARY DRAWING

Drawing is no longer "the imitation of the most beautiful parts of nature in all figures," as Vasari once said. There is no longer any requirement that draftsmanship demonstrate the highest technical skill in reproducing with absolute accuracy and precision everything that the eye sees. Drawings can be a reality in their own right. Drawing no longer represents something else, it is simply itself. As Richard Serra has said, "There is no way to make a drawing—there is only drawing."

In the twentieth century, the literalness with which the drawing's surface is stated, along with the sense that we no longer look through the surface into deep space, are major changes from the Renaissance definition of drawing. Paul Cézanne's *A Corner of the Studio* (fig. 11.36) does not recede as dictated by traditional definitions of drawing. It stays in the front on the picture plane. Drawing makes no claims that technique or composition determines a good drawing. The overlapping rectangles insinuate space but the lack of modeling on their surfaces prevents a deep space reading. They sit upright held in tension by the black hatching behind them. The conventional strategies of drawing have been rejected, and the relationship between graphic tools and materials has been redefined. In the late 1960s and 1970s, drawing discredited and dismissed the idea of Gestalt, the concept of a unified whole, and moved into Process Art, Pop Art, and Narrative, in which the making of art with often impoverished materials became its subject.

FIGURE 11.36
Paul Cézanne, (1839–1906), *A Corner of the Studio (sketchbook page)*, (verso), (c. 1881), pencil. 8½ in. × 5 in. Courtesy of the Fogg Art Museum, Harvard University Art Museums. Bequest of Marian H. Phinney. 1962.24.

Today's students choose their materials, the scale of their drawings, and the processes for making their drawing. They work abstractly, realistically with a narrative, or with no narrative. Modern and post-modern drawing depends on the strength of the students' critical thinking skills, their decision-making abilities, and their vision.

In contemporary art, you will analyze artists and their works, with a broader definition of drawing:

1. Consider the artist's purpose.
2. Research the artist to discover where his or her ideas come from.
3. Consider what the title of the work tells you.
4. Analyze how the artist is using the formal elements.
 - How is line employed in the work?
 - Does the line order or fragment the work?
 - How are light and dark values used in the work?
 - What is the predominant color scheme of the work?
 - What is the relation of shape to space in the work?
 - How has the artist used or manipulated the surface or picture plane?
5. Interpret what the artist is trying to say about the subject matter of the work.
 - What feelings or attitudes does the composition seem to evoke?
 - What specific elements or design choices in the composition account for these feelings?

Robert Moskowitz and Brice Marden

The uniting factor of drawing today is the impulse of artists to explore and to use whatever means, medium, or historical reference they need to make a drawing. Robert Moskowitz is a New York painter who for many years has searched for the iconic image, one that can be reduced to its essentials. Generally his process has been to borrow images from art historical sources, subjecting them to a severe graphic reduction and reinstalling them within a minimalist field to yield concise, enigmatic pictures. He has explored the potential of Rodin's, *The Thinker*, Giacometti's, *Standing Woman*, and Brancusi's, *Bird in Space*, for their emblematic potential. (None of these images were reproduced for this example, if you wish to see them visit www.artnet .com/ magazine/features/edelman/edelman3-12-03.asp).

The drawing, *Untitled*, fig. 11.37 is not of his process of borrowing images here his Minimalist

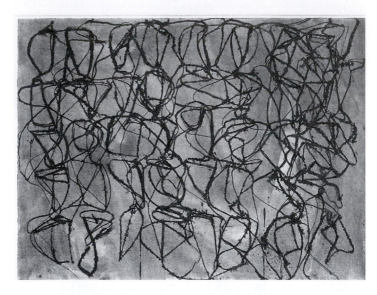

FIGURE 11.38
Brice Marden, (1938–), *Rain*. (1991). ink and colored ink on paper, 25¾ in. × 34¼ in. Gift of the Edward John Noble Foundation, Inc. and Jo Carole and Ronald S. Lauder. © The Museum of Modern Art/Licensed by SCALA/Art Resource, New York, NY. © Artists Rights Society (ARS), New York, NY. (499.1992).

FIGURE 11.37
Robert Moskowitz, (1935–), *Untitled*, (1962), graphite on paper, 23¾ in. × 18⅛ in., (60.33 cm. × 46.04 cm.). Purchase, with funds from the Neysa McMein Purchase Award. Collection of the Whitney Museum of American Art, New York, NY. 65.43.

background is evident in the flatness of the picture plane, but this flatness is contradicted by the suggestion of the form of a window shade. He sends a conflicting message to the viewer who understands that a shade covers a window, which assumes space and depth, but this rendering denies that. The drawing is about a tension between a textured and ripped shape, formed on a grid, the shade, and the smooth, opaque space below it, the suggested window. This space of the window is illuminated from the bottom. Moskowitz plays with the concept of the mythical circle, the halo, by illuminating the ring at the end of the string to pull the shade up and down. Here a ring is raised to the level of a halo. He chose the window shade because often in his early work he chose images of no importance, common subjects that carry no visual baggage. This drawing is an image reduced to its essentials. He has said, "in anything I do, I don't want the viewer" From *View*, San Francisco, 1988.

Brice Marden's work springs from an old and established culture. The *Cold Mountain* series (fig. 11.38) is based on the English translation of the eighth-century Chinese poet Han Shan. It was the poetry in both words and characters that inspired

this series of drawings, paintings, and prints. In *Cold Mountain*, Marden was under the twin influences of traditional Chinese calligraphic practices as well as the practices of Jackson Pollock, the Abstract Expressionist. All *Cold Mountain* drawings and prints contain a specific interior structure, which Marden obscures with his commanding draftsmanship. Following the strictly ordered set of rules for Chinese calligraphy, Marden started in the upper right-hand corner of the drawing and worked left and down, spreading his marks and lines across the picture plane in columns. Marden has limited himself to a small number of aesthetic options: with only swirling lines crisscrossing a flat surface, either on paper or canvas, creating interlocking structures of relative opacity or transparency. His strokes and marks can be crabbed or smooth, spiky or fluid, thick or thin, retiring or aggressive. Regardless of the limitations of this process, each drawing possesses its own character, tone, and aspect. Marden explores the idea of blank space, leaving entire areas of his paper serenely empty. In this series Marden worked much more spontaneously and freely, intuitively laying down lines without preplanning or following the grid.

JOURNAL FOCUS

The possibilities of drawing today are endless, only limited by your ability to think and imagine new directions. Start this journal entry by collecting images out of newspapers. This drawing will be a collage of these newspaper photos, and text glued to pages in your journal. To these pages add other drawn images and words on top of the first layer that have some meaning to your line of thought in choosing these images. For a second drawing take other images from the newspaper, and transfer them into the journal through a rubbing process. Paint their surface with the solvent Citra-Sol, a non-toxic household cleaner that you can purchase at the grocery store. Once you cover the image in Citra-Sol place it face down on the surface of the paper and using your pencil or the end of the paintbrush rub across the back of the image with hatching strokes to transfer it. You may add words, and line drawings on top of these rubbings. You may also rub pastel into the drawing or apply a light watercolor wash. For your third drawing, draw a grid on one page. Then draw a simple contour, outline drawing of any object over the grid. You may use your hand, a lightbulb, a wrench, a vase of flowers, and so on. The grid now provides you with divisions to experiment with various techniques and processes. You may fill one unit or four units at a time with one process. Techniques to use are hatching, ink wash, stippling, rubbing and erasing, chalk pastels, colored pencils, or modeling. When you are done the outline of the image will advance and recede out of the ground changing with each technique. These three exercises ask you to make choices intuitively, and intellectually. The drawing instructions also asked you to respond to your choices to determine your next step in a drawing. This is critical and creative thinking, and the process for inventing new directions in art.

MEDIA

Graphic thinking is drawing combined with the use of drawing tools, to connect an artist's pictorial vision with their personal style in creating artwork. Each artist will have an individual and a personal solution to the same problem, and there will be as many solutions and ways to do a drawing as there are artists and materials. Artists develop drawings by trial and error; one tool may suit one subject or idea, whereas another may be better suited to a different problem. Tools are a means to an end.

Through drawing, an artist can work out different solutions to a problem very quickly. Drawing is a thinking process, a planning process, and an experimenting process that allows you to manipulate, invent, and draw a variety of solutions to any drawing problem. A drawing can also be a finished piece in its own right, and not just a plan for another piece of work.

Robert Smithson's drawing, *Mud Flow* (fig. 12.1), is a perfect example of drawing as thinking. Smithson was a Conceptual and Installation artist working outside with the materials nature provided. He is most famous for the Spiral Jetty in the Great Salt Lake in Utah. A drawing such as *Mud Flow* would be how he envisioned constructing such a mud flow in nature.

FIGURE 12.1
Robert Smithson, (1938–1973), *Mud Flow,* (1969), crayon and felt pen on paper, 17½ in. × 23¾ in. (44.5 cm. × 60.3 cm.). Art © Robert Smithson/Licensed by VAGA, New York, NY. Photograph © 1996 The Whitney Museum of American Art, New York, NY. 77.99

The Italian word for "sketches" is *pensieri*, meaning "thoughts or rough drafts." Artists such as Leonardo da Vinci, used drawing to work out his ideas. In his drawing in fig 1.4, he was designing for a Maritime Assault Mechanism and a Device for Bending Beams. His intellectual curiosity and inventiveness filled volumes of drawing books, in which he saved his ideas for inventions that he could not build during his lifetime. The writing on the drawing was done as a mirror image. If you look closely at the writing, you can see that it is written backwards. He used mirror imaging to protect himself from people who would consider his inventions to be heresy, feeling that those drawings reflected opposition to the church doctrines which might be personally threatening. His vision surpassed that of his compatriots.

DRAWING TOOLS

Drawing tools vary from easy to difficult to use. Pencils are good for line drawings, for cross-hatching and sketching. Vine charcoal, charcoal pencils, Conté, and pen and ink, are excellent for value studies. Conté with white is exciting to use in figure drawing and on colored charcoal papers. Practicing with each tool will help you understand their individual properties. The act of drawing teaches drawing as well as verbal instructions.

Etude II, fig. 12.2 is a mixed media drawing where charcoal was embedded along with oil stick into a wax surface. The surface was scratched, heated with a blow dryer and the image worked into the bees-wax base.

The following is a list of materials generally assigned for beginning drawing courses:

- Drawing board (20 × 26 inches for 18 × 24 inch paper)
- Masking tape to attach the paper to the board (push pins or clips are another option)
- 18 × 24 inch newsprint pad
- 18 × 24 inch 80lb white paper pad
- Graphite drawing pencils (HB, 3B, and 6B)
- Kneaded eraser
- White plastic Mars eraser
- Vine charcoal (soft) and compressed charcoal
- Chamois and stumps (wrapped paper sticks for shading)
- Fixative (Blair no-odor workable fix is a good choice)
- Sharpie permanent ink pens, fine point
- India ink
- No. 10 or 12 Chinese brush
- Conté (black, white, or sanguine, in soft B)
- Woodless pencils
- Ebony pencils

FIGURE 12.2
Sandy Brooke, *Etude II*, (1992), oil stick, encaustic wax, chalk and oil paint on gessoed masonite, 17½ in. × 20 in. Courtesy of Boyd and Sandra Harris © Sandy Brooke, (2006).

DRY MEDIA

CHARCOAL

Vine charcoal is made from heating vine limbs in a kiln. Woods that are used include willow and beech. The end result is sticks about six inches long that may be either a hard, medium, or soft grade. The thin sticks of vine wear down quickly when used in a drawing and soon need to be replaced. Vine ranges from thin to thick sticks. I like Bob's Fine Vine, which is made by hand in Eugene, Oregon. The sticks are square and have a nice softness for drawing. Vine is easy to use, not considered permanent, and can be wiped off with a chamois. Students will find vine charcoal very user-friendly in that the first lines placed in a drawing can be wiped off and replaced with more lines. Wiping off is done with the chamois, your hand, or newsprint. Vine charcoal allows you to continually shift the planes and contours, thereby adjusting the perspective for the final composition.

Charcoal can be used on the side, tip, or corner edge of the stick. By changing the pressure, you change the value. Light pressure results in light lines or areas, and firm or heavy pressure creates dark lines or areas. Charcoal can also be removed with a kneaded eraser or tissue. It can be blended by rubbing it with your fingers or rubbing it with a stump known as a *tortillon*. The chamois is cleaned by washing it or flicking it against a hard surface to shake out the charcoal.

Compressed charcoal is rich, black, and velvety in tone. Compressed charcoal is good for creating both mass and line. It is often used after vine charcoal. However, it is harder to remove than vine charcoal, especially in a drawing that combines the two. The kneaded eraser, chamois, or white plastic eraser will lift some of the blackness off the paper but sometimes compressed charcoal will leave a trace or shadow of the mark being removed. Compressed charcoal can also be used with water to create a wash.

DRAWING EXERCISE 12.1
Using Wet Charcoal

Draw an outline of any cylinder with compressed charcoal, and darken one side or one plane. Use a Chinese soft hairbrush that you dip in water. Paint with the wet brush over the darkened plane of charcoal. The bristles of the brush fill with charcoal. If you lightly dip the brush in water, you can create gray lines or other surfaces in a gray value. Each time you dip the brush in the water, the value of the mark will be lighter. Don't rinse the brush out or swish it around in the water. Dip it only when the brush becomes dry and frayed; then use it to continue to manipulate the values on your cylinder.

Charcoal pencils, like all other pencils, have a light-to-dark rating: from light, at H, to dark, at 6B. A selection of HB, B, and 6B charcoal pencils provide a good range of light to dark. These wooden pencils can be sharpened to a point for fine and dark lines. Some charcoal pencils have a greasy quality. I prefer the drier charcoal pencils.

DRAWING EXERCISE 12.2
Experimenting with Charcoal

On a sheet of white paper, practice with vine charcoal first, then with compressed charcoal. Draw a circle with vine charcoal, holding the charcoal between your thumb, forefinger, and middle finger. Wipe strokes of charcoal from the side plane of the stick, in overlapping layers to cover the bottom half of your circle. Using your finger or a stump, rub the vine charcoal from the middle of the ball toward the top of the circle, stretching it across the top half of the circle while leaving one spot white. With light to firm pressure add another layer of vine charcoal over the bottom of the circle. If necessary, use the kneaded eraser to remove a small area at the top of the circle, which is sometimes referred to as a hot spot.

Do the same with the compressed charcoal, drawing a second circle beside the first. Compare the difference in value between these two types of charcoal.

Draw a three-inch square and fill it in with a layer of vine charcoal. Rub the charcoal gently into the paper with a tissue or stump. Using the compressed charcoal, draw lines on top of the first layer of vine charcoal. Make wide lines and thin lines. Rub some of the compressed charcoal into the layer of vine. You will see how the compressed charcoal being so much darker will stand out on the first layer of vine.

The preferred paper for charcoal drawings has a grainy texture, because grainy papers hold the charcoal in the paper better. (Newsprint, by contrast, has no grain.) The grainy papers hold the charcoal in between the tiny points of the grain, allowing the grain of the paper to show through a light layer of charcoal. A light layer of charcoal is considered a light to medium value in your drawing. Allowing the grain of the paper to show through adds another dimension to your drawing. Adding layers of charcoal will cover the grain eventually. Often beginners feel that they need to cover the paper with a heavy layer of charcoal, not allowing the grain to show, but in some drawings, using the grain is a fine alternative.

CONTÉ

Conté crayons come in soft, medium, and hard grades. Conté is a hard chalk made of compressed pigments in a clay base. It is available in shades of black, brown, white, and earth red. This tool may be handled in various ways. It is superior to charcoal in creating a finer line and is somewhat less messy. Conté is held between the fingers like charcoal. It can be used on its side plane or its end plane. On the end there are four corners and four surfaces between the corners that can be used for drawing.

Conté is applied at first by using hatching strokes and light pressure. On Canson paper, heavy weave, or deckled paper, the Conté can be lightly wiped across an area to create a light or medium value in the drawing. When rubbed in, the Conté smoothes out, but the surface has a dull quality. Place a layer of Conté on the rubbed layer but do not rub it. This top layer that was not rubbed in creates a richer final surface.

All Conté should be applied gradually, building it up in overlapping layers. Cross-hatching is used to build up the medium and dark values. Cross-hatching consists of diagonal, horizontal, and overlapping vertical strokes that are drawn on top of one another. Increasing the pressure of the stroke darkens areas of the drawing. White Conté can be used to "heighten" or to add light planes in a Conté drawing. A kneaded eraser will lift light strokes out and off the paper. Once the Conté is rubbed in, it is hard to remove. Turpentine will dissolve Conté to make a wash. Patti Fergus's drawing (fig. 12.3) is a Conté drawing. You can see where she used the

FIGURE 12.3
Patti Jean Fergus, black and white Conté on colored paper, student drawing, (1999), Oregon State University.

white Conté on the top plane of the figure's arm and in his hair. Perhaps you can see that the graininess of the Conté on the surface is different from the texture of charcoals.

GRAPHITE DRAWING PENCILS

Perhaps the most popular drawing medium is the **graphite pencil.** Graphite pencils are rated from light to dark or hard to soft. The B pencils get softer and blacker as the numbers increase from the F in the middle to HB, B, 2B, 3B, 4B, 5B, 6B, on to 9B. A 9B pencil is very soft, and the lead breaks easily. The H leads get harder and lighter the larger the number. Starting at H, the leads move to 2H and on to 6H, with the marks getting lighter with the larger numbers. Architects prefer the nonsmearing, light, hard leads for their drawings, whereas artists prefer the soft B leads for modeling or shading.

Pressure is important when drawing. The firmer the pressure on a pencil, the darker the line will be. Always start your drawing with light lines, using light pressure to make adjustments in the proportions or to move the lines. Darker lines may be drawn over the original lighter lines to alter the form. By not erasing your first lines, you establish a guide to where you do *not* want the lines to be, and you can then redraw more accurately by working off these first lines. Pencil drawing is cleaner than drawing with charcoal. The pencil can be used on its tip or on its side. There are two ways to hold a pencil. In the first illustration (fig. 12.4a), the index finger is flattened, not curled as when writing. In the second and third illustrations (figs. 12.4b and 12.4c), a second hand grip is demonstrated. Holding the pencil under the hand rather than on top allows you to push and pull the lines around the drawing, and also to move from thin to thick lines easily.

Ebony pencils have a silvery quality of medium dark value. They are soft and nice to draw with. These pencils have the same soft drawing point as the 6B, but they are silvery rather than black.

Woodless pencils are graphic pencils without a wood exterior. They are sticks of graphite, and they can be purchased in grades of B to 6B. They can be sharpened, and the shavings can be saved to use as powdered graphite for rubbing over areas of the drawing. The tip can be extended to a larger surface than the tip of a wood pencil, providing the artist with a different quality of line in drawing.

FIGURES 12.4
Hands holding the pencil in two positions.

DRAWING EXERCISE 12.3
Practicing Using Pencils

Practice with a variety of pencils on newsprint, using both hand positions. Work from the tip of the pencil, rolling it over to its side. Notice the change in line quality. Make a value scale (fig. 12.5) using the HB, 3B, and 6B pencils, plus any other pencil of which you are curious about its range. Draw a simple tower from light to dark, or lay out nine one-inch squares in a row. Leave the first square the white of the paper. In the second square, use the lightest pressure of your pencil, and apply only one layer of graphite. In each of the following boxes, increase the pressure and the number of overlapping layers of lead in each

FIGURE 12.5
Alisa Baker, practice marks.

succeeding box. Try to create a gradual scale from white to black through gray with each pencil.

Fig. 12.5 shows another form of practice with your pencils in which you create light to dark lines by changing the pressure on the pencil's point or side of the lead. Practice making lines, curls, waves, and hatching marks with all your pencils across a sheet of drawing paper.

Morgan Hager drew two-point perspective fig. 12.6 in pencil changing the values in the drawing by leaving some planes white and shading some planes either gray or black.

Lili Xiu's pencil drawing fig. 12.7 is a fine example of fine line hatching to create value changes in a drawing.

Graphite sticks are three inches long by a quarter-inch square. These flattened sticks have blunt ends rather than pointed ends. They are useful in making rubbings on which you lay a thin paper over a surface and then rub the stick across the back of the paper, transferring the image under the paper onto the surface. Graphite sticks are available in grades from B to 6B. This blunt tool is excellent for sketching and for loose gesture

FIGURE 12.6
Morgan Hager, pencil, two point perspective, (1992), student drawing, University of Oregon.

FIGURE 12.7
Lili Xiu, cross-hatched (graphite) pencil, (1999), student drawing, Oregon State University,

drawings. Being flat, the sticks allow the artist to wipe smooth planes of light gray onto the paper. Using the flat sides offers an alternative to hatching and scribbling to create surface, plane, and texture.

Powdered graphite is applied with a soft cloth or your fingers. If you are going to use your hands, gloves are mandatory. A disposable glove is fine, but never use any solvent without gloves on. Wiping graphite on paper creates a smooth, textured tone, it is best to wipe with a scrap of newsprint. It is very soft, and lines can be used to shape forms on top of it. Graphite can be dissolved in benzine or turpentine for wash effects. Powdered graphite is finely ground and packaged in squeeze tubes. It can be purchased in hardware stores and is often used for lubrication. It is pale and silvery in tone. On Bristol board, it can be rubbed to a rich silver tone, conveying soft light for shadows, window surfaces, or doorways.

SILVERPOINT

Silverpoint is a dry drawing medium in which you draw with a piece of firm metal that has a very sharp point. Silverpoint drawings are very delicate. The gray lines gradually change from the silver deposited

on the paper to a mellow brown color after exposure to air for a month. Every stroke shows in the drawing, and there is no erasing. Silverpoint is closely related to **etching**, a printmaking process, in the way that lines are laid down in fine hatching strokes.

The tool may be constructed of a long silver wire attached by wrapping it with string or cord to a stick. Wrap the string tightly around the wire and the stick. You may also put the wire in a mechanical pencil as you would load a piece of lead. A piece of wire one inch long is sufficient. To sharpen the point, rub the end across sandpaper to make a fine point. Silver wire can be purchased in jewelry and craft supply stores. In addition to using a silver wire, you can use copper wire, which will produce a dull green, or lead wire, which turns to blue-gray on the paper.

Silverpoint cannot be done on ordinary paper. The drawing surface should be a coated paper. A special ground must be prepared to hold the silver that is left by the marking action. Using a large watercolor brush, cover a smooth piece of two-ply bristol board or rag paper (BFK or Arches hot press) with Chinese (zinc) white watercolor that has been diluted with just enough water to keep it fluid. The paper should have two or three smooth coats and should be dry before you draw on it. You can also

coat cardboard, tagboard, or drawing paper. Since paper warps when dampened, to keep it flat, tape the sides of the paper down to a drawing board or a piece of smooth masonite before you start. The paper may also be coated with **casein,** a binder made from milk, or with a thin size of rabbit skin glue mixed with a fine abrasive material such as bone dust.

You can practice on clay-coated paper called "cameo." Cameo takes the marks, but the lines are not as clear as on the Chinese (zinc) white. Silverpoint creates a thin line of even width. Tones are produced by the way that lines are grouped together. Because silverpoint lines will not blur, gradations in value are achieved through systematically placing diagonal hatching lines. This is a painstaking process and a methodical procedure that produce an exquisite drawing. Silverpoint drawings are generally small, and students are encouraged to do preliminary studies in hard pencil such as a 6H or 4H.

Acrylic gesso can be used as a coating, when you draw with aluminum nails. It is the contact of metal on the white surface that reacts and leaves a mark or value change. Be careful not to gouge the surface. To make corrections, erase lightly and re-coat the area with the white ground.

Silverpoint should be completed without erasing. It is a difficult medium in which you get only one chance to place the marks. Corrections can be made only by reapplying the ground over the errant marks and redrawing the area. Pavel Tchelitchews drawing (fig. 12.8) *Two Figures* is a fine example of a silverpoint drawing.

COLORED PENCILS, CHALK PASTELS, AND OIL STICKS

Colored pencils come in two varieties—dry and water-soluble. They are applied in loose, cross-hatched patterns with light pressure in the

FIGURE 12.8
Pavel Tchelitchew, American, b. Russia, (1898–1957), *Two Figures*. (1937), silverpoint, sheet: 19⅛ in. × 12³/₁₆ in., (48.5 cm. × 31 cm.), framed: 251/4 in. × 171/4 in., (64.1 cm. × 43.8 cm.). Bequest of Oliver Burr Jennings, B.A. 1917, in honor of Miss Annie Burr Jennings. Yale University Art Gallery, New Haven, Connecticut.

beginning to take advantage of their transparency and semitransparency. The pencils should be sharpened to a fine point. When the hatching strokes are placed side-by-side, the result is solid tones of strong color. A medium pressure creates uniformity in tone. Greater pressure forces the color to fill in the hollows of the paper, eliminating the white of the paper and producing solid darker tones. Light pressure places the color on the raised portions of the paper's tooth, or texture. Leaving the white of the paper showing through lightens the value of the color. To build tones or to create a variance in the color, or to change value or intensity, apply layer upon layer of color. When white or light colors are applied using heavy pressure over darker layers of color, the result is a smooth, polished surface. This process is called **burnishing.** Unburnished areas can be lifted off by pressing the color with a kneaded eraser. Applying repeated layers of color with heavy pressure can produce a foggy quality called **wax bloom.** This can be eliminated by rubbing the surface of the drawing lightly with a soft cloth. A light application of fixative can also be used to prevent bloom.

Chalk pastels are soft and should be used with light pressure. Pastels are available in over 500 colors. Their texture is generally fine and even. Pastels create a rich surface when layered, that is, laying one color down and applying a second color on top of it. In layering pastels, you have options. (1) You may rub two colors together, and then you may rub another color into the first two. (2) You may rub with a stump, your finger, or a tissue. (3) You may make light layers that you do not rub. (4) You may make a layer, get it wet, let it dry, and put chalks on top of this ground. Secondary or tertiary colors can be mixed by layering one color on top of another. It is best to apply pastels with a light touch. Too much pressure creates a lot of chalk dust and eliminates the fine quality of the pastels.

Chalk pastels may be used on damp paper, dry paper, charcoal paper, and white drawing paper. Soft pastels or French pastels are made of dry pigment mixed with an aqueous binder and then pressed into round sticks. The sticks will dissolve in water, to make a light wash. Chalk pastels may be fixed. If you use a workable fix, such as Blair no-odor workable fix, you can add more layers on top of the fixed areas and then fix it again. Fixing prevents the layers from mixing. Some artists prefer not to fix pastels feeling the fix flattens the pastel.

When oil is added to the binder, a semihard pastel is created that is known as an **oil pastel.** Oil pastels dissolve in turpentine and thinner. They are less crumbly than chalk pastels. Hard pastels are a recent offering that are firmer and not so oily. Oil and hard pastels cannot be easily erased. Turpentine can dissolve the oil pastel to a small particle that can pass through the pores of your skin and then it will reside in your liver, wear gloves or protective hand cream to prevent any chemicals from entering your body.

Using pastels allows you to draw in color. A drawing may be constructed by overlapping layers of pastels, with the strokes cross-hatched side-by-side or overlapped. Rubbing will blend colors together. Rubbing too hard will muddy colors. Generally artists will lay in the middle values on the paper first. By starting the drawing with the middle values, you then add the darks and the lights.

Oil sticks are made of oil paint, wax, and linseed oil. Each manufacturer has a little different ratio among the ingredients. Oil sticks dry slowly. To counter the slow drying, both Winsor Newton and Gamblin make alkyd mediums, which dry fast. The medium should be painted on a primed surface first. Then, when you draw into it with the oil stick, it will enhance the drying time. Draw into the medium while it is wet. This surface will dry overnight, sealing the oil stick under the dry surface. You can continue with this process of drawing into the wet medium to create as many layers as you need. Oil sticks and oil paints can be used together in a composition. When you work with oils be sure you put gloves on.

The purest oil sticks with the least amount of wax and additives are made by R&F Pigment Sticks & Encaustic Paint, N.Y. (800-206-8088). These oil sticks are like having a tube of pure oil paint in a stick. They are well pigmented and do not get a thick, leathery skin on the outside of the stick when it dries. Also, they do not crack when dry. These sticks are not hard, waxy crayons but more a malleable paint stick. They make a smooth, richly colored stroke. R&F oil sticks are made of pure, refined linseed oil, beeswax, and purified natural plant waxes. No fillers or adulterants or inferior waxes are used. Oil sticks can be thinned with turpentine or oil. They should be used on a gesso surface or rabbit-skin glue primer.

WET MEDIA

PEN, BRUSH, AND INK

India ink, a very permanent ink, can be used with a brush or a quill pen. **Sumi inks** are also available for ink drawings. Pen points come in many styles: steel, lettering, crow-quill, bamboo, reed, and turkey-quill points. Each pen point makes a specific type of line. Using pen and ink produces a different quality of line from using pencil.

The crow-quill pen produces a delicate line that is thin, textureless, and straight. This fine line is used in cross-hatching to create modeling on forms. Steel-point pens have tips that range from very thin to thick. The lettering points make wide strokes and can make beautiful curves.

Landscape is a good subject for pen and ink drawings. The textures of trees and plants are easy to draw in pen and ink. A wash can be used to change the values in the picture. Line can be placed under the wash or over a dry wash.

Brushes also come in a number of types and sizes. They range in size 0 to 12 and up. A size 6 or 8 in a pointed brush is usually good for line draw-ing. The size 12 flat is good for making washes. A brush creates a flowing and an expressive line. The brush will hold more ink than the pen, but the brush is harder to control.

Wet and dry media may be used together in a drawing. To practice, start a drawing in charcoal pencil, and then put a light **ink wash** over it, using a brush. After it dries, add charcoal pencil lines or hatching on top of the wash, which can then be covered with another layer of wash. Each layer of wash darkens the one before it. Wash dries lighter than straight ink, allowing for great subtleties in value changes. Ink straight out of the bottle oblit-erates whatever it covers. As long as the ink is di-luted with water, it can be layered with other media and is semitransparent. The amount of water added to ink in a wash determines the value. The more water there is, the lighter the value.

In drawings, ink lines are manipulated from thin to thick. Light falling on a form can be re-flected by drawing thin lines that will seem like bright light. Thick lines delineate weight and shadow. Air, straw, fabric, and other textures can be created in pen and ink. Jennifer Springstead's ink drawing (fig. 12.9) is fairly precise, but still

FIGURE 12.9
Jennifer Springstead, ink wash, (1999), student drawing, Oregon State University.

FIGURE 12.10
Franz Kline, (1910–1962), *Two Studies for Shenandoah Wall*, (1957–1958), sumi ink on paper, Drawing, 8 cm. × 53.5 cm. (3.5 in. × 21 in.). Works on Paper: 1945–1975. Washington Art Consortium Virginia Wright Fund. Photographer: Paul McCapia. © The Franz Kline Estate/Artists Rights Society (ARS), New York, NY. 74.11.

there is a nice flow in the shadows from the ink washes. In contrast the lines in fig. 12.10 by Franz Kline are bold and strong expressionistic lines. These bold Sumi ink lines demonstrate the powerful effect that an ink line can create.

BALLPOINT, FELT TIP, AND ROLLER BALL PENS

Drawing with a pen has a distinct advantage over pencil in that you can't erase. Pens are easy to use and good for simple, loose outlines. The sketchy, loose pen line tends to be energetic. Free-flowing ink pens are excellent in creating texture in a drawing. The nonpermanent colored inks will fade if exposed to direct sunlight. You can test for fading by making an ink drawing and then covering half of the drawing with lightproof paper, leaving the other half of the paper exposed to direct sunlight for two or three weeks.

Free-flowing ink pens are excellent to use for gesture drawing. Since you can't erase, you will find a certain freedom in knowing that you are going forward. A flowing line from an ink pen keeps your drawing moving ahead from start to finish without stopping. When you stop to correct lines, you can lose your train of thought. Each decision in a drawing with ink can be replaced with overlapping lines representing your new train of thought or vision.

DRAWING PAPERS

PAPER TYPES

Newsprint The cheapest paper available is **newsprint.** Manufactured from wood pulp, newsprint has a smooth surface best used for studies, quick gesture drawings, or the planning phase. The lack of **tooth,** or texture, to the paper's surface provides the artist no resistance in a long drawing. Newsprint will become yellow and crumble over time, and it isn't strong enough to handle wet media. It is also somewhat misleading, as drawing media will slide easily over the surface, letting you feel that you understand this media, only to find out when you move to 80-pound white drawing paper that the drawing tools handle completely differently.

White Drawing Paper, or Bond Paper White **drawing paper,** also called **bond paper,** is sold in various weights. Of these weights, 60-pound paper is very thin or lightweight and good only for pencil drawings. You will find that 80-pound paper is better for drawing with wet media and charcoal, and it withstands erasing better. Finally, 120-pound or 140-pound papers are wonderful to work on. You can work and rework the surface without tearing the paper, and when you use wet media, the papers resist ripping. If the paper is taped down, it will

often dry flat. The 80-pound papers have a little tooth; the 120- to 140-pound papers have more tooth.

Good papers come in three finishes: **hot-pressed, cold-pressed,** and **rough. Hot-pressed** paper is smooth and good for ink wash and pencil drawings. Hot-pressed paper is like Bristol board and illustration boards. The **cold-pressed,** high-quality papers, such as Arches BFK, Stonehenge, and Copperplate, are traditionally printmaking papers, but they are also great drawing papers. These quality papers are sold by the sheet.

Rag Paper This type of paper is made of 100 percent cotton rag. **Rag paper** is generally sold by the sheet and is more expensive than other papers, but it is wonderful to work on. BFK is 90- to 140-pound paper; Classico Fabriano is 140-pound; and Murillo (Fabriano) from Italy is 360-pound. Other rag papers are Arches, Copperplate Deluxe, German Etching, Italia, and Strathmore Artists. After you practice on pulp papers and feel confident, try a piece of rag paper for an extended drawing. Experienced artists pick their paper by the way the surface feels. Every rag paper has a different surface quality. Some find that it is easiest to draw on, because the marks stay clearly on the surface, and an erasure doesn't damage the paper.

Charcoal Paper Tends to have a rough surface, **charcoal paper** has a lot of tooth. Tooth can be an imprinted texture from a mold that was combined with sand. Charcoal paper comes in various colors, from beige to pink to gray, and is often referred to as Canson, the maker's name. It can be used with vine or compressed charcoal, charcoal pencils, chalk pastels, oil pastels, and Conté.

Rice Paper An extremely sturdy paper, **rice paper** traditionally was used in Oriental brush and ink drawing. It has a soft, absorbent ground. You can use it with chalk pastels, watercolors, or gouache. I have painted on it with acrylics and used it in *Chinécolle,* a collage printing process.

Watercolor Papers Are generally heavier-weight papers used for watercolor paintings and overlapping washes, but they may also be used for drawing. The paper should be taped securely to a board before wetting it. Traditionally, paper tape was used to secure the paper to the board on all sides. Masking tape will work, but it should be wide. The new blue painter's tape is better than regular masking tape. The taping holds the paper so that after the drawing is done, the paper will dry flat. It will ripple and warp during the wetting, but it will shrink and dry back to a flat paper. Generally, watercolor paper has a rough surface. In addition, there is **cold press,** which is moderately textured and matte, and **hot press,** which has the smoothest and least absorbent surface.

Paper for Class Work Paper for this use should be inexpensive. Strathmore, Murillo, and recycled papers are available in 18 × 24″ pads. Practice on this paper, and then treat yourself to a sheet of rag when you have worked through a series of drawing exercises.

Bristol Board Has a hard surface, and comes in two finishes. **Plate,** or smooth finish, is perfect for pen and ink or very hard pencils, **Vellum,** or kid finish, has a slight tooth and works well with rubbed pen and graphite combinations or fine pencil work. It also varies by weight, from a 90-pound to a 200-pound paper.

Illustration Board Is more board like than Bristol board. It is composed of various layers of

FIGURE 12.11
Ellsworth Kelly, (1923), *Oak Leaves,* (1969), graphite, 73.5 cm. × 58 cm. Virginia Wright Fund. The Washington Consortium. Photographer: Paul Brower. 75.2.

surfaced papers mounted on cardboard. It is expensive but durable and has a strong resistance to wrinkling when wet. It is used for pen and ink or clean line work.

OTHER DRAWING TOOLS

ERASERS

A **kneaded eraser** is a drawing tool as well as a tool for erasing. A kneaded eraser absorbs charcoal and Conté. The eraser is made of a soft, gray, gumlike material. To erase an area, press the eraser into the surface and lift the area out. As the eraser gets dirty, it will be unusable until you clean it by stretching the eraser out and rolling it over on itself, back into a small ball. This type of cleaning is similar to pulling taffy. Try not to pull the eraser apart. Stretch it, and then fold it back together. It is very pliable and can be formed into a drawing point by twisting a small section of the kneaded eraser into a pencil point. The kneaded eraser can also be helpful in erasing out narrow areas in a drawing.

A **plastic eraser,** like the white Staedtler Mars eraser, will lift charcoal out as you rub over the area. It also removes pencil and Conté. The surface of the plastic eraser will get dirty. It stops working when it is covered in charcoal or lead. To clean it, rub the dark areas of the eraser on a white area of the paper until the charcoal is rubbed off and the eraser is white again. The edge of the paper is usually clean and available, or you can keep a piece of scratch paper next to you.

SPRAY-FIX

Charcoal can be spray-fixed, but some artists prefer not to fix the surface because doing so sometimes changes the texture of the charcoal. Chalk pastels can be fixed, but often the fix dissolves the top layer of pastel. If they are not fixed and you frame a pastel drawing, the pastel can lift off and stick to the glass. You might want to plan on adding another layer after fixing the drawing. Spray lightly on pastels. Conté drawings should also be fixed. The protective coating of fixative will prevent smudging. Workable fix allows you to work back into a drawing after it has been sprayed. In this way, you can add another layer to the drawing. It is a little hard to erase parts of a drawing that have been spray-fixed with workable fix, but adding layers is easy. To apply fix, hold the can nine to twelve inches over the surface of the drawing, and spray slowly, by moving horizontally from side to side. Do this outdoors or in a well-ventilated room.

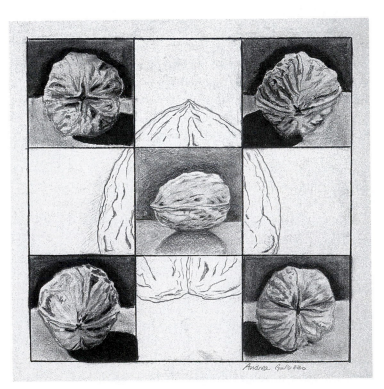

FIGURE 12.12
Andrea Galluzzo, *Interpretation of a walnut with the grid and values,* (1999), charcoal and pencil, student drawing.

INDEX